Exhibiting Irishness

Manchester University Press

STUDIES IN IMPERIALISM

When the 'Studies in Imperialism' series was founded by Professor John M. MacKenzie more than thirty years ago, emphasis was laid upon the conviction that 'imperialism as a cultural phenomenon had as significant an effect on the dominant as on the subordinate societies'. With well over a hundred titles now published, this remains the prime concern of the series. Cross-disciplinary work has indeed appeared covering the full spectrum of cultural phenomena, as well as examining aspects of gender and sex, frontiers and law, science and the environment, language and literature, migration and patriotic societies, and much else. Moreover, the series has always wished to present comparative work on European and American imperialism, and particularly welcomes the submission of books in these areas. The fascination with imperialism, in all its aspects, shows no sign of abating, and this series will continue to lead the way in encouraging the widest possible range of studies in the field. 'Studies in Imperialism' is fully organic in its development, always seeking to be at the cutting edge, responding to the latest interests of scholars and the needs of this ever-expanding area of scholarship.

General editors:

Andrew Thompson, Professor of Global and Imperial History at Nuffield College, Oxford
Alan Lester, Professor of Historical Geography at University of Sussex and LaTrobe University

Founding editor:

Emeritus Professor John MacKenzie

Robert Bickers, University of Bristol
Christopher L. Brown, Columbia University
Pratik Chakrabarti, University of Houston
Elizabeth Elbourne, McGill University
Bronwen Everill, University of Cambridge
Kate Fullagar, Australian Catholic University
Chandrika Kaul, University of St Andrews
Dane Kennedy, George Washington University
Shino Konishi, Australian Catholic University
Philippa Levine, University of Texas at Austin
Kirsten McKenzie, University of Sydney
Tinashe Nyamunda, University of Pretoria
Dexnell Peters, University of the West Indies
Sujit Sivasundaram, University of Cambridge
Angela Wanhalla, University of Otago
Stuart Ward, University of Copenhagen

To buy or to find out more about the books currently available in this series, please go to: https://manchesteruniversitypress.co.uk/series/studies-in-imperialism/

Exhibiting Irishness

Empire, race, and nation, 1850–1970

Shahmima Akhtar

MANCHESTER UNIVERSITY PRESS

Copyright © Shahmima Akhtar 2024

The right of Shahmima Akhtar to be identified as the author of this work has been asserted in accordance with the Copyright, Designs and Patents Act 1988.

Published by Manchester University Press
Oxford Road, Manchester, M13 9PL

www.manchesteruniversitypress.co.uk

British Library Cataloguing-in-Publication Data
A catalogue record for this book is available from the British Library

ISBN 978 1 5261 5726 3 hardback

First published 2024

The publisher has no responsibility for the persistence or accuracy of URLs for any external or third-party internet websites referred to in this book, and does not guarantee that any content on such websites is, or will remain, accurate or appropriate.

Typeset by Newgen Publishing UK

Contents

List of figures	*page* vi
Acknowledgements	viii
Introduction: Irish identities on display	1
1 Famine and industry: Ireland's original exhibitions	26
2 Diaspora and migration: Displayed Ireland abroad	55
3 Home Rule and capitalism: Irish modernities	96
4 Interwar and partition: A divided Ireland	127
5 Debt and disagreement: Post-colonial Ireland	169
Conclusion: Ireland on display	197
Bibliography	203
Index	226

Figures

1.1	The exterior of the Great Exhibition building	page 28
1.2	Return of the number of children admitted between the hours of 9 a.m. and 11 a.m.	34
1.3	Front view of the Irish Exhibition building	36
1.4	Centre Hall of the Irish Industrial Exhibition building	39
2.1	'Her Excellency the Countess of Aberdeen and her Pages at the St. Patrick's Eve Pageant of Irish Industries'	64
2.2	Key to the Midway Plaisance	67
2.3	Donegal Castle – the Irish Village, Midway Plaisance	70
2.4	Postcard of 'Irish Village, Midway Plaisance'	71
2.5	Ground floor plan of Aberdeen's Irish Industrial Village	73
2.6	A bright worker	75
2.7	Lacemaking in the Irish Village	76
2.8	Birds-eye view of the Irish Village	79
3.1	'The Irish Village at the Franco-British Exhibition'	102
3.2	'Main Entrance, Ballymaclinton' postcard	104
3.3	Tuberculosis exhibit at the Franco-British Exhibition with 'healthy' and 'unhealthy' rooms	106
3.4	'Post Office, Ballymaclinton (M'Clinton's town, erected by the makers of M'Clinton's Soap') postcard	108
3.5	'Colleen Dancing at Ballymaclinton' postcard	109
3.6	'Colleens' riding donkeys at Ballymaclinton	116
4.1	Map of the British Empire Exhibition	130
4.2	Palace of Industry	134
4.3	Plan of Exhibition	142
4.4	Irish Pavilion	144
4.5	'Post Office and Tower, The Clachan. Empire Exhibition, Scotland 1938' postcard	146
4.6	41: Industries, Shipping, and Travel; 42: Agriculture, Fisheries, and Forestry	149

4.7	Michael Scott's drawings (1937–39)	153
4.8	Plan of the Pavilion	157
5.1	Ireland's Pavilion, World's Fair, 1964–65	174
5.2	Watercolour sketch of draft drawings of Ireland Pavilion	176
5.3	Map of the New York World's Fair, 1964	180
5.4	Extract from the *Irish Press* (10 April 1964)	183

Acknowledgements

I wish to extend thanks to the Arts and Humanities Research Council, the Royal Historical Society, and the Past and Present Society for the funding that made this research possible. I have been able to visit archives in Dublin, Washington, DC, New York, and Ottawa through their financial support. I have benefited from the generous feedback of colleagues in various reading groups, seminar series, and national and international conferences. I am grateful to all those who engaged with my ideas and offered new ways of thinking through my research material. In particular, Professor Mo Moulton and Dr Nathan Cardon have been immensely helpful in offering expertise, support, and guidance on earlier drafts of this work. A special thanks to Professor Sadiah Qureshi who both advised on the early research for this book and has been an invaluable mentor in navigating the world of academia. Professor Margot Finn, Professor Matthew Hilton, and Dr Saima Nasar have been unique sources of inspiration and help throughout my journey. To various friends, I am thankful for your supportive ear as ideas changed and developed. Hannah Elias and Sundeep Lidher – I am truly grateful for our friendship. My family have been a precious fount of encouragement throughout. To my partner Rob, thank you for being such an excellent hiking companion, climbing partner, and wonderful husband. And finally, to my parents, I am thankful for your superb food, constant love, and steadfast belief. I am grateful to everyone who played a role in the writing of this book.

Introduction: Irish identities on display

In 1851 a vision of Ireland arrived in London. In Crystal Palace an Irish Village stood proud in the Irish Pavilion in Hyde Park, replete with textile looms, printing presses, fabrics, furniture, and harps, as well as glass and silver objects interspersed with sculptures and paintings, carriages, and locomotives. The international exhibition phenomena began with the Great Exhibition of Arts and Industry in 1851, with its high ceilings and grand rooms packed to the rafters with objects to recreate the British Empire for mass consumption. Visitors walked from object to object, taking in the lessons from each exhibit, before pausing at the end of each aisle to reflect on any new opinions formed and moving to a new stall, a new pavilion, another section of the exhibition to take in the engineering, agriculture, art, and human society on display. Within the broad cabinets filled with innumerable objects, one was expected to absorb the teachings of nineteenth-century society, those of the hierarchies between states, the superiority of Britain, and the dependency and hinted inferiority of Britain's colonies. Yet Ireland was an anomaly in this gargantuan display. Bordered between the metropole and the periphery of the empire, its existence served to obfuscate the teachings of global power. The country was uniquely able to use the imperial form of display to authenticate its own narratives, construct its own stories, and display its own objects in an independent display of its country and people. Altogether, this book uncovers how Irishness was displayed across two centuries in diverse historical and geographical spaces.

Many exhibition organisers spent vast sums on building a temporary structure, hiring actors, and soliciting businesses to offer their wares in an advertisement of goods for the masses. The visuals of a flag, a costume, and a piece of bog yew, for example, reinforced a narrative of Ireland centred on hope and prosperity at different historical junctures. For instance, in the Cork Exhibition of 1852, everything from Irish salt to Irish furniture and even an Irish harp circulated in an omnipresent display of Irishness.[1] While this specific Exhibition is discussed in Chapter 1, several observations regarding the broader typology of Irish display can be made. Firstly,

exhibitions were always a spectacle – they responded to desires of entertainment as well as learning; secondly, display required vast sums of money – while those in positions of power and privilege constructed the narrative of the country, they relied on the labour of the public to consume and the performance of the exhibited to succeed. Efforts at creating an authentic image of Ireland were sustained by the ephemeral nature of display which encouraged constant adaptability and change. Throughout my chapters, I demonstrate how the unique formation of exhibitions enables a rich cultural analysis of Irish socio-political identities.

The question of how Irish men and women navigated the imperial space of exhibitions provides the guiding focus of this book. The networks between the Irish who laboured to construct their own national and international stories – becoming active agents who selected the goods on show – the specific industries performed, and the companies advertised are considered throughout. The book does this by first focusing on how Irish men and women utilised experimentation and contradiction to allow competing forms of Irishness to proliferate alongside each other. Hostile, consensual, or peaceful visions of Ireland emerged in the context of Irish political and economic tension to convince visitors of their productive reality. Secondly, the ways in which adaptability became central to Irish self-fashioning through display are also interrogated in detail. This book uncovers how the story of Ireland on display changes over the nineteenth and twentieth centuries during key historical moments in the relationship between Ireland and Britain.

A transatlantic lens pervades each of the chapters and exposes the connections between the colonial, imperial, national, and international in Britain and the United States to illustrate the familiar motifs of Ireland in popular circulation. The focus on exhibited Irish actors (mainly women) ensures a perspective considering divergences between the ideology of the organisers and the experiences of the actors and visitors. Analysing the tensions within Irish exhibitions and broader Irish politics makes clear the instability of depicting Irishness for organisers. For instance, images of contentment within the Union emerged alongside volatile independence debates in the early twentieth century, as Chapter 3 discusses. Specifically, a broad time frame enables comparisons to be formed and reinscribes social, political, and cultural agency to Irish men and women who were intimately involved in shaping their identities through display.

The book's chapters map out the visual cartography of Irishness to identify and deconstruct the multiplicities of negotiation involved in making and transforming Irishness by individual Irish men and women through exhibitions.[2] I take display to mean the performance of self, Irish identity in this instance, as related to identities constructed both individually and as part

of a collective. The term 'display' carries the means through which identity is produced in a public and prominent way, in fairs and national and international exhibitions. I take the visual to be the literal manifestation of these performances of selfhood – how identities were imagined and what was seen and put on show. My understanding of display and the visual connects images of Irishness to how it was produced within exhibits. I focus on 'seeing' as exhibitions centred the visual, and so contemporaries and visitors alike prioritised observation and looking as essential to how they understood the fair and themselves. By tracing the shifting discourses of Irishness, the book's chapters reveal how perceptions of Ireland in exhibitions interacted with the Ireland outside these venues. Crucially, the ebb and flow of Irish symbolism enabled workable juxtapositions to reconcile disconnects between the utopian image of the exhibition and the lived reality of Irish politics.

By investigating a range of Irish identities that covers home and diaspora, Protestant and Catholic, and the north and south of the country, I uniquely expose the rootedness of an Irish culture created in the visual realm by the everyday actions of Irish men and women in multiple spheres. This book examines how exhibitions of Irishness imagined solutions to a multiplicity of Ireland's perceived problems. For instance, Irish men and women used display to act interchangeably as a catalyst to revive rural industry and support newer manufactures, or as a base through which to stem migration and facilitate tourism as well as trade. Each exhibition displayed diverse notions of Irish identity. The unique visions of Irishness largely concerned 'development' and 'progress' in the nineteenth century, and state building and commerce in the twentieth century.

I use printed material produced by and about several key international exhibitions staged between 1851 and 1967, such as catalogues, guidebooks, maps, and descriptive listings, to uncover the creative and multifaceted textual and visual topography of historical constructions of Irishness produced by fair organisers.[3] The chapters that follow examine a wealth of material related to periodicals, editorials, and articles printed in newspapers to complement the exhibition's display from the 1850s to the 1960s, which exposes productive avenues to read visitors' responses, criticisms, and legacies of the displays. To broaden the focus of interpretation, visual sources that illustrate the significance of symbols of Ireland in the form of postcards, photographs, and paintings are read in conjunction with meeting minutes and exhibition committee reports. Within the constructed world of the exhibition, also referred to as the fairground, exhibited Irish men, women, and children worked for several months at a time. The specifics of lived Irish experience are evoked in their letters home and personal diaries. Irish contemporaries took part in the various industries displayed, posed

for photographs, waited and served, and generally made real the fiction of a displayed Ireland. Overall, it is difficult to authentically reconstruct the experiences and reactions of visitors to these exhibitions, and therefore my analysis largely focuses on ephemera and material culture.[4] In the absence of visitor voices, I use the richness of the available sources to analyse imaginations of Irishness within an inclusive narrative framework in the fairground itself but also outside of it (by tracing the purchase of souvenirs, for example).

At the heart of this book's argument is a recognition that the ambitions of the exhibition organisers rarely mapped on to visitor experiences. Irrespective of the much-valued opportunity for didactic instruction that funders and organisers touted, visitor experiences ranged from cursory interest to general entertainment, and, for some, a piqued enthusiasm in a new curiosity they had seen. While world fairs sought to order human thought and action into a neatly constructed vision of knowledge and progress, contemporaries defied this logic and acted in unpredictable ways. This book traces the disorderly interactions of audiences with Ireland's displays during important junctures in the country's nation and state building. After the tragedy of the Famine, many Irish men and women embarked on a course of exhibiting Ireland and its peoples through international and national exhibitions that lasted until the late twentieth century. These exhibits served various functions, including improving the morale of the country, promoting industry, or creating a sense of nationhood. Exhibitions were grand spectacles that showcased the manufactures, industries, arts, technologies, histories, and communities of countries on an international platform for the consumption of millions of visitors. They were mainly located in capital cities around the world, in London, New York, Berlin, Paris, and Dublin, among others, and typically lasted for five to six months at a time.

This book charts how exhibition organisers employed objects and people in a variety of stalls, villages, or pavilions to create an Ireland on display. These models of Irishness relied on language, dress, and behaviour to offer convincing visions of the country. From the 1850s to the 1960s, organisers alternatively presented Ireland through antiquities and treasures from the land such as bog oak, or else through commodified tokens of Irish culture such as shamrocks or spinners, and even later as a vast technocratic economy with the display of Shannon Airport and the Shannon hydroelectric scheme. Exhibits were organised by a host of different historical actors ranging from industrialists and entrepreneurs to philanthropists and national bodies. Several imaginations of an Irish home emerged on the fairground for the consumption of visitors, who in the 1850s were largely working class, and in the 1890s mainly Irish migrants. In the early to mid-twentieth century, the exhibitions largely attracted British and Irish nationals, while in

later decades exhibitions mainly appealed to international diplomatic audiences. Visitor perceptions of the displayed Irish varied according to negative historical prejudices, a hostile contemporary political climate, and concerns over Irish independence.

Historically, long-held racial tropes of Irish duplicity, brutality, and ignorance increased after post-Famine reconstruction in the nineteenth century. An imperial rubric of discrimination stressed Irish deficiency, and Irish peoples were conceived of as violent, stupid Catholics contrasted with the perceived 'rational' Protestant work ethic of the English.[5] Simian portrayals of Irish men and women within British satire translated into aphorisms of the Irish as unclean, uncivilised, and barbarous.[6] A central argument of this book is that epistemological notions of an 'Irish' race and ethnicity were visualised in the fairground, with display offering a valuable platform to disprove racialised stereotypes of the Irish and perform a political allyship with white Britons. The book exposes how racialised discourse of the Irish as a lesser type of a white ethnicity firmly located in the 'Other' sphere was rooted in the popular imperial consciousness. Thereby, exhibitions became a crucial site of popular visual resistance.

In the nineteenth and twentieth centuries, exhibitions captured the imagination of organisers and visitors. Contemporaries held display to be a unique, profitable, and unsurpassed forum for celebrating a country's wares, vying for increased trade, and consolidating national mores. They enabled participating countries to navigate the period's emerging globalisation by straddling the temporal spheres of past, present, and future. Organisers could highlight the supposed backwardness of the past, illuminate the successes of the present, and imagine the triumphs of the future within the creative vitality of exhibitions.

The value of exhibitions comes from the presence they created in terms of the image of Ireland and the significant labour this required. These huge endeavours had powerful potential: planned for years, exhibited over months, and their goods circulated over decades. Their impact carried on for centuries after, with each exhibition constantly referring to a previous one to learn, adapt, and perfect an Ireland on display. Organisers and visitors engaged in the fiction of the fair to affirm, mediate, and even transform their politics. The popular consumption of Ireland flitted between utilising stereotypes of the country to create an accessible, attractive vision of it to offering a contrast to English versions of themselves. The exhibitions I investigate prove the animus between Britain and Ireland on a global stage while highlighting the attempts to reconcile conflicting discourses of Irish identity.

Through interrogating the synecdochal representations of Ireland available for popular audiences, the many functions of adaptability within Irishness become clear. While fluidity became central to discourses of Ireland,

it also imposed an unpredictable character to its exhibits, which extended to visitor responses. The emblems and motifs of Ireland encompassed shifting political expressions and enveloped divergences in a permanent tension. The exhibition platform in its transitory, ephemeral nature enabled nuanced constructions of Irishness to exist alongside one another that revealed the politics of its organisers and the biases of the visitors. Discrete historical moments intersected with turbulent Irish politics to alternatively visualise rurality, quaintness, and rusticity – or else industry, technology, and modernity – all within an accessible idyll.

This cultural history of Irish identity on display highlights the specifics of the Irish experience within modern Europe and indeed former European colonies by bringing to light the particular formulation of the country as a colony, as a place undergoing tremendous change in the wake of recurring famine and disasters, a country suffering continued political unrest in the 1800s and 1900s and extremely high levels of emigration but yet engaging in the costly process of exhibitions, both being exhibited and organising exhibitions. Although exhibitions were cultural sources that organisers claimed as apolitical, the frivolous characteristics of display transformed such performance into a rich site for varied Irish political expression. Exhibitions were a capitalist project and a method to sustain commerce and create trade and profit over international borders. Indeed, the export of Irishness for entertainment purposes was as much a creative as it was a profit-making endeavour. As utopian visions, exhibitions are immensely revealing of the dream of Ireland devoid of the reality of Irish politics.

Exhibiting Irishness tells the story of Ireland on display and carves new terrain in the existing literature on exhibitions produced by historians, anthropologists, geographers, and museum studies professionals over the past few decades.[7] It is the only book to systematically consider Irish exhibitions across two centuries to reveal how the cultural praxis of display utilised experimentation and contradiction to allow multiple manifestations of Irishness to proliferate in tandem. Within the omnipresent nature of the fairground, reactionary, revolutionary, or conciliatory and peaceful visions of Ireland circulated in the backdrop of Irish social and political tensions. The compression of time and space in this ideal view of Ireland became subsumed by paradoxes and yet nevertheless allowed tangible, if hyperbolic, forms of the country to exist. The exigencies of Irishness relied on artifice within the phantasmagoria of display and utilised marketable identifications of Ireland, which became key signifiers of Irishness within contested geographic and political boundaries, as the book's chapters uncover. Scholarship identifies the importance of exhibitions in the international markets, the development of science, and identity formation.[8] Existing histories on exhibitions have primarily focused on colonised extra-Europeans

such as Africans and South Asians, and so ignored exhibited Europeans such as the Irish.[9] Yet, as an internally colonised people, exhibited Irish performers provide a rich case study for examining the multifaceted, changing nature of transnational exhibitionary politics.

Historians of Ireland have attended to the ways in which politics has divided the nation.[10] Originally, *Exhibiting Irishness* explains how the visual and cultural are fundamental to understanding Irish identity.[11] It does this by configuring Ireland through the multiplicity of its national, political, and regional imaginings and thus reworks Irish agency into narratives of the state and policy. It thereby avoids the false uniformity associated with the Irish experience and instead foregrounds the divergences of different political groups. Importantly, international exhibitions visualise how state structures interweaved with an Irish reality in increasingly disorientating ways. For instance, I shed light on how the meaning and power of exhibitions were cultivated to construct Irishness for vast audiences.[12] In this way this book brings the existing literature on Ireland's political, social, and cultural history together with histories on visual spaces as important arenas for knowledge production and identity formation, particularly within a contested imperial framework.[13] By interrogating exhibitions of the Irish in the country's formative period, it contributes to the expansion of Irish studies by analysing the manifest ways Ireland was created through display. The book further illustrates the animus that existed between Britain and Ireland in this period along unionist, nationalist, Protestant, and Catholic lines through interrogating the visual and printed material of the exhibitions.

By recasting how Irish contemporaries used the imperial platform of exhibitions to imagine their own state building, we can reframe the way we think about discursive Irish identities. For instance, the Irish challenged their colonial status in fairs by gradually taking ownership over their display and using it as an important part of their self-definition. This book expands debates about Irish identities as the essential malleability of Irishness across historical periods becomes clear. There was no singular and cohesive identity of Irishness. Likewise, adaptability and disconnect were fundamental to the exhibition project, and visitors persistently negotiated and challenged the organisers' ambitions. Away from earlier conceptions of exhibitions that have highlighted perceived unity and evolutionary teachings, more recent research on exhibitions emphasises their inherent instability. The case study of Ireland furthers this reading of exhibitions, as it reveals how fragmentation became key to Irish identity because it was in constant formulation and flux. Multiple versions of Irishness co-existed. Display was therefore important to both identity formation and to the fluid constructions of the Irish nation and its politics. Fracture thereby became a necessary and productive element of Irish identity making more broadly, both within display and outside of it.

The book maps different formations of nationalism according to tumultuous moments in Irish political history. At each moment, organisers curated a vision of an Irish nationalism on the exhibition platform to respond to the needs of Irish men and women in various localities and geographies. Elizabeth Crooke understands the nation as a political concept that implies a distinct national past, culture, and identity.[14] In the fairground a nostalgic version of an Irish past signalled an Irish nationalism by championing notable historic objects and symbols as being the most reminiscent of an Irish character. This varied nationalism was a feature of the fair itself as exhibitions allowed for multiplicity and hybridity in a way that political parties or cultural movements were unable to. Irishness alternatively manifested as Gaelic, as traditional, and as rooted in a Celtic past. In the nineteenth century, 'Anglo-Ireland decided to write itself out of its English-oriented ancestral history and instead to trace its cultural origins in a nationally Irish … frame of reference,' notes Joep Leerssen.[15] While Leerssen focuses on cultural projects related to language and sport, exhibitions also became a notable platform for these debates and priorities to be displayed in the contexts of imperialism, nationalism, and capitalism.

This book takes inspiration from scholars of Ireland and Empire such as Kevin Kenny and Eóin Flannery, as my cumulative concern is to read participation in or proximity to empire as markers of the complex multiplicity of Irish histories themselves in uncovering the specific transformations of Irish identity across different periods.[16] Despite extensive literature on Ireland and the British Empire, there has been no systematic consideration of Ireland's historic position within British imperialism, colonialism, and neocolonialism through display. The exhibitions were imperial in organisation as the state's purported aim was to celebrate and advertise the British Empire, but nations collated their own exhibits, and so adaptability enabled an independent image of Ireland to emerge within the confines of an imperial platform. Exhibitions as a historical category of analysis offer an important insight into constructions and representations of an Irish identity within a multidimensional space of power and privilege.

Specifically, English imperialism in early modern Ireland was governed by military, political, cultural, religious, and economic concerns, and by a commitment to colonise the island with English settlers.[17] 'Ireland was England's first colony. Yet if Ireland was colonial, it was also imperial. The Irish were victims of imperialism as well as aggressive perpetrators of it,' explains Jane Ohlmeyer.[18] For example, from the seventeenth century to the twentieth century, the Irish played an important role as bureaucrats and soldiers in maintaining British rule in India, as well as offering an imprint for colonial rule in the country.[19] Further, the 1800 Act of Union made Ireland an integral component of the British Empire. Yet, while parliamentary

union did provide Ireland with access to imperial opportunities, and administrative and economic integration, it did not offer political integration, Ohlmeyer argues. In reality, 'Britain continued to rule Ireland like a colony' as there was a separate executive in Dublin overseen by a Chief Secretary and Lord Lieutenant, which was a system of administration later adopted by the British in India.[20] For instance, during the mid-seventeenth century the English state confiscated two and a half million acres of Ireland's land, much of which it redistributed to English colonists. Later, in the Land Wars of the 1930s, President Éamon de Valera refused to pay the tax on this land, arguing it was Ireland's to begin with. Ireland was indeed 'a bulwark of the Empire, and a mine within its walls', as Alvin Jackson has aptly described.[21] This contested Irish land and its people were the subject of much of the country's display.

The chapters that follow demonstrate that the Irish people, at times allied with Britain yet stereotyped as a racialised anomaly within narratives of self-improvement and civilisation, existed across a spectrum of imperial prejudice that allowed them to construct and resist derogatory imperial identifications of their character. Exhibitions functioned alternatively as a tabula rasa for Ireland or a historical remedy to ease the burden of nostalgia; they functioned as political propaganda or as nation building. Displays of the Irish were heterogeneous, unstable, and worked within decades of negative stereotypes. This book notably argues that the in between colonial status of the Irish enabled a transcendence towards local and national, not just imperial, development.

I specifically reveal that Irish colonial experience took multiple forms which involved assimilation and willing co-operation as well as manipulation and force.[22] By analysing Irish social, political, and cultural history through fractured display, there is diverse scope in demonstrating that Ireland was not exclusively a colony, an imperial possession, or a postcolonial entity.[23] Throughout the book I expose the contradictory impulses which enabled Ireland to experience the cruelty, violence, and military might of British imperial rule, while also remaining enmeshed in the machinations of empire by deconstructing printed material from the relevant exhibitions. Issues of the imperial, colonial, and national, while important, are overridden by important considerations of overlap, networks, and mutual contradictions.[24] I locate exhibitions as originally part of a diverse formation of Irishness between the 1850s and the 1960s, which drew on, dialogued with, and complemented historical episodes between the two powers. Seeing Ireland's fluid position within both metropole and periphery spaces transforms discourses of consensus to those of contest and evokes questions of shifting identities.[25] Namely, the lifetime of the fairs – the middle of the nineteenth century to the mid-twentieth century – demonstrates their

connection to the broader structures of imperialism, nationalism, and capitalism emerging at the time. The performance of identity in exhibitionary spaces enabled Ireland to challenge its colonial status and assert an independent post-colonial identity. Thus, hybridity is as much a feature of the fair itself as a genre as about Irish identity and enabled Irishness to engage diasporic audiences at home and abroad.

Indeed, this book offers evidence that Ireland's defining characteristic was an agency regulated within imperial constraints; at times Ireland was seen as a profitable ally while concurrently being a nuisance country in need of complete assimilation or disbandment. Many groups, such as exhibited African and Asian communities, tended to be removed from the processes of organising their own display, whereas Irish people across multiple class, gendered, and imperial backgrounds featured in the planning, hiring, and performing stages of exhibitions and self-fashioned their own identities. In tracing this history, it becomes clear that the construction of Irish relational identifications along highly individualised contours interacted with multiple, fragmentary, yet totalising, overarching identities (such as nationalist, unionist, Catholic, and Protestant) within gendered and classed localities. I expose the vantage points of Ireland within the fairground as a hybrid entity, at once colony, yet nation.[26]

By recognising exhibitions as precious spectacles of tangible fantasy, in which organisers and visitors forged nations and the British Empire, I interrogate how the processes of material consumption in the fair linked to imagined ideals of Ireland, not merely its reality.[27] This is exposed in a thorough analysis of how visitors engaged with exhibitions in the short and long term through souvenirs and other promotional material. By tracing how certain objects within the fair circulated and the ways in which their meaning changed with each production and sale, the intersections with capitalism as it worked to sustain Irishness are highlighted. For example, the exhibitions laid the foundations for the popular tropes used by the booming Irish tourist industry in the 1930s to enact a saleable and commercialised vision of Irish identity. The reception of the audience shaped future exhibits, and there was a constant interaction in the lifespan of the exhibition's materials; for instance, organisers repeatedly showcased popular motifs of Ireland as a response to visitors' enthusiasm, reinvigorating the material significance of objects within assorted public spaces.

Historians such as Neil Harris who have discussed race within exhibitions have tended to focus on the gaze of the white visitors; studying Ireland uniquely offers a way to talk about what happens when the gaze shifts and the difference between the observer and the observed is not so stark.[28] The visitors and the exhibited within Irish display and consumption were located in a spectrum of whiteness and were close geographically

and ethnically. An uninterrogated assumption tends to operate in existing historiography which always holds a difference in colour as historically significant as opposed to hierarchies within colour, whereas Irish exhibitions were whiteness in creation.[29]

Considering exhibitions as a platform through which the Irish performed an ethnic whiteness substantially contributes to and changes the tenor of significant debate on the racialisation of the Irish. Thus far, there has been much dispute as to the degree of racism the Irish suffered in the past, if at all, and whether claims of racism against the Irish have been exaggerated or underplayed.[30] In a productive rethink of historiography on Ireland and race, this book accepts that the Irish were ostensibly white but originally contends that political access to the social and economic privileges afforded to those with perceived racial and civilisational superiority was refused to the Irish, and exhibitions became a platform through which to lay claim to these privileges. It demonstrates that for Irish men and women, the constructions of whiteness became paramount – ones that would allow them to exist alongside Britain or as an independent Irish state. Literature focusing on stark racial differences between black, brown, and white warps the discussion, and it is necessary that we study a white gaze that differentiates between degrees of whiteness.[31] A core concern of the book is to explore how circulating popular images of rural industry and domesticity, both in Irish villages and in postcards as well as photographs, ensured that the spectacle of Ireland flowed through the exhibition's borders. The Irish were not bounded entities, and the performance of, and reception to, Ireland's whiteness was divided and multifarious.[32]

Unpacking the milieu in which an Irish whiteness was produced and maintained presents an insight into the social processes involved in this racial formation and the transient sensibilities implicated in the making of an Irish consciousness.[33] Irish exhibition organisers were active agents in multiple constructions of Irishness, and they often employed hundreds of white Irish women to sell the fantasy of a peaceful and prosperous Ireland. Their conscious decision to largely employ women wove narratives of beauty and purity into discourses of the Irish and performatively proved that the Irish were in fact becoming more civilised like the British through soap and cleanliness. The racialisation of the Irish in the fairgrounds is strikingly discernible within an imperial domestic context that reveals the labour involved in achieving a wider range of modern white privilege.[34] I show in Chapter 3 how this materialised through cleanliness and purification narratives related to the commercial project of selling soap based on motifs of Irishness by two Irish entrepreneurs. Each articulation of Irish whiteness was part of a broader project to modernise, industrialise, and perform civility within the imperial hierarchies of the nineteenth and twentieth centuries. This reveals

the intricacies of performed bodily civility inside the deeply divided British imperial state from the 1850s to the 1960s.

Moreover, focusing on the historical specificity of racialised prejudice against the Irish as opposed to assuming a homogeneous experience is brought to light by analysing the various versions of an Irish whiteness that were geographically as well as temporally situated within international exhibitions.[35] Irishness was lived at the level of community and the locale. Politically, culturally, in everyday practices and patterns of entertainment, Irishness proliferated in unstable, multiple, and multi-directed experiences. By newly conceiving that Irish whiteness was related to access to political privileges during the Home Rule period for capitalist motives instigated by Irish actors, exhibitions offer a unique conjuncture in studies of modern British history and race.[36] The form of the fairs – for instance, the corporate curation of exhibits, their visual emphases, the overarching organisation around nationalist, capitalist production and commercial promotion – contributed to the construction of whiteness as a global category with cultural, commercial, and political value.

Exhibiting Irishness assesses how mutability and fragmentation became key to constructions of Irishness through its broad comparative approach. The book's transatlantic perspective enables a balance between larger contexts and smaller-scale analysis at local or individual levels. It productively showcases the movement of people and ideas between Ireland and other territories through multiple networks and migratory circuits. And my case studies fundamentally highlight the importance of the wider world to Irish history and society by considering, for example, how flying the Union Jack triggered different visitor responses, whether in London, Dublin, or Chicago. Popular symbols of Ireland readily circulated beyond discrete borders were manipulated according to the needs of specific audiences. For instance, the meaning of a shamrock to the Free State in the 1920s was entirely divergent to its earlier iteration as part of a rose and thistle emblem in the 1850s when a union with Britain was championed. Moreover, visitors to the exhibitions, whether in Britain, Ireland, or the United States, desired different stories of Ireland. Centring the topographies of Irishness, we can see how a London-based post-Famine exhibition in 1851 exemplified a new era of Irish industry through tabula rasa narratives linked to free trade in Chapter 1. Chapter 2, however, explains how an American-based exhibition in Chicago expounded ideas of a lost rural Ireland to account for the wants of a migrant population that had settled overseas, in effect a performative salve for their collective feelings of nostalgia. The chapter interrogates how a diasporic Irish identity was formed and how it differed from conceptions of an Irish nation in England or Ireland. Specifically, there were peculiar needs and manifestations of diasporic Irish identities across the world.

And the demands of an Irish diasporic community in the United States sustained a specific type of Irishness that traded in narratives of exile, memory, and nostalgia. My approach offers a pivotal connected history of Irish display that bridges scholarship on Irish migration with the visual through a transatlantic perspective.[37]

International exhibitions were the predecessors to the formation of museums in the nineteenth century in Britain, Ireland, and the wider empire when the idea of showcasing the world in a miniature form, whether in open air or a physical building, took hold.[38] Contemporary discourse suggested that museums would be a key source of education and knowledge making for the public, as well as for sustaining citizenry. Like exhibitions, Crooke has documented how in Ireland the founding of museums centred around desires to create a sense of belonging and to represent the nation.[39] Importantly, Crooke explains that museums derived largely from the ideological force of nationalism which dominated Irish politics and through which a particular understanding of the relationship between the past and political endeavour emerged. Museums helped to produce a self-legitimising 'national' interpretation of the past, symbolised through antiquity and a traditional Irishness which glorified the country. In a similar fashion to exhibitions, museums became a display of power in the reordering and presentation of the past. Evidently, it is important to recognise that nationalism moulds the characteristics of the nation to create a popular and simplified ideology that reinforces the political process. National museums, notes Flora Kaplan, and the collections within them facilitate distinct ideology and spread knowledge to the public.[40] In this way, the past becomes an active symbol in a process of identity making in which it is continually shaped according to the needs of the time.[41] Ultimately, knowledge about the past was foregrounded in the museum and exhibition phenomena and used flexibly by historical actors.

This book explores how the politics of display influences the production of Irish identity according to a host of contexts. The practices of display were shaped by issues of funding, organisers' motives, and the larger purpose of the event itself, which in turn fed back into Irish understandings of themselves politically, economically, socially, or culturally as industrialists, capitalists, women, Home Rulers, British imperialists, nationalists, Republicans, and post-colonialists. It comfortably sits within the 'new imperial history', exemplified by the work of scholars such as John MacKenzie, Catherine Hall, and others, which critiques nation-centred historical approaches and seeks to reformulate British history.[42] In this analysis colonial powers may exist as the nucleus of a vast network of intertwined discourses; but in revealing those trajectories the centre itself is decentred, as Britain is, in my study of Ireland.[43] The fluid nature of embodied Irish identity in international

contexts as it moved from a colonial to an independent state is evoked in my larger analysis. I place each exhibition in the wider political, economic, and cultural context of its time. Thus, the lens of exhibitions reveals several original arguments about Irish identities as singular and broader collectives working with and through gender, class, and race in a larger configuration of empire and whiteness from the 1850s to the 1960s.

By analysing exhibitions, which allowed individuals to identify themselves as Irish, this book fundamentally alters our understanding of Irish identities within the context of Britain, the Empire, and Ireland itself. At key historical moments, the chapters uncover how multiple visions of Irishness co-existed at any one time. The intention is not to cover all the various exhibitions and displays in which Ireland or some form of Irish identity features across the nineteenth and twentieth centuries but instead to interrogate targeted case studies that are particularly revealing of the social and political changes of the time. For instance, images of Ireland in the 1850s became tied to issues of industrialisation, whereas by the 1910s Ireland on the fairground largely centred on a capitalist sale of goods. The individual chapters foreground how distinct fantasies of Ireland related to the country's development and progress, or its modernity and industrialisation, functioned in a constant exchange that modified itself according to pressing historical episodes.

Throughout each chapter of this book, it becomes apparent that authors commissioned to write exhibition reports constructed a narrative of uniformity and positive reception to mask the inherent contradictions present in the displays. Further, each case study follows the development of new Irish cultural practices within an expansive network of visitors, organisers, and reporters. It carefully demonstrates that discrete images of Ireland emerged alongside and through the political sphere, while diverse stories of the country emerged out of the needs attached to Irish identities at various points. Exhibitions held significance in numerous moments of Irish history to rectify the effects of famine and poverty, to sustain migration and diasporic settlement, or to ease national discord as well as religious tension created by independent movements, particularly partition, and later postcolonial nation building revealing Irish agency within the geographic and political boundaries the country was historically constrained within.

The form of fairs themselves enabled flexible and ever-changing constructs of an Irish land and people. Firstly, the book traces the changes in displays of the Irish and illuminates the dissonance typical of Irish exhibitions. For instance, rurality and authenticity were juxtaposed alongside industry and modernity within the fairground. Despite both being regarded as important narratives for Ireland's trade, they functioned in direct opposition. Relying on recognisable stereotypes of Ireland's rural industries created an

accessible narrative; however, its focus on the past contradicted portrayals of an Irish modernity in the future that was prosperous and profitable based on industry and technology. Secondly, ideas and experiences of Irishness shifted unpredictably within exhibitions of the Irish, and this is made clear by reflecting on the contrary responses of visitors. For example, Chapter 4 reveals that visitors were more interested in witnessing Ireland's Gaelic rusticity as a tourist site instead of marvelling over its technological prowess as the exhibitions' organisers hoped. And thirdly, claims to authenticity were fundamental in convincing visitors to attend the exhibitions, and Ireland's claims to 'reality' in the fairground continually circulated. Yet actual events in Ireland in the nineteenth and twentieth centuries did not feature in the exhibitions of the country and its people, thereby revealing the tensions between display and reality as opposed to assuming a congruence between the two that problematically simplifies the discussion.

In this book's reconstruction of displayed Ireland, the chapters tell interconnected stories involving a cast of diverse characters that elucidate formative moments in Irish social, cultural, and political history across a host of Irish pasts, presents, and futures. To begin, Chapter 1 explores Ireland's post-Famine exhibitions in the 1850s to argue that they became a vital stage through which to debate post-Famine reconstruction policies. It highlights how ideas of Ireland's recovery after its national tragedy were contested along nationalist and unionist lines to contrasting effects. Tracing the diasporic imaginary overseas, Chapter 2 examines the Famine exodus to the United States and considers the 1893 Chicago World's Fair to illustrate how exhibitions of the Irish interacted with transatlantic activism and philanthropy. It also asks how elite women used Irish exhibitions to combat Irish poverty by championing a rural Ireland worthy of revival that capitalised on Irish migration to America. By focusing on several key decades where Britain and Ireland intersect or collide with one another, Chapter 3 investigates the trajectory of a single Irish Village in the early-twentieth-century exhibitions and demonstrates how agitation over Home Rule was bodily enacted within the fairground through performing whiteness. The second half of the chapter points out that a commercial union with Britain was constructed by two Irish entrepreneurs who advertised soap by exploiting popular images of Ireland.

Chapter 4 explores the interwar British Empire Exhibitions to show how the Irish Free State and Northern Ireland each used display to champion their own global agendas and distinct relationships to the British Empire to differing degrees of success. It ends by examining the last international Exhibition before the outbreak of the Second World War (the New York World's Fair of 1939) to evaluate how images of Ireland had transformed from presenting the country as a British possession to one rooted in nostalgic visions, and

finally to a display of political expression that allowed Irish men and women to claim cultural advancement and prestige to consolidate their authority over Irishness in the fairground. Taking the logic of Ireland's state formation to its end (before Ireland joined the European Economic Community in 1973), Chapter 5 examines Ireland's display in the 1960s to interrogate the country's post-colonial moment. It explores how the rationale behind exhibitions had significantly shifted by the 1960s, as success was no longer defined by immediate financial profit but within the diplomatic sphere. Crucially, exhibitions became redundant for mass advertising, which made the ideological motives of exhibits obsolete in the 1960s. Yet this chapter analyses how visitors undermined the efforts of Irish officials to present a post-colonial vision of the nation as they had become used to a century of stereotypes of Irishness under global capitalism.

The different case studies reveal how questions of Irishness intersected with broader ideas of citizenship, race, and ethnic formation. For instance, Irish identities changed significantly in this period and with different degrees of labour: organisers in the 1850s utilised religion to encourage visits; Irish American audiences in the 1890s participated in a fictitious Ireland to soothe their cognitive dissonance post-migration; visitors in the early twentieth century avidly participated in the commercialisation of Ireland through postcards, souvenirs and letter writing; interwar audiences demonstrated a reflexive awareness of an Irish nation evident through the many criticisms and critiques analysed; and visitors in Ireland's post-colonial displays demanded a historic portrayal of Ireland. Irish men and women exercised their agency and demonstrated whether they approved of an exhibition or not. This potential for the visual to elicit multiple and contrasting responses demonstrates how exhibitions could respond to and encourage an ever-changing understanding of what it meant to be Irish.

Throughout the book I use the terms 'exhibitions', 'world's fairs', and 'expositions' interchangeably in my discussions of large-scale displays to a global audience. The different terms relate to various historical epochs and country-specific preferences. 'Exhibitions' is a term typically used by English organisers in the nineteenth and twentieth centuries to refer to their expansive displays. The term is also used in most scholarship on display in the British sphere. 'World's fairs' is often used by American scholars and American contemporaries in their discussions of these events in the nineteenth and twentieth centuries. 'Expositions' is a word that can be traced to the late twentieth and twenty-first centuries and, in contemporary discourse, covers displays throughout the world. My use of these terms follows the parameters set by John E. Findling and Kimberly D. Pelle in their authoritative *Encyclopaedia of World's Fairs and Exhibitions* published in 2008. They explain that 'exhibitions are similar to fairs but are quite different

in one respect: exhibitions are solely for displaying or exhibiting goods, while fairs connote commerce, as in the sale of goods being displayed'.[44] Alternatively, exposition is a word that 'etymologically bridges the gap between fair and exhibition', and 'an exposition is larger, more extensive, and perhaps more formally organised than a fair'.[45]

Overall, examining the ways in which Irishness was negotiated over successive decades and the practices and assumptions that accompanied this era of exhibitions offers a distinctive juncture in understanding the dynamics of Irishness that evolved during the formative decades of Irish nationhood. The wider formation of an Irish agency during the process of migration and settlement as an exchange between home and abroad is tethered throughout. The book closes by exploring the possibilities of writing a cultural history of Ireland and bringing Irish and display spheres together in a meaningful way. At the same time, the quotidian formulations of Irish identities are centred in this story. Crucially, the book evidences an Irish globality that was geographically rooted in the temporal and spatial boundaries of the exhibition grounds within larger transnational conceptualisations of Irishness. The chapters trace how the exhibitions in question shaped historic visions of Ireland and consider the impact of repeatedly seeing minerals, flax and beet, agricultural tools, and machinery, alongside the Royal Tara Brooch, muslin, and poplin sandwiched between ploughs and diggers, as well as whisky and tobacco.

Notes

1 R. Williams, *Culture and Society 1780–1950* (New York, 1983), p. 18.
2 For similar methodologies, see P. Kramer, 'Power and Connection: Imperial Histories of the United States in the World', *Radical History Review*, 116:5 (2011), 1348–91, 1349. See also Robert W. Rydell, 'New Directions for Scholarship about World Expos', in Kate Darian-Smith, Richard Gillespie, Caroline Jordan, and Elizabeth Willis (eds), *Seize the Day: Exhibitions, Australia and the World* (Melbourne, 2008), pp. 4–5; Peter H. Hoffenberg, 'Equipoise and Its Discontents: Voices of Dissent during the International Exhibitions', in Martin Hewett (ed.), *An Age of Equipoise? Reassessing Mid-Victorian Britain* (Aldershot, 2000), pp. 39–67.
3 Such sources have generally been used by scholars from the 1980s to the 1950s in exhibition historiography; see P. Greenhalgh, *Ephemeral Vistas: The Expositions Universelles, Great Exhibitions and World's Fairs, 1851–1939* (Manchester, 1988); R. W. Rydell, *All the World's a Fair: Visions of Empire at American International Expositions, 1876–1916* (Chicago, IL, 1984); J. M. MacKenzie, *Propaganda and Empire: The Manipulation of British Public Opinion, 1880–1960* (Manchester, 1984); B. Benedict, *The Anthropology of World's Fairs: San Francisco's Panama Pacific International Exposition of*

1915 (New York, 1983); W. A. Williams, *Empire as a Way of Life* (New York, 1980); K. M. Roemer, *The Obsolete Necessity: America in Utopian Writings, 1888–1900* (Kent, OH, 1976); R. H. Wiebe, *The Search for Order, 1877–1920* (New York, 1967); W. L. Burn, *The Age of Equipoise: A Study of the Mid-Victorian Generation* (New York, 1964); D. M. Potter, *People of Plenty* (Chicago, IL, 1955).

4 The following works are concerned with mapping visitor experiences: R. Bain, 'Going to the Exhibition', in Richard Staley (ed.), *The Physics of Empire: Public Lectures* (Cambridge, 1994), pp. 113–42; G. Davison, 'Festivals of Nationhood: The International Exhibitions', in S. L. Goldberg and F. B. Smith (eds), *Australian Cultural History* (New York, 1988), pp. 158–77; D. Silverman, 'The 1889 Exhibition: The Crisis of Bourgeois Individualism', *Oppositions: A Journal of Ideas and Criticism in Architecture*, 8 (1977), 71–91.

5 See R. A. Fried, 'No Irish Need Deny: Evidence for the Historicity of NINA Restrictions in Advertisements and Signs', *Journal of Social History*, 49:4 (2016), 829–54; J. Cleary, 'Amongst Empires: A Short History of Ireland and Empire Studies in International Context', *Éire-Ireland*, 42:1–2 (2007), 11–57; H. Morgan, 'An Unwelcome Heritage: Ireland's Role in British Empire-Building', *History of European Ideas*, 9 (1994), 619–25.

6 G. Schaffer and S. Nasar, 'The White Essential Subject: Race, Ethnicity, and the Irish in Post-War Britain', *Contemporary British History*, 32:2 (2018), 209–30; D. R. Roediger, *Towards the Abolition of Whiteness* (New York, 1994); D. R. Roediger, *The Wages of Whiteness: Race and the Making of the American Working Class* (New York, 1991). For criticism, see E. Arnesen, 'Whiteness and the Historians' Imagination', *International Labour and Working-Class History*, 60 (2001), 3–32.

7 Early histories include: R. D. Altick, *The Shows of London* (London, 1978); J. Allwood, *The Great Exhibitions* (London, 1977); K. W. Luckhurst, *The Story of Exhibitions* (London, 1951).

8 See, for instance, literature produced in the 2000s and 1990s: R. W. Rydell and R. Kroes, *Buffalo Bill in Bologna: The Americanization of the World, 1869–1922* (Chicago, IL, 2013); R. W. Rydell, J. E. Findling, and K. E. Pelle, *America: World's Fairs in the United States* (Washington, DC, 2013); D. Stephen, *The Empire of Progress: West Africans, Indians, and Britons at the British Empire Exhibition 1924–25* (New York, 2013); J. Gilbert, *Whose Fair? Experience, Memory, and the History of the Great St Louis Exposition* (Chicago, IL, 2009); A. Lewis, *An Early Encounter with Tomorrow: European's, Chicago's Loop, and the World's Columbian Exposition* (Champaign, IL, 2001); P. H. Hoffenberg, *An Empire on Display: English, Indian and Australian Exhibitions from the Crystal Palace to the Great War* (Berkeley, CA, 2001); J. A. Auerbach, *The Great Exhibition of 1851: A Nation on Display* (London, 1999); D. Poole, *Vision, Race, and Modernity: A Visual Economy of the Andean Image World* (Princeton, NJ, 1997); A. E. Coombes, *Reinventing Africa: Museums, Material Culture and Popular Imagination in Late Victorian and Edwardian England* (New Haven, CT, 1994); R. W. Rydell and N. Gwinn (eds), *Fair Representations: World's*

Fairs and the Modern World (Amsterdam, 1994); R. W. Rydell, *World of Fairs: The Century-of-Progress Expositions* (Chicago, IL, 1993); R. W. Rydell, *The Books of the Fairs: Materials about World's Fairs, 1834–1916* (Chicago, IL, 1992); T. Mitchell, *Colonising Egypt* (Berkeley, CA, 1991); T. Richards, *The Commodity Culture of Victorian England: Advertising and Spectacle, 1851–1914* (Stanford, CA, 1990); J. E. Findling and K. D. Pelle (eds), *Historical Dictionary of World's Fairs and Expositions, 1851–1988* (New York, 1990).

9 See R. Corbey, 'Ethnographic Showcases, 1870–1930', *Cultural Anthropology*, 8:3 (1993), 338–69; M. Armstrong, 'A Jumble of Foreignness: The Sublime Musayums of Nineteenth-Century Fairs and Expositions', *Cultural Critique*, 23 (1992–93), 199–250.

10 Terence McDonough (ed.), *Was Ireland a Colony? Economics, Politics and Culture in Nineteenth-Century Ireland* (Dublin, 2005). See M. de Nie and J. Cleary, 'Editors Introduction', *Éire-Ireland*, 42 (2007), 5–10; Joe Cleary, 'Postcolonial Ireland', in Kevin Kenny (ed.), *Ireland and the British Empire: Oxford History of the British Empire Companion Series* (Oxford, 2004), pp. 251–88; T. Garvin, *Preventing the Future: Why Was Ireland so Poor for so Long?* (Dublin, 2004); T. Garvin, *The Birth of Irish Democracy* (Dublin, 1996); T. Garvin, *The Evolution of Irish Nationalist Politics* (Dublin, 1981).

11 For the ways in which Ireland has been conceived through visual culture, see J. McAleer and J. M. MacKenzie (eds), *Exhibiting the Empire: Cultures of Display and the British Empire* (Manchester, 2015); P. Kirwan, J. P. Byrne, and M. O'Sullivan, 'Introduction', in Padraig Kirwan, James P. Byrne, and Michael O'Sullivan (eds), *Affecting Irishness: Negotiating Cultural Identity within and beyond the Nation* (New York, 2009), pp. 1–17; K. Kumar, 'Nation and Empire: English and British National Identity in Comparative Perspective', *Theory and Society*, 29:5 (2000), 575–608; D. Kiberd, *Inventing Ireland: The Literature of the Modern Nation* (Cambridge, 1996); A. Brah, *Cartographies of Diaspora: Contesting Identities* (London, 1996); R. F. Foster, 'We Are All Revisionists Now', *Irish Review*, 1 (1986), 1–5.

12 Recent literature that emphasises concessions and discontent within exhibitions includes: N. Cardon, *A Dream of the Future: Race, Empire, and Modernity at the Atlanta and Nashville World's Fairs, 1895–1897* (Oxford, 2018); Marta Filipová (ed.), *Cultures of International Exhibitions: 1800–1940: Great Exhibitions in the Margins* (London, 2015); S. Qureshi, *Peoples on Parade: Exhibitions, Empire and Anthropology in Nineteenth Century Britain* (Chicago, IL, 2011); A. C. T. Geppert, *Fleeting Cities: Imperial Expositions in Fin-De-Siècle Europe* (New York, 2010); L. Kriegel, 'After the Exhibitionary Complex: Museum Histories and the Future of the Victorian Past', *Victorian Studies*, 48 (2006), 681–704; P. Kramer, 'Making Concessions: Race and Empire Revisited at the Philippine Exposition, St. Louis, 1901–1905', *Radical History Review*, 73 (1999), 75–107; S. Conn, *Museums and American Intellectual Life, 1876–1926* (Chicago, IL, 1998); M. Niquette and W. J. Buxton, 'Meet Me at the Fair: Sociability and Reflexivity in Nineteenth-Century World Expositions', *Canadian Journal of Communication*, 22 (1997), 81–133; A. L. Stoler and

F. Cooper, 'Between Metropole and Colony: Rethinking a Research Agenda', in Ann L. Stoler and Frederick Cooper (eds), *Tensions of Empire: Colonial Cultures in a Bourgeois World* (Berkeley, CA, 1997), pp. 1–58; P. Harvey, *Hybrids of Modernity: Anthropology, the Nation State and the Universal Exhibition* (London, 1996).

13 For excellent examples of this new type of history, see E. Hanna, *Snapshot Stories: Visuality, Photography, and the Social History of Ireland, 1922–2000* (Oxford, 2020); N. NicGhabhann, *Medieval Ecclesiastical Buildings in Ireland, 1789–1915: Building on the Past* (Dublin, 2015); M. Moulton, *Ireland and the Irish in Interwar England* (Cambridge, 2014); E. Mark-FitzGerald, *Commemorating the Irish Famine: Memory and the Monument* (Liverpool, 2013); A. Dolan, *Commemorating the Irish Civil War: History and Memory, 1923–2000* (Cambridge, 2003); D. G. Boyce and A. O'Day (eds), *The Making of Modern Irish History: Revisionism and the Revisionist Controversy* (London, 1996).

14 E. Crooke, *Politics, Archaeology and the Creation of a National Museum of Ireland* (Dublin, 2001), p. 93.

15 J. T. Leerssen, *Remembrance and Imagination* (Cork, 1996), p. 12. See E. Hobsbawm and T. Ranger (eds), *The Invention of Tradition* (Cambridge, 2012).

16 For broad works on Ireland, see Thomas Bartlett (ed.), *The Cambridge History of Ireland. Vol IV. 1880 to the Present* (Cambridge, 2018); E. F. Biagini and M. E. Daly (eds), *The Cambridge Social History of Modern Ireland* (Cambridge, 2017); R. F. Foster, *Vivid Faces: The Revolutionary Generation in Ireland 1890–1923* (Dublin, 2015); J. R. Hill (ed.), *A New History of Ireland. Vol. VII. Under the Auspices of the Royal Irish Academy Planned and Established by the Late T. W. Moody 1921–84* (Oxford, 2010); W. E. Vaughan (ed.), *A New History of Ireland. Vol. VI. Ireland under the Union, II, 1870–1921* (Oxford, 1996); W. E. Vaughan (ed.), *A New History of Ireland. Vol. V. Ireland under the Union, I, 1801–1870* (Oxford, 1989); K. T. Hoppen, *Ireland since 1800: Conflict and Conformity (Studies in Modern History)* (London, 1989); R. Foster, *Modern Ireland* (Dublin, 1988); M. E. Daly, *Dublin: The Deposed Capital: A Social and Economic History 1860–1914* (Cork, 1985); J. V. O'Brien, *'Dear, Dirty Dublin': A City in Distress 1899–1916* (London, 1985); T. W. Moody, F. X. Martin, and F. J. Byrne (eds), *A New History of Ireland. Vol. IX. Maps, Genealogies, Lists* (Oxford, 1984); O. MacDonagh, *States of Mind: A Study of Anglo–Irish Conflict 1780–1980* (London, 1983); T. W. Moody, F. X. Martin, and F. J. Byrne (eds), *A New History of Ireland. Vol. VIII. A Chronology of Irish History to 1976, I* (Oxford, 1982); F. S. Lyons, *Culture and Anarchy in Ireland 1890–1939* (Oxford, 1979); P. O' Farrell, *Ireland and England since 1800* (Oxford, 1970).

17 During the late sixteenth and early seventeenth centuries, the crown embarked on a series of initiatives that sought to 'civilise' and 'Anglicise' Ireland. Central to this was the widespread use of English common law, the promotion of the English language, English culture, architecture, settled agricultural practices, and religion (Protestantism): J. Ohlmeyer, 'Ireland, India and the British Empire', *Studies in People's History*, 2:2 (2015), 169–88, 169.

18 Ohlmeyer, 'Ireland, India and the British Empire', 175–6. See S. Akhtar, D. Hassett, K. Kenny, L. McAtackney, I. McBride, T. McMahon, C. N. Dháibhéid, and J. Ohlmeyer, 'Decolonising Irish History? Possibilities, Challenges, Practices', *Irish Historical Studies*, 45:168 (2022), 303–32.
19 See B. Crosbie, *Irish Imperial Networks: Migration, Social Communication and Exchange in Nineteenth–Century India* (Cambridge, 2011) and S. B. Cook, *Imperial Affinities: Nineteenth-century Analogies and Exchanges between India and Ireland* (New Delhi, 1993).
20 Ohlmeyer, 'Ireland, India and the British Empire', 173.
21 Alvin Jackson, 'Ireland, the Union, and the Empire, 1800–1960', in Kevin Kenny (ed.), *Ireland and the British Empire: Oxford History of the British Empire Companion Series* (Oxford, 2004), pp. 123–53, p. 123; Ohlmeyer, 'Ireland, India and the British Empire', 176.
22 S. Howe, *Ireland and Empire: Colonial Legacies in Irish History and Culture* (Oxford, 2000), p. 232. See S. Howe, 'Historiography', in Kevin Kenny (ed.), *Ireland and the British Empire: Oxford History of the British Empire Companion Series* (Oxford, 2004), pp. 220–50; Roger W. Winks (ed.), *The Oxford History of the British Empire. Vol V. Historiography* (Oxford, 1999); Deirdre McMahon, 'Ireland and the Empire-Commonwealth, 1900–1948', in W. Roger Louis and Judith M. Brown (eds), *The Oxford History of the British Empire. Vol IV. The Twentieth Century* (Oxford, 1999), pp. 138–62; S. Howe, *Anticolonialism in British Politics: The Left and the End of Empire 1918–1964* (Oxford, 1993).
23 Howe, *Ireland and Empire*, p. 232. See S. Howe, 'The Politics of Historical "Revisionism": Comparing Ireland and Israel/Palestine', *Past and Present*, 168:1 (2000), 227–53; David Fitzpatrick, 'Ireland and Empire', in Andrew Porter (ed.), *The Oxford History of the British Empire. Vol III. The Nineteenth Century* (Oxford, 1999), pp. 494–521; Thomas Bartlett, '"This Famous Island Set in a Virginian Sea": Ireland in the Eighteenth-Century British Empire', in P. J. Marshall (ed.), *The Oxford History of the British Empire. Vol II. The Eighteenth Century* (Oxford, 1998), pp. 254–76; Donal Lowry, 'Ulster Resistance and Loyalist Rebellion in the Empire', in Keith Jeffrey (ed.), *An Irish Empire? Aspects of Ireland and the British Empire* (Manchester, 1996), pp. 191–215; C. Brady, *Interpreting Irish History: The Debate on Historical Revisionism, 1938–1994* (Dublin, 1994).
24 See R. M. Douglas, 'Anglo-Saxons and Attacotti: The Racialization of Irishness in Britain between the World Wars', *Ethnic and Racial Studies*, 25:1 (2002), 40–63.
25 Jane Ohlmeyer, 'Conquest, Civilization, Colonization: Ireland, 1540–1660', in Richard Bourke and Ian MacBride (eds), *The Princeton Guide to Modern Irish History* (Princeton, NJ, 2015), pp. 220–47; M. Silvestri, *Ireland and India: Nationalism, Empire and Memory* (London, 2009); K. O'Malley, *Ireland, India and Empire: Indo-Irish Radical Connections, 1919–64* (Manchester, 2009); J. Wright, *Ireland, India and Nationalism in Nineteenth-century Literature* (Cambridge, 2007); A. I. Macinnes, *Union and Empire: The Making of the United Kingdom in 1707* (Cambridge, 2007); Jane Ohlmeyer,

'A Laboratory for Empire? Early Modern Ireland and English Imperialism', in Kevin Kenny (ed.), *Ireland and the British Empire: Oxford History of the British Empire Companion Series* (Oxford, 2004), pp. 26–60; J. Smyth, *The Making of the United Kingdom, 1660–1800* (Harlow, 2001); Peter J. Marshall, 'The English in Asia to 1700', in Nicholas Canny and W. Roger Louis (eds), *The Oxford History of the British Empire: Volume I: The Origins of Empire: British Overseas Enterprise to the Close of the Seventeenth Century* (Oxford, 1998), pp. 264–85; A. Murdoch, *British History, 1660–1832: National Identity and Local Culture* (Basingstoke, 1998).

26 See E. Flannery, *Ireland and Postcolonial Studies: Theory, Discourse, Utopia* (London, 2009); J. Lennon, *Irish Orientalism* (Syracuse, NY, 2004); E. Said, 'Orientalism Reconsidered', *Race and Class*, 27 (1985), 1–15; E. Said, *Orientalism; Culture and Imperialism* (London, 1978). Also, H. K. Bhabha, 'Life at the Border: Hybrid Identities of the Present', *New Perspectives Quarterly*, 14:1 (1997), 30–2; H. K. Bhabha, 'Of Mimicry and Man: The Ambivalence of Colonial Discourse', 28, *Discipleship: A Special Issue on Psychoanalysis* (1984), 125–33.

27 A. L. Stoler, *Carnal Knowledge and Imperial Power: Race and the Intimate in Colonial Rule* (Berkeley, CA, 2009); A. L. Stoler, 'On Degrees of Imperial Sovereignty', *Public Culture*, 18:1 (2006), 125–46. See also Tony Bennett, 'Speaking to the Eyes: Museums, Legibility, and the Social Order', in Sharon Macdonald (ed.), *The Politics of Display: Museums, Science, Culture* (London, 1998), pp. 25–35; H. K. Bhabha, *The Location of Culture* (London, 1994); C. Breckenridge, 'The Aesthetics and Politics of Colonial Collecting: India at World Fairs', *Comparative Studies in Society and History*, 31:2 (1989), 195–216.

28 Neil Harris, 'All the World a Melting Pot? Japan at American Fairs, 1876–1904', in Akira Iriye (ed.), *Mutual Images: Essays in American–Japanese Relations* (Cambridge, MA, 1975), pp. 47–54. See Robbie McVeigh, ' "There's No Racism because There's No Black People Here": Racism and Antiracism in Northern Ireland', in Paul Hainsworth (ed.), *Divided Society: Ethnic Minorities and Racism in Northern Ireland* (London, 1998), pp. 11–32; Robbie McVeigh, 'Is Sectarianism Racism? Theorising the Racism/Sectarianism Interface', in David Miller (ed.), *Rethinking Northern Ireland: Culture, Ideology and Colonialism* (London, 1998), pp. 179–94; Robbie McVeigh, *The Racialization of Irishness: Racism and Anti-Racism in Ireland* (Belfast, 1996); Peter Cohen, 'The Perversions of Inheritance: Studies in the Making of Multi-racist Britain', in Peter Cohen and H. S. Bains (eds), *Multi-Racist Britain* (Basingstoke, 1988), pp. 9–118; J. Kirkaldy, 'English Newspaper Images of Northern Ireland 1968–1973: An Historical Study in Stereotypes and Prejudices' (PhD dissertation, University of New South Wales, 1979); Sheridan Gilley, 'English Attitudes to the Irish in England, 1780–1900', in Colin Holmes (ed.), *Immigrants and Minorities in British Society* (London, 1978), pp. 81–110; L. P. Curtis, *Apes and Angels: The Irishman in Victorian Caricature* (Washington, DC, 1971); L. P. Curtis, *Anglo-Saxons and Celts: A Study of Anti-Irish Prejudice in Victorian England* (Bridgeport, CT, 1968).

Introduction

29 See L. Gibbons, 'Race against Time: Racial Discourse and Irish History', *Oxford Literary Review*, 13:1 (1991), 95–117. Gibbons compares discrimination against the Irish to racism towards American Indians in L. Gibbons, 'Race against Time: Racial Discourse and Irish History', in Catherine Hall (ed.), *Cultures of Empire: Colonizers in Britain and the Empire in the Nineteenth and Twentieth Centuries: A Reader* (Manchester, 2000), pp. 207–23, 208–9. Also, D. Lloyd, 'Race and Representation', *Oxford Literary Review*, 13:1 (1991), 62–94; C. Wills, 'Language, Politics, Narrative, Political Violence', *Oxford Literary Review*, 13:1 (1991), 21–60.

30 See P. Kolchin, 'Whiteness Studies: The New History of Race in America', *Journal of American History*, 89 (2002), 154–73; B. J. Fields, 'Whiteness, Racism, and Identity', *International Labour and Working-Class History*, 60 (2001), 48–56; D. Brundage, *'Green over Black' Revisited: Ireland and Irish-Americans in the New Histories of American Working-Class 'Whiteness'* (Oxford, 1997); Vron Ware, 'Defining Forces: "Race", Gender and Memories of Empire', in Iain Chambers and Lidia Curti (eds), *The Postcolonial Questions: Common Skies, Divided Horizons* (London, 1996), pp. 142–56.

31 The scope of this literature on whiteness is far too large for a single note. An indicative example in the last thirty-five years is B. Rolston, 'Are the Irish Black?', *Race and Class*, 41:1 (1999), 95–102; M. F. Jacobson, *Whiteness of a Different Color: European Immigrants and the Alchemy of Race* (Cambridge, 1998); B. Dooley, *Black and Green: The Fight for Civil Rights in Northern Ireland and Black America* (London, 1998); N. Ignatiev, *How the Irish Became White* (New York, 1995); R. Frankenberg, *White Women, Race Matters: The Social Construction of Whiteness* (London, 1993); b. hooks, *Black Looks: Race and Representation* (Boston, MA, 1992); V. Ware, *Beyond the Pale: White Women, Racism and History* (London, 1992); Kerby A. Miller, 'Class, Culture and Immigrant Group Identity in the United States: The Case of Irish-American Ethnicity', in Virginia Yans-McLaughlin (ed.), *Immigration Re-Considered* (Oxford, 1990), pp. 97–125; D. H. Akenson, *Being Had: Historians, Evidence and the Irish in North America* (Charlottesville, VA, 1985).

32 See G. K. Peatling, 'The Whiteness of Ireland under and after the Union', *Journal of British Studies*, 44:1 (2005), 115–33; L. Gibbons, 'The Global Cure? History, Therapy and the Celtic Tiger', in Peadar Kirby, Luke Gibbons, and Michael Cronin (eds), *Reinventing Ireland: Culture, Society and the Global Economy* (London, 2002), pp. 89–106; Mary J. Hickman, 'Alternative Historiographies of the Irish in Britain: A Critique of the Segregation/Assimilation Model', in Roger Swift and Sheridan Gilley (eds), *The Irish in Victorian Britain: The Local Dimension* (Dublin, 1999), pp. 236–53; A. Bonnett, 'How the British Working Class Became White: The Symbolic (Re)formulation of Racialized Capitalism', *Journal of Historical Sociology*, 11 (1998), 316–40.

33 Contested works on Irish whiteness include: S. Garner, *Racism in the Irish Experience* (London, 2004); M. Nie, *The Eternal Paddy: Irish Identity and the British Press, 1798–1882* (Madison, WI, 2004); M. Nie, 'A Medley Mob of Irish-American Plotters and Irish Dupes': The British Press and Transatlantic Fenianism', *Journal of British Studies*, 40 (2001), 213–40; R. McVeigh, 'The

Last Conquest of Ireland? British Academics in Irish Universities', *Race and Class*, 37 (1995), 109–22; N. Stepan, *The Idea of Race in Science: Great Britain, 1800–1960* (Hamden, CT, 1982); N. Lebow, *White Britain and Black Ireland: The Influence of Stereotypes on Colonial Policy* (Philadelphia, PA, 1976); M. Hechter, *Internal Colonialism: The Celtic Fringe in British National Development, 1536–1966* (Berkeley, CA, 1975); N. Lebow, 'British Historians and Irish History', *Éire-Ireland*, 8:4 (1973), 3–38.

34 See Peatling, 'The Whiteness of Ireland', 134–45; Kerby A. Miller, '"Scotch-Irish" Myths and "Irish" Identities in Eighteenth and Nineteenth Century America', in Charles Fanning (ed.), *New Perspectives on the Irish Diaspora* (Carbondale, IL, 2000), pp. 81–98; K. N. Conzen, D. A. Gerber, E. Morawska, G. E. Pozzetta, and R. J. Vecoli, 'The Invention of Ethnicity: A Perspective from the U.S.A', *Journal of American Ethnic History*, 12 (1992), 3–41.

35 M. J. Hickman and B. Walter, 'Deconstructing Whiteness: Irish Women in Britain', *Feminist Review*, 50:1 (1995), 5–19. See also M. J. Hickman and B. Walter, 'Racializing the Irish in England: Gender, Class and Ethnicity' in Marilyn Cohen and Nancy J. Curtin (eds), *Reclaiming Gender: Transgressive Identities in Modern Ireland* (New York, 1999), pp. 267–92; B. Walter, 'Challenging the Black/White Binary: The Need for an Irish Category in the 2001 Census', *Patterns of Prejudice*, 32 (1998), 73–86; M. J. Hickman and B. Walter, *Discrimination and the Irish Community in Britain: A Report of Research Undertaken for the Commission for Racial Equality* (London, 1997); M. J. Hickman, *Religion, Class and Identity: The State, the Catholic Church and the Education of the Irish in Britain* (Avebury, 1995).

36 See Eóin Flannery, 'The Art of Resistance: Visual Iconography and the Northern "Troubles"', in Eóin Flannery and Michael Griffin (eds), *Ireland in Focus: Film, Photography and Popular Culture* (Syracuse, NY, 2009), pp. 125–43; Hall (ed.), *Cultures of Empire*.

37 See Niall Whelehan (ed.), *Transnational Perspectives on Modern Irish History* (Abingdon, 2014); N. Whelehan, *The Dynamiters: Irish Nationalism and Political Violence in the Wider World, 1867–1900* (Cambridge, 2012); E. Delaney, 'Our Island Story? Towards a Transnational History of Late Modern Ireland', *Irish Historical Studies*, 37:148 (2011), 599–621.

38 See J. M. O'Leary, 'Manufacturing Reality: The Display of the Irish at World's Fairs and Exhibitions 1893 to 1965' (PhD dissertation, Kent State University, 2015); C. R. Malloy, 'Exhibiting Ireland: Irish Villages, Pavilions, Cottages, and Castles at International Exhibitions, 1853–1939' (PhD dissertation, University of Wisconsin-Madison, 2013).

39 Crooke, *Museum of Ireland*, p. vi.

40 F. S. Kaplan, *Museums and the Making of 'Ourselves': The Role of Objects in National Identity* (Leicester, 1996).

41 Crooke, *Museum of Ireland*, p. 154. See also S. Longair and J. McAleer (eds), *Curating Empire: Museums and the British Imperial Experience* (Manchester, 2016).

42 See C. Hall and S. O. Rose (eds), *At Home with Empire: Metropolitan Culture and the Imperial World* (London, 2006); A. S. Thompson, *The Empire Strikes Back: The Impact of Imperialism on Britain* (London, 2005); Stuart Hall (ed.), *Representation: Cultural Representations and Signifying Practices* (Cambridge, 1997); Shahmima Akhtar, Erika Hanna, Peter Hession, Mobeen Hussain, Krishan Kumar, Naomi Lloyd-Jones, Jane Ohlmeyer and Ian Stewart, 'Roundtable: Four Nations', *Modern British History*, 35, 1 (2024), 30–48.
43 S. Howe, 'Questioning the (Bad) Question: 'Was Ireland a Colony?', *Irish Historical Studies*, 36 (2008), 138–52, 143.
44 J. E. Findling and K. D. Pelle (eds), *Encyclopaedia of World's Fairs and Expositions* (Jefferson, NC, 2008), p. 8.
45 Ibid.

1

Famine and industry: Ireland's original exhibitions

In the aftermath of the Famine, contemporaries theorised Ireland as a transitional space in constant need of development, and practical solutions for industrialisation were offered in the fairground. Post-Famine, the surviving Irish middle class became the organisers and financial backers of Ireland's exhibitions, and they sought to engage the Irish populace with the project of commerce.[1] They capitalised on the opportunities afforded by the Great Exhibition of Arts and Industry held in London in 1851 after the Famine.[2] The Crystal Palace was the first international Exhibition and with its 100,000 objects from over 15,000 contributors attracted almost six million visitors. Irish industrialists and entrepreneurs used the international platform to respond to the immediate and more long-term concerns exposed by the disaster. The Famine led to a rupture in Irish society in the short term, but, for many, it also highlighted the deep-rooted weaknesses of the Irish economy. The Irish display in 1851 functioned on two levels. On the one hand, it demonstrated Ireland's purported recovery from the direct impact of the Famine; on the other hand, it advertised the country's potential for modernisation in the future. This two-pronged approach enabled Ireland to petition for foreign investment and trade as a corrective to its current tragedy as well as for its imagined prosperity. This chapter investigates how exhibitions of the period projected a liberal solution to problems of Irish poverty and land reform based on individual labour, cloaked in narratives and imagery rooted in the Irish past. Further, observers could fit these into competing nationalist or unionist narratives, as the chapter demonstrates. For instance, the 1851 Exhibition has been a source of great historical interest, yet the 1852 Cork Exhibition offers a unique opportunity to consider how local Irish businessmen navigated colonial pressures, organised as it was by Cork's middle class in this era of exhibits.[3] Further, the Great Industrial Exhibition in 1853 held in Dublin offered a composite beacon of Irishness after the horrors of the Famine.

This chapter argues that through the consistent narration of Ireland as a developing nation, the exhibitions of the 1850s did not demonstrate

the country's prowess to the world but instead became an opportunity for Ireland to learn from the industry of others. Sir Charles E. Trevelyan (1807–86), Assistant Secretary to the Treasury, was the most senior official who oversaw Famine relief efforts in Ireland. He contentiously prioritised economic principles over immediate Irish survival in his policymaking.[4] Gaining traction from Trevelyan, perspectives on how Ireland should develop shifted according to the exhibitions' organisers. While the 1851 Exhibition can be read as what the English Government allied with Irish industrialists wanted for Ireland, the exhibitions in 1852 and 1853 reveal how an Irish nationalism interacted with the period's broader imperialism to secure the country's technological advancement. The exhibitions of the 1850s demonstrate that a hybridity of politics on Irish development were held by Irish men and women within the mixed loyalties of Irish unionism and Irish nationalism.

I show in this chapter how discourses on famine and empire intersected with gender and class in narratives of Irish development. For one, Ireland's exhibitions in the 1850s contributed to the entrenchment of class inequality. The individual bore the burden of their personal advancement and that of the nation, and the state bowed down to the 'invisible hand' in the market. Such laissez-faire politics plagued Famine relief policies in the 1840s when humanitarian concerns came second to free trade priorities.[5] In the aftermath of the Famine, the same belief in free markets featured in the international exhibitions of the 1850s, and the powerful in Ireland cemented capitalist economics as fundamental to Irish development. Ireland's recovery was distinctly tied to gendered ideas of labour with discrete spheres for masculine and feminine industries. Within this, poor men and women were imagined working for the consumption of the monied Irish class; poor women in particular were held to possess the skills and techniques to further rural industries for Ireland's development and develop the agricultural industry that poor men worked within.

I firstly discuss the 1851 Exhibition. I reveal how for unionists the Empire became central in their hopes of Ireland becoming a developed nation profiting from British investment and the British imperial marketplace. In this narrative, Irish goods would be equal to Britain's with the necessary financing from England and labour from the Irish working poor. I then move on to the Cork Exhibition of 1852. I demonstrate how for Irish nationalists, their hopes for development saw them take pride in Irish goods. Yet they blamed Irish labourers for supposedly not investing in their own country (through the purchase of Irish goods and not migrating) while also lambasting Britain's role in depressing Irish industry (through underinvestment). The lack of national policies in this arena was a source of great distress for Irish industrialists as it hampered both traditional and newer industries. The final case study in this chapter is the 1853 Exhibition in Dublin. I uncover

how a local Irish businessman came to act as a national figurehead to inspire the Irish populace by his own display of industry and commerce. The exhibitions of the 1850s illustrate the difficulties in how these contemporaries sought Irish development. They prioritised traditional skilled labour as being uniquely Irish but tried to compete with the mechanisation of Britain and other industrialised nations by seeking technological advancement themselves. The fluid nature of the exhibitions highlighted specific priorities for different constituents in Ireland that however contradictory were a function of the form of the fair itself.

Ireland's blank slate: Great Exhibition of the Works of Industry of All Nations, London 1851

The industrious ideology of the 1851 Exhibition is neatly encapsulated in *A Tribute to the World's Industrial Jubilee*: '[a] peaceful contest of arts and industry' that had ambitious aims for the future 'in which art, science, and commerce, literature, and brotherly kindness, should go hand-in-hand among all the nations of the earth', revealing how international competition was revered as spurring national advancement.[6] The architect of the Crystal Palace, Joseph Paxton (1803–65), epitomised the cosmopolitanism of the Exhibition as a 'self-made man' who designed the 456-feet wide and 66-feet high grand parallelogram in London (Figure 1.1).[7] The sketch reveals in detail the architectural ingenuity of the vast building with its clean lines and domed roof. An array of well-dressed men, women, and children circulate

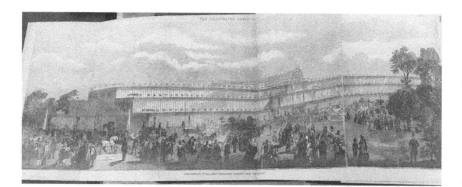

Figure 1.1 The exterior of the Great Exhibition building (manuscript by J. Cassell, *The Illustrated Exhibitor, A Tribute to the World's Industrial Jubilee: Comprising Sketches, by Pen and Pencil, of the Principal Objects in the Great Exhibition of the Industry of All Nations, 1851*, 1851)

in this prominent attraction where flags of the world adorn the front of the building. The inclusion of trees reflects the broader blend between nature and urbanisation that Crystal Palace sought to evoke. Overall, the image conjures a scene of an eager group of spectators ready to absorb the lessons of the fair. The chief adviser for the 1851 Exhibition, Lyon Playfair, organised the Exhibition's products into four sections: raw materials, machinery, manufactures, and fine arts.

For English policymakers and Irish industrialists, out of all of Britain's colonies, Ireland became seen as the most in need of development after the Famine.[8] Exhibition organisers held that labour was of utmost significance, and, for Ireland specifically, the physical capacities of the country and its people took on national importance. Thereby, the central tenet of the 1851 Exhibition's organisers was that the Irish could 'work' themselves out of the poverty caused by the Famine – through the productive Union with Britain. Organisers individualised the process of recovery by emphasising the importance of personal desire and entrepreneurship as a way out of distress. Crystal Palace was an effusive example showing that the tools for Irish progress and industry were readily available – it just relied on the labouring poor to work. The middle class could act as investors and consumers and the working-class labourers as the producers. Irish businessmen and investors largely contributed to the exhibits from Ireland that were displayed in 1851. As liberal capitalist entrepreneurs, they were interested in showcasing the best of Irish products to appeal to international and namely British investment. The *Official Catalogue* made innumerable laudatory statements on the plentiful lessons of the Exhibition: 'We heartily say "God Speed!" to all attempts to give employment to the population of Ireland.'[9] It espoused that Ireland's potential future could be 'more successful and more active' after its 'lamentable depression' in the 1850s.[10] Visual displays were perceived to be sufficiently instructive to change the lives of the Irish poor, according to popular discourse – for instance, by demonstrating how certain industries and machines worked. In turn the poor would internalise and act on these examples.

Further, the recurrent characterisation of the Irish as 'developing' positioned Ireland as tentatively straddling backwardness and modernity, agriculture and manufacturing, tragedy and progress. The Irish performed a modernity that was achievable, timely, and profitable, provided they invested in the latest machinery. For example, the country largely engaged in agricultural industry, but the tools and equipment agricultural labourers used was shown to be old-fashioned.[11] Concurrently, the English often criticised the present Irish condition as backwards, stagnant, and at times hopeless. Yet the exhibition platform brought these two conflicting positions together and allowed a fictionalised reconciliation to occur; whatever

past stereotypes of the Irish existed, their display of industry and labour represented the possibility of a hopeful future irrespective of their present condition. As Peter Hoffenberg demonstrates, the need to be 'developed' became the trope of a rudimentary nation.[12] 'Developing' did indeed tease the prospect of potential equity with industrialised nations while exemplifying the country's backwardness in the present, which in turn reinforced imperial control.[13] For instance, official Exhibition literature exhaustively detailed Britain's role in developing the Irish textile industry. It reported that 'the British government had granted £1,000 for the purpose of affording instruction in the proper cultivation and treatment of flax', thereby highlighting their significance in Ireland's economy.[14]

In this way Ireland's planned industry and development relied on the Union and broadly revealed a popular pro-Union and, by extension, pro-Empire stance in the mid-nineteenth century.[15] One of the key aims of the Exhibition project was to stimulate a growing commercial interest in Ireland. The burden of industry became the responsibility of the poor, and particularly women.[16] Contemporaries praised and encouraged female industriousness both in the Exhibition and beyond. The *Illustrated Exhibitor* imagined that a 'brighter day [would] dawn on the Sister-land, [without] famine and despair' only 'when the Irish peasant shall be industrious and prosperous'.[17] Within this discourse a rural, traditional (and feminine) Ireland was epitomised as a virtue, offering hope. For example, female peasants were typically involved in textile production, which gained notoriety during the Exhibition. The newspaper expounded that 'the term "Irish" is universally known as the name of the finest [textiles]', such as flax, linen, lace, muslin, and poplin.[18] The manufacture of textiles in Ireland was primarily a domestic industry in the 1840s, taking place in women's homes, and 'almost every kind of useful and ornamental work' took place in well-attended female schools and peasants' cottages in Ireland.[19] These schools were popular projects for gentry women interested in local philanthropy and relied on large charitable donations.

Moreover, the Exhibition was part of a broader move towards wage labour to enable individuals to earn money and spend money in buying luxury products. This sentimentalisation of labour paradoxically equated a new consumer market with unaffordable and highly ornate goods. *Tallis's History and Description of the Crystal Palace* proclaimed that the exhibits in 1851 were typically the 'crowning representation[s] [of particular trades] rather than the articles of everyday use', and Lara Kriegel has shown how this made exhibited items more appropriate for expensive, well-decorated homes.[20] Despite not being suitable for everyday consumption, this changed the dynamics between the poorer, industrial, and middle classes in Ireland with the acceleration of free trade discourses in the 1850s. Thus, a dual

influence operated in Ireland's display which sought to employ the abundant cheap female labour in the country to furnish a new Irish middle class who were unaffected or otherwise profited from the Famine. Evidently, emerging capitalism in the nineteenth century influenced labour practices and consumption in Ireland.

Indeed, the Exhibition only interacted with the real-life conditions in Ireland on a superficial basis; there was a significant disparity between the realities of a barely recovering Ireland post-Famine and the Exhibition's celebratory proclamations. Enda Delaney has shown that the impact of the Public Works programmes, the strikes, and the riots of the late 1840s still had real consequences decades later.[21] Newspapers reported daily on the departures of 'wretched creatures' escaping from poverty.[22] Further, there was such large-scale emigration from Ireland in this period that Irish-born people accounted for a third of New York's population in 1855.[23] Despite these seismic demographic changes, individual Irish men and women received praise as the bastions of the future through their perceived integrity and perseverance coupled with new mechanisation. For instance, the *Exhibitor* boasted that 'the Briarean arm of steam-power and machinery will accomplish that which the maiden's arm once sufficed to do'.[24] Ireland's portrayal as a rural hinterland with undeveloped natural resources and a backward manufacturing system extended the narrative of potential development both through the individual and technology. The newspaper lamented that 'Ireland contains some of the richest iron-ores in Europe, and yet they are allowed to lie unused beneath the soil'.[25] The Irish land and its people were ripe for cultivation in the eyes of many.[26]

Such criticisms of an underdeveloped Ireland found traction in the English press, the Irish press, and Exhibition literature. However, critiques of Ireland were diffused through the country's partnership with Britain, which granted Irish industrialists an elevated sense of superiority in the hierarchy of displayed nations. The Union, in this way, was vastly profitable, performatively if not in reality. Within the webs of empire, Ireland could claim prestige merely by association. For some authors of official state propaganda, its relatively low 300 goods granted it a renowned position in the competition of industrialisation. The Irish symbolically used their personal physical labour to supplement the economy of the imperial state, and so power remained within the imperial English nucleus. Overall, the teleological pretensions of fairs offered a ready-made solution to economic instability in mid-nineteenth-century Ireland in the form of the labour of its people. Ireland's chameleon-like status in 1851 saw it assert itself as being on the brink of industrialisation, if only its people and the English state would help.

Ireland's interim display: National Industrial Exhibition of Ireland, Cork 1852

Moving on, the Industrial Exhibition of Ireland in 1852 held in Cork emerged out of the widely held belief that exhibitions caused economic growth, and the general disappointment with the goods Cork had sent to the 1851 Exhibition. In 1851 the overall 300 contributors from Ireland was made up of 'Dublin's 197 [goods], Belfast [had] 53; Cork 22; [and] Limerick 12'.[27] The Cork Exhibition lasted three months from 10 June to 10 September and hoped 'to develop and foster ... hitherto neglected resources'.[28] It was organised by John Francis Maguire (1815–72), former Mayor of Cork. He was determined to

> display to the country its own resources and capabilities, to inspire confidence, to remove doubt, to banish prejudice, to awaken interest ... to give employment, diminish poverty, lessen taxation, promote happiness, and elevate the moral and physical condition of the mass of the people, by the practical encouragement of native industry.[29]

These extensive objectives again placed the burden of improvement on the Irish people, notably its poorest. It even assigned blame to them. Maguire lamented the over-reliance on the potato, which he saw as causing the Famine: 'the whole framework of Irish society rested on the frail support of a perishable root'.[30]

Maguire's politics reveals an Irish nationalism popular in the nineteenth century which sought to develop the country's manufacturing industry through better technology, to make Irish products appealing for Ireland's benefit, and further to counter anti-Irish prejudice that supposedly made the populace 'purchase everything English'.[31] The exclusive consumption of English products became a distinctive form of nationalism for unionists who were committed to an alliance with England, even at the cost of Irish industry. Maguire despaired that prejudice against Ireland permeated 'the lowest to the highest class, from the peasant to the peer', acting as 'a moral blight upon the minds and hearts of Irish men and Irishwomen'.[32] For instance, contemporary newspapers deplored that, even after Irish exhibitions, '[where] people viewed and admired the various specimens of native genius and industrial skill', they still 'purchased English and foreign goods as usual'.[33] The Cork Exhibition was therefore part of a broader process of challenging the perceived higher status attached to English-made goods in the mid-nineteenth century and reasserting the quality of Irish manufacturers.

Moreover, Maguire was highly critical of Irish migration, describing the Irish as 'impulsive children' for settling abroad in the 1850s.[34] In Maguire's

nationalist view, emigration because of hardship in the country was childlike and immature, and he himself was an example of the successes Irish men and women could achieve if they stayed in Ireland. Here, 'impulsivity' becomes a metaphor for abandoning the country. The Exhibition thus emerged out of negative conceptions of Ireland, and its people specifically; it became a workable solution, a lifeline, and a much-needed chance for development. The prospective 'employment of the idle and the poor' was the Exhibition's 'main object'; in other words, the Exhibition and all it represented offered people a reason to stay.[35] Around 140,000 people visited Maguire's display. The number of visits by season ticket holders was 54,936, and 74,095 paid at the entrance.[36] Of this, it is difficult to know how many of the poorer classes attended, but Maguire introduced sixpenny days to attract visitors from the labouring communities.[37] Furthermore, some had their admission paid by their employers, like workers from Queenstown, Blackrock, and Cloyne, among others, for 'whom the day of their excursion was made a joyful holiday'.[38]

However, Maguire and his contemporaries were not just interested in ensuring that Irish workers visited the Exhibition but perhaps more importantly that they behaved appropriately. For example, in the *Report of the Cork Cuvierian Society for the Cultivation of Sciences* (1855) the author claimed that: 'The very humblest and poorest preserved their self-respect, by the propriety and gravity of their deportment, and as rigidly complied with the prescribed regulations as the richest and proudest.'[39] This patronising appraisal reveals the scepticism within which the labouring class operated in the mid-nineteenth century and the anxiety to dispel any fears that they would upset the Exhibition project. To a certain extent, there was significant effort to present images of a fraternal unity within the nation for the benefit of the country as a whole. The official pamphlet of the 1852 Exhibition stated: 'All classes, from the fashionably-dressed holder of the season ticket, to the humbly attired payer of the six-penny admission fee ... in point of demeanour, deportment, and conduct, there did not seem to be [the] slightest difference.'[40] The historical accuracy of such a position is impossible to recover; however, again we see the importance of regulating human behaviour within the constraints of contemporaries' class groupings. Maguire and others reinforced class-based inequality and prejudice to rebuild Ireland post-Famine, in a way that modelled capitalist England.

Similar to the 1851 Exhibition, organisers of the 1852 display championed the Union to show 'how worthy [Ireland] is to form a portion of the British Empire'.[41] Organisers saw the Union as fundamental to Ireland's future development and industrialisation but maintained Irish distinctiveness. Their ultimate ambition was that 'Ireland should be considered as a[n] integral portion of the British Empire, and not to be considered as a

province or a dependency of the Empire'.[42] As in 1851, the mythical capacities to fix Ireland post-Famine circulated: the 'spirit of charity and patriotism' on display would 'awaken intelligence ... excite emulation ... impart knowledge' so Ireland could mechanise apace.[43]

Building on ideas of Ireland's importance within the British Empire, it is necessary to consider what was exhibited and who saw these exhibits. The Cork Exchange Building displayed everything from minerals, salt, flax and beet to machinery, hardware, whisky, tobacco, poplins, tabinets and velvets, furniture, and harps 'to educate the masses' (Figure 1.2) – even a shamrock table.[44] The image reveals the number of children admitted on various days of the Exhibition's run, and there were almost a thousand more girls who visited than boys, which reveals a continuation in gendered aspirations from the 1851 Exhibition that relied on women being industrious. Many of the girls came from schools of rural industries and church organisations, and the boys from various religious and military institutions. The higher number of girls may reflect the fact that women were tasked with the revival of rural industries, and these girls came to be seen as having the potential capacity to save Ireland with their industrious hands. However, boys and men typically

Figure 1.2 Return of the number of children admitted between the hours of 9 a.m. and 11 a.m. (manuscript by J. F. Maguire, *The Industrial Movement in Ireland, as Illustrated by the National Exhibition of 1852*, 1853, p. 469)

held the responsibility of the mechanisation deemed necessary for Irish recovery, and their lower numbers may reveal the general failings of this project. Boys did not visit the Exhibition to further Irish progress, perhaps because of a lack of interest, or lack of opportunity. We can further see that some charities bought girls and boys tickets to attend, and this indicates that children were one of the Exhibition's main target audiences. The focus on children reflects Maguire's desire to prevent migration at a later age: if citizens could see and be inspired to further the industry of their country, they may eventually have opted to settle in Ireland during adulthood. Again, Irish men and women evolved as the saviours of the country – devoid of the state.

In the end the entire Exhibition enterprise was celebrated despite its lack of practical achievements (it failed to produce a profit). It was an 'unaided effort of one of the poorest and most depressed countries on the face of the earth', and the vast project was an achievement in terms of organisation and general reception.[45] The practical impact of the Exhibition, Alun C. Davies has shown, ranged from stimulating the growth of flax to sustain Ulster's productive linen industry to introducing sugar beet as a staple in the Irish diet and the expansive irrigation of salt mines.[46] Ultimately, in the words of Maguire, the 1852 Exhibition was 'another stride, in the path of National Regeneration'.[47] Thus, 1852 entrenched ideas of an Irish nationalism partly allied with the Union based on the power of the visual, the abilities of the individual and technology, and the gift of the natural environment in the quest to reform Ireland to fight against the 'forgeries of the foreigners',[48] forgeries referring to mass-produced machine-made products in this instance and foreigners to British manufacturers and their hold on the Irish market. Ireland's displays so far in the 1850s stood as convincing exemplars of potential progress. The country's productive future was on the horizon; Irish men and women need only reach out and grasp it.

Ireland's recovery: Great Industrial Exhibition of Art and Industry, Dublin 1853

Finally, in a celebratory display of Irish industry created by a successful industrialist, the International Irish Exhibition of Arts and Industries opened on 12 May 1853 for six months on the grounds of Leinster House, Dublin (Figure 1.3).[49] The impressive building was smaller in size and grander than the 1851 display with an imposing front (each dome was 425 feet in length and 100 feet in height).[50] A host of well-dressed men and women, some on horses, circulate on the lawn, evoking images of sophistication and prestige. A few of the guests point admiringly at the building itself, and trees drawn on either side illustrate the importance of nature in this grand display

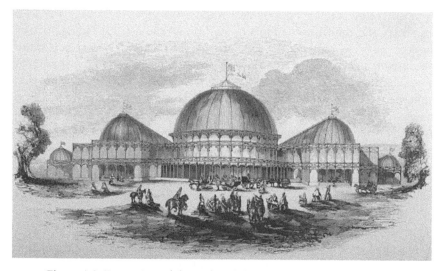

Figure 1.3 Front view of the Irish Exhibition building (manuscript by J. Sproule, *The Irish Industrial Exhibition of 1853: A Detailed Catalogue of Its Contents: With Critical Dissertations, Statistical Information, and Accounts of Manufacturing Processes in the Different Departments*', 1854, p. 69)

of industry. John Benson (1811–74), a county surveyor of the East Riding of Cork, and engineer to the Cork Harbour Commissioners, designed the building.[51] Over one million visitors witnessed a proclaimed rebirth of the Irish nation, a determined show of industrial solidarity in the wake of their tragedy; here was an Ireland recovering and beginning anew. Its opening, attended by representatives of the Church, university, army, and guilds, became a

> Day of jubilation and of pride – for Ireland invites in peaceful convocation to her metropolis a nobler assemblage than ever met in her ancient halls of kings, and she has raised a structure for their reception more august than that Teagh Mor, which in the days gone by, stood on the Hill of Taragh. Already our streets and thoroughfares are thronged with strangers, denizens of lands with whom our intercommunication is ordinarily limited and fortuitous.[52]

The presentation of the grand building and vast tourism to Dublin is in stark contrast to the millions who died and the millions who emigrated after the Famine. Despite such tragedy, a few in Ireland benefited from the changed Irish economy.[53] The 1853 Exhibition became a 'Sublime causeway of knowledge by which the spirit of man climbs up from earth to heaven' and ultimately came to be an 'Epic of Labour!' which enabled visitors to 'See the Titan's progress through all the regions and times of the earth', showing

the importance of the visual in fairs but also the key role of comparison in inspiring and furthering industrial development.[54] Overall, 160,000 acres celebrated the achievements of labour, lauded as the 'Heaven-sent benefactor of mankind!' and the ultimate tool of progress and development.[55] As in London and Cork, official Exhibition reports abounded in such declarations of the historical and ancient importance of work. Again, human toil and perseverance became the solutions to structural and environmental problems. The 'universal brotherhood' that Ireland imagined remained a 'glorious paternity of Labour' for the benefit of all.[56]

Where the 1852 Exhibition stressed the role Irish men and women could play in rebuilding the nation, the Exhibition of 1853 valorised the character, industry, and ambition of one man. William Dargan (1799–1867) organised the Fair. He profited from the railway boom in the 1830s and developed canals, roads, and viaducts in Ireland.[57] Dargan wanted to respond to the 1851 Exhibition in London and to build on the 1852 Industrial Exhibition in Cork to assert Ireland's industrial development. Thus, he offered £20,000 to begin the project of an international Exhibition for Dublin in 1853, and he eventually contributed around £90,000 to the enterprise. The display expanded the exhibitions held triennially by the Royal Dublin Society.[58] The *Illustrated Magazine of Art* described Dargan as 'an object for the interest and admiration of all the world. A man in whom so much energy and perseverance are united with so much patriotism.'[59] He epitomised the spirit of the Dublin Exhibition as the embodiment of individual success. The fact that he acted alone buoyed his grand tale: '[he was not helped] by any adventitious aid from fortune, but by probity, patience, and thriftiness at the outset', and subsequently 'the mere word "Dargan"' had become the 'synonyme [sic] ... of the magnitude and the success of nearly every great public work in Ireland'.[60]

Dargan has been described as the 'child of Daniel O'Connell' (1775–1847). Jamie Saris explains that they both shared connections to a modernising bourgeoisie, held ambitions to rebuild Ireland as a modern nation, and believed 'that the great mass of poor people in the country required immediate social and economic development'.[61] O'Connell played an important role in the political split between Protestant and Catholic Ireland in this period and became the vanguard for Irish disaffection with the Union.[62] In the late eighteenth century, Paul Bew argues that it was possible for many of the Protestant political class in the north to have a 'primary identification with "Ireland"'.[63] However, Bew insists that this connection was steadily eroded. For one, under O'Connell a form of Catholic nationalism emerged, which overlooked Protestant liberals; two, the rapid industrialisation of Belfast created uneven development throughout the rest of the country; and three, Britain considered Irish Protestants as a potential defence against

Catholic revolt in Ireland. Consequently, within the United Kingdom, Irish Protestants were pointedly integrated (against Irish Catholics).

In addition, Daniel O'Connell mobilised the Irish citizenry in his Catholic Association, founded in 1823, which united 'Gaelic clansmen and local Catholic gentry' to campaign for Catholic emancipation.[64] O'Connell disparagingly called Britain 'the most intellectual and commercial nation on the face of the world ... a mighty empire, upon whose limitless dominion the sun never sets', with which the Irish Protestant community allied themselves.[65] In the fairground, however, non-practising Catholic Dargan legitimised the transformative powers of the individual (irrespective of religion) and became a role model for the post-Famine survivors. As a businessman with wealth helping the poor of Ireland, he stimulated an impassioned Irish nationalism, and the industrious poor could emulate him. Thus, the surviving middle and working classes would rescue their country in his wake. Dargan embodied national and religious conciliation for the benefit of Ireland as a whole.

In the Dublin Exhibition, organisers again adopted Playfair's classification system of raw materials, machinery, manufactures, and fine arts. The value of seeing and internalising productivity appeared in the sheer mass of exhibited objects. The *Exhibition Expositor and Advertiser* wrote: 'The first sensation experienced by the visitor upon entering the Great Hall of the Industrial Exhibition is that of wonder and admiration ... everything crowds alike upon the eye and upon the mind' (Figure 1.4).[66] High ceilings contributed to the profusion of objects within the immense Centre Hall, and the vast display included sculptures and paintings on both sides of the room. People clustered around the middle of the hall, looking up, looking around, and generally admiring the exhibits on display in the image. The capacity to overwhelm visitors with objects to indicate growing prosperity was manifested in the excessive quantity of objects in each room. A commentator reported that the vast array of displayed goods offered 'special knowledge; so that the present may be compared with the past, and suggestively, with the future'.[67] A cyclopaedic range of information sought to stimulate the consumption of visitors, and to build the confidence of the Irish manufacturers who had 'struggle[d] against apathy and neglect' due to historical prejudices.[68]

Advertisements for the 1853 display declared that Irish men and women could travel the world and learn from other nations in Dublin as visitors could become 'mighty traveller[s] ... [who had] traversed all the regions of the earth; ... [and] journeyed thousands of leagues, and seen and learned the sights and the knowledge of the world'.[69] This reinforces Timothy Mitchell's concept of 'world-as-exhibition' and reveals the realism that the display relied on to attract visitors.[70] Clearly, this was propaganda, but it

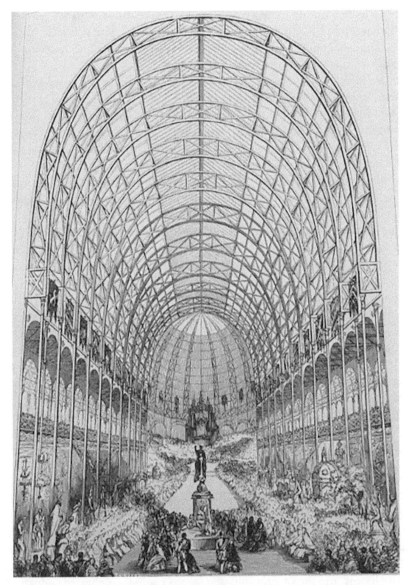

Figure 1.4 Centre Hall of the Irish Industrial Exhibition building (Sproule, *Catalogue*, p. 53)

is interesting to reflect on whether at a time of expensive and out-of-reach travel, a cheap train ride to the Exhibition did indeed feel like tourism of the continent. Visitors were advised to absorb the Exhibition's teachings like a sponge and 'fill [their] heart with the marvels that crowd upon [them]; then

pause a while and meditate upon them'.[71] This reveals the perceived developing nature of Ireland and Irishness in this period; there was still much to learn, and Irish individuals needed to continue on the path of discovery and industry to further the country's progress.

Indeed, visually if not psychologically, visitors saw that free trade would ensure Ireland's resources could be 'known and investigated', regions explored, people understood, and manufacturers encouraged so that the 'wealth of other countries should find its way into Ireland … in the constant intercourse of commerce' and capitalism.[72] People 'of all climes' were physically consuming a utopian Ireland within laissez-faire economics for the 'material interests of [the country]'.[73] Further, a large-scale tourist enterprise capitalised on the Exhibition, with many newspapers advertising inexpensive excursions and popular attractions to see and visit in Ireland.[74]

Within the Exhibition a progressive timeline of Ireland's history materialised with technology, such as carriages and locomotives, fine arts, medieval artwork, and antiquities, in addition to agricultural tools and Irish designs in silk, linen, and wool – epitomising a diverse set of exhibits from ancient Ireland to the present in the 1850s. The exhibits encompassed 'a romantic, backward-looking nostalgia for the country's past glories juxtaposed with an ambitious, forward-looking notion of progress', notes Margaret M. Williams, and this created a teleological timeline in which Ireland continued to advance.[75] Ireland's displays in the 1850s typically straddled different temporal spheres. The exhibits' presentation of time allowed Irish men and women to rationalise the industrial struggles of the present as a temporary obstacle when compared to the successes of the past and the hopes of the future. Overall, visual bonds linking an Irish past, present, and future created an accessible Irish national community that stressed commonality, solidarity, and a shared history.

Specifically, machinery became 'the most important [exhibit] in the entire Exhibition' and 'surpass[ed] the wonder of enchantment' for Irish contemporaries.[76] To Ireland, machinery offered a gargantuan opportunity for technology's power to save the country from stagnant industry. The machinery section devoted 400 feet to printing presses, engines, reaping machines, ploughs, diggers, haymakers, and dairy utensils. Displays of textile looms, the art of printing, and steam engines celebrated industry to 'illustrate errors of the past and to bring a change as regards the future'.[77] The exhibits included literature on their uses and benefits and traded on the belief that observation in the present equalled utilisation in the future. For example, the *Illustrated Dublin Exhibition Catalogue* lamented Ireland's deficiencies in the land: 'coal and iron and limestone in abundance [left undisturbed], mines have been but very partially worked; with water-power … runn[ing] idl[e]'.[78] Therefore, the virtue of 'seeing' at the Exhibition

would purportedly further the 'social, industrial, and political welfare of the people', through replication, production, and consumption.[79] By observing the technological revolution in the exhibits, the next logical step for visitors was to apply these developments for the benefit of the country. The inherent simplicity assigned to Irish development made the aims of the fair accessible if not wholly practical. The ultimate message of the exhibits held that mechanisation was a productive solution or a remedy to human (read Irish) deficiency. Here was an opportunity to learn from one's mistakes, particularly the tragic error of relying on the potato.

In contemporary reports on the 1853 Exhibition, Ireland's sought-after development was daily discussed and debated. Namely, the *Illustrated Magazine of Art* explained that while London was 'the metropolis of the British Empire', Dublin was the city of a kingdom 'lately risen from the slough of famine and despond'.[80] It is curious to consider whether mention of the Famine sought to heighten the achievement of the display itself or to offer a (well-justified) reason for any weaknesses in the exhibits. Direct comparisons between the 1851 and 1853 exhibitions naturally produce vast differences in quality of display, but we need to keep in mind why visitors attended the Exhibition. If it was because they recognised Ireland's slow recovery and wanted to help propel its industry, its underdeveloped exhibits may have encouraged them to commerce and investment. Alternatively, if they wanted to see the height of technology, Britain's exhibits were more advanced, but Ireland was tied to England and so benefits of trade had the potential to overlap. For the organisers of the Exhibition, this was the opposite of the desolation of the Famine, and a remedy to perceived Irish apathy.

However, official Exhibition literature adopted an inconsistent discourse on the 'artificial world's partnership with nature' in Dublin.[81] Contemporaries described the 1853 Exhibition as 'the commencement of a new era' or 'a revival of prosperity', otherwise 'the last grand convulsion throes of an expiring nation'.[82] The contradictory reporting of Ireland's display reflects the organisers' anxieties about competition and comparison. For instance, the *Illustrated London Magazine* worried that '[Ireland] exhibits her own shortcomings ... Dublin Exhibition – a gigantic anomaly in a land long celebrated for its paradoxes'.[83] The author expressed fears that as the Famine was technically not even a decade old during the Fair, the country's limited recovery would be obvious. Ireland competed in displayed commerce partly because of the pressures of the global market, and there was uncertainty among Irish organisers and Irish citizens alike as to the public reaction to the Irish exhibits specifically, and the Dublin display more broadly.

In this vein, there was a limited acknowledgement of Ireland's historic mistreatment in certain publications. The *Expositor* noted that Ireland

occasionally became a 'terra incognita' due to unfair diplomacy and investment. It continued: 'When Ireland becomes like other countries – like Scotland ... will she have her fair chance of rising as other lands rise, of taking her legitimate place amongst the nations of the earth.'[84] Despite not naming England, there is slight tension and bitterness here towards the country as hampering Ireland's development. Evidently, nationalist agents within Ireland resented the differences in policy and treatment within the nations of the United Kingdom and wanted a greater parity. Moreover, in a graphic appraisal of the situation, the *Southern Reporter and Cork Commercial Courier* wrote that the two countries 'were as if united by a syphon, the long leg of which was in England, and through which Ireland was emptied for the bloating of the other'.[85]

Yet allyship with Britain remained crucial in the practical encouragement of industry. The *Illustrated Dublin Exhibition Catalogue* vied for 'increased intercourse' and 'a more intimate acquaintance with the people and the capabilities of Ireland ... [to stimulate the] inflow of English capital'.[86] The Exhibition belonged to a broader narrative of union between Britain and Ireland that facilitated increased co-production and prosperity for Ireland's benefit. This sentiment percolated throughout the Fair, and the Lord Lieutenant expounded at the Exhibition's opening ceremony that England and Ireland's interests were 'mutual and inseparable'.[87] The valorisation of a renewed co-operation reflected Irish anxiety to prove their value and worth as a 'sister country' to England, while recognising English misgovernance of Ireland in the 1850s.

Fundamentally, Ireland's negotiation of Empire and capitalism at these fairs was evident in the complex discourse on the Irish display at Dublin in 1853. By adopting contradictory language, Ireland could hope and occasionally achieve greater trade and the irrigation of its resources, but it left room for improvement, always labouring for a better future. Vague and contrary reporting tempered expectations of Ireland in an era of global trade with its focus on the individual and profit. Laudatory statements could act as an inspiration for Irish men and women at home and potentially popularise the country's wares globally. This partially protected Ireland against criticism but also furthered hopeful ambitions for the country's development.

Notably, the *Dublin University Magazine* published a column on the 1853 Exhibition that focused on improvements in Dublin, which may have indicated the rise in living standards after the mass deaths of the Famine.[88] For instance, the unnamed author commented on houses looking 'particularly bright and cheery'.[89] They identified the changing crowd of the city, with the 'people themselves [fashionably] dressed' – which revealed the prosperity of the middle class after the population decline of the labouring poor in the 1840s. The author wandered and sought out the 'little old man,

with the white apron'. This was a nostalgic remembrance of a Dublin past, but it also illuminated the rapid extinction of the poor in Ireland, whether from starvation, disease, or migration. This was a story of transition, of a revived present containing hope for the future based on the elimination of the poorest. Some Irish industrialists held that 'pestilence and famine [were] the ultimate purifier and regenerator', and so 1853 offered a tabula rasa for Ireland's future prosperity. Consequently, the Dublin Exhibition building was a stark difference to the 'fever sheds and the soup kitchens' set up throughout the capital in the 1840s.

Only a few years prior, the *Cork Examiner* exclaimed 'death ... desolation in every district – whole families lying down in fever – hovels turned into charnel houses – entire villages prostrate in sickness or hushed in the last sleep'.[90] But, in the *Dublin University Magazine* column, a compression of time sought to displace the reality of the Famine into a new era of prosperity and survival. The idea of famine as rebirth emerged in official Exhibition literature such as the *Exhibition Expositor and Advertiser*: 'National pulse was again beating with somewhat of its former health and the spirit of trade and enterprise [was] again renascent.'[91] Such commentary was reminiscent of Trevelyan's arguments in the 1840s that the tragedy of the Famine provided an opportunity for the reform and revival of Ireland's economy. His Famine relief policies championed economic initiatives such as workhouses over immediate financial aid. The 1853 Exhibition therefore represented the continuation of a discourse that enabled the mass deaths of Ireland's poor by in effect celebrating the fatalities of the Famine as a type of positive social cleansing for the benefit of Ireland and showcasing the new industrial exhibits that the surviving populace could benefit from.

Specifically, Ireland's western periphery had suffered significantly during the Famine and became a priority in the country's regeneration. The 1853 Exhibition included even the 'small farmers of the remote regions of Donegal, of Erris, and of Kerry' in its nationwide recovery.[92] A vast railway enterprise and discounted tickets made the Exhibition accessible to these remote communities.[93] However, the Exhibition's impact on these areas is questionable. The *Exhibition Expositor and Advertiser* admitted that the 'larger proportion of the rising generation [wa]s not included among the visitors ... [and a] comparatively small number of boys [visited] ... the parties who would be likely to derive most advantage for it' thus building on Maguire's hopes of educating children to ensure their contribution to Irish society in adulthood.[94] Despite the fact that over one million people visited the Exhibition, 'not one in every twenty of the inhabitants from Dublin ever entered the building', visitors from other parts of Ireland were negligible, and so the Irish middle class were the main beneficiaries.[95] Reviews in the *Exhibition Expositor and Advertiser* regretted the excessive cost of

admission, with five shillings being unaffordable for the poorer sections of Ireland's post-Famine population.[96] In the first month, daily visitor numbers ranged from a low 300 to a reasonable 3,000 (the Exhibition building could hold 15,000).[97]

For those who did visit, the Exhibition became a place of socialisation. But organisers complained that 'One sees the same person's day by day walking up and down, apparently with a view of exhibiting themselves rather than with that of becoming acquainted with the objects around them', reinforcing that didactic instruction was at the heart of the display's purpose, a lesson that the metropolitan upper classes seemed to ignore.[98] Here we can see that attendance conferred a particular prestige to the middle class – a type of social capital. Moreover, elite men and women were a regular feature in the Exhibition, and many dignitaries, including Martin Van Buren (1782–1862), former President of America, visited.[99] Perhaps inevitably, this middle-class enterprise was ineffective in reaching its target audience of the urban poor. While this seems to have been a largely unintentional outcome, the Exhibition organisers created an exclusive and hostile environment for the labouring classes.

Both during and after the Famine, some contemporaries blamed Irish men and women for their own deaths and starvation, rather than recognising the role of inadequate state infrastructure or lack of investment in Ireland. The continual proclamations, such as: '[a] degree of apathy [existed] on the part of a large proportion of our people', probably did not endear labouring Irish men and women to visit the Exhibition to hear how wrong and ignorant they were.[100] Furthermore, many were still recovering from the Famine and so reluctant to spend scarce money on visiting a display that highlighted their supposed personal inadequacies in commerce and enterprise. The immediate and physical burden of improving the Irish condition fell on those hardest hit by the blight in the absence of a shared responsibility with the state and its resources. Repeatedly, the *Exposition Expositor and Advertiser* grumbled that 'There are still numerous of our fellow-citizens who have not been in the Exhibition building.'[101] *The Advocate: or Irish Industrial Journal* lamented that 'cousins from the country constitute a very small percentage of visitors'.[102]

Instead of considering why, the author directed personal rebukes to a certain 'class [of people who] would think little of spending the price of admission on some folly'.[103] Therefore, the author describes certain Irish citizens 'as irretrievably plunged in the slough of despond' because they refused this benevolent opportunity to improve. An elitist attitude interpreted the behaviour of those still suffering from the after-effects of the Famine as apathy and a rejection of personal improvement. It reveals a continuation of Famine-era discourse, which blamed the country's poverty on the Irish people themselves.

The wealthy were eager to overcome a suffering that little affected them. The environmental disaster of the 1840s fuelled a strand of nationalist discourse that urged the poorest people of Ireland to do better. In the last month of the Exhibition, organisers reduced admission to sixpence, and visits increased to 4–5,000 daily, with a peak of 11,000 in the Exhibition's last week.[104] The second to last week is reported in the *Exhibition Expositor and Advertiser*, where visitor numbers were as follows: Monday: 10,418; Tuesday: 6,403; Wednesday: 8,714; Thursday: 8,816; Friday: 8,602; Saturday: 6,219.[105] The attendance figures proved that people were interested; they simply could not afford to go.

Surviving satire is indicative of the Exhibition's variable impact on the poor. For example, a letter from 'I. Donoghoe' (I Do Not Go) to his brother Dan titled *A Versified Description of the Great Industrial Exhibition* (1853) is illuminating. The text included a note by 'Scribbler, of Scribbletown, Esq'. Scribbler wrote that this letter was written by one of his tenants:

> The letter was intended by Donoghoe for a brother of his in New York, but, owing, to the singularity of the address, it failed to reach its destination, found its way to the Dead Letter Office, and thence, under cover, to me. I now, with Donoghoe's consent, venture to place it before a discerning public, in the persuasion that many persons will feel gratified in being enabled by means of its perusal, to ascertain the actual impression upon an unsophisticated mind, by so novel and imposing a spectacle as our Great Industrial Exhibition.[106]

The satirical piece adopted condescending humour to illustrate some of the failings of the Dublin display. The fictional story explains that Donoghoe was incredibly 'aiger … to go' to the Exhibition but could not afford it until the publication of the 'chape 'scursion tickets' offered by a railway company. Donoghoe narrated his difficulties in attending, from having to mend his tattered clothing to trying to speak well. This fabrication revealed that the targeted audience of the urban working poor were savvy to the condescension of the Exhibition's organisers. The mockery offered in this 'letter' elucidated some legitimate problems of the exhibit. For instance, the character remarks that he could not absorb all the information: 'come out/No wiser not whin I wint in'. The display relied on sheer quantity and the power of the visual, and it is likely that the Exhibition had little transformative power for the casual visitor. Evidently, elite attempts at social engineering were being ridiculed. The satire laboured the questionable educative capacity of looking and observing by noting that Donoghoe, despite seeing the ideal 'house iv wood', exclaimed he 'prefar[ed] a snug cabin of mud'. While making derogatory jibes at this invented character, the parody concluded with Donoghoe feeling impressed with 'man' and the 'thoughts of the hand' and vowing to 'be thankful, and useful, and quite'. The satire revealed the

problems of an Exhibition centred on educating the poor, as well as the limited capacity for developing new skills and knowledge. While playing with many of the prejudices about the working class popular in mid-nineteenth-century Ireland, the satire critiqued and highlighted that the simple fact of Dublin being a beautiful spectacle did not immediately confer any practical qualities.

As a corrective to such satire, the organisers of the Exhibition employed diverse methods to amass interest in the display, one of which was using religious practitioners to increase visits to Dublin. Two sermons popularly circulated during the 1853 display to encourage local engagement. Their central argument held that mechanisation and industrialisation displayed God's work and so deserved admiration and duplication. For instance, the Presbyterian Reverend James Milligan intoned: 'We are bound to study those works by which God is known.'[107] He echoed official Exhibition literature that celebrated the benefits of offering a 'stimulus to industry, and national enterprise' through 'interchange in commerce' to 'give employment to our half-starved population'.[108] While significant contemporary Exhibition literature narrated the Famine as a horror past, this is one of the few acknowledgements that the after-effects of the Famine were ongoing. The contemporary reluctance to use the word 'famine', Delaney argues, reflected an unwillingness to 'confront fully the human consequence of the failure of the potato crop'.[109] And euphemisms such as 'distress', 'crisis', or 'destitution' featured instead, as a partial acknowledgement of structural starvation that avoided the larger pauperisation and demoralisation of Ireland and its economy. The Presbyterian Church committed itself to ensuring that Irish men and women absorbed the lessons of the display to further God and country in 1853.

Religious texts also advertised the accessibility of the 1853 Exhibition with free admission, free travel, free clothing, and free accommodation.[110] The pamphlets of Presbyterian Church propaganda epitomised the idea that the Irish Crystal Palace was a type of Heaven on earth, that there was a religious duty to industry and labour, and laziness and unemployment were an 'earthly sin'. The widespread collusion of the Irish people with the Exhibition enterprise indicates that many Irish businessmen and women were keen for industrialisation. The recurring themes of the importance of dress and decorum reinforce the fact that the main consumers of the Fair were wealthy magnates and industrialists, necessitating the need for extensive measures to include the urban working class.[111]

Dargan epitomised national revival in the wake of the Famine as he was personally responsible for the employment of almost 60,000 men during the building of the Exhibition and its six-month display.[112] He lost £20,000 at the Exhibition's close, and he rejected the offer of peerage from Queen

Victoria (1819–1901) citing his humble origins. In the spirit of Dargan, the Exhibition hoped to resolve Ireland's problems with industry, even remedying emigration from the country: the *Freeman's Journal* wrote: 'We found every outport crowded with emigrants, every railway thriving by the myriads travelling by them.'[113] However, it does not damn these individuals indefinitely and recognises that 'Those who went to America always talked of making money and returning at some time or another in their lives', and so sympathises with their suffering. The Exhibition thus adopted a two-pronged approach; if the Exhibition did not convince Irish citizens to stay, the future development of Ireland would suture the continual departures for they 'never went without a souvenir of the old land. A sod, a pot of shamrock, or a little earth.'[114]

Meanwhile, Christine Kinealy takes the following words of a contemporary in County Donegal to epitomise 1850s Ireland: 'The Famine killed everything'; the 1853 Exhibition boasted about its 'commonwealth of industry and enterprise'.[115] The stark difference between these two statements decidedly reveals that exhibitions existed in the realm of fantasy, and their utility rested in this utopian capacity. Display enabled individuals to revel in a fiction divorced from reality, and this aspect offers the greatest value to historians. Studying exhibitions offers a unique insight into how people imagined themselves, a look into the very intimate field of their psyche – how they perceived and longed for their country to be. Overall, a wholesale transformation of Ireland's anachronistic economy, which included the workers and consumers, the public and private, the landscape and its irrigation, circulated in a digestible dose of development in the fairs of the 1850s.

However, the exhibitions of 1851, 1852, and 1853 did not transform the labour practices of mid-nineteenth-century Ireland. They did not embolden the labouring classes to shoulder the entire burden of economic recovery. Practically, they did not provide material solutions to Irish poverty post-Famine. Most of the industry displayed in the exhibitions of the 1850s was inappropriate for the predominantly agricultural economy of Ireland, and so stood as aspirational symbols. Further, sustained development through long-term state building and the creation of a robust manufacturing infrastructure needed to work alongside financial investment to emulate Britain. Yet such a narrative was elided, and hyperbolic ambitions of societal transformation, national regeneration, and individual sacrifice persisted throughout the exhibitions of the 1850s in a typically contrary fashion.

In the mid-nineteenth century, popular narratives of Ireland's future in London, Cork, and Dublin, like the reporting and receptions of its exhibitions, were contradictory and subject to revision. In the 1850s, questions of the land

and widespread poverty dominated Irish–English relations. The period was the quietest in terms of political agitation in the nineteenth century. But it paved the way for a reworking of Ireland's relationship with Britain in future years: was it a sister country, a region, or a sovereign state? And this is where I turn next. The discrepancies between the rising urban middle class and rural peasantry which I have considered here took on increased significance in the United States. Ireland's development in the 1850s relied on the symbolism of respite and renewal. Chicago in the 1890s provided fertile ground for the consolidation of these hallmarks of Irishness in the fairground. Irish migrants carried the trauma of the Famine across the Atlantic, which 'shap[ed] the Irish psyche for generations', and this burden of memory saw images of Ireland adapt for Irish migrants in the United States.[116] During moments of political and social tension, an Irishness rooted in an expatriate nationalism, centred on the Anglophobia of Irish migrant communities and sustained by aristocratic patronage, was cultivated. This is the subject of Chapter 2.

Notes

1 For classed stereotypes on the Irish, see M. Nie, 'The Famine, Irish Identity and the British Press', *Irish Studies Review*, 6:1 (1998), 27–35.
2 Recent works on the 1851 Exhibition include: G. Cantor, 'Anglo-Jewry in 1851: The Great Exhibition and Political Emancipation', *Jewish Historical Studies*, 44 (2012), 103–26; L. Merrill, 'Exhibiting Race "under the World's Huge Glass Case": William and Ellen Craft and William Wells Brown at the Great Exhibition in Crystal Palace, London, 1851', *Slavery and Abolition*, 33:2 (2012), 321–36.
3 See Jeffrey A. Auerbach, 'Empire under glass: The British Empire and the Crystal Palace', in John McAleer and John M. MacKenzie (eds), *Exhibiting the Empire: Cultures of Display and the British Empire* (Manchester, 2015), pp. 111–41; Louise Purbrick, 'Introduction', in Louise Purbrick (ed.), *The Great Exhibition of 1851: New Interdisciplinary Essays* (Manchester, 2001), pp. 1–25; Andrew Hassam, 'Portable Iron Structures and Uncertain Colonial Spaces at the Sydenham Crystal Palace', in Felix Driver and David Gilbert (eds), *Imperial Cities, Landscape, Display and Identity* (Manchester, 1999), pp. 174–93; J. A. Auerbach, *The Great Exhibition of 1851: A Nation on Display* (London, 1999); Tim Barringer, 'The South Kensington Museum and the Colonial Project', in Tim Barringer and Tom Flynn (eds), *Colonialism and the Object: Empire, Material Culture and the Museum* (London, 1998), pp. 11–27; P. Greenhalgh, *Ephemeral Vistas: The Expositions Universelles, Great Exhibitions and World's Fairs, 1851–1939* (Manchester, 1988).
4 See C. Ó Gráda, *Ireland's Great Famine: Interdisciplinary Perspectives* (Dublin, 2006).

5 See Christine Kinealy, 'Was Ireland a Colony? The Evidence of the Great Famine', in Terence McDonough (ed.), *Was Ireland a Colony? Economics, Politics and Culture in Nineteenth-Century Ireland* (Dublin, 2005), pp. 48–65, p. 62.
6 British Library, London, 606 *48* DSC, manuscript by J. Cassell, 'No. 1', *The Illustrated Exhibitor, A Tribute to the World's Industrial Jubilee: Comprising Sketches, by Pen and Pencil, of the Principal Objects in the Great Exhibition of the Industry of All Nations, 1851*, 7 June 1851, p. 1–20, p. 1. Copies of the *Illustrated Exhibitor* cost two pence and were roughly twenty pages in length. See Brian Maidment, 'Entrepreneurship and the Artisans: John Cassell, the Great Exhibition and the Periodical Idea', in Purbrick (ed.), *The Great Exhibition of 1851*, pp. 79–113.
7 Ibid., p. 3. Existing literature: P. Young, *Globalization and the Great Exhibition: The Victorian New World Order* (Basingstoke, 2009); Louise Purbrick, 'Defining Nation: Ireland at the Great Exhibition of 1851', in Jeffrey A. Auerbach and Peter H. Hoffenberg (eds), *Britain, the Empire, and the World at the Great Exhibition of 1851* (London, 2008), pp. 47–75; Lara Kriegel, 'The Pudding and the Palace: Labour, Print Culture, and Imperial Britain in 1851', in Antoinette Burton (ed.), *After the Imperial Turn: Thinking through and with the Nation* (Durham, NC, 2003), pp. 230–45; Lara Kriegel, 'Narrating the Subcontinent in 1851: India at the Crystal Palace', in Purbrick (ed.), *The Great Exhibition of 1851*, pp. 146–78; Steve Edwards, 'The Accumulation of Knowledge, or William Whewell's Eye', in Purbrick (ed.), *The Great Exhibition of 1851*, pp. 26–52; Jamie Saris, 'Imagining Ireland in the Great Exhibition of 1853', in Leon Litvack and Glen Hooper (eds), *Ireland in the Nineteenth Century: Regional Identity* (Dublin, 2000), pp. 66–86.
8 See J. Bailkin, *The Culture of Property: The Crisis of Liberalism in Modern Britain* (Chicago, IL, 2004).
9 'No. 11. Ireland's Contributions to the World's Fair', *Illustrated Exhibitor*, 16 August 1851, pp. 181–200, p. 197.
10 'The Exhibition of 1851', *Cork Examiner* (13 November 1850).
11 See D. Lloyd, *Irish Times: Temporalities of Modernity* (Dublin, 2008), p. 6.
12 P. H. Hoffenberg, *An Empire on Display: English, Indian and Australian Exhibitions from the Crystal Palace to the Great War* (London, 2001), pp. 167–8.
13 Purbrick, 'Defining Nation', p. 70.
14 'No. 9', *Illustrated Exhibitor*, p. 146. See S. Errington, *The Death of Authentic Primitive Art and Other Tales of Progress* (Berkeley, CA, 1998).
15 See Terence McDonough, 'Post-Colonial Perspectives on Irish Culture in the Nineteenth Century', in McDonough (ed.), *Was Ireland a Colony?*, pp. 249–59.
16 See 'No. 14. Needle-Work in the Great Exhibition', *Illustrated Exhibitor*, 6 September 1851, pp. 237–56; 'No. 24. Porcelain Works in the Great Exhibition', *Illustrated Exhibitor*, 15 November 1851, pp. 433–52.
17 'No. 10. Ireland's Contributions to the World's Fair', *Illustrated Exhibitor*, 9 August 1851, pp. 161–80, p. 169.

18 'No. 9', *Illustrated Exhibitor*, p. 146.
19 'No. 10', *Illustrated Exhibitor*, p. 169.
20 British Library, London, W30/2382, manuscript by J. Tallis, *Tallis's History and Description of the Crystal Palace, and the Exhibition of the World's Industry in 1851*, Vol. 2, 1852, p. 260. Cited in L. Kriegel, *Grand Designs: Labour, Empire and the Museum in Victorian Culture* (London, 2007), pp. 123–4.
21 E. Delaney, *The Curse of Reason: The Great Irish Famine* (Dublin, 2012), p. 225.
22 'The Irish Immigration', *Reynold's Newspaper* (23 March 1851).
23 Delaney, *The Curse of Reason*, p. 221. See also Hasia R. Diner, ' "The Most Irish City in the Union": The Era of the Great Migration, 1844–1877', in R. H. Bayor and T. J. Meagher (eds), *The New York Irish* (London, 1996), pp. 87–107.
24 'No. 9', *Illustrated Exhibitor*, p. 146.
25 'No. 10', *Illustrated Exhibitor*, p. 177.
26 Leon Litvack, 'Exhibiting Ireland, 1851–1853: Colonial Mimicry in London, Cork and Dublin', in Leon Litvack and Glen Hooper (eds), *Ireland in the Nineteenth Century: Regional Identity* (Dublin, 2000), pp. 15–57, p. 33.
27 'No. 9. Ireland's Contributions to the World's Fair', *Illustrated Exhibitor*, 2 August 1851, pp. 141–60, p. 159.
28 British Library, London, 7956.f.33, manuscript by J. F. Maguire, 'The Industrial Movement in Ireland, as Illustrated by the National Exhibition of 1852', 1853, p. 8.
29 Ibid., p. 17.
30 Ibid., p. 9.
31 Ibid., p. 10.
32 Ibid.
33 'Exhibition of the Manufactures of the World in 1851 – True Encouragement for Irish Talent and Industry', *Freeman's Journal and Daily Commercial Advertiser* (29 July 1850).
34 Maguire, 'Industrial Movement in Ireland', p. ii.
35 Ibid., p. 17.
36 Ibid., p. 424.
37 'Cork National Exhibition', *Bell's Weekly Messenger* (19 July 1852).
38 Ibid., p. 427. See A. C. Davies, 'The First Irish Industrial Exhibition: Cork, 1852', *Irish Economic and Social History*, 2 (1975), 46–59, 50.
39 Ibid., p. 428. See also National Library of Ireland, Dublin, p. 432(1), manuscript 'Report of the Cork Cuvierian Society for the Cultivation of Sciences', 1855. For the working class and exhibitions, see A. Short, 'Workers under Glass in 1851', *Victorian Studies*, 10:2 (1966), 193–202.
40 Ibid.
41 British Library, London, D–7956.f.18, manuscript 'Exhibition Inaugural Address Delivered by His Grace, The Archbishop of Dublin, in the Exhibition Pavilion, Cork, on the Evening of the Tuesday, 19th June, 1852, on the Opening of a Course of Lectures, Illustrative of Irish Art, Industry, and Science', 1852, p. 3.

42 Ibid., p. 5.
43 Maguire, 'Industrial Movement in Ireland', p. 7.
44 *Cork Constitution* (24 November 1855). See 'Cork Exhibition', *Roscommon & Leitrim Gazette* (14 August 1852) and *Cork Constitution* (8 June 1852).
45 Maguire, 'Industrial Movement in Ireland', p. 425. 'National Exhibition to be held at Cork', *The Evening Freeman* (24 April 1852) noted the many contributions received for the 1852 display from private merchants to philanthropists.
46 Alun C. Davies, 'Ireland's Crystal Palace, 1853', in J. M. Goldstrom and L. A. Clarkson (eds), *Irish Population, Economy, and Society* (Oxford, 1981), pp. 250–1.
47 Maguire, 'Industrial Movement in Ireland', p. 430.
48 'The National Exhibition at Cork', *Southern Reporter and Cork Commercial Courier* (18 May 1852).
49 Davies, 'Ireland's Crystal Palace', pp. 249–70; Litvack, 'Exhibiting Ireland', pp. 15–57.
50 British Library, London, 7958.aa.2, manuscript by T. D. Jones, 'Record of the Great Industrial Exhibition, 1853: Being a Brief Description of Objects of Interest, etc', 1853, p. 43. See S. M. Kilfeather, *Dublin: A Cultural History* (Dublin, 2005), pp. 143–4.
51 University of Illinois Urbana-Champaign, Chicago, 821 B32G, manuscript by W. J. Battersby, 'The Glories of the Great Irish Exhibition of All Nations, in 1853', 1853.
52 British Library, London, LOU.IRL S12, newspaper 'First Week of the Exhibition', *Exhibition Expositor and Advertiser*, 1853, p. 1. The newspaper was published in the Exhibition building for the whole twenty-five weeks of the display, and it cost two pence unstamped, or three pence stamped.
53 See C. Ó Gráda, *Black '47 and beyond: The Great Irish Famine in History, Economy and Memory* (Princeton, NJ, 1999).
54 'First Week of the Exhibition', *Exhibition Expositor*, p. 1. See also British Library, London, P.P.2505.r, manuscript 'Irish Exhibition Almanack', 1853. The almanack cost sixpence and was described as 'a memento to one of the most interesting events in the History of Ireland'; cited in *Wexford Independent* (29 October 1853).
55 Ibid.
56 Ibid., p. 2. See 'Inauguration of the Great Exhibition, 1853', *The Advocate: or, Irish Industrial Journal* (11 May 1853).
57 Saris, 'Imagining Ireland', p. 75. See S. O'Donnell, 'The Works of William Dargan', *Éire–Ireland*, 22:1 (1987), 151–4.
58 British Library, London, D–7956.bb.25, manuscript 'Official Catalogue of the Great Industrial Exhibition (in Connection with the Royal Dublin Society), 3rd edition', 1853, p. 7.
59 'William Dargan and the Irish Exhibition of 1853', *The Illustrated Magazine of Art*, 1:3 (1853), pp. 152–5, p. 152. See also F. Mulligan, *William Dargan: An Honourable Life, 1799–1867* (Dublin, 2013).
60 'Dargan and the Irish Exhibition', p. 152. See 'Irish Industrial Exhibition for 1853', *Dublin Evening Mail* (9 July 1852).

61 Saris, 'Imagining Ireland', p. 75.
62 David W. Harkness, 'Ireland', in Robin W. Winks (ed.), *The Oxford History of the British Empire. Vol V. Historiography* (Oxford, 1999), pp. 114–33, pp. 115–16.
63 P. Bew, *Ireland: The Politics of Enmity, 1789–2006* (Oxford, 2007), p. 369.
64 R. Foster, *Modern Ireland* (Dublin, 1988), pp. 300–1.
65 Cited in Bew, *Ireland*, p. 369. See Philip Ollerenshaw, 'Industry 1820–1914', in Liam Kennedy and Philip Ollerenshaw (eds), *An Economic History of Ulster* (Manchester, 1985), pp. 62–108.
66 'Third Week of the Exhibition', *Exhibition Expositor*, p. 5.
67 'First Week of the Exhibition', *Exhibition Expositor*, p. 1.
68 'Exhibition of the Manufactures of the World in 1851 – True Encouragement for Irish Talent and Industry', *Freeman's Journal and Daily Commercial Advertiser* (29 July 1850).
69 'Ninth Week of the Exhibition', *Exhibition Expositor*, p. 7.
70 T. Mitchell, 'The World as Exhibition', *Comparative Studies in Society and History*, 31:2 (1989), 217–36, 218.
71 'Ninth Week of the Exhibition', *Exhibition Expositor*, p. 7.
72 Ibid.
73 'Fifth Week of the Exhibition', *Exhibition Expositor*, p. 1.
74 See 'Tours in Ireland, 1853. Dublin Industrial Exhibition', *Coventry Standard* (14 October 1853); *Carlisle Journal* (14 October 1853); *The Globe* (26 April 1853).
75 Margaret M. Williams, 'The "Temple of Industry": Dublin's International Exhibition of 1853', in Colum Hourihane (ed.), *Irish Art Historical Studies in Honour of Peter Harbison* (Dublin, 2004), pp. 261–76, pp. 261–2.
76 *Official Catalogue of the Great Industrial Exhibition*, p. 17. See 'Exhibition. Section D – Machinery', *Dublin Weekly Nation* (18 June 1853).
77 'Fourth Week of the Exhibition', *Exhibition Expositor*, p. 1. See British Library, London, D–7956.b.59.(2.), manuscript by C. Adley, *'Synopsis of the Contents of the Great Industrial Exhibition 1853 in Connection with the Royal Dublin Society'*, 1853.
78 British Library, London, J/7960.dd.29, manuscript, 'Illustrated Dublin Exhibition Catalogue, Published in Connection with the Art Journal', 1853, p. v.
79 'The Irish Industrial Exhibition', *The Illustrated Magazine of Art*, 2:9 (1853), pp. 135–43, p. 135.
80 Ibid.
81 'The Dublin Exhibition: A Trip to Killarney', *Liverpool Mail* (21 May 1853).
82 'Dublin Industrial Exhibition of 1853', *Freeman's Journal and Daily Commercial Advertiser* (16 September 1853).
83 Ibid.
84 'Ninth Week of the Exhibition', *Exhibition Expositor*, p. 7.
85 'The National Exhibition at Cork', *Southern Reporter and Cork Commercial Courier* (18 May 1852).
86 'Illustrated Dublin Exhibition Catalogue', p. v.

Famine and industry 53

87 Ibid., p. vii.
88 See P. Gray, *Famine, Land and Politics: British Government and Irish Society 1843–1850* (Dublin, 1999).
89 Cited in 'Ninth Week of the Exhibition', *Exhibition Expositor*, p. 7.
90 *Cork Examiner* (8 September 1847). Cited in Bew, *Ireland*, p. 196.
91 'Ninth Week of the Exhibition', *Exhibition Expositor*, p. 7.
92 'Fifth Week of the Exhibition', *Exhibition Expositor*, p. 1.
93 An equivalent enterprise took place in Scotland; see, for instance, *Greenock Advertiser* (13 September 1853), which advertised regular steamships from Glasgow to Dublin for the Exhibition; also 'Dublin Exhibition', *Dundee, Perth, and Cupar Advertiser* (5 July 1853).
94 'Twelfth Week of the Exhibition', *Exhibition Expositor*, p. 1.
95 Jones, 'Record of the Great Industrial Exhibition', p. 36; British Library, London, 7957.c.17, manuscript by J. Sproule, 'The Irish Industrial Exhibition of 1853: A Detailed Catalogue of Its Contents: With Critical Dissertations, Statistical Information, and Accounts of Manufacturing Processes in the Different Departments', 1854, p. 4, pp. 21–6 contains tables of visitor breakdowns.
96 Davies, 'Ireland's Crystal Palace', p. 267.
97 A typical week is reported in 'Third Week of the Exhibition: The Progress of the Exhibition', *Exhibition Expositor*, p. 1. Admission for 13 May – Holders of Season Tickets: 2,833; Persons paying 5s: 290; Excursion Ticket Holders: 0 and 21 May – Holders of Season Tickets: 4,533; Persons paying 5s: 295; Excursion Ticket Holders: 46.
98 'Twelfth Week of the Exhibition', *Exhibition Expositor*, p. 1. Cited in Davies, 'Ireland's Crystal Palace', p. 267.
99 *Kings County Chronicle* (29 June 1853) reported on distinguished visitors such as Van Buren, who was accompanied by his son and Campbell, Governor of one of the states.
100 'Thirteenth Week of the Exhibition', *Exhibition Expositor*, p. 1.
101 'Sixteenth Week of the Exhibition', *Exhibition Expositor*, p. 1.
102 'Great Industrial Exhibition of 1853', *The Advocate: or, Irish Industrial Journal* (3 August 1853).
103 'Sixteenth Week of the Exhibition', *Exhibition Expositor*, p. 1.
104 Cited in Davies, 'Ireland's Crystal Palace', p. 268. See 'Great Industrial Exhibition of 1853', *The Advocate: or, Irish Industrial Journal* (17 August 1853), which reported that a 'large number of tickets [were] purchased by employers for their working men [in this last month]'.
105 'Nineteenth Week of the Exhibition', *Exhibition Expositor*, p. 7.
106 British Library, London, RB.23.a.15618, manuscript by Scribbler, 'A Versified Description of the Great Industrial Exhibition, in Dublin, 1853, in a letter from I. Donoghoe to his Brother Dan', 1853.
107 British Library, London, 4477.a.75, manuscript by J. Milligan, 'The Great Exhibition of 1853. Its Utility Defended; And Its Glory Eclipsed! A Sermon Preached on the Lord's Day Succeeding the Opening of the Exhibition', 1853, p. 5.

108 Ibid., pp. 7–8.
109 Delaney, *The Curse of Reason*, p. 228.
110 British Library, London, 4406.b.60, manuscript 'Good News! Or, Free Admission to the Great Exhibition', 1853, p. 4.
111 S. Rains, '"Here Be Monsters": The Irish Industrial Exhibition of 1853 and the Growth of Dublin Department Stores', Irish Studies Review, 16:4 (2008), 487–506, 496.
112 Sproule, 'The Irish Industrial Exhibition of 1853', p. v.
113 'Dublin Industrial Exhibition', *Freeman's Journal*.
114 Ibid.
115 Cited in C. Kinealy, *A Death-Dealing Famine: The Great Hunger in Ireland* (Dublin, 1997), p. 155; Sproule, 'The Irish Industrial Exhibition of 1853', p. 1.
116 Delaney, *The Curse of Reason*, p. 235.

2

Diaspora and migration: Displayed Ireland abroad

In the 'Land of our hope!', the Columbian Exposition of Chicago in 1893 contained civilisation's most gloried possessions.[1] From industrial treasures to arts and crafts, from mechanised progress to cultural artefacts and people – all celebrated aspects of the West circulated in visual form. Visitor numbers reached enormous figures: twenty-seven million attended from its opening to the public on 1 May 1893 to 30 October 1893. There were displays on the virtues and potential transformative powers of civilisation spanning 600 acres, demonstrating industry, architecture, and culture. Crucially, an in between place operated in the form of the Midway Plaisance, acting as the bridge between progress and development. The Midway Plaisance was a mile-long, 600-foot-wide strip of land linking Washington Park to Jackson Park.[2] Placed at the far end of the fairground, the Midway acted as a barometer for the world's progress and development. Embodying a 'torch of civilization', it contained everything from a Japanese Bazaar to a Javanese as well as a German Village, and even a Brazilian Concert Hall and an entire Street in Cairo, and it was completed by a 'Wild East Show' by the Ottoman's Arab Camp and Sitting Bull's Log Cabin.[3] In this presentation visitors could see the development of humanity, beginning with the 'white' Irish and Germans, closest to the Fair's White City, and then descending according to perceived civilisational status away from the Fair. Visitors witnessed varying stages of mechanisation such as railway systems, irrigation networks, and military achievements.[4] In this mélange of the world's people, the Irish, curiously, featured twice for the affordable price of twenty-five cents. An Irish Village, including Donegal Castle by Alice Hart, neighboured Lady Aberdeen's Irish Industrial Village and Blarney Castle.

In order to examine the motives, display, and reception of Ireland in 1890s Chicago, this chapter asks how Ireland featured in the two separate villages and why. The villages reflect broader trends within transatlantic female activism and philanthropy in the late-nineteenth-century United States and Ireland.[5] Recognising the plight of the 'peasantry in the congested districts, the scenes of recurring famine', many monied women sought to

rectify and reverse some of the life-threatening poverty they witnessed in the western counties of Ireland in a continuation of popular discourse on Irish development in the 1850s.[6] The Chicago World's Fair uniquely demonstrates the importance of female philanthropy and female labour in the context of nostalgia and Irish American nationalism.

Alice Hart, an Englishwoman interested in helping Donegal's poor, owned the Irish Village, including Donegal Castle, and Lady Ishbel Aberdeen, an aristocratic Scottish woman famed for her charity, owned the Irish Industrial Village and Blarney Castle, and both sought to remedy Irish poverty through a revival of rural industries. The two women recognised that women's work often supplemented the male householder's income during extreme poverty. Labouring men typically held seasonal work, which was weather-dependent and lacking in winter months.[7] Concurrently, Hart and Aberdeen saw a solution to chronic poverty in rebirthing rural industries of spinning, sewing, and weaving, and exhibitions became an important way to bolster sales, raise awareness, and create trade and profit for the destitute Irish in Ireland. Like many other entrepreneurs, they capitalised on the advertising potential of display and organised separate exhibits in Chicago.

Hart and Aberdeen relied on the financial and political support of Irish migrants in the United States. The two women recognised the vast opportunity of America, especially with Chicago's sizeable Irish population. In 1866 Irish-born men made up an estimated 27 per cent of police officers in Chicago.[8] Almost six out of the eight men in the detective department were of Irish citizenship, notes Sophie Cooper, as well as three captains and two sergeants in the force. The rapid professionalisation and politicisation of the Irish immigrant class in Chicago created a ready audience for the Exhibition. America's Irish immigrant community felt sympathy for their homeland and were willing to spend money in the fairground on sustaining rural industry in Ireland. Millions of Irish Americans participated enthusiastically in the fantasy of Ireland in the 1893 Exhibition.

Initially, the chapter considers how the Irish Industries Association (IIA) and the Donegal Industrial Fund (DIF) operated in Ireland and later the United States, and how the display of rural Ireland was organised in the Chicago Irish villages. What became important was witnessing an Irish past and an Irish history rooted in rural industries and tradition in an idiosyncratic conception of an Irish modernity. Aberdeen and Hart were convinced that a revival of rural industry would save Ireland, whereas most other countries (including at the Chicago Fair) vied for increasing urban industrialisation through technological mechanisation and modern architecture. The two women traded on a romanticised version of an Irish past that prioritised female labour as a saviour to the Irish nation, revealing a continuation of Famine-era discourse. They recognised that rural industries were declining

in Ireland but hoped that through reviving them, wages would increase and the cost of living would be shared by both men and women across the seasons. Clearly, an Irish modernity that was on the brink of industrialisation became concomitant with 'saving Ireland' for these elite women. Ireland's potential for development through rural industries embodied hope for the country's future. This reinforced both the imperial networks that sustained Irish poverty as well as the hierarchies within labour that bolstered unequal production and consumption.

Symbols were essential to convince Irish, American, British, and international visitors of the vitality and prosperity of Ireland on the fairground. A unique visual politics appealed to Irish American audiences and exploited their feelings of dislocation after migration to support Irish men and women who remained in Ireland. Narratives of nostalgia functioned amid ideas of the nation to resonate with the Irish American migratory experience. Irish images became integral to the process of settling into a new community, representing the transferable and fluid nature of symbols of Ireland. Recent and more established Irish migrants in the United States could identify with the picturesque Ireland they were seeing on the fairground that recreated their homeland as a lost utopia available to save from destitution. The narrative was powerful and relied on visiting the fairgrounds, buying souvenirs, and celebrating a forgotten rural Ireland in the United States.

Unlike in Chapter 1 where Irish organisers of the fairs in the 1850s, such as John Francis Maguire and William Dargan, prioritised mechanisation and technological advancement in aiding the country's commerce, Aberdeen and Hart saw machinery as being an acute evil in depressing traditional Irish rural trade. Yet both sets of individuals perceived the industry of the poor as vital for Irish development (particularly female rural industry) and recognised Britain's expansion in factories in the nineteenth century as a source of concern. Hart and Aberdeen eschewed such technology in their rural handicrafts, preferring highly skilled work, while Dargan and Maguire very much sought mass production in Ireland as a way to compete with Britain. However, even if Aberdeen and Hart were fighting a losing battle against the giants of British industry, their philanthropy was tied to the Gaelic Revival in Ireland. A nostalgic vision of a pure Irishness untouched by English expansionism sustained the two women's vision of rural industry.

Finally, I will assess the specific successes and failures of Aberdeen and Hart's projects of Irish rural revival and eventual Irish economic and physical survival through display in 1893 to reveal how the unique form of exhibitions was used by individuals with different priorities and politics outside of the borders of England and Ireland. The women's philanthropy saw them embody Irishness in a way that transcended their own heritage of Scottish and English women respectively, as they declared themselves

to be 'more Irish than the Irish themselves'.[9] Their commitment to create a pseudo-Ireland rooted in a nostalgic remembrance of a communal solidarity expanded beyond country of birth and commodified an Irish ethnicity across transatlantic waters. I conclude by assessing the individual legacies of Alice Hart's and Lady Aberdeen's rural revival projects as exemplified in the Chicago Fair.

Transatlantic philanthropy

Lady Ishbel Aberdeen (1857–1939) was an aristocratic woman born to the Majorbanks of Scotland. 'Ishbel' is the Gaelic version of 'Isabella'. Her husband, John Aberdeen, was Lord Lieutenant of Ireland in 1886 and again in 1906–15. Doris French Shackleton, Aberdeen's biographer, explains how husband and wife were avowed Home Rulers and supportive of the Gladstone administration.[10] Alice Hart (1848–1931) was a middle-class English woman who dedicated her life to reversing the effects of poverty in the west of Ireland and helping prevent future famines.[11] Hart had more radical politics than Aberdeen as she believed England was responsible for much of Ireland's suffering; however, both women wanted Home Rule for Ireland. The two separate exhibits reflected their distinctive views but functioned within a broader collective ideology of philanthropy.

The Irish Home Rule debate dominated not only Irish-British politics but also the expatriate Irish American community. Irish leaders of the Home Rule League, the predecessor of the Irish Parliamentary Party, under Isaac Butt, William Shaw, and Charles Stewart Parnell, demanded a separatist form of Home Rule, with the creation of an Irish parliament within the United Kingdom of Great Britain and Ireland. Arguments that the Union (epitomised by individuals like Trevelyan) was responsible for the Famine became the bedrock for nationalist critiques of Britain and the campaign for Home Rule in the 1870s and 1880s.[12] For instance, the Irish nationalist newspaper *The Nation* expounded: 'If this country were governed by its own people – governed by [those] who knew its resources and would willingly come together in brotherly love to save it, by willing labour and sacrifices … [these] evils might be turned aside. '[13] Historians have documented the period after the Famine as a time of infighting and political conflict, and four Home Rule Bills were commissioned by 1920.[14] Aberdeen and Hart championed their Home Rule politics of a devolved union through the Chicago Fair.

At the time of the Columbian Exposition in Chicago, Ireland had suffered agitation over Home Rule and land ownership as well as experienced new forms of cultural nationalism. These political currents shaped the Irish

diaspora in the United States in profound ways. By 1880 1.2 million of 1.8 million Irish-born migrants lived in the same states in the United States, or 67 per cent.[15] David Noel Doyle posits that in contrast to the agricultural rurality of Ireland, the Irish in the United States were urban and industrial.[16] Viewed as a tradition of the past, in the nineteenth century, rural industries became a method to save the destitute Irish from a life of poverty. While over the sea the Irish had become city-like and urban, in their homeland rural and cottage-based industries remained the valued norm. Therefore, the Exhibition in 1893 was operating within a dual influence of aspirational rural revival industry as well as a lost past for the Irish diasporic citizens. Irish American nostalgia for their homeland was particularly sensitive to these discourses of their country ailing under the rigours of industrialised modernity, which they could rescue through charity.

Many Irish communities in America expressed some dislike towards Britain, and a significant number of Irish Catholics felt concern about Irish Protestants.[17] Ulster Protestants made up the majority of eighteenth- and early-nineteenth-century immigrants, Rochelle Raineri Zuck notes, while Irish Catholics comprised the largest percentage of the famine immigrants of the 1840s. Declining capacity for agricultural labour in Ireland, alongside the reduction of Irish wages compared with those in America, pushed millions to settle in the United States. In the United States, Doyle argues, Irish communities grew by continuous arrivals from Ireland in industrial hotspots inhabited by successive generations of different families.[18] By utilising the conceptual framework of the 'diasporic imagination' that Bruce Nelson and others have used to explain the common symbols, ideologies, and rituals that became popular to specific Irish American groups, exhibitions clearly functioned within the realm of politics as well as entertainment and popular nostalgia in offering a fictional Irish community for migrants.[19] Visions of an Irish home had value, both financial and political, in the fairground.[20] Overall, an Irish subculture of varying Irish nationalist ideologies proliferated in the overseas communities, which became integral in funding and furthering the Irish independence movement, especially in the 1880s and from 1910 to 1922.[21]

The backdrop of Irish American nationalism interacted with female philanthropy and labour. A broad-based coalition of individuals and groups emerged in the late 1880s and 1890s who again believed that Ireland's agricultural economy needed overhauling to become more sustainable to compete on the world's market. Activists and politicians alike championed the revival of rural industries through state intervention and individual charities. In the 1880s many people in the west of Ireland were suffering from the effects of the 1879 Famine when the potato crop failed for a third successive year.[22] Consequently, Chief Secretary of Ireland Arthur Balfour (1848–1930)

established the Congested Districts Board (CDB) in 1891.[23] The responsibilities assigned to the CDB were vast, as Carla King has shown; it was able to buy tenants' interest in their holdings, facilitate emigration and migration, furnish seed potatoes or oats when required, help the fishing industry, aid agriculture, and support weaving, spinning, and other industries.[24] Hart's and Aberdeen's exhibits in Chicago therefore contributed to this wider project of reviving Ireland's rural industries to relieve privation.

As a form of 'Constructive Unionism', the CDB aimed at 'pacifying' Irish agrarian unrest through a 'combination of coercive and conciliatory measures'.[25] The board addressed rural poverty in the western counties of Donegal, Sligo, Mayo, Leitrim, Roscommon, Kerry, and the west riding of Cork. Before this policy, Ciara Breathnach has shown that the imperial exchequer offered aid to the alleviation of distress in Ireland under different acts.[26] The board was the first of its kind to suggest long-term solutions to rural poverty instead of the ineffective short-term policies of outdoor relief. 'Congested', Breathnach explains, was a label given to the western counties in 1882 in the first report of 'Mr Tuke's Fund'; these reports facilitated the system of assisted emigration from the west of Ireland to North America, which became a traditional remedy for overpopulation.[27] But despite all its efforts, the board was unable to prevent the recurrence of crisis in the late 1880s. Aberdeen and Hart echoed this official state legislature through their individual philanthropic enterprises, and the exhibits in Chicago formed part of this larger rural revival charity initiative to help the Irish poor.

Lady Aberdeen fits within this broader-scale intervention to help Ireland's destitute population. She founded the IIA in the late 1880s. It aimed '[t]o organise the Home, Cottage, and other Industries of Ireland, and to bring the various centres of these industries into communication with one another'.[28] The IIA was the institutional body of the Royal Dublin Society that triennially organised exhibitions in Ireland to stimulate agriculture and industry. The IIA sought to facilitate arrangements 'whereby good designs may be brought within the reach of workers in all parts of Ireland; [find] suitable markets for Irish work; promote the establishment of local centres and committees [and] offer advice'; promote and advertise the use of Irish goods; and collect donations to bolster the trade and ultimately to make rural industries profitable again in Ireland for the benefit of the poor.[29] Horace Plunkett, a founder of agricultural co-operatives, was an active member of the IIA.[30] Local branches of the IIA were established in Clones, Limerick, Cork, and elsewhere in the 1880s and 1890s. Aberdeen's ultimate aim was to organise and develop rural industries for profit (local and regional) in Ireland, and she received substantial financial and personal support. She was generally interested in reviving bog-oak carving, spinning, weaving, and knitting. She considered national and international exhibitions a valuable and necessary

way to exhibit Irish industry and ensure its survival, as well as the survival of the Irish people.

Alice Hart sought to 'revive the old cottage industries and to develop the ancient arts of spinning, weaving, knitting, sewing, and embroidery' among peasants in the Congested Districts of Donegal.[31] She planned to build a network of technical schools in Donegal and 'find new markets for the goods'. A 'carefully devised system of village technical training' skilled in the 'making of homespuns of a kind and quality never before attempted in Ireland' would in Hart's mind 'enable a peasantry so honest, industrious, virtuous, and estimable as that of Donegal to live in homesteads in the country, instead of being driven to inhabit the slums of a city'. Hart set up a permanent depot for the sale of her industries at 43, Donegal House, Wigmore Street, London, where the 'Kells embroideries, hand-knit and hand-woven hosiery and gloves, hand-sewn under-linen, lace, crochet, embroidered handkerchiefs, Irish linens ... [could] be purchased, or orders given by post'.[32] She travelled to Ireland in March 1883 to appraise the situation of the country. Her tour of Irish poverty coincided with the trial of Charles Stewart Parnell and his colleagues in the Land League for their suspected involvement in the Phoenix Park murders. Hart's biographer, Janice Helland, speculates that the timing of her visit may have been 'more than mere coincidence', reflecting a more nationalist bent to Hart's politics.[33] Hart, like Aberdeen, also recognised the potential of exhibits to advertise Irish cottage industries and took part in various exhibitions such as the London International Inventions Exhibition in 1885, the Edinburgh Exhibition in 1886, and the International Exposition in Paris in 1889. Helland has neatly surmised that Hart's venture sought a 'cultural biography of [Irish] things' to rescue crisis-stricken Ireland, which relied on the most familiar images of Irish land, people, and objects to attract and sustain the consumption of Irish-made products.[34]

Hart's project underscores the ambitions of the Irish Revival movement of the late nineteenth century. The Celtic Revival began in the 1880s and was mainly literary and bound up with Irish national politics. For example, organisations that dealt with prominent aspects of Irish culture, such as the Gaelic Athletics Association in 1884 to revive ancient games and sports in Ireland, the National Literary Society in 1892, and the Gaelic League in 1893, proliferated. The League encouraged Irish language and culture and held a festival each year, the *Oireachtas na Gaeilge*, with literary prizes and competitions for Irish songs and dancing.[35] Specifically, Paul Larmour explains that 'managed on sound economic principles though philanthropic in aim, with all profits being devoted to the furtherance of technical teaching, Alice Hart's cottage industries were one of the great successes of the Irish Revival'.[36] Further, Éimear O'Connor explains that the revival of

cottage industries rested on an acceptance of the plight of the poor, coupled with a belief that developing philanthropic activities to sustain their labour would resolve their chronic poverty through personal hard work.[37] For example, Aberdeen insisted that 'God had created a hierarchical society and that it was the duty of the wealthy to protect, guide and help the lower ranks, maintaining a firm moral superintendence'.[38] Her membership fees – paid mainly by the upper classes – facilitated workshops in lacemaking and other home industries in a cyclical system of production and consumption.

Lady Aberdeen and Alice Hart shared many similarities: they both wanted to revive Irish industries and demonstrate Irish ingenuity against popular negative prejudices about the country in the 1890s. Yet both were outsiders to the Irish project; they both understood how and why the English had exploited Ireland, but they also succumbed to the reductive desire to romanticise the Irish folk and the peasantry. They both saw the utility of national and international exhibitions and displayed at the Columbian Exposition in Chicago. The early 1890s was an ideal time for their exhibits given that successive waves of Irish emigration continued, inflating the significant numbers of second- and third-generation Irish men and women who had already settled in the United States. Unlike in England, where Irish migrants remained among the working classes of Britain's populace, mainly labourers, the Irish generally occupied a better economic position in the United States – with Irish civil servants becoming a common feature, particularly in the War Department.[39] The relative success of migrant Irish men and women in the United States not only fostered feelings of solidarity with family members and friends in Ireland suffering because of hardship and deprivation but meant they could spend money on charity, alleviating their struggles.

Ireland in the Columbian Exposition of 1893

Despite plans for the two women to work together on a single Irish Village in Chicago, the final display included two Irish villages.[40] The two activists fell out over the material conditions of their respective exhibits and their ideological justifications and methods of improving the Irish lot. Aberdeen held a 'position in the inner [circle] of British rule', whereas Alice Hart was a middle-class woman with less political prestige and status.[41] A competing difference in class and politics within aristocratic and bourgeois spheres fermented tensions between the two women. For instance, Aberdeen exercised her power by seeking to influence the wealthy and elite to sympathise with Ireland's plight; whereas Hart's activism revolved around the high street and the encouragement of a popular mass-market appeal of Irish goods

and products among the rapidly growing middle class. The stories of how these women displayed two different Irish exhibits at the 1893 Fair therefore reveal the broader machinations of female activism and philanthropy in the nineteenth century.

Irish women were fundamental to the survival of their families in this period, and it became the preserve of relatively wealthy outsider women to formulate and sustain their industriousness. Evidently, the inadequacies of local government provisions saw charities alleviate penury to make the poor economically independent in the wake of famine and international competition. The popular adoption of mass-produced, machine-spun goods, Breathnach notes, had had a detrimental effect on the textile industry by the 1890s.[42] Hart wanted to compete in this market by cultivating handmade textiles as a unique specialised good only available in bespoke high street businesses. While Aberdeen and Hart agreed on the need to revive rural industries to save the Irish poor, they came unstuck as to how they should bring this about. One was concerned with the elite and the other with the mass public; both were convinced their scheme was the only effective method.

Differences between the two women emerged on varying scales. Aberdeen vehemently believed that the entrepreneurial capacity to promote Irish industry should continue unabated in the domestic and public sphere. She was an ardent advocate of advertising Irish clothing and design through her own body. She frequently wore Irish-made clothing, encouraged her peers to do the same, and generally performed an imagined Irishness. For instance, Aberdeen held a garden party at the Vice-Regal Lodge in Dublin in the summer of 1886. The *Aberdeen Press and Journal* noted that 'all the guests should come clothed in garments of Irish manufacture as far as possible'.[43]

Many local designers avidly picked up the dress code: R. T. Martin, a costumier and ladies tailor of Grafton Street, had several advertisements in local newspapers to attendees of the garden party of 'suitable Irish Materials … in accordance with the styles requested by Her Excellency'.[44] Contemporaries described the 'party [as] a brilliant success', and the *Freeman's Journal* was not alone in expounding: 'a gayer, brighter and pleasanter scene has not been witnessed for many years', with its nearly 2,000 costumed guests.[45] Irish materials and manufactures abounded; Lord Aberdeen wore an 'electric suit of silvery grey poplin cloth and white hat', and their children wore 'Irish costumes modelled in conformity with authentic designs taken from the Royal Irish Academy'.[46]

Aberdeen took the dress code one step further and personified Irish industries (Figure 2.1). She conflated her own personhood with Ireland by dressing as Aoife, the twelfth-century Irish bride of Norman invader Strongbow,

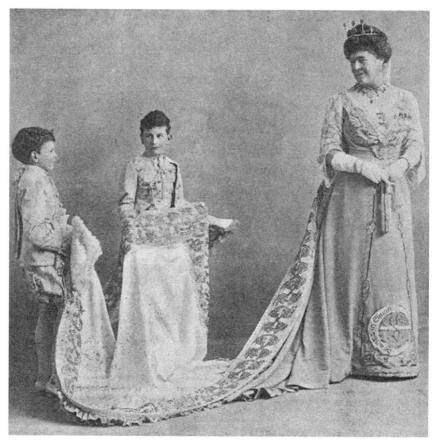

Figure 2.1 'Her Excellency the Countess of Aberdeen and her Pages at the St. Patrick's Eve Pageant of Irish Industries' (*The Gentlewoman* (20 March 1909), p. 54 – cited in J. Helland, 'Ishbel Aberdeen's "Irish" Dresses: Embroidery, Display and Meaning, 1886–1909', *Journal of Design History*, 26:2 (2012), 152–67, 160 – courtesy of the British Library)

'in a wealth of white poplin and gold lace'.[47] In the image she is wearing a crown, and her two sons are holding the train of her dress. Aberdeen offered elite, socially minded contemporaries an opportunity to emulate her activism, which tied entertainment with pleasure. She even went as far as wearing Balbriggan stockings 'embroidered with shamrocks by Mr Smyth'. This gaudy identification with Ireland unhelpfully romanticised deprivation as a lowly position that resolved itself through the creation of worthwhile rural products and hard labour. While Aberdeen recognised that the many injustices suffered by Ireland's poor were beyond their control, such

reductive stereotypes of rurality reinforced tragedy as the norm for Ireland and its peoples, instead of highlighting it as an exceptional occurrence rallied against by Irish men and women.

Utilising the poor as symbols and appendages to aristocratic entertainment emphasises the hypocrisies of elite female activism in the nineteenth century. Aberdeen and others may have had good intentions, but their ownership over the revival industries hinted at a more sinister dismissal of poverty as an individualised ailment that Irish citizens could independently overcome. These expensive dresses were only available to the wealthiest. Clearly, Aberdeen did raise awareness of Irish poverty and Irish rural industry, but the extent to which her philanthropy facilitated change with its sole targeting of the upper echelons of British and Irish society was questionable.

Alice Hart criticised women who bought non-Irish clothing and products, but she did not suggest or perform a mimetic response between herself and Irish rural revival/survival. Unlike Aberdeen, Hart was less visible in public spectacles. Helland has comprehensively shown that Hart's focus was on the development of tweed, frieze, and knitting, particularly on the production and purchase of decorated fabrics.[48] Hart was more critical of England's role in Ireland than Aberdeen and gave public lectures on the topic.[49] Her lectures also included shocking photographs of poverty in Ireland taken during her visits to the country – reaffirming constantly the connection between philanthropy and the visual in the rural revival project. While both women operated independently of state help, relied on their personal resources to liberate the Irish from the shackles of poverty, and 'lived' their politics, they complemented and reinforced the more state-based, collective CDB enterprises.

Apart from their personal endeavours, Hart's and Aberdeen's involvement in Chicago meant they could target a broader audience. Exhibitions were popular affairs made accessible for the workers, the middling, and the elite of British, Irish, and American society. However, tensions began to emerge between the two women. Aberdeen's IIA had a rigid bureaucratic structure, and mainly lordly men and women were on its committee.[50] However, Hart resisted merging the DIF under the umbrella organisation of the IIA. She may have disliked the committee's exclusively aristocratic composition, and the DIF had an established presence. Moreover, alliance with Aberdeen cost individual success and recognition; for instance, at the 1886 International Exhibition Association of Industry, Science, and Art in Edinburgh, only the Countess of Aberdeen received the highest award, the Diploma of Honour for the 'whole exhibit of Irish women's industries'.[51]

It is interesting that even within the same cause of reviving rural industries, the hierarchies of class interfered. The machinations of benevolent philanthropy were subject to tensions of class privilege and preoccupations

with the types of products advertised, methods of advertisement, and intended audience in 1890s Chicago. This period carried the class divisions from earlier centuries, and particularly the 1850s, on to an international stage. The two women were engaged in an opposition that is hinted at in the archival records: a confrontation of sorts can be inferred but a very polite, particular sort.

Aberdeen and her husband were staunch supporters of a devolved union with Britain through Home Rule. They admired the Irish character and praised Irish land and industry, but Aberdeen still advocated for an English monarchy and aristocracy within the functioning of nineteenth-century society. However, Hart considered the English aristocracy largely responsible for the ills of Ireland and vied against Lady Aberdeen's power and prestige. Their differences became visible to the public during the 1893 Columbian Exposition. Aberdeen wrote: 'The idea of a village had first been evolved by [Alice] Hart, in connection with her Donegal Industrial Fund, but we persuaded her that it would be better for all concerned if the Irish Industries Association and the Donegal Industrial Fund combined for a joint effort, each taking shares of the expenses and profits.'[52] However, according to Aberdeen's memoir:

> differences arose between the two sections; on one occasion we found ourselves obliged to adjourn our meeting for a week in order to consider what could be done to come to an agreement. When we met again, we received a cable informing us that [Alice] Hart had arrived in Chicago and was in treaty for a concession for a second Irish village.

And she concludes: 'we had just to make the best of it'.[53]

Fair organisers granted Hart a separate commission for a second Irish Village in a bid to boost profits, albeit on the same plot and only a few metres away from Aberdeen's Village with similar ambitions and materials on display. Specifically, Hart differed with her interest in the Celtic Revival project, particularly embroidered Book of Kells motifs. Hart largely sought to rectify the ills caused by 'machine competition' and held that the 'Donegal peasant women [were] the finest knitters in the United Kingdom', and her Kells embroidery showcased designs 'worked in flax on flax'; all were 'genuine specimens of the work of the Irish people' and had popular appeal in England, Ireland, and the United States.[54] Her ultimate aim was to help 'distressed ladies', and through a 'steady outlet for the work of the Irish peasants', she hoped to 'rescu[e] thousands from destitution, [by] planting in large districts hope and industry in the place of despair and idleness'.[55] Hart believed that such 'self-acting and self-sustaining' work would further lead to the 'salvation of Ireland', and she employed up to '800 cottagers [proficient in] spinning, weaving, and dyeing' as part of her heritage-based revival.[56]

Approximately 70,000 square feet at the Midway Plaisance entrance was dedicated to the two Irish villages and their buildings of industry, shops, entertainments, and greenery (Figure 2.2). The Midway boasted of containing: 'All the world', with a 'contrast in the extremes of humanity' and featuring a 'confusion of life', including dancers, music, the first Ferris wheel, food from around the world, theatres, villages, huts, squares, and an 'opportunity for a study of national character of great variety'.[57] It was home to 'beautiful displays of the liberal arts, the glories of the fine arts, the wonders of the mechanic arts, the marvels of electrical science; also the agricultural, forestry, fishery, horticultural [were on display]'. Ireland was next to the Japanese Bazaar and the Javanese Village, and close to the popular Street in Cairo and the Moorish Palace, complete with a Garden Café, in the strict Social Darwinist logic of the Midway. Ireland was thereby located within the earlier stages of perceived civilisation in the racialised organisation of the broader Chicago Fair.

Exhibition literature claimed that in the Midway:

Mankind saw his brothers – unseen brothers that hitherto were but names or scarce even that to him. They came from the night some North and the splendid South, from the wasty [sic] West and the effete East, bringing their

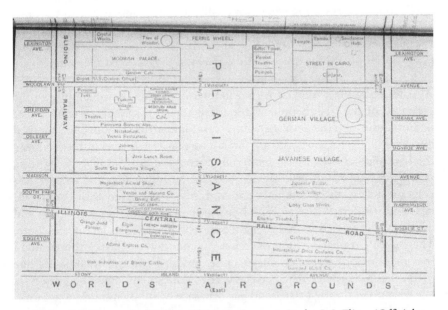

Figure 2.2 Key to the Midway Plaisance (manuscript by J. J. Flinn, 'Official Guide to the Midway Plaisance. Otherwise known as "The Highway through the Nations"', 1893, p. 25 T500.A1 F69 – courtesy of Library of Congress, Prints and Photographs Division)

manners, customs, dress, religions, legends, amusements, that we might know them the better ... man, woman and child and they lent life and colour to the evanescent panorama that charmed so many million eyes ... We must not forget however that in the midst of peoples so new and strange to us there were others nearer akin. To many Americans 'Old Vienna', the 'German Village' and the 'Irish Villages' gave information of the customs of their fathers.[58]

The Midway therefore operated in a dual space of inviting wonder and shock towards countries outside of Europe and Britain but further reaffirming and admiring the ostensible triumphs of white societies. The presence of the Viennese, German, and Irish villages in particular was suggestive of an ancestry inclined towards industrial development and offered a template for future progress to the perceived lesser industrialised nations.

The Irish villages stood amid the spectacle of a 'jumble of foreignness' that Meg Armstrong has described. Armstrong explains that an aesthetic ideology existed on the Midway of 'exotic [as] chaos, a jumble, a sublimely grotesque and bawdy array of colours, sights, scents, and sounds'.[59] Clearly, on the spectrum of cultures displayed, Ireland represented the apex of civilisational narratives, equal to Germany and Austria. Positioned at the front of the Plaisance, the Irish villages depicted the penultimate achievement of human progress before entering the 'civilised' space of the Fair's 'White City'. Ireland was on the fringes of civilisation, en route to the industrious excellence that would warrant it a ticket to the main fairground that housed the machinery, electrical, technical, and cultural achievements of the United States, Britain, and the other world powers of the nineteenth century.[60]

Ireland's capacity for industrial civilisation was the narrative that Aberdeen and Hart worked within in their activism. They championed the potential of the Irish people and made it their life's work to unlock that potential through the development of rural industry for immediate survival and eventually for the good of the country as a whole. On the Midway the Irish performed an Irish modernity through industrial labour engaging in the mechanisms of product and production physically, and in part as a response to racialised international concerns of perceived Irish backwardness and idleness.[61] Therefore, a hopeful narrative for future progress and development existed within reductive stereotypes of Irish labour practices. The possible transformation of Ireland's economy was firmly rooted in an imagined history of the country's underdevelopment and weaknesses due to the Irish character that persisted from the Famine era. The corrective was visualised through the literal performance of rural labour by the exhibited Irish.

For Aberdeen and Hart, rural industry would keep the Irish from poverty and allow them to compete with large-scale mechanisation through their unique high-quality goods opening a space for trade and profit in a

transatlantic business. This narrative resonated with Irish American communities generally, and in Chicago specifically. The immediate sensory exposure to rural Ireland on the fairground heightened the valuable opportunity to capitalise on feelings of guilt from migration, as well as exploit the pride taken in native Irish goods. Heralded as a final hope for the country, the solution seemed obvious, easy even. Thus, it made sense for the Irish villages to feature on the Midway: here was the entry point for their future prosperity, and if contemporaries sold enough, visited enough, and bought enough, Ireland could be as profitable as her neighbouring countries.

The Exhibition grounds and the labours of Aberdeen and Hart can be conceptualised within Mary Louise Pratt's 'contact zones' of imperial encounters, the space in which peoples geographically and historically separated come into contact with each other and establish ongoing relations, usually involving 'conditions of coercion, radical inequality, and intractable conflict'.[62] For instance, through international exhibitions Ireland intimately came into contact with the imperial power of Britain through spectacle. It further competed on a grand scale with the industrial, architectural, and societal prowess of former colonies. Yet it was consigned to the space reserved for colonies and racialised Others on the Midway Plaisance. Here, as Pratt has conceptualised, imperial and colonial trajectories intersected, and a co-presence emerged relying on interaction and mutual understandings and practices, 'within radically asymmetrical relations of power'. Pratt coined 'autoethnography' or 'autoethnographic expression' to refer to instances in which colonised subjects chose to represent themselves through the coloniser's terms, and we can productively consider the international exhibitions in this way.[63]

Alice Hart's Village featured 'typical Irish residences' accessed through a replica of the St Lawrence Gate in Drogheda. The 'scene [wa]s quaint, picturesque, and uniquely Irish' with a reproduction of Donegal Castle and a tall round tower (Figure 2.3).[64] There was a series of whitewashed cottages where 'homespuns [we]re made by hand'. The Village had a medieval feel with a castellated gateway complemented by trees and foliage. The sketch offers a composite vision of an Irish past. Irish art and industry took centre stage with demonstrations of spinning, weaving, embroidered hangings, coverlets, curtains, lace, and hosiery exhibited in the Village Hall. An Irish history was present with a wishing chair 'exactly reproduced to scale and measurement' from the Giant's Causeway, 'standing on Irish soil, brought from Ireland in crates'. Visitors could also witness the dancing of the Irish jig on the village green in an immersive Irish paradise.

Irish Americans supportive of Home Rule would likely have derived the most interest and pleasure from Hart's Village with her politics of a devolved union with Britain to revitalise Ireland and its industries. Hart,

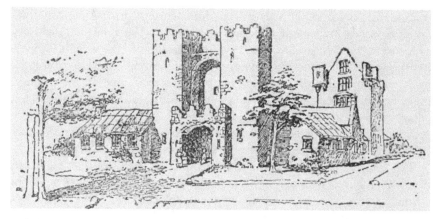

Figure 2.3 Donegal Castle – the Irish Village, Midway Plaisance (Flinn, 'Official Guide to the Midway Plaisance', 1893, p. 14 T500.A1 F69 – courtesy of Library of Congress, Prints and Photographs Division)

like Aberdeen, charged a standard twenty-five cents entrance fee, and all monies from tickets and goods went to the respective charities. There was a vibrant interest in Irish connectedness to the land, and 'Souvenirs of bog oak', Irish jewellery, and illustrated books were a few of the many items sold in the Village's shops. Helland has discussed that Kells art embroideries epitomised for Hart an Irishness unspoiled by Englishness.[65] Irish contemporaries used ideas of an ancient Irish past to fantasise about a future independent Irish nation, notes Elizabeth Crooke. For example, Crooke explains that archaeology identified the 'sacred, venerable, and hallowed' in Ireland's past. Like the Book of Kells, the Tara Brooch and Ardagh chalice became part of an Irish 'heritage' whereby these objects became revered as symbols of the Christian period, or else the golden age of Irish nationalism.[66] In a similar fashion, official Exhibition literature celebrated that the historical and artistic objects attracted most attention from visitors, particularly the Druidical stones and early Christian crosses, reflecting interest in an Irish past and an Irish history (devoid of Englishness) among Irish Chicagoans and visitors more broadly.

Newspapers and magazines in the United States, Britain, and Ireland reported positively on the villages. According to the *Dundee Evening Telegraph*, Hart's Village 'wonderfully exemplifie[d] the deftness of hand and artistic ability of Irish women'.[67] And the *Chicago Tribune* celebrated the 'vivacious cosmopolitan medley' of the Midway.[68] Moreover, the *Dublin Evening Telegraph* reported that 'Six [medals were awarded to Hart's Donegal Village] ... for dyeing, woodcarving, jewellery, silversmith's work, altar furnishings, and ironwork, respectively'.[69] Further, the *English*

Dover Express expounded that Donegal Village was 'one of the most quaint and picturesque of [the] presentments [on the Midway]'.[70] However, the Plaisance was anything but peaceful and whimsical, being home to dozens of stalls, mock villages, pavilions, and a whole host of entertainment spectacles. Such newspaper reporting responded directly to the needs of an emigrant Irish population in the United States to see their homeland as unspoiled and prosperous. Overall, the Chicago Village became an attainable project to remedy Irish penury in the extreme climes of Donegal's 'bogs and moors' where Hart and others held that 'distress is the normal condition of the villages and country districts'.[71] Visiting the Exhibition was a sound business decision to revive once flourishing rural industries (and Ireland itself) that combined patriotism and profit in a transatlantic forum.

Peter White was the manager of Aberdeen's Irish Village. He was the first secretary of the Irish Woollen Company and received a salary of £500 a year. However, he died of pneumonia on 7 April before the Fair opened, and his wife took over. Mrs White 'fulfilled her promise to take his place as far as she could'.[72] The Midway's bazaars, cottages, and villages complemented one another. The entrance to Aberdeen's Irish Village was a replica of the 'north doorway to the chapel built by Cormac, the bishop king of Munster, in the early part of the twelfth century' (Figure 2.4).[73] The photograph depicts besuited men and women, and so highlights the social spectacle of

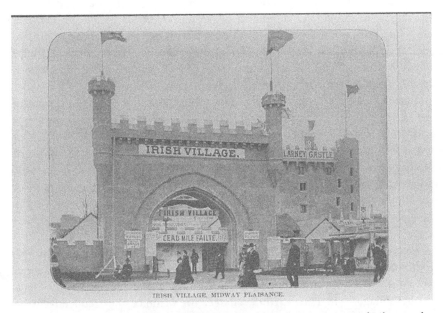

Figure 2.4 Postcard of 'Irish Village, Midway Plaisance' (courtesy of Library of Congress, Prints and Photographs Division)

the Fair (like the fairs of the 1850s) as a place where visitors wanted to be seen by others with its coded messages of edification and prosperity. The image reveals signs of Irish industries and the 'hundred thousand welcomes' on offer; this became a postcard popularly circulated during the Exhibition and later.

Aberdeen's Village contained a replica of the ruins of Muckross Abbey and several cottages 'where the inhabitants of this busy little community ply their industries'. Visitors could see lace and crochet work, homespuns, hosiery, and bog-oak carving. They could also observe Celtic jewellery in the making as well as finished pieces, replicas of the Tara Brooch, and various antiquities. A model of an ancient Celtic cross completed the historic portrayal of the country, reflecting the 'early civilization and art of Ireland'.[74] Nationalist identity in Ireland, Stephen Rohs argues, was 'white' first and foremost as well as 'distinctive[ly] Celtic'.[75] Building on this, Aberdeen's Village was less explicitly Celtic than Hart's, as she did not object to England as much as her peer, but both traded on ideas of a Celtic Irish whiteness that was productive and valuable.

Public ways and purposefully placed yards allowed visitors to circulate effectively in Aberdeen's section of the Chicago Fair. Ishbel Aberdeen's Irish Village replicated Blarney Castle (Figure 2.5) – a gargantuan symbol of true Irishness. The ground floor plan of Aberdeen's Village shows the vast green space in the centre amid numerous buildings. Visitors congregated in the middle of the village green and sequentially worked their way through, admiring the various exhibits on show. Here, there were trees to stimulate the effect of a village, and shops in strategic positions enabled the purchase of profitable souvenirs. Visitors could wind their way from music to woodcarving, and even a dairy, over a relatively short distance.

Blarney Castle allowed visitors to kiss the 'magic stone' for ten cents and get 'a view of all Ireland' from the battlements.[76] The Castle, a medieval fortress in Cork, Ireland, witnessed battles for its possession from different warring families over the centuries; it traded hands from the King of Munster to Queen Elizabeth I, Oliver Cromwell, and innumerable lords and castellans. Its compelling history and rumours of magical powers from the famed Blarney Stone established it as a popular site of tourism by the nineteenth century.[77] Aberdeen's recreation of it in her Village signified the steady consumerisation of stereotypical Irishness for profit and play.

Personified symbolism of Ireland was rampant within the Chicago Exhibition and beyond. Hart mused during her tour of Donegal: 'People are wild for work', and both women prominently displayed Irish women in the Village.[78] In Hart's 1893 Village, for instance, her 'colleens' were dressed 'in Connemara red petticoats, fishwife skirts and blouses, and scarlet cloaks … [and] look[ed] very pretty'.[79] The conflation between the soil

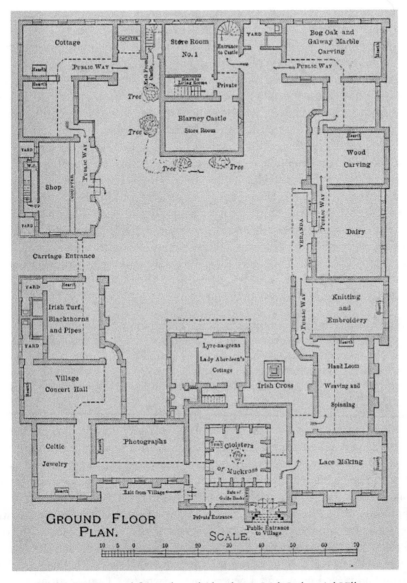

Figure 2.5 Ground floor plan of Aberdeen's Irish Industrial Village (manuscript 'Guide to the Irish Industrial Village and Blarney Castle' – the exhibit of the Irish Industries Association – President, the Countess of Aberdeen – 'Eire go Bragh', 1893 T500.K1 I6 – courtesy of Library of Congress, Prints and Photographs Division)

of Ireland and the bodies of its inhabitants inferred that the agency of the individual was separate and unaffected from the functioning of the state, echoing popular post-Famine discourse. To place such importance on the corporeal form, and particularly the female form, reinforced narratives of individual labour overcoming environmental disaster, and the inefficiencies of poor relief. Regardless, in the same way that Aberdeen's politics took her own body as synonymous with the rural revival movement, both women saw the bodily action of Irish women as indistinguishable from their activism. Overall, the performance of female labour and presentations of beauty and youth became indefatigable in convincing visitors that rural industry in Ireland was worth protecting.

Aberdeen held female labour as sacred, as is evident in the way she picked the 'colleens' to 'work' and display themselves in the Village. Aberdeen undertook a tour of the industries in western Ireland in the 1890s to select women to work in the Chicago Village, accompanied by seven of the IIA's Committee and her daughter, Lady Marjorie Gordon, visiting Clones, Carrickmacross, Limerick, Cork, Skibereen, Youghal, Kinsale, and finally New Ross. Aberdeen wrote in her memoirs:

> Everywhere I met with a most extraordinary reception, addresses and meetings were arranged, at which were present persons of the most opposing creeds and politics. Committees of representative men were appointed at [different counties] ... Lord Mayor[s], county people, bishops, and mayors ... all kinds of representative folk [attended]. The enthusiasm shown everywhere was remarkable.[80]

Aberdeen visualised an image of a non-partisan politics – a conciliatory vision of vast support for the revival of rural industries for the good of the country. She valued authenticity when representing Ireland, revealing how claims to realism interacted with trade and profit. She selected only the 'fittest colleens' (Figure 2.6) – skilled in their trade and eager to develop. Interestingly, appraisals of beauty and youth surfaced during the selection process, with Aberdeen often complementing her 'bevy of pretty, fresh-looking Irish colleens'.[81] The 'bright worker' in the photograph was smiling and dressed in traditional Irish garb. She stood in front of a slightly worn Irish cottage, which had peeled paint and a general overgrown feel. Connotations of rusticity were artfully composed to celebrate the industry of these fair women. With her hands crossed in front of her chest, the viewer could feel confident in the ability of this 'colleen' and the countless Irish women she represented. The woman photographed was happy in her labour and its production. The whiteness of the women associated beautiful white Irish women with Ireland.

The revival of rural industries relied on a comely image of Irishness presented as skilled, quaint, and inviting – ripe for investment and trade – and

Diaspora and migration

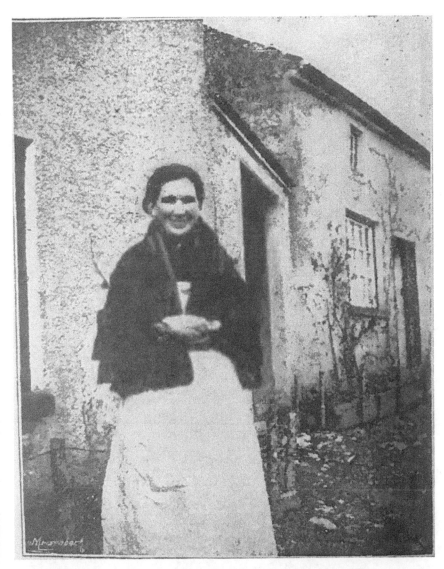

Figure 2.6 A bright worker ('Guide to the Irish Industrial Village and Blarney Castle', 1893 T500.K1 I6 – courtesy of Library of Congress, Prints and Photographs Division)

its success depended on the normative male gaze of the fair-goer. Female labour personified itself in the Village with an opportunity to observe the 'making of many of the different kinds of lace and crochet-work manufactured in Ireland'.[82] For instance, the *Official Guide to the Midway Plaisance* published several accounts of the different trades daily performed. To pick

a few examples of Irish industry being individualised and so humanised and made accessible:

> Ellen Aher trained at the Presentation Convent at Youghal County Cork, makes the beautiful needle-point lace which is so highly prized; Kate Kennedy illustrates the making of applique lace as it is done in the cottage homes of Carrickmacross, and Mary Flynn [makes the] much admired fine crochet work made by the poor women around Clones, in County Monaghan, and which is already much appreciated in America; Ellen Murphy shows how the pretty light Limerick lace is made ... Bridget McGinley works at her old-fashioned wheel in the next cottage ... delightful homespuns whose merits have been found out of late years by the fashionable world; ... Maggie Dennehy, who talks real Irish, also sits nearby and shows how Miss Fitzgerald has taught the women of Valencia Island, County Kerry, to earn their livelihood by knitting.[83]

Figure 2.7 shows a 'colleen' lacemaking in the Irish Village. She is in a kitchen with a dresser full of plates as well as cutlery, and a pot boils over the fire. The woman's surroundings are indicative of a domestic hub, with fabric and thread spooled over her dressing table where she sits at work. The 'colleen' is focused on her endeavours, revealing a degree of skill and expertise. The image neatly encapsulates how such rural industries became

Figure 2.7 Lacemaking in the Irish Village (Flinn, 'Official Guide to the Midway Plaisance', 1893, p. 15 T500.A1 F69 – courtesy of Library of Congress, Prints and Photographs Division)

productive – in the domestic sphere of women's homes where they could privately labour to save Ireland – extending discourse from the exhibition organisers of the 1850s.

Authentic female labour had financially profitable appeal in both Ireland and the United States. Images of female industry particularly appealed to Irish Americans, encouraged to think of their past lives in Ireland envisioning their mothers, grandmothers, or great grandmothers participating in such work. A romantic image of an Irish past rooted in the domesticised body of femininity and rural industry became carefully cultivated by prompting memories, or at the very least some kind of nostalgic remembering, of an Irishness experienced, heard, or read about. The women did not only perform traditional industry but also combined it with new techniques and inventions. For instance, in the display of the dairy industry, 'three dairymaids at the Village ha[d] been trained at the Munster Dairy School [near Cork]', famed for its scientific agriculture. The *Guide to the Midway Plaisance* celebrated the 'delights of a well-trained dairymaid's profession ... what dainty and appetising results can be turned out by a deft pair of hands with the aid of the convenient recently introduced dairy utensils in comparison with the older-fashioned methods', in a productive blend of rural industry and technology that was also vied for in the exhibitions of the 1850s.[84]

Irish progress was ultimately rooted in traditional rural industry tethered to the future labouring in the present. The two women's attachment to a rustic Ireland which they could save created a disconnect between the Irish villages and images of the future on display in the rest of the White City. The refusal to let an imagined quaint Ireland expire sustained their rural revival project. Their ideological understanding of Ireland championed a dying industry and emulated the tenets of colonialism that sought to transform colonised countries from the outside – from an external perspective of what was needed for the good of the people as opposed to engaging with the cycles of industrialised modernity of the time. Preserving the rural aesthetics of Ireland for elite consumption became equal to 'saving Ireland' within the well-established hierarchies of colonialism in the nineteenth century.

Beauty was distinctly profitable within the terms of female employment, as Aberdeen wrote: 'Our only difficulty to the selection of the girls was that the gentlemen of the party always wished to choose the prettiest, without reference to their qualifications in connection with their various industries.'[85] Clearly, 'working' and 'acting' for the good of Ireland was a sensible economic opportunity for many women. This uneasy tension problematises gendered notions of industry. On the one hand, women became saviours at times of disaster, but further, their crucial labour became redundant during seasons of prosperity in Ireland. For instance, Aberdeen hired 'colleens' based on attractiveness and not necessarily skill, which insidiously

suggested that female labour was superfluous to everyday workplace hardship. Women emerged at moments of difficulty only to return to the home when the exhibition was over, or the winter months ended. In instances where the women came from factories, their new roles required them to perform work on the smaller scale of an exhibition village: a disorientating project of acting one's lived reality. According to Aberdeen's hiring practices, women only needed to be industrious in times of real tragedy or because of aristocratic demand.

An intimate symbiosis between the exhibited Irish women and the Irish land was crucial in convincing visitors that things were in fact exactly like this in Ireland and were worth investing in. The interior of Blarney Castle consisted of living and sleeping rooms for the Village workers. Altogether, 105 employees were working in the Village, including the band and restaurant girls. Irish women who temporarily worked abroad were seen as limiting the perceived harm of migration to the country. Contemporaries lamented that 'Donegal now sends her away her comely sons and daughters. Everywhere one hears the same sad story of emigration; everywhere resounds the cry, "If the people could only be kept in the country!" What they want is manufactures and such industries as sewing, embroidering, and lacemaking', echoing Maguire's lamentations from earlier.[86] Here, the benefits of rural female labour that taught and celebrated the display of a skill abroad in order to continue its practice at home in Ireland is evident. The return was crucial: Aberdeen wrote: 'Everywhere there were hosts of candidates, but I had to promise the mothers that I would guarantee the safety of their daughters and bring them safe back.'[87] In this way Irish female labour would return to the home country and continue to be productive in a two-way lucrative international exchange between Ireland and the United States.

The Exhibition space epitomised the voyeuristic display of female bodies as visitors could linger, observe, interact, or converse in English or Irish with the female workers. Tens of thousands of people bought season tickets, and it is interesting to reflect on whether those who repeatedly visited the Exhibition had certain favourite exhibits or actors.[88] The women were employed for six months, and it is probable that they forged relationships with those who came to visit them as a one-off or periodically. Within the Fair, women occupied the fictional home for the consumption of the public and particularly aristocratic consumers in Aberdeen's case.

The success of the Irish Exhibitions in 1893 came from the perceived sense of a true Irishness and spoke mainly to Catholic ideals of Home Rule with their Scottish and English organisers. For the most part Irish Americans participated enthusiastically with the perceived authentic Ireland in the fairground (Figure 2.8), whatever the specificities of their political affiliation.[89] The birds-eye view of Aberdeen's Village revealed the centrality of Blarney

Diaspora and migration

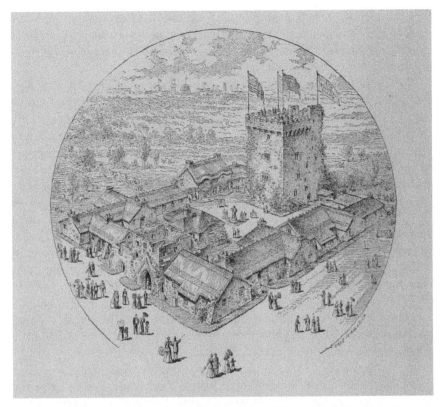

Figure 2.8 Birds-eye view of the Irish Village (Flinn, 'Official Guide to the Midway Plaisance', p. 46 T500.A1 F69 – courtesy of Library of Congress, Prints and Photographs Division)

Castle and the general interest of visitors in the display of Ireland at the Columbian Exposition. The Village did not reside in any countryside, but the sketch contained individuals and groups admiring and pointing to the Village amid a backdrop of trees and greenery. There were tall buildings and pavilions in the distance and the congenial atmosphere reflected a broader satisfaction and interest in Aberdeen's fiction.

However, the fact that Aberdeen wanted to continue a partial alliance with Britain (within a devolved Home Rule) caused tension for some. Early in the autumn of 1893, 'A very serious disturbance arose at Lady Aberdeen's Irish Village' when a group of Irish men attempted 'to pull down the British flag which was floating from the tower of Blarney Castle in honour of the visit of the Governor General of Canada'.[90] The men 'made an attempt to tear down the flag, because they did not think it ought to be unfurled there'. Employees and guards 'drove the offenders into the Plaisance', but before

they could be arrested, 'thousands ... congregated around the [police] wagon' sympathising with the men's attempts and even 'set[ting] three of [those apprehended] at liberty'. Eventually, 'the ringleaders were taken as prisoners after a conflict with the guards and police'.

The protests and arrests highlight the fractious workings of a display sponsored by aristocratic men and women and the fragility of the support for Home Rule in the United States, while also illustrating the popularity of more extreme Irish nationalist movements. This may reflect the naivety under which Aberdeen operated. Perhaps a British flag was appropriate to an English or Scottish audience, but this was certainly not the case for Irish Chicagoans. Historians have documented that the Irish community in Chicago and America more broadly disagreed over how to achieve Irish independence – whether to engage in violence or a more peaceful process to gain constitutional change. While some Irish Americans campaigned for a devolved Home Rule, others wanted a complete separation from England in the form of a republic.[91] This brings into question who the intended audience for the Village was; certainly, some Irish in America did not adhere to Aberdeen's politics and were avowedly nationalist, and so it is curious to consider whether the Village was more for American or British visitors, not necessarily Irish men and women. Clearly, a sympathy for Home Rule prevailed and occasionally caused concern.

Exhibitionary narratives of an Irish nation operated within nostalgic remembrance and interacted with accessible Irish symbolism to salve the pain of migration for Irish diasporic citizens. I have shown so far in this chapter how Irish migrants navigated their new homes in the United States through exhibits and charity.[92] Jeffery K. Olick and Joyce Robbins have argued 'that history is the remembered past to which we no longer have an "organic" relation' and further, 'the past that is no longer an important part of our lives, while collective memory is the active past that forms our identities'.[93] Consequently, historical memory allows us to 'celebrate even what we did not directly experience, keeping the given past alive for us'. Building on this, international exhibitions were memory sites and practices that functioned as central loci for identity formation. Clearly, the past produces itself in the present and is thus malleable – offering fertile ground for multiple constructions of Irishness on the fairground in a productive cacophony of Irish images that soothed, attracted, and enlivened experiences of being Irish in America.

Nostalgia in the nineteenth century and in the case of the Irish refers broadly to a fluid, vague, collective longing for a 'bygone time rather than an individual desire to return to a particular place'.[94] And we can see how this operated in Hart's and Aberdeen's exhibits. Peter Fritzsche argues that nostalgia embodies the melancholic feeling of dispossession, and

narratives of loss involve the recognition of bodily and societal difference, which enables the construction of distinct national identities.[95] From the 1970s onwards, significant historical literature interpreted Irish migration as undertaken reluctantly, suffocated by feelings of loss and political banishment.[96] While it is true that migration took place within a context of broad social and political crisis, the complementary complex narratives of hope and belonging remain overlooked. Historians such as Matthew Frye Jacobson have been integral in widening the discourse of Irish migration as a story of 'departure and absence', as well as 'arrival'. He states that for the Irish 'in the New World [migration] entailed a poignant absence from the Old; ... packing off to North America meant taking up residence on the periphery of one's former world, and yet former centres did not necessarily lose their centrality'.[97]

Whether or not these migrants were voluntary or forced exiles has dominated much of the debate, but it is clear that they encountered a complex set of social and political currents imbibed within celebratory and difficult relocations.[98] Significant literature has critiqued the over-reliance on the most dramatic stories of migration and simplistic narratives of loss following famine and disaster.[99] Doyle has recently argued that Irish immigrants held on to earlier attachments of Irishness within American communities. He argues that Irish migrants continually engaged with Ireland on a social and political level, and his thesis challenges linear models of assimilation.[100] A straightforward perception of migration as a process of departure and settlement skews the organic transference of home and diaspora narratives that were common in this period. A new transatlantic historical consciousness formed rooted in a sense of exclusivity and aversion to white Britons. This might explain the riot in Aberdeen's Irish Village: the similarities to a foreign interloper creating a utopian version of Irishness hinted suggestively to the ongoing power of colonialism in the nineteenth century.

In the fairgrounds we can see in operation the type of nostalgia that Svetlana Boym has conceptualised: one that involves a 'longing for a home that no longer exists or has never existed'.[101] The rural industries displayed in the 1893 Exhibition relied on the renewed mechanisation of traditional crafts, the creation of new global markets, and the publicity of unique handmade Irish goods. The industry was in decline at the high point of Irish migration to the United States in the mid-nineteenth century, and so the Chicago display enabled a connection with a lost past possibly experienced in childhood, if only through stories of former generations. Boym considers nostalgia as a 'romance with one's own fantasy' possessing a utopian dimension directed towards the future.

The display of Ireland in 1893 makes it clear that nostalgia is not always about the past; it can be retrospective but also prospective in the sense that

it held the potential to display what a future Ireland could look like.[102] Fantasies of the past emerged out of the harsh conditions and needs of the present and so shaped the imagined realities of the future. Fair-goers and fair organisers relied on the revival of rural industries to save Ireland's present and future. A fiction of a future that profited from rural female labour for the harmonious working of Irish society as a whole, a future devoid of poverty and hardship and allied constitutionally (and partially) with Britain for the prosperity of all, emerged.

Popular nostalgia of Ireland in the 1893 Exhibition intersects with touristic images of the country in the same period. Tourism of Ireland, Martin Ryle has shown, emerged out of romantic landscape aesthetics of remote Celticism, which was concerned with overdevelopment in European cities, the mass migration from rural areas, as well as discourses of 'tradition' and environmentalism.[103] The exhibits of the Irish in Chicago relied on the connection between tradition and history as a legitimate and sought after Irishness. Similar to the way that English literary travellers' representations of Ireland focused on the extinction of rural England, the exhibits within the Irish villages functioned within a messy temporal space always at threat of famine and poverty (and broader industrialised modernity and competition). In both Irish tourism and the Irish villages, the rurality in Ireland and the rural revival project took precedence, in part responding to a displaced sense of longing for an idealised vision of the past. The political and cultural position of the British, including the Scottish Lady Aberdeen and the English Alice Hart, brings into question considerations of representation and cultural authority, given Ireland's contested colonial status.[104] Importantly, there existed a focus on untouched landscapes within Irish tourism. This was similar to the supposed pure, native, authentic Irish rurality on display within popular female philanthropy of the nineteenth century. In the case of tourism and display, such tropes of Ireland had enormous value for trade and profit, as they circulated to positive effect in the fair.

Nationalism and Ireland in the fairground

We can broadly see that Irish migration cultivated and fermented the development of a wide range of Irish nationalist views that appealed to the homeland and so lent support to the revival of a rural, untouched, sacred Ireland.[105] The Irish land question amalgamated into issues of Home Rule, which subsumed discontent into a larger metaphor of Irish nationalism. The displays in 1893 belong to this broader nativist Irish project that favoured continued, yet regulated, contact with England in a separate Irish government. Kerby Miller, among others, has documented the vast web of Irish

nationalism in the United States from groups such as the Fenian Brotherhood and the Ladies Land League, the Ancient Order of Hibernians, and Clan na Gael – with Irish migration becoming the greatest symbol of Ireland's suffering because of England.[106]

The mass politicisation of Irish economic and political hardship mobilised an immigrant movement that complemented the activism in Ireland itself, and visitors carried their politics on independence to the Irish villages in Chicago.[107] The Fenians were the most significant Irish political group in nineteenth-century America and Ireland. Brian Jenkins has shown that the Fenians relied heavily on Irish American sympathy and support, particularly when they attempted large-scale raids across the international border into British North America. The group initially perceived armed conflict as the only possible method of securing Ireland's wholesale independence from the British.[108] An Irish Republic imagined itself along dualistic lines rooted in the historical past, in the uncertain arena of the present, with ambitions for the future, for Irish men and women in both Ireland and the United States.

With the failure of the Fenian Brotherhood in 1867, a transatlantic activism, which the 1893 displays were part of, was nurtured, and the Gaelic movement emerged in tandem – epitomised in Douglas Hyde's presidential address to the National Literary Society in Dublin on 'the necessity for de-anglicising the Irish nation' in November 1892.[109] The exhibitions resonate strongly with the context of the broader Irish Revival in the late nineteenth century. For instance, revival writing was not just concerned with the salvation of a pre-modern past but also with the production of an idealised ethnicity.[110] Hyde rallied against 'West-Britonism' and championed an exclusive Irish lifestyle, involving the Irish language, clothing, and food, even music and games. In this vein, Brian Ó Cuív notes that the Gaelic League's prime objective was to ensure the survival of the Irish language in and around Ireland. To this end, it hoped to be apolitical and devoid of religious factions. Hyde's supporters, Crooke explains, 'colonised the past, misrepresenting it in a nationalist mode as a kind of pre-Norman Utopia of comely maidens and chivalrous men of song and story'.[111] Yet the League received substantial interest for around twenty years.

The sum of all these groups was the production of a wide-ranging spirit of independence that encompassed those with divergent views, interests, and loyalties.[112] Chicago's Irish villages visualised and furthered a relationship between home and migration by encouraging Irish Americans to experience their homeland through the exhibits of Ireland in 1893. They became a celebration of Irishness for recent Irish immigrants and American descendants of Irish immigrants. Hart expounded that the display and demonstration of 'Irish hand industry … from County Donegal' will 'pave the

way for their permanent introduction into America'.[113] The Irish exodus to America, notes Roy Foster, created 'fierce' and 'obsessive identification' to the homeland, which is epitomised in the displays of 1893.[114] The *Guide* was full of sensory invitations to experience Ireland, from the sights to the smells of the Fair, and the taste of Irish goods; there was even a restaurant to take refreshment 'under the shade of trees' in an immersive Irish paradise.[115]

Irish men and women could also read the political in the Exhibition. Hart included a model of Daniel O'Connell's Memorial Chapel. The representation of O'Connell with his vehement opposition against the Act of Union and avowed championing of Home Rule may have irked Lady Aberdeen as a too extreme form of Irish independence.[116] This reading of the political relates to Steven Conn's argument in *Museums and American Intellectual Life, 1876–1926* that the narrative of the Exhibition, much to the organisers' distress, was entirely fluid and subject to revision by the visitors.[117] The 1893 exhibit could alternatively highlight an Irish history to demonstrate how the country had profited from a union with Britain and still maintained its own national identity, or visitors could read the exhibit as an example of nationalist symbolism to reaffirm their politics of an independent Irish state. Moreover, the politics of a historic Ireland permeated not only the objects on display but also the souvenirs available for purchase. If one wished to continue the fantasy of Ireland beyond the fairground, they merely had to expend a few cents to 'carry [a] bit of "Ould Ireland" in the New World!'[118] This transfiguration of a native Ireland on to portable paraphernalia enabled Irishness to transcend geographical and material boundaries and circulate within the imaginary and lived spheres of Irish migrants. Souvenirs allowed the transference of politics to continue through the trajectories of display and its larger dissemination.

Declan Kiberd came up with the concept of an 'Irish consciousness' to account for the Gaelic Revival in *Inventing Ireland: The Literature of the Modern Nation*.[119] I have shown how exhibitions became an important platform of revival symbolism for individuals like Aberdeen and Hart, and advertisers that lobbied for a stall, a mention, or a printed advertisement during the 1893 Fair typically defined themselves and their products in terms of 'Irishness'. This type of Irishness, John Strachan and Claire Nally argue, often appeared in 'brand name, visual image, font, and typography, and – sometimes – in overtly nationalist rhetoric of various political hues', and the Irish villages in the Fair were resplendent with Irish motifs of spinning, weaving, and sewing – neatly encapsulated in the form of the Irish woman.[120]

From the 1890s onwards, advertisers on a broad scale, and philanthropists such as Lady Aberdeen and Alice Hart, appealed to the patriotic spirit of the consumer and profited from exploiting it financially. Strachan and

Nally have convincingly argued that the Irish Revival's literary and cultural project complimented Irish economic nationalism.[121] Aberdeen and Hart encouraged 'De-anglicising' through popular Irish activism in the form of their 'buy Irish campaigns', for example. Strachan and Nally have shown how this ushered in a type of 'protectionism by the back door' and functioned as a 'voluntary protectionism', which circumvented the reliance on British imported goods and British ideals of free trade.[122] The legacy of nationalist Irish trading continued from the 1850s with the desire to increase Irish consumption of Irish goods (not English ones), expounded by Maguire in the 1852 Cork Exhibition and Dargan in the 1853 Dublin Exhibition. In the 1890s, Irishness remained profitable for both producers and activists; organisers could expound their national allegiance while concurrently making money. The national cause and commerce interacted in a way that appeased the consumer, their politics, and Irish production. Prioritising home goods over imported products was an attractive, easy fix to bigger questions of Irish Home Rule that complemented the capitalism of the late nineteenth century and the volatility of Irish-British politics.

Endings

Hart's and Aberdeen's projects responded to the broader social-political context. Helland has shown how Alice Hart's business sought to ferment Irishness through prioritising the 'achievements of Ireland's Golden Age' as part of the Gaelic Revival tradition that romanticised the rural peasantry.[123] Importantly, the influence of the DIF peaked in the 1880s and the 1890s, and Dun Emer, part of the Celtic Revival movement, replaced it in the early twentieth century. Moreover, Aberdeen supported Irish art and manufacture and ardently encouraged consumers to buy Irish goods exclusively, with the entire process of production and consumption to benefit the Irish manufacturer. She embraced Celtic culture, and this type of philanthropic benevolence worked in tandem with the British state and looked to improve the Irish lot through individual diligence instead of external state help.[124] She became an aristocratic champion of the Irish poor, furthering Home Rule through crafts, industries, and clothing – using her body as a point of replication. Aberdeen declared in the Women's Building at the Chicago World's Fair: 'Look at the homespun skirt I am wearing, made in the wilds of Donegal ... this fine crochet work from Clones, this point lace handkerchief from Youghal. The work of trained human fingers is still superior ... to the iron monsters devised by human brains.'[125] The exhibition of Irish goods made by the IIA continued until the final Exhibition in 1900 in Windsor, which promoted the two most expensive fabrics: tweed

and lace.[126] Both women's revival projects continued to function along the lines of benevolent colonialism. They offered a unity of product and people to humanise the poor and sell their wares. The trend of charitable investment and ethical consumption persisted in the advertising of rural industries by elite entrepreneurs, and campaigns to buy Irish goods made by the Irish poor, into the early twentieth century.

Aberdeen's Irish Village made a gross profit of £50,000, with half of that taken by the Exhibition authorities, £20,000 paid to the workers in Ireland, and some settling the balance of hiring out a depot in Chicago and paying the salary of the manager.[127] In Aberdeen's memoirs she wrote that 'Mr. Horace Plunkett pronounced himself well satisfied with the efficiency and economy with which the whole enterprise had been conducted.' Hart wanted to 'rescue an agricultural population, living on smallholdings, from destruction'.[128] To this end, relatively extant industries became accessible for the 'idle and poverty-stricken', and from her 1886 Exhibition alone, the DIF sold '£6,000 worth of Irish lace and homespun goods' and '10,000 yards [of homespuns]'.[129]

Both women's philanthropy was in keeping with the revival ethos popular in nineteenth-century Ireland and supported the renewal of cottage industries by presenting the country as a tranquil space in the fairground. Here, the people were docile and friendly, and a coalition between the nobility, the middle class, and peasantry sought a revitalised Ireland. Both the IIA and the DIF implemented large-scale improvements. Helland has shown how the DIF facilitated the machinery for improved expert weaving, regulated the practice of natural dyes, and popularised innovative patterns for tweed, lace, and knitted products.[130] Aberdeen opened the market for Irish products to an elite society ready to spend large sums in keeping with the late-nineteenth-century trend of reviving rural industries. The aristocrats and upper classes sported different types of Irish fabric, which by their very possession raised awareness and furthered sales in a productive cyclical way to the benefit of the workers in the west counties of Ireland.

Evidently, the story of nineteenth-century Ireland changes when we take seriously the work of women. Lady Aberdeen and Alice Hart were crucial to the rural revival project and were integral in creating transnational conceptions of Irishness. Their respective Irish villages shaped visitor opinions and further instigated and spearheaded a movement to develop the industrial structures of Ireland for the benefit of the poor. Their split and the eventual presentation of two Irish villages reveal differences in the Irish Home Rule movement, with Aberdeen adopting a more moderate vision in contrast to Hart's more radical perspective. Clearly, the philanthropic movement was expansive enough in the nineteenth century to accommodate their divergent views within the larger project of female labour. Ireland in the 1893

Columbian Exhibition embodied a rural nation that had vast potential for development, initially with cottage industries and later with broader mechanisation and trade opportunities.

Most importantly, the two activists' displays interacted with the wider political conditions affecting Ireland. This becomes a story of how individuals and often women navigated the gaps left by poor government funding, and how within this, exhibitions functioned as a core platform for change and hope – continuing trends from the 1850s. Aberdeen and Hart manoeuvred their way through the politics of the time by championing rural industries. They offered a direct solution to questions of the land in Ireland and recurring poverty: here was a clear example of how the country could have a profitable and sustainable rural industrial enterprise. The advertising of Ireland tugged on the heartstrings in a clever, profitable way: visitors could buy a trinket or souvenir and simultaneously feel like they were helping further Irish industry.

Displays of Irishness, whether through exhibitions or print media, enabled a language of nationalism to emerge that reinforced a separation from England and a connectedness with Ireland in the United States. Exhibits addressed issues of migration and an Irish nation by offering a transnational representation of a rural Ireland accessible to migrant Irish men and women so that they could embrace an Irish American identity. In the Chicago Exposition a 'heady mix of nostalgia, romance, and high drama [was] provided' to further rural Ireland in modern America.[131] The two women's avowed stance on Home Rule and broader liberal political activism remained consistent in their exhibits, and they engaged with different nationalist movements, particularly the Gaelic Revival. Clearly, world's fairs were not just rhetorical but primarily experiential in nature, and they reacted fluidly with the contemporary climate.

Everything was made available to the visitor, from bog oak carving to Galway marble carving, woodcarving, a dairy, knitting and embroidery, handloom weaving and spinning, lacemaking, and Celtic jewellery, to create an ethnic Irish solidarity. Due to the sources available, this chapter has focused on organisations and their organisers; however, I am keenly aware that the work was done by rural Irish men and women, and the labour of those engaged in cottage industries should not be lost. Female activism interacted with serious poverty and political tension to offer viable answers through the medium of exhibits; Ireland was on the cusp of being saved, if only its rural industries were revived. Again, discourse about the country's potential for development carried over from the post-Famine era. Irish recovery contributed to the commercialisation of Irishness, and this continued into the twentieth century but with a heightened focus on profit and state building. The next chapter advances the discussion on the intersections

between capitalism and Irishness, and analyses how a single Irish business came to represent Ireland in the fairgrounds as both a charitable and a profitable enterprise by selling soap in the early twentieth century.

Notes

1 Library of Congress, Washington, DC, T500.K1, manuscript by K. Tynan, 'An Ode for the Opening of the Irish Village at Chicago, Guide to the Irish Industrial Village and Blarney Castle. The Exhibit of the Irish Industries Association. President, the Countess of Aberdeen. 'Éire go Bragh', 1893, p. 29. See E. Larson, *The Devil in the White City: Murder, Magic and Madness at the Fair That Changed America* (New York, 2003) and W. Cronon, *Nature's Metropolis: Chicago and the Great West* (London, 1991).
2 C. M. Rosenberg, *America at the Fair: Chicago's 1893 World's Columbian Exposition* (San Francisco, CA, 2008), p. 254.
3 Library of Congress, Washington, DC, T500.A1 F69, manuscript by J. J. Flinn, 'Official Guide to the Midway Plaisance. Otherwise known as "The Highway through the Nations"', 1893, p. 1.
4 See M. Armstrong, 'A Jumble of Foreignness: The Sublime Musayums of Nineteenth-Century Fairs and Expositions', *Cultural Critique*, 23 (1992–93), 199–250.
5 See Ciara Breathnach, 'Lady Dudley's District Nursing Scheme and the Congested Districts Board, 1903–1923', in Margaret Preston and Margaret Ó hÓgartaigh (eds), *Gender and Medicine in Ireland, 1700–1950* (Syracuse, NY, 2012), pp. 138–53. The Lady Dudley scheme worked with the CDB to organise medical care in the home and to improve public health in the west of Ireland in the early 1900s.
6 See S. Akhtar, 'Learning "The Customs of their Fathers": Irish Villages in Chicago's Columbian Exposition, 1893', *Journal of Victorian Culture*, 20:20 (2023), 1–25. British Library, London, 8277.d.15.(5.), manuscript by A. Hart, 'The Cottage Industries of Ireland, with an Account of the Work of the Donegal Industrial Fund', 1887, p. 4.
7 David Fitzpatrick, 'A Curious Middle Place: The Irish in Britain, 1871–1921', in Roger Swift and Sheridan Gilley (eds), *The Irish in Britain 1815–1939* (London, 1989), pp. 10–59, pp. 16–9.
8 *Chicago Tribune* (1 January 1866); cited in S. Cooper, 'Irish Migrant Identities and Community Life in Melbourne and Chicago, 1840–1890' (PhD dissertation, University of Edinburgh, 2017), pp. 37–8. See S. Cooper, *Forging Identities in the Irish World: Melbourne and Chicago, C.1830–1922* (Edinburgh, 2022).
9 British Library, London, Mic.F.232 [no. 13920], manuscript by W. T. Stead, 'Lord and Lady Aberdeen: A Character Sketch', 1893, p. 51. For more recent work on charity, see S. Roddy, J. Strange, and B. Taithe, *The Charity Market and Humanitarianism in Britain, 1870–1912* (London, 2018).

10 D. F. Shackleton, *Ishbel and the Empire: A Biography of Lady Aberdeen* (Toronto, 1996), p. 17.
11 J. Helland, *British and Irish Home Arts and Industries, 1880–1914: Marketing Craft, Making Fashion* (Dublin, 2007), p. 26. See also J. Helland, 'Authenticity and Identity as Visual Display: Scottish and Irish Home Arts and Industries', in Fintan Cullen and John Morrison (eds), *A Shared Legacy: Essays on Irish and Scottish Art and Visual Culture* (London, 2005), pp. 157–72.
12 E. Delaney, *The Curse of Reason: The Great Irish Famine* (Dublin, 2012), pp. 151–2.
13 Cited in P. Bew, *Ireland: The Politics of Enmity 1789–2006* (Oxford, 2007), p. 177.
14 Matthew Kelly, 'Home Rule and Its Enemies', in Alvin Jackson (ed.), *The Oxford Handbook of Modern Irish History* (Oxford, 2014), pp. 582–602; Brian Barton, 'Northern Ireland, 1920–25', in J. R. Hill (eds), *A New History of Ireland. Vol VII. Under the Auspices of the Royal Irish Academy Planned and Established by the Late T. W. Moody 1921–84* (Oxford, 2010), pp. 161–98; A. Jackson, *Home Rule: An Irish History, 1800–2000* (Oxford, 2003); F. S. Lyons, 'The Developing Crisis, 1907–14', in William E. Vaughan (ed.), *A New History of Ireland. Vol VI. Ireland under the Union, II, 1870–1921* (Oxford, 1996), pp. 123–44.
15 David N. Doyle, 'The Remaking of Irish-America, 1845–1880', in Vaughan (ed.), *A New History of Ireland. Vol VI.*, pp. 725–63, p. 740.
16 Ibid., pp. 740–1. See also Enda Delaney, 'Diaspora', in Richard Bourke and Ian McBride (eds), *The Princeton History of Modern Ireland* (Princeton, NJ, 2016), pp. 490–508; E. Delaney, 'Our Island Story? Towards a Transnational History of Late Modern Ireland', *Irish Historical Studies*, 37:148 (2011), 599–621.
17 R. R. Zuck, *Divided Sovereignties: Race, Nationhood, and Citizenship in Nineteenth-Century America* (Athens, GA, 2016), p. 143.
18 Doyle, 'The Remaking of Irish-America, 1845–1880', pp. 725–6.
19 B. Nelson, *Irish Nationalists and the Making of the Irish Race* (Oxford, 2012), p. 11. See also M. H. Thuente, 'The Folklore of Irish Nationalism', in Thomas Hachey and Lawrence McCaffrey (eds), *Perspectives on Irish Nationalism* (Lexington, KY, 2015), pp. 42–60; Kerby A. Miller, 'Ulster Presbyterians and the "Two Traditions" in Ireland and America', in J. J. Lee and Marion R. Casey (eds), *Making the Irish American: History and Heritage of the Irish in the United States* (New York, 2007), pp. 255–70.
20 See Kevin Kenny, 'Irish Emigrants in a Comparative Perspective', in Eugenio F. Biagini and Mary E. Daly (eds), *The Cambridge Social History of Modern Ireland* (Cambridge, 2017), pp. 405–22, p. 420; Timothy Meagher, 'Irish America', in Biagini and Daly (eds), *The Cambridge Social History of Modern Ireland*, pp. 497–514; Kevin Kenny, 'American-Irish Nationalism', in Lee and Casey (eds), *Making the Irish American*, pp. 289–301; K. Kenny, 'Diaspora and Comparison: The Global Irish as a Case Study', *Journal of American History*, 90:1 (2003), 134–62; R. Scally, *The End of Hidden Ireland: Rebellion, Famine,*

and Emigration (Oxford, 1995); L. C. Wade, *Chicago's Pride: The Stockyards, Packingtown, and Environs in the Nineteenth Century* (Urbana, IL, 1987).

21 For divisions between these communities, see D. H. Akenson, *Being Had: Historians, Evidence and the Irish in North America* (Charlottesville, VA, 1985); R. A. Wells, 'Aspects of Northern Ireland Migration to America: Definitions and Directions', *Ethnic Forum*, 4 (1984), 49–63; C. McGimpsey, 'Internal Ethnic Friction: Orange and Green in Nineteenth Century New York, 1868–1872', *Immigrants and Minorities: Historical Studies in Ethnicities, Migration and Diaspora*, 1 (1982), 39–59.

22 See C. Ó Gráda, *Famine: A Short History* (Princeton, NJ, 2009), p. 25.

23 C. B. Shannon, *Arthur J. Balfour and Ireland, 1874–1922* (Washington, DC, 1988), p. 22.

24 C. King, *Michael Davitt: After the Land League, 1882–1906* (Dublin, 2016), p. 436.

25 C. Breathnach, *Congested Districts Board, 1891–1923* (Cork, 2005), p. 11. See L. P. Curtis, *Coercion and Conciliation in Ireland: A Study in Conservative Unionism* (Princeton, NJ, 1963).

26 Ibid. See also C. Breathnach, 'Handywomen and Birthing in Rural Ireland, 1851–1955', *Gender and History*, 28:1 (2016), 34–56.

27 Ibid. Overpopulation was used synonymously with the term 'congestion'. See G. P. Moran, *Sending out Ireland's Poor: Assisted Emigration to North America in the Nineteenth Century* (Dublin, 2004).

28 'Guide to the Irish Industrial Village and Blarney Castle', p. 17.

29 Ibid., pp. 17–18.

30 See K. T. Hoppen, 'Gladstone, Salisbury and the End of Irish Assimilation', in Mary E. Daly and K. T. Hoppen (eds), *Gladstone: Ireland and beyond* (Dublin, 2011), pp. 45–63; M. McAteer, 'Reactionary Conservatism or Radical Utopianism? AE and the Irish Cooperative Movement', *Éire-Ireland*, 35:3–4 (2000–01), 148–62; C. Nash, 'Visionary Geographies: Designs for Developing Ireland', *History Workshop Journal*, 45:1 (1998), 49–78; A. Gailey, *Ireland and the Death of Kindness: The Experience of Constructive Unionism, 1890–1905* (Cork, 1987).

31 Alice Hart, 'Mrs Ernest Hart and Donegal Cottage Industries', *Londonderry Sentinel* (14 June 1889).

32 Alice Hart, 'Irish Cottage Industries. To the Editor of the Northern Whig', *Northern Whig* (16 June 1887).

33 Helland, *British and Irish Home Arts and Industries*, pp. 27–8.

34 Ibid., p. 34.

35 See also N. G. Bowe and E. Cumming, *The Arts and Crafts Movements in Dublin and Edinburgh, 1885–1925* (Dublin, 1998).

36 P. Larmour, *The Arts and Crafts Movement in Ireland* (Dublin, 1992).

37 É. O'Connor, *Art, Ireland, and the Irish Diaspora: Chicago, Dublin, New York 1893–1939. Culture, Connections, and Controversies* (Dublin, 2020), p. 2.

38 Cited in Helland, *British and Irish Home Arts and Industries*, p. 5.

39 R. Swift and S. Campbell, 'The Irish in Britain', in Biagini and Daly (eds), *Cambridge Social History of Modern Ireland*, pp. 515–33. They argue that by

the end of the nineteenth century, Irish migrants largely occupied unskilled and semi-skilled labour in England, and a small proportion of second-generation Irish men found skilled employment in industrial districts as mechanics, boilermakers, smiths, and fitters, and Irish women were engaged in a variety of low-paid professional occupations, including social work and nursing – p. 518. See also R. Swift, 'Heroes or Villains?' The Irish, Crime and Disorder in Victorian England', *Albion*, 29:3 (1997), 399–421.

40 For initial plans for the two women to work together, see British Library, London, W47/3147, manuscript by J. C. G. Aberdeen and Temair (1st Marquis Of) and I. G. Aberdeen and Temair (Marchioness Of), '*We Twa*': *Reminiscences of Lord and Lady Aberdeen, Volume 1 & 2*, 1925; 'The Countess of Aberdeen in Ulster', *Northern Whig* (19 July 1893); 'Lady Aberdeen's Tour', *Flag of Ireland* (22 July 1893); 'Politics and Persons', *St James's Gazette* (9 May 1892).
41 Stead, 'Lord and Lady Aberdeen', p. 42.
42 Breathnach, *Congested Districts Board*, p. 15. See C. Clear, *Social Change and Everyday Life in Ireland, 1850–1922* (Manchester, 2007), pp. 25–6.
43 'Lady Aberdeen and Irish Industries', *Aberdeen Press and Journal* (21 November 1903).
44 'The Countess of Aberdeen's Garden Party', *Dublin Daily Express* (12 April 1886).
45 'Aberdeen's Garden Party', *Freeman's Journal and Daily Commercial Advertiser* (7 June 1886). See also in *Aberdeen Press and Journal* (29 May 1886).
46 'Aberdeen's Garden Party', *Freeman's Journal*. See Helland, *British and Irish Home Arts and Industries*, pp. 84–5.
47 See Helland, *British and Irish Home Arts and Industries*, pp. 82–8.
48 Ibid., p. 29.
49 The first lecture Alice Hart gave in London on the DIF was in 1885. See British Library, London, 8275.cc.24.(9.), 'Cottage Industries, and What They Can Do for Ireland', 1885. Hart's lectures in the Village were based on previous talks she had given. For instance, she discussed home arts as a branch of technical education at a conference held at the Leeds Philosophical Hall on Wednesday 7 December 1887. See *Bradford Daily Telegraph* (8 December 1887).
50 'Irish Home Industries', *Kerry Evening Post* (31 July 1886).
51 *The Queen* (6 November 1886), p. 535; cited in Helland, *British and Irish Home Arts and Industries*, p. 45.
52 Aberdeen, *Reminiscences of Lord and Lady Aberdeen*, p. 323.
53 Ibid., pp. 323–4.
54 Hart, 'Donegal Cottage Industries'; 'Irish Cottage Industries', *The Globe* (14 July 1885).
55 Alice Hart, 'Irish Cottage Industries. To the Editor of the Northern Whig', *Northern Whig* (16 June 1887).
56 *Dundee Evening Telegraph* (28 May 1887); 'Letter to the Ladies. Irish Industries', *Dundee Evening Telegraph* (1 January 1887).
57 Library of Congress, Washington, DC, T500.C1 O8, manuscript, 'Oriental and Occidental Northern and Southern Portraits of the Midway: A Collection of Photographs of Individual Types of Various Nations from All Parts of the World

Who Represented, in the Department of Ethnology, the Manners, Customs, Dress, Religions, Music and Other Distinctive Traits and Peculiarities of their Race', 1894. No page numbers available.
58 Ibid. For recent works that complicate the space of the exhibitions, see N. Cardon, 'The South's New Negroes and African American Visions of Progress at the Atlanta and Nashville International Expositions, 1895–1897', *Journal of Southern History*, 80:2 (2014), 287–326; W. F. Brundage, 'Meta Warrick's 1907 "Negro Tableaux" and (Re)Presenting African American Historical Memory', *The Journal of American History*, 89:4 (2003), 1368–400; C. R. Reed, *All the World Is Here: The Black Presence at the White City* (Bloomington, IN, 2002); D. M. Guss, *The Festive State: Race, Ethnicity, and Nationalism as Cultural Performance* (Berkeley, CA, 2000); P. Kramer, 'Making Concessions: Race and Empire Revisited at the Philippine Exposition, St. Louis, 1901–1905', *Radical History Review*, 73 (1999), 75–114.
59 Armstrong, 'A Jumble of Foreignness', 201.
60 See L. Kruger, '"White Cites", "Diamond Zulus", and the "African Contribution to Human Advancement": African Modernities and the World's Fairs', *TDR: The Drama Review*, 51:3 (2007), 19–45; B. Kirshenblatt-Gimblett, *Destination Culture: Tourism, Museums and Heritage* (London, 1998); R. Corbey, 'Ethnographic Showcases, 1870–1930', *Cultural Anthropology*, 8:3 (1993), 338–69; A. E. Coombes, *Reinventing Africa: Museums, Material Culture, and Popular Imagination in Late Victorian and Edwardian England* (New Haven, CT, 1984); B. Benedict, *The Anthropology of World's Fairs: San Francisco's Panama Pacific International Exposition of 1915* (London, 1983).
61 See L. Gibbons, *Transformations in Irish Culture* (Dublin, 1996), pp. 165–70.
62 M. L. Pratt, *Imperial Eyes: Travel Writing and Transculturation* (London, 2008), p. 8.
63 Ibid., p. 9.
64 Flinn, 'Official Guide to the Midway Plaisance', pp. 13–14.
65 Helland, *British and Irish Home Arts and Industries*, p. 62. For a discussion on '"Kells Embroidery" Cottage', see Flinn, 'Official Guide to the Midway Plaisance', pp. 15–16.
66 E. Crooke, *Politics, Archaeology and the Creation of a National Museum of Ireland* (Dublin, 2001), p. 151.
67 'Letter to the Ladies. Irish Industries', *Dundee Evening Telegraph* (1 January 1887).
68 *Chicago Tribune* (30 April 1893); cited in Armstrong, 'A Jumble of Foreignness', p. 202.
69 'British Awards at the World's Fair, Chicago', *Dublin Evening Telegraph* (31 October 1893).
70 'The Donegal Village at the World's Fair', *Dover Express* (7 April 1893).
71 *Dundee Evening Telegraph* (28 May 1887).
72 Aberdeen, 'Reminiscences of Lord and Lady Aberdeen', p. 327.
73 Flinn, 'Official Guide to the Midway Plaisance', p. 45.
74 Ibid., p. 48.

75 S. Rohs, *Eccentric Nation: Irish Performance in Nineteenth Century New York City* (Cranbury, NJ, 2009), pp. 133–4, p. 188.
76 Flinn, 'Official Guide to the Midway Plaisance', p. 47.
77 Bestowing loquaciousness and an 'Irish wit' was the perceived magic of the stone. See M. W. Samuel and K. Hamlyn, *Blarney Castle: Its History, Development, and Purpose* (Cork, 2007).
78 Hart, 'The Cottage Industries of Ireland', p. 11.
79 'The Irish Industrial Villages at the Chicago Exhibition. A Chat with Mrs Hart', *Derry Journal* (6 July 1892).
80 Aberdeen, 'Reminiscences of Lord and Lady Aberdeen', p. 325; A. Mackay, 'Selection of the Fittest: Or, How Irish Colleens Were Chosen to Represent Ireland at the World's Fair. A Tour on Behalf of the Irish Village', 'Guide to the Irish Industrial Village and Blarney Castle', p. 31.
81 Ibid., p. 328.
82 Flinn, 'Official Guide to the Midway Plaisance', p. 45.
83 Ibid., pp. 45–6.
84 For recent literature on the importance of women to the exhibition project, see Lisa K. Langlois, 'Japan – Modern, Ancient, and Gendered at the 1893 Chicago World's Fair', in T. J. Boisseau and Abigail M. Markwyn (eds), *Gendering the Fair: Histories of Women and Gender at World's Fairs* (Chicago, IL, 2010), pp. 56–74; J. M. Weimann, *The Fair Women* (Chicago, IL, 1981).
85 Aberdeen, 'Reminiscences of Lord and Lady Aberdeen', p. 326.
86 Tynan, 'The Cottage Industries of Donegal', 'Guide to the Irish Industrial Village and Blarney Castle', p. 56.
87 Aberdeen, 'Reminiscences of Lord and Lady Aberdeen', p. 326.
88 Mackay, 'Guide to the Irish Industrial Village and Blarney Castle', pp. 40–1. See Helland, *British and Irish Home Arts and Industries*, pp. 56–7.
89 F. Cullen, *Ireland on Show: Art, Union, and Nationhood* (London, 2012).
90 'Lady Aberdeen's Irish Village. Attempt to haul down the British Flag', *Ulster Gazette* (28 October 1893).
91 M. F. Jacobson, *Special Sorrows: The Diasporic Imagination of Irish, Polish and Jewish Immigrants in the United States* (Cambridge, 1995), pp. 30–2.
92 For statistics on Irish migration, see C. Ó Gráda, 'A Note on Nineteenth Century Emigration Statistics', *A Journal of Demography*, 29 (1975), 143–9.
93 J. K. Olick and J. Robbins, 'Social Memory Studies: From "Collective Memory" to the Historical Sociology of Mnemonic Practices', *Annual Review of Sociology*, 24 (1998), 105–40, 111.
94 P. Fritzsche, 'Spectres of History: On Nostalgia, Exile, and Modernity', *The American Historical Review*, 106:5 (2001), 1587–618, 1591.
95 Ibid., 1589.
96 See K. Kenny, 'Twenty Years of Irish American Historiography', *Journal of American Ethnic History*, 28:4 (2009), 67–75; F. S. Lyons, *Ireland since the Famine* (London, 1971).
97 Jacobson, *Special Sorrows*, p. 2. See also Kevin Kenny (ed.), *New Directions in Irish-American Historiography* (Madison, WI, 2003); P. Griffin, *The People*

 with No Name: Ireland's Ulster Scots, American's Scots Irish, and the Creation of a British Atlantic World, 1689–1764 (Princeton, NJ, 2001).

98 For scholarship on Irish migration to Britain, see Enda Delaney, 'Diaspora', in Richard Bourke and Ian McBride (eds), *The Princeton History of Modern Ireland* (Princeton, NJ, 2016), pp. 490–508; E. Delaney, *The Irish in Post-War Britain* (Oxford, 2007); Graham Davis, 'The Irish in Britain, 1815–1939', in Andy Bielenberg (ed.), *The Irish Diaspora* (Harlow, 2000), pp. 19–36; E. Delaney, *Demography, State and Society: Irish Migration to Britain, 1921–1971* (Liverpool, 2000); R. Swift, *The Irish in Britain: 1815–1914: A Documentary History* (Cork, 1990); Alan O'Day, 'The Political Organization of the Irish in Britain, 1867–90', in Roger Swift and Sheridan Gilley (eds), *The Irish in Britain 1815–1939* (London, 1989), pp. 183–211; David Fitzpatrick, '"A Peculiar Tramping People": The Irish in Britain, 1801–70', in William E. Vaughan (ed.), *A New History of Ireland. Vol V. Ireland under the Union, I, 1801–1870* (Oxford, 1989), pp. 623–60.

99 See J. Bodnar, *Transplanted: A History of Immigrants in Urban America* (Bloomington, IN, 1985); O. MacDonagh, 'The Irish Famine Emigration to the United States', *Perspectives in American History*, 10 (1976), 430–46; C. Wittke, *The Irish in America* (Baton Rouge, LA, 1956); O. Handlin, *Uprooted: The Epic Story of the Great Migrations That Made the American People* (Philadelphia, PA, 1952).

100 David N. Doyle, 'The Remaking of Irish-America, 1845–1880', in Lee and Casey (eds), *Making the Irish American*, pp. 213–52, p. 243; Vaughan (ed.), *A New History of Ireland. Vol. VI*, pp. 725–63, p. 762.

101 S. Boym, *The Future of Nostalgia* (London, 2001), p. xiii.

102 Ibid., p. xvi.

103 M. Ryle, *Journeys in Ireland: Literary Travellers, Rural Landscapes, Cultural Relations* (London, 1999), p. 3.

104 See D. Cairns and S. Richards, *Writing Ireland: Colonialism, Nationalism and Culture* (Manchester, 1988). Also, Joep T. Leerssen, 'The Western Mirage: On the Celtic Chronotope in the European Imagination', in Timothy Collins (ed.), *Decoding the Landscape: Contributions towards a Synthesis of Thought in Irish Studies on the Landscape* (Galway, 2003), pp. 1–11; T. Eagleton, 'The Ideology of Irish Studies', *Bullan*, 3 (1997), 5–14.

105 See Kerby A. Miller, 'Class, Culture, and Immigrant Group Identity in the US: The Case of Irish-American Ethnicity', in Virginia Yans-McLaughlin (ed.), *Immigration Reconsidered: History, Sociology, and Politics* (New York, 1990), pp. 96–129; M. E. Daly, *Social and Economic History of Ireland since 1800* (Dublin, 1981); R. Kee, *The Green Flag: A History of Irish Nationalism* (London, 1972); T. A. Jackson, *Ireland Her Own* (Dublin, 1970); J. C. Beckett, *The Making of Modern Ireland* (London, 1966).

106 K. A. Miller, *Emigrants and Exiles: Ireland and the Irish Exodus to North America* (Oxford, 1985), pp. 441–6.

107 See L. J. McCaffrey, E. Skerrett, M. F. Funchion, and C. Fanning, *The Irish in Chicago (Ethnic History of Chicago)* (Champaign, IL, 1987); M. F. Funchion, *Chicago's Irish Nationalists, 1881–1890* (Chicago, IL, 1976).

108 B. Jenkins, *The Fenian Problem: Insurgency and Terrorism in a Liberal State, 1858–1874* (Liverpool, 2008), p. x. See Zuck, *Divided Sovereignties*, pp. 139–74.
109 Cited in Brian Ó Cuív, 'Irish Language and Literature, 1845–1921', in Vaughan (ed.), *A New History of Ireland. Vol. VI*, pp. 385–435, pp. 402–3. See K. Moss, 'St Patrick's Day Celebrations and the Formation of Irish-American Identity, 1845–1875', *Journal of Social History*, 29:1 (1995), 125–48.
110 P. Bixby and G. Castle (eds), *Irish Modernism: From Emergence to Emergency: A History of Irish Modernism* (Cambridge, 2019), pp. 1–24, p. 6.
111 Crooke, *Museum of Ireland*, p. 24.
112 Jacobson, *Special Sorrows*, p. 54. See E. Delaney, 'The Irish Diaspora', *Irish Economic and Social History*, 33 (2006), 35–45; K. Kenny, *The American Irish: A History* (London, 2000); D. Fitzpatrick, *Oceans of Consolation: Personal Accounts of Irish Migration to Australia* (Ithaca, NY, 1994).
113 *Leeds Mercury* (26 March 1892); 'A Chat with Mrs Hart', *Derry Journal*.
114 Foster, *Modern Ireland*, p. 372.
115 Flinn, 'Official Guide to the Midway Plaisance', p. 16.
116 David Harkness, 'Ireland', in Robin W. Winks (ed.), *The Oxford History of the British Empire. Vol V. Historiography* (Oxford, 1999), pp. 114–33, pp. 115–16.
117 S. Conn, *Museums and American Intellectual Life, 1876–1926* (Chicago, IL, 1998), pp. 3–13.
118 'Guide to the Irish Industrial Village and Blarney Castle', p. 15.
119 D. Kiberd, *Inventing Ireland: The Literature of the Modern Nation* (Cambridge, 1996), p. 3.
120 J. Strachan and C. Nally, *Advertising, Literature and Print Culture in Ireland, 1891–1922* (London, 2012), p. 1.
121 Ibid., pp. 37–8.
122 Ibid., p. 39.
123 Helland, *British and Irish Home Arts and Industries*, p. 65.
124 Ibid., p. 104. See British Library, London, 83/30328, manuscript by J. Drummond, 'Onward and Upward: Extracts (1891–96) from the Magazine of the Onward and Upward Association Founded by Lady Aberdeen for the Material, Mental and Moral Elevation of Women', 1983.
125 'Lady Aberdeen on Irish Domestic Industries', *Aberdeen Press and Journal* (13 November 1893).
126 See Larmour, *Arts and Crafts Movement in Ireland*, p. 24.
127 Aberdeen, 'Reminiscences of Lord and Lady Aberdeen', p. 333.
128 Hart, 'Donegal Cottage Industries'.
129 *Dundee Evening Telegraph* (28 May 1887); 'The Donegal Industrial Fund', *Donegal Independent* (28 May 1887).
130 Helland, *British and Irish Home Arts and Industries*, p. 10.
131 Cooper, 'Irish Migrant Identities and Community Life in Melbourne and Chicago', p. 193.

3

Home Rule and capitalism: Irish modernities

In 1908 a contemporary named François G. Dumas, having spent an entire day taking in the delights of an Irish Village 'complete from the Emerald isle and dropped within the walls of the Exhibition', reflected on his visit to the Irish farmyard, Irish cottages, the Irish round tower, and many more wondrous sights.[1] Having eaten some Irish soda bread, he wistfully remarked that in Ballymaclinton 'you are with quiet and peace'; 'Here you are free of the hurdy-gurdy air … of the Outside City.'[2] He was admiring of the entire Village enterprise and the break it offered from busy city life in the 1900s. Taking advantage of the entertainments in the Exhibition, Dumas, like the two million other visitors to the display, revelled in the peace, tranquillity, and contentment of the utopian rustic Irish Village, exhibited in both Britain and Ireland.

The prefix 'Bally' simply means 'town of' and is not named after any real Irish village. However, it began to take on this persona. In the early twentieth century, exhibitions of the Irish took on a renewed significance; as grand spectacles of a country's power, prowess, and prestige, they heralded new modernities. Images of Ireland continued to envision the country according to the beliefs of the organisers, and two brothers, David and Robert Brown, built Ballymaclinton. Their birth and death dates are unknown. The brothers owned a soap factory in Donaghmore, County Tyrone, and their specialist luxury soaps contained plant ash and vegetable oils rather than the harsher animal fats used by other soap producers.[3]

The Browns were committed to the expansion of their soap company and saw a continued union with Britain as vital to their success. This chapter shows that membership of the Union relied on affirming whiteness through demonstrating compatibility and suitability with the English market (by espousing a popular Protestant unionist position) in a genuine contribution to scholarship in whiteness studies. The two brothers erected a model village of Ireland in various exhibitions to advertise their soap on a commercial basis, while also confirming their whiteness. Their village sought to consolidate a facsimile of a quaint Irish community for the purpose of soap sales.

The chapter first maps out the socio-political context of the early twentieth century before exploring in detail the Village in the 1908 Franco-British Exhibition in London.

The Irish Village first appeared at the 1907 Irish Industrial Exhibition in Dublin, and it toured several British Empire exhibitions. Interestingly, the brothers were also committed to the anti-consumption campaign in Britain and educated the populace on tuberculosis preventative behaviours as part of their programme of events. Continuing the trend of earlier displays, the brothers advertised native Irish labour practices to support declining rural industries in Ireland. Their tripartite motivations to sell soap by proving whiteness, to combat tuberculosis, and to help revive rural industries sustained the popular display over successive exhibitions. The overarching aim was to ensure healthy Irish bodies ready for industry and international trade. The most important component of their Village was its inhabitants; it was populated with over 200 'colleens' and 100 'bhoys'. Barbara O'Connor explains that 'colleen' is a direct translation from the Irish language term for young girl – *cailín* – and the suffix 'in' 'denotes the diminutive and connotes both affection and junior status, not just in age terms' but also in 'social standing'.[4] 'Bhoys' is a Celtic term for young men. The 'colleens' and 'bhoys' lived in Ballymaclinton for six months at a time, as the Village transformed into '[the] real ould country'.[5]

The Browns are unique in exhibition history as this was the first time that an exclusively Irish-based business individually organised a display of Ireland for their corporation's profit. The family-owned soap company sought to increase its revenue by appealing to a foreign market and establishing soap as an international commodity that relied on familiar Irish stereotypes. Their Irish 'brand' was utilised to convince international visitors of the Irish men and women's whiteness, seen as necessary for commercial profit. The display, organised by a privately owned, Irish-based company, held women as central to their commercial project, revealing a continuation of practices adopted by Lady Aberdeen and Alice Hart in the nineteenth century. The brothers tapped into the trend of performing Irishness through an attractive people to encourage interest and consumption. We can read the Village in different ways, but the Browns were interested in advertisement and sales; through Ballymaclinton we can see how Irishness became a lucrative, saleable commodity, in its advertising of soap and its promotion of whiteness, by championing Protestant unionism.

So far we have seen how in the 1850s Irish organisers of the fairs sought Irish commercial development by visualising how important the British Empire was to Ireland's economy through English investment or access to the imperial marketplace. Yet the Scottish and English philanthropists from the 1890s utilised nostalgic visions of an Irish past in Chicago to revive

rural industries to combat large-scale poverty. And this chapter discusses how the Browns used the exhibition form to advertise their pro-Union and anti-Home Rule stance to further their business. It is thereby evident that exhibitions through their sheer diversity and complexity enabled multiple, contradictory, and fictive visions of Ireland to be reinvented and reimagined throughout the nineteenth century and into the twentieth, whether in England, Ireland, or the United States.

Curiously, the Browns' picturesque rural idyll existed during turbulent British–Irish relations. The Home Rule debate threatened the foundation of Britain's historic relationship with Ireland. The call for self-government had its roots in the 1870s and continued to divide opinion in the early twentieth century. Forceful iterations of Irish nationalism rocked the status quo and challenged the two countries. The Brown brothers were ardently against Home Rule and were committed unionists (and Presbyterians). Their display thus spoke to a desire to maintain the Union and demonstrate a rural, peaceful, quaint Irish populace who wanted to maintain British alliances. Within this, the fractious nature of intra-Protestant identities played out, since as Presbyterians, the Browns and many of their workers might have perceived themselves as alienated from the Anglican (Protestant) establishment as Roman Catholics. Yet Irish imperial and domestic harmony was visualised and affirmed in the Village by performing whiteness. A whiteness that rejected derogatory British imperial discourse of Irish men and women, but a whiteness that maintained English colonial rule over Ireland. The Union in this configuration was a voluntary political identification with willing Irish subjects who were deserving of a partnership with it. The relationship with England was not a forced, violent imposition but a likeminded partnership with Irish people who were similar, industrious, and capitalist. Irish whiteness became synonymous with unionism in the Brown brothers' display and emerged through the villagers who sold soap. The Exhibition showcased how Irishness was compatible with Britishness, and by extension the Union, and how trading with Ireland created profit with Irish men and women who were familiar and white like the British.

Again, women's vital role in the Exhibition project is highlighted. In the 1850s, female industry appeared as a corrective to the depressed Irish state in the post-Famine period. In the 1890s, female rural labour emerged as a saviour to the Irish economy and to Irish culture by continuing native industries. Moreover, in 1893 women proved their usefulness by performing their labour in the Midway Plaisance. In a similar fashion the 1908 Village curated an Irish utopia inhabited by peaceful, diverse, and happy Irish women to create an appealing Ireland on display that could convince, cajole, and authenticate Irishness for visitors. Specifically, in Ballymaclinton the role of the inhabitants was to further the sale of soap, yet the broader

ambition of the Exhibition project as affirming one's own political priorities remained constant throughout this period.

Many Protestants opposed Home Rule.[6] The issue of Home Rule for Ireland began with Prime Minister Gladstone's (1809–98) attempts to pass devolution legislation in the late nineteenth century. After Gladstone's conversion to Home Rule in 1886, Roger Swift notes that most Irish Catholics supported the Liberal Party, while Irish Protestants supported the Conservative and Unionist Party; however, many of the Irish Catholic working class voted for the emerging Labour Party in twentieth-century Britain.[7] There were three Home Rule Bills which were modified and defeated when in 1910 Sir Edward Carson (1854–1935) became leader of the Unionist Party in Ireland.[8] A widespread unionist propaganda campaign ensued that reached its peak in 1912 with the founding of the Solemn League and Covenant on 28 September. Almost 500,000 unionists, including the Brown brothers, signed this document and vowed that they would use 'any means which may be found necessary', including armed rebellion, to protect the Union.[9] David Fitzpatrick reminds us that a quarter of northern Protestants refused to sign it, namely ministers and the clergy.[10]

Irish Unionists in the 36th (Ulster) Division fought at the opening day of the Somme on 1 July 1916 during the First World War. The battle was immortalised within unionist narratives as a benevolent sacrifice made by Ulstermen for the British Empire to keep Ulster joined with Britain.[11] Subsequently, the demands for Home Rule escalated, leading to the Irish War of Independence (January 1919–July 1921) between the Irish Republican Army and British security forces in Ireland which killed thousands. Militia tactics, brutal assassinations, and siege-like warfare gripped the country for almost two years. The conflict ended with the Anglo-Irish Treaty that provided for the establishment of the Irish Free State within a year as a self-governing dominion. It also allowed Northern Ireland (six counties), created by the Government of Ireland Act 1920, to opt out of the Irish Free State, which it did.[12]

The post-Treaty conflict led to the Irish Civil War (June 1922–May 1923), yet despite such turbulent politics, the Browns presented Ireland in the fairground as an apolitical, non-partisan space – to great success. The Brown brothers created a convincing image of Irish people as happy within the Union and labouring for the benefit of Ireland, and concurrently Britain. Home Rule emerged as a non-issue within Ballymaclinton despite it dominating Irish-British politics in the early twentieth century. Their project rested on performing an Irish whiteness through the labour of the Village's inhabitants. The Browns deployed convincing images of contentment, industry, and progress within the Irish Village to bolster the Union and assure British visitors that all was well within the unionist portion of Ireland.

Historians have written extensively about the Irish in twentieth-century Britain.[13] According to some scholars, the Irish in Britain assimilated rapidly. For instance, Fitzpatrick argues that the Irish failed to develop an 'autonomous community' and quickly merged with British life and politics.[14] Moreover, Alan O'Day has written extensively on the 'mutative ethnicity' of the Irish, which allowed them to integrate into British society.[15] However, the literature on assimilation that assumes a neutral incorporation of the Irish into British society has been significantly criticised. Historians such as Mary Hickman have led the challenge against the 'narrative of homogeneity', which subsumed all difference within the functioning of the British state.[16] Hickman refers to Stuart Hall's contention that nation-states tended to falsify national unity despite tensions to perform a peaceful national community.[17] Recent historiography has attempted to bridge the polarised camps; Mo Moulton points out that the Irish Catholic minority in interwar England was a distinctive subculture within a larger story of amalgamation.[18]

Although Irish historians disagree over the processes and outcomes of Irish migration, the assimilation/segregation debate is important for Ballymaclinton as it reveals how exhibitions became a platform through which to affirm a white affinity with the English. For the Browns, this whiteness was crucial as the Union was key to their plans to establish an international market for their goods. The Browns' project of whiteness was expansive and included the whole Irish populace. Catholic and Protestant women who lived in the Irish Village bodily performed Irish whiteness. This twentieth-century commercial project interacted with structural changes in the country; Enda Delaney records that in Britain the arrival of 'more visible migrants' had the function of allowing the Irish 'to move up the [ranking] of newcomers in British society'.[19] The Village was therefore one of many processes that consolidated the whiteness of Britain's Irish population.

This research complicates reductive understandings of race, which regard hierarchies of skin colour as the prime locator of difference in access to power and privilege.[20] I show that complexion works within the framework of empire, class, and gender to construct 'whiteness' as desirable, progressive, and Irish. Thus, I take whiteness as a socially constructed and politically contested category with an ideological connection to those who we might recognise as 'white'.[21] For the Browns, proving whiteness became necessary to access socio-economic privileges, which English contemporaries refused to the Irish based on a racialised discourse of civilisation.

To offer an overview, this chapter considers the 1908 Franco-British Exhibition to ask questions about the broader significance of Irish display. It first maps out how the brothers created the commercial Village and for what purpose and assesses its relationship to the Irish question in the early

twentieth century. It then considers the gendered roles exercised within this project – honing in on the lives of the exhibited women and men. Ultimately, this is a story of how commercialised images of Ireland centred on white femininity navigated a contradictory Irish existence. Using postcards and photographs, we can see how particular symbols of Ireland had popular monetary and aesthetic value, particularly in relation to touristic portrayals of the country. There was a continuation in motifs of Irishness related to rural industries of the nineteenth century and the production of sewing, spinning, and weaving in the figure of the Irish woman; however, by the twentieth century a distinct commercial motive took precedent, and the figure of the white woman as related to soap instead of textiles became profitable.

The Irish exhibition's unique function as state propaganda took on a renewed significance during the turbulent political climate of the Home Rule debate and the explosive Irish nationalism of the 1900s. This became intimately connected to the commercial project of profit and trade, which relied on a quasi-authentic Ireland, imbibed within whiteness. Ballymaclinton Village expounded a Protestant unionist project against any kind of separation from England or devolved Home Rule. Recognising the success of this project highlights the broader role of the nostalgic power of white Irishness for selling the country and its politics.

Ballymaclinton Village

The Brown brothers first exhibited at the Irish Industrial Exhibition in 1907 from May to October. They contributed a small display of model whitewashed cottages complete with white 'colleens' selling Colleen soap, Sheila soap, and Hibernia shaving cream in the Home Industries section.[22] Almost half a million people visited the Browns' cottages in 1907, and they sold more than 30,000 bars of McClinton's soap.[23] Robert Brown included a photograph of the cottage in the Fair's official souvenir guide, notes John Philip O'Connor, that gave pre-paid McClinton's soap samples to any address within the United Kingdom. Consequently, they received a substantial number of orders, convincing the Browns of their soap's profitability in the national market, which enabled a larger display the following year.[24]

The Franco-British Exhibition opened in Shepherd's Bush, London, between 14 May and 31 October 1908 to celebrate the entente cordiale between Britain and France, which settled existing colonial disputes in North Africa. It became affectionately known as the 'White City' with its palatial white buildings and lake – offering continuity from the 'White City' of the

1893 Columbian Exposition in Chicago. Here, in a 'cosy corner ... in the big show', stood the Irish Village, designed to sell soap by profiting from an Irish whiteness.[25] Ballymaclinton's ten and a half acres was complete with thatched cottages, a round tower of old Kilcullen, a cross of Donaghmore, various Irish monuments such as the Ogham Stone, a Galway's Fisherman's Cottage, a village shop, a post and telegraph office, a forge, laundry, Blarney Stone, a restaurant, a sanatorium, a village hall, an industrial hall, and houses composed of 'genuine colleens at work at lace, embroidery, carpets' (Figure 3.1).[26] The image reveals a farmyard containing the traditional pig of Paddy, a herd of Kerry cows, and fowls. 'Colleens' with donkeys carrying baskets of unidentifiable goods circulate in the scene. The women are typically facing away from the camera and so unveil a working snapshot of village life. Villagers are standing with their hands on their hips, either solitarily or with friends, in a backdrop of the Exhibition space, complete with cottages and a boat. A well-dressed man observes the 'colleens', and a crowd congregates on one side of the Village, which creates a dual image of distance yet proximity in the presentation of the exhibit.

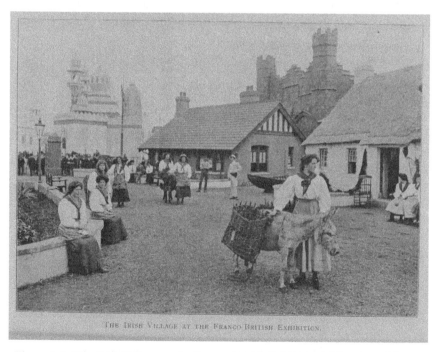

Figure 3.1 'The Irish Village at the Franco-British Exhibition' (*Good Health: An Illustrated Monthly Magazine devoted to Hygiene and the Principles of Healthful Living*, 6:8 (1908), p. 228 – courtesy of the Wellcome Collection)

The *Official Guide* declared that the Village of Ballymaclinton had a popular appeal and 'cannot fail both to interest and amuse'; 'Whatever [connection] one has in the Emerald Isle – by birth, friends, or visits.'[27] Many contemporaries enjoyed the immersive sensory effect of the Village, complimenting the 'fresh young voices' who sang the Irish songs, the ponies, and jaunting cars idling through the Village, and the 'veritable chatter of the women busy with their various handicrafts'.[28] This was more than an experiential affair with 'dancing on the village green, hornpipes, jigs, reels … fiddles, melodeons, and bagpipes'.[29] Clearly, the Village stimulated 'actual contact with Irish life, its poetry and romance, its abounding joy and its deep pathos' in the Browns' effort to market their soaps.[30]

Through the archival material, we can map the lives of those who inhabited and worked within the multinational commercial venture of the Village. The Brown brothers widely published advertisements for 'colleens' to work in the Village in the *Waterford Standard*, the *Irish Independent*, and the *Tyrone Courier*. The *Tyrone Courier*, specifically, became invested in covering the Village as the soap factory was in the same county, and so it acted as good publicity for the area. The brothers assured prospective female employees that they 'make no charge for space; we pay all expenses and take all risk'.[31] The working schedule was 'a healthy life … eight hours sleep, eight hours work, and eight hours play'. They also reassured the women that a 'real home life' waited for them in Ballymaclinton during their six-month emigration from Ireland. The 'colleens' stayed in four-roomed cottages that each contained a kitchen, a sitting room, and two bedrooms.

Moreover, clergy of all denominations, doctors, and nurses worked in the Village. Importantly, the Browns provided all travel expenses as well as board, lodgings, and clothes to the selected applicants (a subsidised two shillings in rent was required for the cottages). Overall, the Browns presented village life as a wonderful opportunity to live and work in London for a time. They did not hire actors; instead, middle-class women as well as women who worked in rural industries in Ireland were employed. Assuredly, 'Girls of good social position [we]re desired and those with distinctively Irish accents w[ere] preferred.' The entire Village enterprise hinged on convincing visitors that they were experiencing Ireland; the material buildings and the corporeal body and costume of the female inhabitants marked authenticity.

In the Franco-British Exhibition, the entrance to Ballymaclinton was through a castellated gateway with a sixteenth-century portcullis (Figure 3.2). The gateway contains Christian crosses carved into the stone and a famed Irish round tower is visible in the background. The postcard is revealing in several ways; there are men working in the Village farm on the left of the scene and women working in the cottages to the far right of the image. All this industry catered to the guests captured in the foreground,

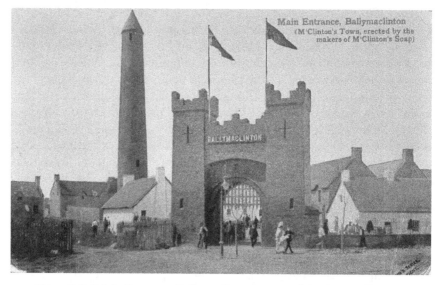

Figure 3.2 'Main Entrance, Ballymaclinton' postcard (author's collection)

who were generally admiring the exhibits. There are visitors walking in both directions, suggesting a constant flow of British and international attendees keen to witness an Ireland on display. The postcard's recipients would be able to observe an appealing snapshot of village life including picturesque cottages and village workers.

Round towers were a popular nationalist symbol in this period, explains Elizabeth Crooke, as they came to signify the 'greatness of the Irish nation'.[32] Their value came from the fact that they exclusively resided in Ireland and so had currency as being characteristically Irish. They were easily identifiable and for Irish nationalists became enveloped in a unique and ancient shared Irish heritage. Similar to the function of the Book of Kells motif for Alice Hart, round towers offered proof of an Irish culture untouched by Englishness. Specifically, George Petrie has demonstrated that they were of Christian and ecclesiastical origin, they were built between the fifth and thirteenth centuries, they served as belfries and places of security, and they may have been used as watchtowers.[33] However, their importance came less in their defence features and more in their creation of an authentic, revered, and collective Irish identity rooted in antiquity.

The 'colleens' cottages were in the style of a 'typical peasant's home of the olden times'.[34] The accommodation was also a replica of the cottages built by the Brown brothers in their home county of Donaghmore in the 1900s for their soap factory workers. The homes therefore existed within a dual realism – both of a past history and present industry; visitors could

observe the 'colleens' as they would be in the Browns' factory, making and packaging soap. The commitment to an authentic Irishness preoccupied all the buildings displayed in the Irish Village. For instance, the Donegal fisherman's cottage '[wa]s built with boulders taken from the beach of Donegal' and the 'windows and doors [we]re taken from the local cottage which served as a model for th[e] structure'.[35]

The landscape of the Village cultivated an idealised vision of rural Ireland. Once visitors entered the grounds of the Village, they saw the 'inevitable pig' and all the smells and sounds of a farmyard. From here, visitors could wander over to the factory to see men and women making McClinton's soap and, crucially, buy soap. Further on, visitors could admire 'the weaving of damask linens, for which the North of Ireland [was] famed', and a number of girls were 'engaged in the making of Irish lace and embroidery'.[36] The voyeuristic display of women in the 1893 Chicago Fair was again deployed to complement the surroundings, and passing along the 'Main Street', visitors could enjoy the traditional round tower and an old ruined abbey, built in the 'Hiberno-Romanesque' style. The women formed part of the landscape and vice versa.

The delights of the Village continued with the Blarney Stone, popular with American visitors, in a continuance of prized Irish attractions from the nineteenth century. Ireland's historic architecture emerged in a replica ancient Irish holy well, a Donaghmore cross, and a facsimile of a high cross – all evoking symbols of an ancient Christianity. High crosses, almost twenty-feet high, were characterised by a ring encircling the intersection of the shafts and arms. As historiography on Irish tourism has argued, the tropes of a traditional Irishness had become a profitable method to stimulate travel and interest in Ireland by the early twentieth century through its emphasis on the nation's Gaelic heritage and the Gaelic language.[37] Spurgeon Thompson, among others, has pinpointed trends in clichés of Irish life which gained currency in tourism discourse and the sale of Irish history, hospitality, and entertainment.[38] The Browns effectively capitalised on popular Irish images to encourage the consumption of their soap and investment in their country. The richness and variety of material on display actualised a quaint Irish experience containing hints of an Irish modernity via the sophisticated soap factory within a stereotypical past Irishness through the 'colleens'' dress and their cottages.

Ireland's proposed steady march towards white Western European progress emerged through Ballymaclinton's tuberculosis exhibit. It contrasted a clean and an unclean room. Given that cleanliness was synonymous with racialised narratives of civilisation in this period (to be discussed in detail later), the exhibit showed the country performatively ridding itself of disease to prove its whiteness. Ireland was moving from disease to cure in the

same way it was progressing from dirt and backwardness to progress and effective white society. The *Mid-Ulster Mail* explained that the first contrast bedroom contained thick dirty carpets and thick dusty curtains, 'with dusty nick-nacks and stuffed blinds and dingy wallpaper'.[39] The second room had a floor of polished wood, and 'all the dust-gathered objects w[ere] banished' (Figure 3.3). The contrast is stark, and the left half of the image shows an appealing and clean environment, compared with the dank, depressing room on the opposite side. Lighting exacerbates the difference in both sides of the photograph, with the dirty section almost black in its representation. A clear argument of the medical and civilisational harm caused by uncleanliness and the straightforward way out through cleanliness is visualised.

Copies of literature on avoiding tuberculosis circulated throughout the exhibit, and Kilkenny Woodworkers supplied the furniture available to purchase for £5 5s.[40] The 'well-organised and aggressive campaign' against tuberculosis in Ballymaclinton also included lectures in the village hall on ventilation practices, cleanliness, and food and milk supply.[41]

The *Irish Independent* described Ballymaclinton as an example of 'Ireland's villages as they ought to be – not what, unfortunately, in many cases they are, crumbling to decay and depopulated by emigration'.[42] The

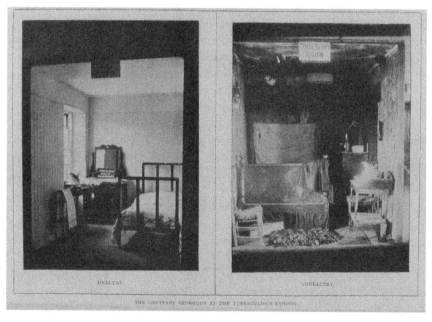

Figure 3.3 Tuberculosis exhibit at the Franco-British Exhibition with 'healthy' and 'unhealthy' rooms (in *Good Health*, 1908, p. 238 – courtesy of the Wellcome Collection)

lively nature of Irish rural life was epitomised in the 'typical Ulster farm, rich in live-stock, and with the characteristic big stock of peat'. Visitors experienced 'the smiles and greeting of Irish [men and 'colleens'] who [were] engaged in many occupations, including the tending of cows [and] poultry'. The Irish 'bhoys' worked in the village forge 'making Lucky Horseshoes', available for six pence apiece.[43] The typology of the Village relied on the commercialisation of tradition, with the restaurant nearby selling soda bread 'baked by Irish girls on Irish griddles, heated by Irish peat'.[44]

A bustling rural Irish Village was home to the 'colleens' and 'bhoys' for six months at a time. Organisers undertook great efforts to make sure that 'everything and everybody in the village' was Irish.[45] The Browns donated the profits from the Village to the anti-consumption campaign, and so the Village changed from being a source of entertainment to a joint act of philanthropy. The spectacle of the fairground did not end with the turnstiles, for even 'when off duty on Sunday', the 'colleens' wore their 'red or blue cloaks, bearing a shamrock badge', and so their 'comely looks' transcended the landscape of the Franco-British Exhibition, and re-emerged within the city of London.[46] The Brown brothers' triptych of motivations – to encourage the purchase of their soap, to combat tuberculosis, and to support rural industries – together conjured an attractive Irish Village for visitors.

There was a post office in the Irish Village, and Valentine and Sons Ltd of Dundee, London, and New York printed the official postcards.[47] There were 3,800,000 picture postcards delivered as well as an average of 200 telegrams sent each day from the Ballymaclinton post office. Robert Brown keenly promoted the village post office as a way to enjoy 'real Ireland': one 'can see what [Ballymaclinton] looks like by sending [one shilling] for fourteen picture postcards, reproduced from actual photographs'.[48] The author's statement stressing an authentic insight of Ireland from postcards reinforces Declan Kiberd's concept of an 'Irish consciousness' discussed in the previous chapter; there were sustained efforts by contemporaries to sell Ireland within distinctive, affable imagery of the country.[49]

The postcard titled 'Post Office, Ballymaclinton' (Figure 3.4) depicts the post office in the style of a whitewashed, thatched cottage. Despite its exterior rurality, its interior reveals a modern communications structure personified by the Village's white 'colleens' busy reading letters, delivering letters, or otherwise chatting in groups.[50] This bustling image of rural life and the modern network of sending letters is juxtaposed to the donkey and cart in the centre of the scene. Some 'colleens' sit on the donkey, others on the cart – revealing that this ancient transportation system still operated in the Village. The bright red and green of the 'colleens'' costumes, alongside the ostensible Englishman tending to a horse, paints a picturesque atmosphere. The male presence reveals the omnipresence of the visitors,

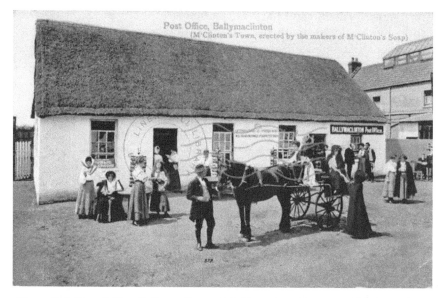

Figure 3.4 'Post Office, Ballymaclinton (M'Clinton's town, erected by the makers of M'Clinton's Soap') postcard (author's collection)

who were the much vied for recipients of this Village extravaganza because of their commercial value.

Moreover, the *Hall and Theatre Review* reported that workers daily loaded the profits made by Ballymaclinton on to a 'sack and sl[u]ng [it] across the back of a donkey, in the same way as Irish peasant women t[ook] their produce to market'.[51] We can see how the Brown brothers married tradition and rurality with the urban and modernity to capitalise on profit from soap. Images like the one described above were popular, and there remains an international circulation of the Village's paraphernalia, with postcards still widely available on eBay today.

There are some interesting letters written by the 'colleens' and their friends and family. Familiar themes crop up in the exchanges: that of the longing felt by a partner left behind in Ireland, joy and excitement at being in London, and praise of the entire exhibition enterprise. For instance, a 'colleen' named Molly O'Reilly wrote home that 'Mr Brown is a true Irishman' in a letter later published in a newspaper.[52] She goes on to say that the Village was home to 'a lot of boys and girls of which any nation might be proud, gathered from every part of Ireland'. Here we see the importance of an authentic Irishness as marking the true value of the Village.

Another recurring theme was how much fun the 'colleens' were having and how popular they were among visitors. For example, Rhea I. Carson

wrote home that 'we entertain the general public by singing and reciting, and those who are nimble with their feet dance ... the Irish Jig' (Figure 3.5). In the postcard the 'colleens' are engaged in synchronised dancing in pairs and groups. Their homes have perfectly manicured lawns within a gated environment. There are spectators on the outside of the Irish Village admiring the Australian Pavilion opposite. Some of the 'colleens' stand to the side, as if waiting for their turn to dance. A congenial atmosphere of frivolity emerges in the image. We can see how the Brown brothers meticulously planned and paid for the 'colleens'' existence, and the scene's ostensible cleanliness engenders a striking contrast to stereotypes of Irish dirtiness. Women played games on a daily basis; one involved catching fish, and '[Visitors] w[o]n a prize if they ca[ught] three fish in succession'. The 'colleens' and the 'bhoys' enjoyment did not end with the Exhibition's close. Sheila M'Davis wrote of how sometimes 'all the colleens and the bhoys [we]re taken out at night by Mr. Brown to see the shows in the exhibition'.

Furthermore, the 'colleens' attended concerts at the village hall and visited the theatre and local London shops during their days off.[53] The entire Village enterprise became an inviting, enjoyable, almost holiday-like experience in popular reporting. However, some of the letters in the small sample analysed above came from newspapers to advertise the Village and boost visitor numbers. We must therefore question the reliability of these sources, as the Brown brothers would have selected only the most positive appraisals

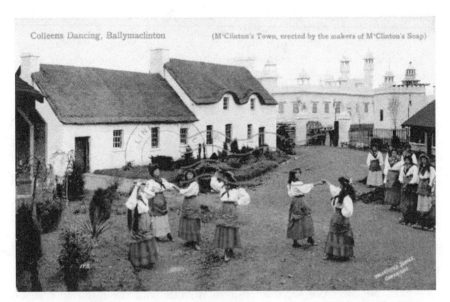

Figure 3.5 'Colleen Dancing at Ballymaclinton' postcard (author's collection)

to circulate in the popular press. Despite this, the letters are still useful in revealing the support of the press in bolstering the Village and the great satisfaction of many of the Village's workers. The Village was a white Irish unionist utopia and affirmed the affinity (read whiteness) of Irish men and women in Britain's imperial matrix.

In a column printed in the *Tyrone Courier*, Mrs Bull wrote a piece on Ballymaclinton that reveals fears of vulnerable female sexuality in the perceived sinful metropolis. She noted that the 'genuine peasant girls' of the Irish Village were 'mostly young and pretty'.[54] Within colonial discourse, Barbara O'Connor argues that Irish women were chaste because of their whiteness, but sufficiently different to be deemed 'exotic', 'softer', and 'warmer', becoming objects of 'romantic longing and desire'.[55] Bull regarded their youth and beauty as a path to moral corruption, echoing the patriarchal concerns of the twentieth-century British imperial state. For instance, she remarked positively that every evening ended with a merry dance but assured readers that 'mere outsiders may only look on, lest all the male youth of London town should flock in to waltz with the light-footed "colleens"'.[56] Bull stressed that there were clear demarcations between Village and visitor spaces, creating a type of protective barrier around the sought after 'colleens'. This piece may have existed to reassure the families and friends of the Village's 'colleens'; however, its attempt to control the sexuality of the women hints at broader prejudices about the urban environment, popular in the twentieth century. Bull insisted that the priority for these 'colleens' was that they return to Ireland 'as rustic and unsophisticated as if they had never left their native hamlets'.[57]

The narrative of contamination through contact was a popular trope of the early twentieth century; Stephanie Rains has shown that there were widespread fears of increasing urbanisation and its potential negative impact on rural life.[58] The perceived degradation of industrialisation imagined a hopeful solution in unspoiled village life. The Village therefore functioned through a working juxtaposition: it celebrated the traditional peasantry both through the Village itself and the inhabitants, yet it boasted an Irish modernity with the soap factory and the niche market for luxury rural Irish goods – all within the urban metropolis. The boundaries between the rural and the modern were preciously protected in the urban environment – occasionally allowed in with the circulation of visitors but jealously guarded for fear of despoilment. The 'colleens' therefore worked within a strict patriarchy delineating acceptable behaviours.

However, the agency of the 'colleens' was still paramount; Bull worried that the 'colleens' sometimes danced '[as if] forgetful of any audience'.[59] It was possible therefore for the 'colleens' to flirt with the imposed restrictions on their existence and employment in the Exhibition. Rest assured,

Bull repeated that the 'girls sleep in dormitories within the guarded precincts of the village'. This excerpt reveals how important the women were to the Village enterprise and also how integral their moral behaviour and virtuous conduct became in insulating rural life inside the urbanity of early-twentieth-century London. The perceived virtue and innocence of the 'colleens' may have been the prime attraction for visitors in contrast to the freer sexuality of women in the English metropolis, and the above extract reveals the instability of these imposed boundaries.

Ballymaclinton also featured in stories of spurned hearts and lost loves. There is an amusing story in the *Tyrone Courier* of a love-struck boyfriend named Barney from County Kerry appealing to his girlfriend Bridget, working as a 'colleen', to avoid the 'Saxons in London' during the 1908 Exhibition.[60] He appealed: 'I [am] breaking my heart' reading how 'the boys over in London are gone mad over the girls at the exhibition and are buying them all sorts of presents'. He had heard rumours of one 'colleen' in particular who received 'a new red cloak to go to mass every Sunday'. He implored her to stay faithful while recognising the new opportunities in her life. For instance, he hoped she did not go 'to Ameriky [sic] when she's done at the Ballysomething [sic] place' to 'make soap' and thereby win a fortune and get married in the United States to a wealthy man. Barney implored Bridget to be happy being a miner's wife and return home to Ireland.

Bridget responded cuttingly and dramatically by declaring a complete disinterest in Barney now she was in 'this big place'. She claimed to have 'forgotten all about County Kerry' and relished in the male attention she received. For instance, she boasted of having sold 'more Soap' than any of the other 'colleens'. Further, she had had the pleasure of the custom of 'Frenchmen, Germans, Italians, Danes, Spaniards, Americans, and one of the Greeks'.

As the story progresses, it becomes clear that this exchange between the two lovers was a marketing ploy by the Brown and Son Soap Company. For the 'colleen', Bridget, remarkably claimed that as soon as she began to wash her face with the 'colleen' soap, 'no more Irish for me, I'm going to be a lady'. She declared to have transformed from using the soap and had become 'all English now' and was disinterested both in Barney and in Ireland itself. The complete transformation to civilised whiteness saw Bridget change her name to Marie Theresa Moriarty. This is an interesting deception and reveals how the Browns envisioned the utility of their soap; it had the potential to change one's physical virtues and, importantly, to complete the project of unionism, as individuals could now become English if they only used the soap, both physically and politically. Embodying whiteness was central to the Browns' project of selling soap by selling Irishness; the displayed Ireland for sale was white and familiar, peaceful, and allied with Britain. The fact that these women would return

home ensured that their transformation could spread among Irish citizens in a fluid interaction of whiteness and unionism.

The fiction of 'colleen' soap echoes the narratives of soap advertisements discussed by Anne McClintock, which claimed one could become white by using popular British soaps. McClintock contends that Victorian soap advertising typically visualised a metaphor for civilisational growth, and the cleansing of the private sphere became synonymous with the ablution of the public sphere, both in the metropolis and the periphery. This regeneration was available to all ethnicities, and soap's perceived ability to create whiteness and 'purity' was a stereotyped promotional image in popular commodity culture.[61] The imagined exchange between the two lovers fulfilled the fantastical properties of the Browns' soap and visualised soap's ability to enact miracles and change one's heritage (political or otherwise) to become fully unionised with Britain. Ballymaclinton's success relied on the 'colleens' convincing visitors of the Village's realism and selling soap to customers. Concurrently, the soap, with its magical virtues, dually attracted visitors to the product and the woman. The drama of Ballymaclinton saw the transformation of the village workers and their complete commodification into women to be wooed and consumed. Everyone and everything was commercialised for the selling of the Brown brothers' soaps.

Some Irish contemporaries objected to Ballymaclinton Village's campaign against tuberculosis. The *Guide and Souvenir of Ballymaclinton* stated that tuberculosis in Ireland killed between 10,000 and 12,000 men and women every year, primarily between the ages of fifteen and thirty-five.[62] An Exhibition official named A. B. Amos wrote the *Guide*, and most newspapers of the time printed these statistics. However, a journalist in the *Irish News and Belfast Morning News* insisted that Amos's numbers were a 'gross exaggeration, and those who circulate[d] it [we]re no friends to Ireland'.[63] He explained that Amos's mistaken numbers were because he was an Englishman and so prejudiced against Ireland. F. W. Crossley, the leader of the Irish Tourist and Shannon Development movements, shared this opinion and resented the focus given to the anti-consumption campaign as painting an inaccurate idea of the incidence of tuberculosis in Ireland.[64] However, a contemporary named Sir William Thompson, Registrar General for Ireland, corroborated Amos's figures and accounted for 10,000 deaths from tuberculosis in 1912.[65] The volatile debate therefore reflects concerns of reinforcing negative prejudices of Ireland despite factual accuracy.

The Brown brothers' priority was to promote and sell their soap, although they also wanted to improve the health and industry of Ireland through supporting the anti-consumption campaign and by displaying rural industries. Both these latter projects were rectifying negative developments in Ireland, one relating to public health and the other to declining rural investment.

The anti-consumption campaign became linked to the brothers' soap industry. For the brothers, soap created cleanliness (through whitening) and by proxy good health; the actual properties of soap were highly prized in an era of industrialisation and inadequate public health. The transformative qualities of soap therefore established a link to the idealised rural life of the 'colleens' and their use of the product, as Rains has shown.[66] Soap became a deterrent to disease in this narrative.

The complaint that the tuberculosis exhibit's prominence and the focus on cleanliness inadvertently affirmed Irish dirtiness is supported by Bronwen Walter's thesis, which argues that the portrayal of 'unkempt and slovenly houses' was directly contrasted with the 'cleanliness and order of [English] homes' that reified the cult of domesticity and maintained industrial capitalism in the twentieth century.[67] In this narrative, Irish men and women, and particularly the women, were responsible for the spread of tuberculosis as they did not clean enough, reinforcing ideas of Irish people's inherent dirtiness and the role of Irish women in alleviating the crisis by consuming soap and acting as role models.

Most of the Village postcards had captions reading: 'the Irish colleens use this soap; note their beautiful complexions'; thereby the 'colleens' personified the benefits of soap in the Browns' artful construction of rural life. *Good Health* reported that the complexion of the Irish woman is the 'envy of [many] ... fashionable ladies'.[68] These 'colleens' embodied good British citizens engaged in an affirmative whiteness that respected the Union. 'Colleens'' soaps main selling point was that one could be healthy, clean, and beautiful with ease (even in the busy, polluted metropolis).[69] However, it may have unintentionally indicated that the 'colleens' needed copious washing. Racialised discourses, notes Kavita Philip, relied on a 'functional incoherence – an oscillation between contradictory ideas – that legitimated specific political positions'.[70] At times, and particularly with the tuberculosis campaign, the brothers, while attempting to better Ireland, undermined their own project of displaying an Irish modernity allied to the Union. Clearly, the complex project to sell soap was open to misinterpretation and contradiction.

Ballymaclinton Village was also criticised from multiple angles by varied people. The brothers rejected that the Village was a self-serving enterprise by framing their display through an altruistic lens: 'had there been no consumption there would have been no Ballymaclinton'.[71] They prided themselves in their health propaganda which claimed that the Village reduced deaths from tuberculosis through its lectures, for example. Significant criticism related to questions of authenticity. For instance, Crossley argued that the girls were not Irish and denounced the whole Village as a 'fake'. Robert Brown responded that 'every girl here ... came straight from Ireland'. He

boasted that the 'colleens' '[we]re dressed in Irish linen, and linen mesh underwear, with Balbriggan stockings, scarlet Galway cloaks, or blue Kerry ones'. The detail offered here reinforces the patriarchal control the brothers exercised over their workers. The fact that they prescribed every item of the 'colleens'' garb, even down to the type of underwear, is suggestive of a voyeuristic gaze common to exhibited colonial women.[72] The brothers' commitment to authenticity relied on a stringent regulation of the 'colleens' along the lines of dispossessed female bodies exhibited in other popular displays of the time.[73]

While the Irish costume became revered by the Browns as a measure of authenticity, it suggested a fantasy of Ireland. Irish peasants in the early twentieth century did not wear these red and green clothes, nor were the 'colleens' peasants, but employees working for a wage. Robert Brown veered into distinctly nationalist language to defend the white Irish idyll of his making: '[It is] surely better to have Irish linen than the cheap finery (the cast off clothes of English swells, or the rubbish turned out by Whitechapel sweaters) which is so much worn in Ireland.'[74] The symbolism of the Village (both clothes and objects) heightened in significance when physically reproduced on the 'colleens'; they became repositories for a white Unionist politics and a distinct Irish identity inside the framework of Britain. The 'colleens' bodily enacted an Irish whiteness through their display. The Browns deployed Celtic Revival motifs (also used by Aberdeen and Hart) throughout the exhibit in a continuation of the Gaelic League's principles from the nineteenth century.[75]

The picturesque exhibit further contradicted the Village's claims to authenticity. Visitors cast doubt on any Irish village being 'decorated with flower gardens and kept so trim' – raising suspicions about the entire Village enterprise.[76] A writer in *The Lancet* described the cleanliness as 'positively depressing'.[77] Contrastingly, some accepted that the Village was not an actual portrayal of real Ireland but enjoyed the experience nonetheless. For instance, the *Northern Whig* printed: 'Where are we to find such wide streets, such neatly thatched roofs, so much clean white-wash on the cottage walls?', but there is 'quite [an] impressive realism'.[78] Further, in *Illustrated Review*, Dumas noted that in Ballymaclinton everything was perfect, describing it as: 'spick and span at every turn and twist, wide and white and clean'.[79] The fact that a rural village was unlikely to be as clean was ignored; instead, the constructed fantasy of Ireland was celebrated. The focus on cleanliness proved that the Irish were indeed becoming white (and civilised), like their British compatriots. A true Irishness may not have been replicated, but an ideal, imagined, utopian one was certainly simulated and praised. Steve Garner argues that racialisation involved discursively associating bodies to fixed identities, and the static artificial nature of the Irish Village consigned its features as forming the fabric of Irishness.[80]

Overall, the criticisms of Ballymaclinton mainly argued that it was an unconvincing, inaccurate portrayal of Ireland – despite this being the brothers' prime intention. However, this suggests that the target audience of the Village may not have been Irish men and women themselves but British and international visitors who likely would have been unfamiliar with rural Ireland, and therefore more likely to have been satisfied with the exhibit. Further, this reveals that an imagined realism was key – a fictional portrayal of ideal Ireland was paramount – to present the country as (white) safe, inviting, healthy, and clean, ready for trade and investment. The gritty reality of a rural space could be washed over if only wealthy businessmen were convinced to spend money on Irish products in London, and later in Ireland.

Irish whiteness tentatively straddled difference and contradiction as its defining characteristics. Paul Greenhalgh has contextualised that the display of Irish rural industries and soaps equated Ireland's future industrial revolution with Africa's. He demonstrates how particular trends in display shaped the presentation of colonies or former colonies as rural and backward, while imperial nations emerged as city-like and industrial. Greenhalgh contends that exhibits of industrial technology created and expanded the power as well as the superiority of core countries. The imbalance of power was furthered both visually and textually, and Greenhalgh highlights that by depicting Ireland 'as a nation of hand-loom weavers and Gaelic singers', they were subsumed as 'part of the empire'.[81] For the Brown brothers, Ireland's association with the United Kingdom was central to their business expansion, and such a conflation may have been interpreted positively since it consolidated their Irish brand, despite Greenhalgh's reading of the exhibit as reinforcing subordination.

Images of the white 'colleens' in rural scenes reinforced Ireland's dual colonial position rooted in the past (Figure 3.6). One woman sits on the donkey and two stand beside her. Again, they are in Irish costume and look nonchalantly at the camera and the viewers beyond.

Barbara O'Connor argues that the symbolic importance of the red homespun and home-dyed cloth of the 'colleens'' costumes comes from its associations with 'indigenous authenticity and sexuality'.[82] As discussed in the previous chapter, the transnational currency of the attractive costumed Irish woman united the landscape to local crafts and peasant self-sufficiency. In the image the spindle visible in the corner evokes the centrality of rural industries to the Village enterprise. The open windows and the debris surrounding the whitewashed cottage reveal the everyday use of the space by Ballymaclinton's inhabitants. The importance of white Irish women to the Browns' imperial project is underscored by Walter's contention that Irish women occupied 'discursive positions at both the margins and the heart of the British nation' in the project to construct national identities.[83] Irish

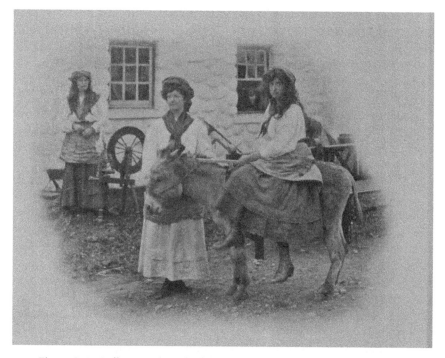

Figure 3.6 'Colleens' riding donkeys at Ballymaclinton (in *Good Health*, 1908, p. 230 – courtesy of the Wellcome Collection)

women in these allegorical representations mediated the extremities of violence and political upheaval often associated with Irish men in the popular British press to encourage attraction to, and the consumption of, Ireland in a welcoming space.

It is clear that an Irish whiteness united the Browns' project to Britain's imperial enterprise. The Browns' desire to sell soap relied on enacting a whiteness associated with Britain, based on attractive and traditional forms of Irishness which commodified the country as a whole. Moreover, while the African villages depicted a rural way of life rooted in a separation from Britain, Ireland's rurality emphasised connectedness and affability to Britain.[84] And so visualisations of the past and present, rurality and modernity, tradition, and commerce worked in unison for Ireland.

One author wrote that the 'most exotic thrill in the [1908 Exhibition] is Ballymaclinton ... The Village Senegalais [sic] is not nearly so strange.'[85] The author explained that seeing the true 'Gael' in the form of the 'Irish peasant' was so shocking that visitors did not need to visit the Senegalese Village for strangeness. He held that in reality the Irish displayed in 1908 were different to the 'grotesque monstrosity, the stage Irishman' and 'utterly

unlike the caricature of the music halls', and it was the shock of seeing this rural Irishness as distinct from their urban compatriots that was the 'exotic thrill'. The esteem with which rural life was held and the power of Irish exhibits to change visitors' assumptions and challenge their prejudices are highlighted in this piece.

Philip has shown that while the 'ludicrous stage-Irishman, "Paddy", and the simian, savage Celt' were often depicted in the popular press of the early nineteenth century, the latter heightened in significance as political disputes became increasingly polarised throughout the century.[86] Further, Philip argues that British ethnography represented groups such as the Irish as 'racially degraded and inherently backward' due to their position on the margins of the Empire.[87] By the early twentieth century, established racial stereotypes concerned with Irish duplicity, violence, and ignorance were prevalent among the popular consciousness of white Britons. Compared to the 'rational' Protestant work ethic of the English, Mary Hickman has demonstrated that the Irish emerged as blood-thirsty sectarians and uninformed Catholics in widespread discourses of Irish inferiority.[88] Further, Jane Ohlmeyer has convincingly argued how these ethnocentric attitudes towards the Irish – that the 'Irish Catholic population was lazy, savage, monkey-like and in desperate need of civilisation' – became a necessary project in dehumanisation in order to help justify English imperialism.[89]

By the mid-twentieth century, Gavin Schaffer and Saima Nasar have shown that Irishness was occasionally associated with dirt, disease, and ignorance, and Irish people were characterised as alcoholics and petty criminals; however, such stereotypes often co-existed with reductive tropes of 'jolly, happy-go-lucky, friendly Irish'.[90] The Browns were part of this larger project and monopolised on the assimilationist narratives offered to the Protestant Irish; however, they also included Catholics within their modernising, non-sectarian project. In a survey of Irish brands, John Philip O'Connor has shown that 'colleen' soap sought to cleanse the Catholic elements of Irish identity most vigorously, to prove that Irish contemporaries were becoming white and part of the United Kingdom under an expansive British citizenship.[91] Uniquely in the fairground – under the umbrella of whiteness – Ireland was appealing, alluring, and united across Protestant and Catholic divides.

The author who wrote about the 'exotic thrill' of Ballymaclinton channelled familiar historical prejudices. He at once celebrated Irishness while giving voice to a reductive discourse that sensationalised a rural existence. The author insisted that the Irish poor were untainted by modernity and 'pure Celt[s]', 'a splendid type of the sturdy Irish peasant'.[92] He continued the objectification of rural life by describing the women as 'specimens' – objects visitors could admire like the workers' cottage or the high cross. He talked

positively of the 'shy Irish colleen' with 'short skirts show[ing] their black shoes and shapely ankles'. He completed his voyeuristic appraisal: 'girls sit shyly together in groups, making their Carrickmacross lace, and embroidering and knitting with lowered eyes'. This visitor's infantilising description of Irish rurality was symptomatic of larger public opinion among audiences that held admiration for Irish rurality on the one hand with a deep prejudice against Irish existence on the other. Specifically, the author's appraisal of Ireland's display contained patronising and harmful stereotypes of the backwards Irish. Crucially, the contradictions in his opinions remained uninterrogated, and so contrary opinions of the Irish persisted throughout the early twentieth century.

Furthermore, the Village worked on many opposing levels; it stressed rurality and tradition to appeal to Irish history and authenticity. It further displayed industry and mechanisation to stimulate future trade and investment in the country, primarily through the consumption of McClinton's soap. Yet it packaged trade within stereotypical presentations of a white Ireland, revealing how an accessible, relatable (if prejudiced) vision of Irishness became important. The history of anti-Irish feeling explains conflicting audience responses, and a sympathetic reading of the Exhibition was entirely unpredictable.

The Browns constructed a true Irish utopia: the ultimate aim of their unionism was for Catholics and Protestants to peacefully co-exist under the joint enterprise of capitalism. Therefore, they made religious arrangements for both Protestant and Catholic worship. Every Sunday during the six months of the Exhibition, Revered Father Daly conducted a Catholic service in the village hall, attended by around fifty people each time.[93] The *Tyrone Courier* reported that over a hundred Ballymaclinton 'colleens' were Catholic. Further, every Sunday the 'village was astir with worshippers wending their way to the village hall' and 'differences of creed were forgotten at the Sabbath morning meal … Protestant and Roman Catholic, stern Orangeman and laughing "colleen" were united in appreciation of fruit and nut butter'.[94] A congenial space for different religious practice existed, and for Protestant worship, 'Gone were crucifix, bell, and candles.' The 'colleens'' whiteness and participation in commercial profit united them. Ballymaclinton offered a hopeful vision of a peaceful Irish identity within the United Kingdom during divisive Home Rule politics and the escalation of extreme Irish nationalism.[95]

The *Mid-Ulster Mail* celebrated that 'every Englishman has a warm place in [their] heart for Ireland and the Irish'.[96] The magic of Ballymaclinton was its apolitical, non-partisan virtues where factional groups co-existed without tension. The strength of unionism, supported by the militant Orange Order in Ulster and Britain, furthered the radicalisation of Irish politics

after 1900.[97] Donald MacPherson has shown how women became 'Orange Sisters' to extend a British world founded on the Empire and Protestantism in the early twentieth century.[98] However, there was no violence or strife reported in Ballymaclinton, and the brothers went to great efforts to present a peaceful, positive, conciliatory portrait of Ireland. Visitors, the press, and contemporary publications did not challenge the fiction of a neutral Irish politics. International exhibitions were exceptional spaces, and organisers designed them to be laudatory and grand; however, it is curious that obvious connections were not made between the episodes of political violence in the early twentieth century and the peculiar absence of Irish politics in the Franco-British Exhibition. Clearly, an imagined space was sacred, and this became a vision of a potential future Ireland – free from violence and with white Catholics and Protestants co-producing a profitable country.

Curiously, Ballymaclinton Village hosted at least fourteen engagements and ended with a wedding. The *Weekly Irish Times* reported:

> Two years ago [in the Franco-British Exhibition of 1908] a Civil Servant ... paid a visit to the Irish Village for tea. He was attended to by a very pretty black-eyed Irish girl, and he fell in love with her so much that he proposed there and then. Last week the happy couple were married [in the Japan-British Exhibition of 1910], and the wedding breakfast was given in the Irish Village.[99]

The *Mid-Ulster Mail* corroborates the wedding and reports:

> After the ceremony a reception was given by the Messrs. Brown in the Irish Village, when over 100 were entertained in the staff dining-room. R[obert] Brown, in proposing the health of the bride and groom said that Ballymaclinton had succeeded in doing what statesmen and politicians had failed to accomplish – namely, the union of Ireland and England – a true union of hearts.[100]

While Barney and Bridget mentioned earlier had parted ways because of the Village, this mixed-ethnic marriage between an Englishman and an Irish woman was formed in the Village; the Village itself thereby became the ultimate achievement in unionist propaganda based on whiteness.

The Irish Village was part of larger interests to bolster the Irish economy, particularly through tourism. For instance, the *Official Guide* contained many advertisements to visit Ireland via bus, railway, or ship. It advertised tours to see mountain, lake, and sea, and recommended hotels with the promise of cheap tourist tickets sold daily. Its prime attractions were the natural environment and outdoor activities such as fishing, boating, cycling, and coaching.[101] But attraction to Ireland's inhabitants also stimulated tourism. Robert Brown boasted that a 'prettier, wittier, more modest set [of 'colleens'] never left Ireland, and no firm ever had more willing helpers; the girls are splendid. We think there is not a merrier set of people on the planet.'[102] And it was this merriness that created interest in the country. Countless newspapers

participated in an advertising network to encourage tourism to Ireland, with many commenting on positive interactions with the 'colleens'. For instance, the *Wharfedale & Airedale Observer* typically celebrated the 'winsome and sprightly Irish lasses, garbed in green and red, short-petticoated' and the 'native wit' supposedly the 'prerogative of every colleen'.[103] The growth of tourism, L. P. Curtis highlights, coincided with images of Erin and Hibernia depicted on 'every kind of artefact including cards, china, silverware ... harps' by the early twentieth century.[104] In the fairground the white 'colleens' were integral in creating a 'happier, healthier and more prosperous Ireland', and their primary role was as saleswomen – both selling soap in the present and selling Ireland as a tourist destination in the future.[105]

Ballymaclinton Village continued its display after 1908, where it received two million visitors. Total attendance to the Franco-British Exhibition was more than 8.4 million visitors, and the Exhibition itself made a profit of almost £40,000.[106] The Village remained part of a broader, more comprehensive consolidation of international interest in Ireland in decades to come.[107]

The Brown brothers carefully combined business and philanthropy to sell soap in their commercial extravaganza. As an advertising vehicle, they offered 'a sleepy rurality, a vision free from violence, discord and threat to the English' that appealed to millions of visitors.[108] The romanticised static image of white rurality described as an 'Irish Colony in London' was distinctly profitable.[109] The Village created the most widespread images of Ireland in the first few decades of the twentieth century, with its popular circulation of photographs, souvenirs, and postcards.[110] The Brown brothers gave visitors 'Ireland in a nutshell. Ireland in an English atmosphere built upon English soil and in the centre of a London suburb.'[111] Ballymaclinton took a strident stance against Home Rule and visualised the benefits of unionism for the broader Irish and British populace. It cultivated a white Irishness that amalgamated an Irish past – rooted in history and tradition – and an Irish present and future – stemmed in industry and investment. The coupling of these two narratives often clashed and revealed the internal contradictions of the Village project.

Ballymaclinton traded on stereotypes of Ireland to create an accessible vision for consumption, and, to a certain extent, it succeeded with its popular display. The Village displayed reductive narratives of becoming civilised (and white) in the early twentieth century with its focus on cleanliness and soap. This inadvertently suggested an inherent dirtiness, epitomised by their anti-tuberculosis campaign. The Village was a commercial project devoid of the Irish state, and so the brothers did not need to offer any 'accurate' representation of Ireland as they worked within the unregulated forum of advertising. That Ballymaclinton did not mention the factionalism of Irish

politics reinforces the exceptional nature of the fairground and its raison d'être to present utopian dreams. A lived reality of Irishness was insignificant. The Village relied on white women to sell soap, but the Browns also exhibited them as features of attraction. The women could exist as examples of quaint, rustic, picturesque Irishness and as objects of sexual desire, all the while affirming whiteness.

Ballymaclinton proves that an Irish whiteness emerged fluidly in terms of colonial status, ethnic difference, or industrial capabilities and was not neatly assigned to differences in skin colour. Irish men and women who tied commerce to a public health initiative uniquely funded and constructed the Exhibition enterprise. The Brown brothers expended significant energy in creating a peaceful white Ireland despite the tensions of Home Rule, and the 'town of' contained a phantasmagoria of Irishness – all in a bid to sell soap. The next chapter extends the development of Irish commerce, which reveals how exhibitions became enmeshed in the project of Irish nation building in the interwar period by state actors, all of whom were Irish.

Notes

1 *London Evening News* (27 April 1908).
2 British Library, London, J/7957.h.15, manuscript by F. G. Dumas, 'The Franco-British Exhibition: Illustrated Review', 1908, p. 287.
3 British Library, London, P.P.2706.aka, manuscript 'Ballymaclinton and the Crusade against Tuberculosis in Ireland: Some Particulars Concerning One of the Most Remarkable and Successful of Modern Health Movements', *Good Health: An Illustrated Monthly Magazine Devoted to Hygiene and the Principles of Healthful Living*, 6:8 (1908), p. 231. See also British Library, London, LOU.EW S159, manuscript 'Herald of the Golden Age and British Health Review', 15:4 (1912). There are no page numbers.
4 Barbara O'Connor, '"Colleens and Comely Maidens": Representing and Performing Irish Femininity in the Nineteenth and Twentieth Centuries', in Eóin Flannery and Michael Griffin (eds), *Ireland in Focus: Film, Photography, and Popular Culture* (Syracuse, NY, 2009), pp. 144–65, p. 145.
5 'Ballymaclinton', *Wharfedale & Airedale Observer* (28 August 1908).
6 A. R. Holmes and E. F. Biagini, 'Protestants', in Eugenio F. Biagini and Mary E. Daly (eds), *Cambridge Social History of Modern Ireland* (Cambridge, 2017), pp. 88–112, p. 100. See also G. K. Peatling, *British Opinion and Irish Self-Government, 1865–1925: From Unionism to Liberal Commonwealth* (Dublin, 2001).
7 R. Swift and S. Campbell, 'The Irish in Britain', in Biagini and Daly (eds), *Cambridge Social History of Modern Ireland*, pp. 515–33, p. 522.
8 L. J. McCaffrey, *The Irish Question: Two Centuries of Conflict* (Lexington, KY, 1995), pp. 126–7.

9 Cited in J. G. V. McGaughey, *Ulster's Men: Protestant Unionist Masculinities and Militarization in the North of Ireland, 1912–1923* (Dublin, 2012), p. 17.
10 Cited in Holmes and Biagini, 'Protestants', p. 100.
11 McGaughey, *Ulster's Men*, p. 18.
12 See B. Nelson, *Irish Nationalists and the Making of the Irish Race* (Oxford, 2012), pp. 242–53.
13 See M. Ghaill, 'The Irish in Britain: The Invisibility of Ethnicity and Anti-Irish Racism', *Journal of Ethnic and Migration Studies*, 26:1 (2000), 137–47; Graham Davis, 'The Irish in Britain, 1815–1939', in Andy Bielenberg (ed.), *The Irish Diaspora* (Harlow, 2000), pp. 19–36; R. Swift, *The Irish in Britain: 1815–1914: A Documentary History* (Cork, 1990); Alan O'Day, 'The Political Organization of the Irish in Britain, 1867–90', in Sheridan Gilley and Roger Swift (eds), *The Irish in Britain 1815–1939* (London, 1989), pp. 183–211; David Fitzpatrick, '"A Peculiar Tramping People": The Irish in Britain, 1801–70', in William E. Vaughan (ed.), *A New History of Ireland. Vol V. Ireland under the Union, I, 1801–1870* (Oxford, 1989), pp. 623–60.
14 David Fitzpatrick, 'A Curious Middle Place: The Irish in Britain, 1871–1921', in Swift and Gilley (eds), *The Irish in Britain 1815–1939*, pp. 10–59, p. 41.
15 A. O'Day, 'A Conundrum of Irish Diasporic Identity: Mutative Ethnicity', *Immigrants and Minorities: Historical Studies in Ethnicities, Migration and Diaspora*, 27:2 (2009), 317–39, 317. See also R. Swift, 'Identifying the Irish in Victorian Britain: Recent Trends in Historiography', *Immigrants and Minorities: Historical Studies in Ethnicities, Migration and Diaspora*, 27:2 (2009), 134–51; Alan O'Day, 'Varieties of Anti-Irish Behaviour in Britain, 1846–1922', in Panikos Panayi (ed.), *Racial Violence in Britain in the Nineteenth and Twentieth Centuries* (Leicester, 1996), pp. 26–43.
16 Mary J. Hickman, 'Alternative Historiographies of the Irish in Britain: A Critique of the Segregation/Assimilation Model', in Roger Swift and Sheridan Gilley (eds), *The Irish in Victorian Britain: The Local Dimension* (Dublin, 1999), pp. 236–53, p. 244.
17 Ibid. See S. Hall, 'Our Mongrel Selves', *New Statesmen and Society* (19 June 1992); E. Balibar, *Race, Nation, Class: Ambiguous Identities* (London, 1991).
18 M. Moulton, *Ireland and the Irish in Interwar England* (Cambridge, 2014), p. 9.
19 E. Delaney, *The Irish in Post-War Britain* (Oxford, 2007), pp. 125–6.
20 See R. Dyer, *White: Essays on Race and Culture* (New York, 1997), pp. 25–34.
21 P. Jackson, 'Constructions of 'Whiteness' in the Geographical Imagination', *Area*, 30:2 (1998), 99–106, 100.
22 'Herald of the Golden Age and British Health Review'. Rains has discussed the 1907 display in relation to empire and labour politics in *Commodity Culture and Social Class in Dublin, 1850–1916* (Dublin, 2010), pp. 185–97.
23 Cited in Brown, 'Where Is Ballymaclinton?', *Waterford Standard*.
24 J. P. O'Connor, '"For a Colleen's Complexion": Soap and the Politicization of a Brand Personality, 1888–1916', *Journal of Historical Research in Marketing*, 6:1 (2014), 29–55, 38. See also J. P. O'Connor, '"Déanta i nÉirinn": The Reconstruction of Irish Stereotypes, 1888–1914' (PhD dissertation, University of Limerick, 2012).

25 *Tyrone Courier*, 14 May 1908. See Caroline R. Malloy, 'Exhibiting Ireland: Irish Villages, Pavilions, Cottages, and Castles at International Exhibitions, 1853–1939' (PhD dissertation, University of Wisconsin-Madison, 2013), pp. 119–58, for a discussion of the Village.
26 British Library, London, 7957.de.32, manuscript 'Official Guide for the Franco–British Exhibition, 1908', p. 53. See M. C. Sheehan, 'Issues of Cultural Representation and National Identity Explored in the Irish Village, Ballymaclinton at the Franco-British Exhibition, Shepherd's Bush, London, 1908' (MA dissertation, Royal College of Art, 2000).
27 Ibid., p. 54.
28 S. A. Tooley, 'Night at Ballymaclinton', *London Daily News* (8 July 1908).
29 'Frolics at Ballymaclinton', *Mid-Ulster Mail* (11 July 1908).
30 *Good Health*, 234.
31 Brown, 'Where Is Ballymaclinton?'. Also printed in the *Tyrone Constitution* on 15 May 1908 and *Tyrone Courier* on 14 May 1908.
32 E. Crooke, *Politics, Archaeology and the Creation of a National Museum of Ireland* (Dublin, 2001), p. 82.
33 G. Petrie, 'The Ecclesiastical Architecture of Ireland, Anterior to the Anglo-Norman Invasion; Comprising an Essay on the Origin and Uses of the Round Towers of Ireland' (Dublin, 1845); cited in Crooke, *Museums of Ireland*, p. 82.
34 'The Irish Village: A Typical Irish Cottage', *Irish Independent* (11 April 1908).
35 *London Evening News* (27 April 1908). The *Tyrone Constitution* reported that the fisherman's cottage was home to a 'typical West Coast fisher family', in 'Ballymaclinton. The Model Irish Village (Visit by a Paris Correspondent)' (31 July 1908).
36 'Irish Village', *Irish Independent*.
37 E. Zuelow, *Making Ireland Irish: Tourism and National Identity since the Irish Civil War* (Dublin, 2009), p. xxxii.
38 S. W. Thompson, *The Postcolonial Tourist: Irish Tourism and Decolonization since 1850* (Paris, 2000), pp. 11–12.
39 '"Ballymaclinton" in London', *Mid-Ulster Mail* (16 May 1908).
40 *Tyrone Courier* (23 July 1908).
41 *Good Health*, p. 229, pp. 235–6.
42 'Irish Village', *Irish Independent*.
43 *Tyrone Courier* (26 August 1909).
44 'Irish Village', *Irish Independent*. See J. C. Simpson, 'At Ballymaclinton', *Tyrone Courier* (26 August 1909), reported that the 'waitresses [wore] … green linen uniforms with pretty white muslin aprons and looked the picture of comfort amidst the good cheer'.
45 *Daily Chronicle* (18 April 1908).
46 'Irish Village', *Irish Independent*.
47 'The Anti-Tuberculosis Campaign. £10,000 from Ballymaclinton', *Belfast Weekly News* (22 October 1908). See D. R. Knight, *The Exhibitions: Great White City, Shepherds Bush, London: 70th Anniversary, 1908–1978* (London, 1978), p. 60.

48 *Tyrone Constitution* (21 August 1908). See Robert Rydell, 'Souvenirs of Imperialism: World's Fairs' Postcards', in Christraud M. Geary and Virginia-Lee Webb (eds), *Delivering Views: Distant Cultures in Early Postcards* (Washington, DC, 1998), pp. 147–77.
49 D. Kiberd, *Inventing Ireland: The Literature of the Modern Nation* (Cambridge, 1996), p. 3.
50 See S. Rains, 'The Ideal Home (Rule) Exhibition: Ballymaclinton and the 1908 Franco British Exhibition', *Field Day Review*, 7 (2011), 4–21, 9, for a discussion of a similar postcard.
51 *Hall and Theatre Review* (24 July 1908).
52 'Impressions of Four Ladies', *Tyrone Courier* (26 August 1909).
53 'Snatches of Irish Songs' reported that 'a large party visit[ed] the Zoological Gardens as guests of a lady member of the society; and [colleens were] taken to Hampstead Heath as the guests of Mr. Amos, one of the officials at the village', in the *London Evening Standard* (10 August 1908).
54 'Impressions of Four Ladies', *Tyrone Courier*.
55 O'Connor, ' "Colleens and Comely Maidens" ', p. 151, p. 153.
56 'Impressions of Four Ladies', *Tyrone Courier*.
57 Ibid. For fears about the migration of Irish women, see S. Caslin, *Save the Womanhood! Vice, Urban Immorality and Social Control in Liverpool, c. 1900–1976* (Liverpool, 2018); Lindsey Earner-Byrne, 'Gender Roles in Ireland since 1740', in Biagini and Daly (eds), *Cambridge Social History of Modern Ireland*, pp. 312–26.
58 S. Rains, 'Colleens, Cottages and Kraals: The Politics of "Native" Village Exhibitions', *History Ireland*, 19:2 (2011), 30–3. See also Rains, 'The Ideal Home (Rule) Exhibition', 19.
59 'Impressions of Four Ladies', *Tyrone Courier*.
60 'Agony Aunt', *Tyrone Courier* (19 November 1908).
61 A. McClintock, *Imperial Leather: Race, Gender and Sexuality in the Colonial Contest* (New York, 1994), pp. 208–10, pp. 212–13; O'Connor, 'For a Colleen's Complexion', p. 37.
62 British Library, London, H.3986.hh.(21.), manuscript 'Guide and Souvenir of Ballymaclinton', 1908. No page numbers available. *Good Health* reported that the '[tuberculosis] carrie[d] off some 12,000 of [Ireland's] fairest sons and daughters every year', p. 234.
63 'Response in "Ballymaclinton" ', *Irish News and Belfast Morning News* (23 September 1908).
64 'Ballymaclinton', *The Lancet* (22 August 1908).
65 Cited in G. Jones, *'Captain of All These Men of Death': The History of Tuberculosis in Ireland in Nineteenth and Twentieth Century Ireland* (New York, 2001), p. 162.
66 Rains, 'The Ideal Home (Rule) Exhibition', 19.
67 B. Walter, *Outsiders Inside: Whiteness, Place and Irish Women* (London, 2001), p. 110. See C. Clear, *Social Change and Everyday Life in Ireland, 1850–1922* (Manchester, 2007), pp. 142–5.

68 *Good Health*, p. 234.
69 For discussions on the history of soap advertising, see J. Sivulka, *Stronger than Dirt: A Cultural History of Advertising Personal Hygiene in America, 1875–1940* (Amherst, NY, 2001); Anne McClintock, 'Soft-Soaping Empire: Commodity Racism and Imperial Advertising', in Nicholas Mirzoeff (ed.), *The Visual Culture Reader* (London, 1998), pp. 304–16.
70 K. Philip, 'Race, Class and the Imperial Politics of Ethnography in India, Ireland and London, 1850–1910', *Irish Studies Review*, 10:3 (2002), 289–302, 298.
71 'Ballymaclinton and Its Critics', *Freeman's Journal and Daily Commercial Advertiser* (15 August 1908). Also printed in the *Tyrone Constitution* (21 August 1908).
72 Malloy, 'Exhibiting Ireland', pp. 144–5, pp. 146–7, p. 153.
73 See A. E. Coombes and A. Brah, 'Introduction: The Conundrum of "Mixing"', in Annie E. Coombes and Avtar Brah (eds), *Hybridity and Its Discontents: Politics, Science, Culture* (New York, 2000), pp. 1–17.
74 'Ballymaclinton and Its Critics', *Freeman's Journal*.
75 McCaffrey, *The Irish Question*, pp. 112–14.
76 'Ballymaclinton and Its Critics', *Freeman's Journal*.
77 'The Irish Village: The Tuberculosis Exhibition: A Comparison between an Irish Labourer's Home and That of His Fellow in Rural Norfolk', *The Lancet* (25 July 1908).
78 'The Irish Village in London. An English Appreciation', *Northern Whig* (22 August 1908).
79 Dumas, 'The Franco-British Exhibition', p. 287.
80 S. Garner, 'Ireland: From Racism without "Race" to 'Racism without Racists', *Radical History Review*, 104 (2009), 41–56, 46.
81 Greenhalgh, *Ephemeral Vistas*, pp. 107–8.
82 O'Connor, '"Colleens and Comely Maidens"', p. 155.
83 Walter, *Whiteness, Place and Irish Women*, p. 81.
84 The African villages have been analysed in A. E. Coombes, *Reinventing Africa: Museums, Material Culture and Popular Imagination in Late Victorian and Edwardian England* (New Haven, CT, 1994).
85 J. Douglas, 'Ballymaclinton. Irish Exiles at Shepherd's Bush', *Tyrone Courier* (28 May 1908).
86 Philip, 'Race, Class and the Imperial Politics of Ethnography', 296. See also T. Ballantyne, *Orientalism and Race: Aryanism in the British Empire* (New York, 2002).
87 Ibid., 295.
88 M. J. Hickman, *Religion, Class and Identity: The State, the Catholic Church and the Education of the Irish in Britain* (Avebury, 1995), p. 213. See K. Kumar, 'Nation and Empire: English and British National Identity in Comparative Perspective', *Theory and Society*, 29:5 (2000), 575–608, 604.
89 J. Ohlmeyer, 'Ireland, India and the British Empire', *Studies in People's History*, 2:2 (2015), 169–88, 175.

90 G. Schaffer and S. Nasar, 'The White Essential Subject: Race, Ethnicity, and the Irish in Post-War Britain', *Contemporary British History*, 32:2 (2018), 209–30, 213.

91 O'Connor, '"For a Colleen's Complexion"', 42. See also Malloy, 'Exhibiting Ireland', pp. 147–50.

92 Douglas, 'Ballymaclinton'.

93 'Mass at Ballymaclinton', *Tyrone Courier* (2 July 1908).

94 'Church services in the Irish Village', *Tyrone Courier* (27 August 1908).

95 Fitzpatrick, in 'A Curious Middle Place', argues that the largest Irish society in Britain was the Irish Self-Determination League of Great Britain with hundreds of branches, formed in October 1919, p. 43.

96 '"Ballymaclinton" in London', *Mid-Ulster Mail*.

97 D. M. MacRaild, *Faith, Fraternity and Fighting: The Orange Order and Irish Migrants in Northern England, c. 1850–1920* (Liverpool, 2005), p. 4.

98 D. MacPherson, *Women and the Orange Order: Female Activism, Diaspora and Empire in the British World, 1850–1940* (Manchester, 2016), p. 3.

99 'A Little Romance of the Irish Village', *Weekly Irish Times* (5 November 1910).

100 'Good-bye Ballymaclinton', *Mid-Ulster Mail* (5 November 1910). I was not able to find any marriage records from the time; however, the story's power came from its fiction and its widespread circulation; for many in Britain, this narrative of a peaceful union was what they wanted to hear, devoid of contemporary reality.

101 'Official Guide for the Franco–British Exhibition'. There are no page numbers because these adverts were placed at the back of the catalogue.

102 'Ballymaclinton and Its Critics', *Freeman's Journal*.

103 'Ballymaclinton', *Wharfedale & Airedale Observer*.

104 L. P. Curtis, *Images of Erin in the Age of Parnell* (Dublin, 2000), p. 11.

105 'Guess Girls', *Waterford Standard*.

106 'Exhibition Attendances', *Journal of the Royal Society of Arts*, 56:5 (1908), 733.

107 S. Akhtar, '"Have I Done Enough for Japan Today?": Japan's Colonial Villages in the Japan–British Exhibition of 1910', *Journal of National Taiwan Normal University*, 67:1 (2022), 41–69.

108 P. Greenhalgh, 'Art, Politics and Society at the Franco–British Exhibition of 1908', *Art History*, 8:4 (1985), 434–52, 440.

109 *Tyrone Courier* (26 August 1909).

110 Malloy, 'Exhibiting Ireland', p. 158; J. M. O'Leary, 'Manufacturing Reality: The Display of the Irish at World's Fairs and Exhibitions 1893 to 1965' (PhD dissertation, Kent State University, 2015), p. 241.

111 'A Visit to Ballymaclinton by a London Irishman', *Tyrone Courier* (3 September 1908).

4

Interwar and partition: A divided Ireland

The malleability of Irish selfhood took on a greater significance in interwar Irish exhibitions as it encompassed diverse national identities. Existing literature on interwar Ireland is vast – covering key touch points of the period including the Irish War of Independence (1919–21) and the Irish Civil War (1922–23).[1] However, during the political upheaval of the time, Ireland continually reimagined its position within the British Empire, both socially and culturally. Exhibitions thus became a notable way for the island to evoke its distinct relationships to imperial Britain to a global audience. Specific tensions arose over the exact style and content of the two countries' representations in the interwar British Empire exhibitions. Various imaginings of an Irish nation competed for power and prestige. Both the Irish Free State and Northern Ireland envisioned social, economic, and cultural harmony despite their geographic separation. However, each territory championed their specific political and religious differences for national and international visitors. The Free State imagined the unification of the country, whereas Northern Ireland enmeshed itself in the United Kingdom. While broader symbols of Irishness circulated in both country's exhibits, distinctions were made across a host of sectarian ideologies. How these discrete visions of Irishness were constructed and contested in interwar displays is the subject of this chapter.

The 1924 British Empire Exhibition (reopened in 1925) featured an Ulster Pavilion, representing the new state of Northern Ireland only, as the Irish Free State did not participate, and its exhibits affirmed the nation's union with the United Kingdom. Later, both Irish blocs participated in the 1938 British Empire Exhibition; the Irish Free State had an individual Pavilion and emphasised its separation from the British imperial project under de Valera's independent policies. Whereas Northern Ireland continued its unionist politics and exhibited in the British section in 1938. The division of Ireland on display continued to the New York World's Fair of 1939, and I end by assessing the success of these diverse exhibits in furthering Irish state formation across the partitioned countries.

The above exhibitions highlight that participation was politically charged and ideologically motivated; Irish and British newspapers avidly reported on whether or not Northern Ireland and the Irish Free State would exhibit in British Empire exhibitions and in what form. Mo Moulton argues that Irishness in interwar England mainly emerged through 'memory, nostalgia, and entertainment rather than political struggle' to redress the importance of culture and its connection to Irish-British politics.[2] Through this lens we can see how international exhibitions worked together with the growing Irish tourist industry, which capitalised on accessible images of Ireland, to encourage visits to a six-month exhibit or to the country for a holiday. For example, I interrogate specific displays of Irish identity to reveal how an Irish culture circulated in exhibitions was reinforced in the tourist enterprise; both these projects created the most popularly consumed symbols of Irishness within the United Kingdom and Ireland in the interwar period.

The changing status of Ireland was powerfully evoked in international exhibitions according to local and national identity politics. Exhibits reflected both the popularisation of Irish culture for mass audiences and an Irish politics made accessible to visitors. Overall, I reveal the variety and scope of the divisive identities of the Irish Free State and Northern Ireland in fairs. Using exhibitions to map Irishness dynamically reinstates the value of the visual as a mediator between the government and the Irish people. Exhibitions were the labour of politicised Irish men and women engaged in imagining themselves through display, and the interwar years are key flashpoints in this story.

Ireland in the 1920s

Conflict and contestation overwhelmed interwar Irish politics. The Government of Ireland Act 1920 created Northern Ireland (part of the United Kingdom), and the Irish War of Independence was brought to a close by the Anglo-Irish Treaty on 6 December 1921. The Treaty ended British rule in most of Ireland and led to the creation of the Irish Free State as a self-governing dominion.[3] The new Free State would have the same constitutional status to Canada; members of the Free State Parliament were required to take an oath of allegiance, and a Governor-General was appointed to represent the British Crown.[4] Fearghal McGarry describes the 1920s as a long and violent struggle for political independence, with IRA killings in the *Dáil* and retaliatory death sentences issued by the new nation.[5] The Free State contained a measure of self-government that could evolve towards greater sovereignty; however, it was not the republic that Irish separatists

had fought for since 1916, and its connection with Britain was not voluntary but enforced by fear of reprisal.[6]

Underlying discontent in the interwar period stemmed from several unresolved issues, the main one being the Boundary Commission and its failed attempt to redraw the line separating the Free State from Northern Ireland in the 1920s. The governments of Northern Ireland, the Irish Free State, and Britain established the Boundary Commission decreed in Article 12 of the Treaty. The findings of the Commission leaked to the press in 1925 and revealed that Catholic majority counties would not go to southern control, and only minor changes would be recommended. This caused a national furore and initiated a series of angry protests.[7] Consequently, the Commission lay stagnant for years, and in the end the existing borders remained.[8] Ireland's borders were a source of contention for decades after and became a catalyst for protracted fighting in the interwar period.

Violence was a recurring feature in interwar Ireland. The Northern Protestant Irish suffered from IRA violence, while violent acts by unionists targeted Southern Irish Catholics. Such conflict varied in scale from minor skirmishes to more dangerous assaults.[9] Andrew Holmes and Eugenio Biagini have documented that in 1922 sectarian rioting in Belfast left 500 dead and forced a further 23,000, mainly Catholics, from their homes.[10] An assortment of protections materialised to defend vulnerable groups, with differing effects.[11] In the context of this political upheaval, sometimes expressed through outward conflict and at other times manifested in localised hatreds, the two territories engaged in formative processes of identity formation. Whether through their religious practices, national myths, or public celebrations, the creation of an identifiable Irishness was fundamental to the two areas as a source of national unity, and ideas of an Irish nation continued to be contested through spectacle.

1924 British Empire Exhibition, London

The 1924 British Empire Exhibition (23 April to 31 October 1924) opened in Wembley Park, London, over 220 acres (Figure 4.1).[12] Northern Ireland used the Exhibition to expound its allegiance to the United Kingdom after the turbulence of partition. Uniquely, Northern Ireland was no longer displayed next to the colonial villages and instead was housed in the Palace of Industry and amalgamated within Britain's displayed modernity. Moreover, the Free State's non-participation in the Exhibition reinforced the country's separation from the unionist project and heightened Northern Ireland's loyalty to the UK. The Palace of Industry and the Palace of Engineering, along with the Garden and Empire Stadium, occupied most of the space in

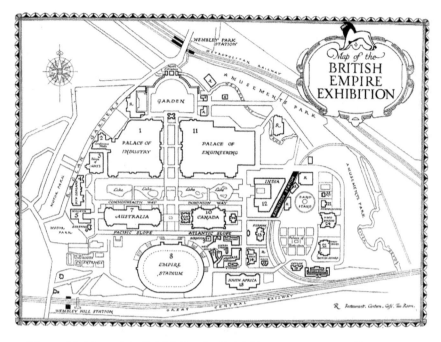

Figure 4.1 Map of the British Empire Exhibition (manuscript 'Official Guide to the British Empire Exhibition, 1924', 1924, p. 6)

Wembley. Multiple train routes made the Exhibition accessible for visitors. King George V (1865–1936) declared at the Exhibition's opening ceremony:

> You see before you a complete and vivid representation of [Britain's] Empire. The Dominions, India, the Colonies, the Protectorates, and Mandated Territories ... picture of our Commonwealth of Nations ... shows the craftsmanship, the agricultural skill, the trading, and transport organisation of [Britain's] territories. [And] a living picture of the history of the Empire ... [reveals] that the most powerful agency of civilization has ... peaceful aims [for] the good of mankind'.[13]

The speech was considered a technological marvel as it was broadcast live via radio to millions in the United Kingdom.[14]

The address revealed the desire to re-establish Britain as a benevolent world power following the trauma of the First World War; the Exhibition epitomised the height of imperial propaganda – an urgent call for visitors to 'unitedly and energetically develop the resources of the British race'.[15] Newspapers, official Exhibition literature, and visitor reviews declared that mass audiences popularly received the jingoistic enterprise. Hyperbolic

claims that the 1924 Exhibition was 'the greatest exhibition contrived by human hands in historic time' were common. This stocktaking of the 'wonders … of the world' cost one shilling six pence for adults and was half-price for children.[16] 'Hope', pride, and education enveloped the encyclopaedic portrait of Britain's Empire to seventeen million visitors in 1924.[17] As on the Midway in the 1890s, the 'study of Europe, of America … Arcadian communities of the Pacific, dreamers of the mystic East' was encouraged.[18] Modern industry and mechanised economies existed as perceived comparative lessons in the development of humanity in Wembley. However, the Exhibition's laudatory proclamations are undone through a consideration of the controversies surrounding Ireland's display since issues of participation underscored greater Irish disputes over the role of empire and the power of the English metropole in the interwar period.

The Irish Free State and the Exhibition organisers extensively debated the country's involvement in the 1924 Exhibition.[19] William Cavendish, the Duke of Devonshire (Chairman of the Exhibition Executive Committee), wrote several letters to Tim Healy (Governor-General of the Irish Free State) asking Ireland to participate in the display. From as early as December 1922, Cavendish, who was also Secretary of State for the Colonies, wrote to Healy explaining that acceptance of the invitation 'would not only produce an excellent impression over here and no doubt also in the other Dominions, but would be of material assistance to the Free State in advertising their economic resources and industries'.[20] The most significant financial contributors to the Fair, apart from the British government, notes Deborah Hughes, were British industrialists and their investors as they scouted opportunities to grow their inter-imperial markets and develop contacts with investors in Africa, Australasia, Asia, and the Caribbean.[21] Arguments concerned with trade and profit sought to convince Ireland to participate despite the imperial ambitions of the 1924 event.

Cavendish argued that if Ireland agreed to exhibit, it would be depicted alongside the other five self-governing dominions (Canada, Australia, New Zealand, South Africa, and Newfoundland). Their pavilions hoped to illustrate 'the existing position of [each dominion's] industries, and the opportunities of which advantage might be taken for the expansion of [their] trade and the development of [their] resources'.[22] Cavendish enthusiastically described the enterprise as 'afford[ing] a valuable impetus to trade and promot[ing] in no small measure the mutual interests of the British Commonwealth of Nations' after each dominion financed the cost of their pavilion.

However, the Free State refused to take part in the Wembley Exhibition and instead protected its newly found independence. Months and then years of political wrangling by the Exhibition Affairs Industry and Commerce

Committee to solicit the Free State's participation in the display followed. Cavendish and others argued that there were economic benefits to exhibiting and a degree of national status would be conferred, while insisting that Ireland's absence would harm the unity of Britain's dominions. Early in 1923 the Free State provisionally agreed to participate in the Exhibition, and their involvement was initially estimated at 'an expenditure not exceeding £30,000 [by the *Dáil*]'.[23] However, there was significant disagreement over the cost of the country's Pavilion, and the Free State withdrew their decision citing economic constraints post-conflict.

The Irish Minister of Industry and Commerce, Joseph McGrath, wrote in March 1923 that 'difficulties arising from the present condition of the country in organising an adequate display of its products and industries [render] the participation of [the Free State] ... impractical'.[24] Consequently, Sir Travers Clarke (Deputy Chairman of the Exhibition Committee) engaged in protracted negotiation to reduce the cost of the Free State's involvement. He sought to increase the contributions made by the British government and reduce the size of the Free State's Pavilion to lower the rent. Letters repeatedly informed that 'all the countries, dominions and colonies of the British Commonwealth of Nations, except the Irish Free State, Gambia and North Borneo', were exhibiting, and so the absence of the Free State would be a disaster.[25]

In January 1924 organisers offered the Irish Free State the Civic Hall for their Pavilion: 'very fine ... with a floor space of approximately 10,000 square feet' at the head of the Western Avenue.[26] Clarke held that the Civic Hall would also feature the resources of Scotland and Wales and offer 'specially [sic] intensive propaganda' at a lower cost. The High Commissioner in London, James McNeill, carried out the arrangements for the Free State's Pavilion. McNeill argued that 'even if the net cost to the state rose to £5,000 [at most] the advertisement would be more valuable than newspaper adverts costing the same amount'.[27] McNeill further argued that 'a reputable and valuable exhibit of Irish produce and manufactures' was desired, and 'if no effort [wa]s made to use this means of advertisement there w[ould] not only be loss by default but loss by antagonism'. Organisers hoped that the Civic Hall location would rectify earlier concerns by McGrath that too small a space would 'neutralise' the advantages of an Irish display as 'the importance of *Saorstát* trade in relation to Great Britain and the Dominions would be unduly depreciated'.[28]

Dáil Éireann repeatedly discussed participation.[29] Concerns over 'loss of advertisement' were paramount as the fledgling Free State could have advertised the country's trade and resources to stimulate much-needed commerce and investment, whether through business or tourism.[30] James Hatchell's memorandum on the British Empire Exhibition described it as

a 'vast window display' for the dominions. The memorandum reported that the other dominions were all participating, with around 20–150,000 square feet of space respectively. Australia and Canada had 150,000 square feet each, New Zealand had 40,000 square feet, and Burma 22,000 square feet.[31] Hatchell noted that if the Irish Free State did not want to share with Scotland and Wales, 'there [wa]s a general Agricultural Section which [could] be useful for displaying any articles which could not be housed in the Irish Free State Pavilion'. By late 1923 the Governor-General of the Irish Free State wrote that there was little enthusiasm in the Exhibition by the Free State's various industries and shipping and railway companies. They concluded that 'since traders and manufacturers [were not taking] interest in the matter [it was] unlikely that any great commercial advantages would result from [the Exhibition]'.[32]

Confidential meeting minutes reveal that the British Exhibition Committee was tacitly aware that it was more than just lack of public interest that prevented Irish participation: 'the question appears to the Ministry largely a political one'.[33] The new state's reluctance to ally itself with the British Empire meant that arguments for Irish participation which emphasised that 'abstention seem[ed] to be neither good politics or good business' were ignored.[34] After all the discussion and debate, the Free State did not exhibit in 1924 because 'the name of the exhibition d[id] not attract', according to Hatchell. The British government objected to the Free State's abstention, but for the smaller country inclusion in Wembley may have suggested an Irish camaraderie or perhaps subjugation to the imperial power in the aftermath of partition and war.

In the decade after 1921, Ireland played a major role in expanding the constitutional independence of the Commonwealth. Deirdre McMahon has shown that Ireland pushed for the Balfour Report of 1926, which stated that Britain and its dominions of Canada, South Africa, Australia, and the Irish Free State were constitutionally equal to one another: as 'autonomous Communities within the British Empire' and 'in no way subordinate one to another in any aspect of their domestic or external affairs' and 'freely associated as members of the British Commonwealth of Nations'.[35] The Report was a decisive move in disavowing the disputed appendages of the British Empire for the dominions and an important step for Ireland to achieve greater sovereignty.[36] The Report became law in the Statute of Westminster of 1931 which repealed the right of the British Parliament to legislate for the dominions and became the founding document of the Commonwealth.

For the new Irish Free State, dominion status was contentious, and its independence already came with the largely reviled oath of loyalty to the British Crown.[37] Commonwealth membership, for some Irish nationalists, signified a partial continuation of British rule, and the Free State's refusal to

exhibit alongside the British Empire in Wembley prevented any further association with the imperial nation, either voluntary or forced. Any allegiance with Britain through the 'display [of] the Natural Resources of the various countries within the Empire and the activities, industrial and social, of their peoples' was actively avoided by the Irish Free State and the architects of its new independence.[38] While the potential financial profit of advertising Irish products dominated its exhibits from the 1850s, the interwar period saw a new Irish nation committed to their sovereign independence and a separation from Britain even at the cost of precious trade.

Following the Free State's absence in the 1924 British Empire Exhibition, Ireland emerged in the 'Ulster Pavilion'. All of Northern Ireland lay under the identification of 'Ulster', which offered a distinctive unity to the various provinces and also conflated the industrial abilities of the region with the larger country. The Pavilion was situated in the Palace of Industry (one of the largest buildings in the entire Exhibition) that covered over ten acres and 40,000 square feet (Figure 4.2). The British flag and the flags of the countries of the world flew prominently atop poles, evoking the internationalism of the Fair and its global audience. A steady stream of visitors, on the walkways, the bridge, and inside the Pavilion, reflected the popularity of the Exhibition more broadly. The Palace of Industry featured the raw materials

Figure 4.2 Palace of Industry ('Official Guide to the British Empire Exhibition, 1924', 1924, p. 23)

of Britain's Empire, and 'every form of industrial activity in [the Empire's] Islands [wa]s represented'.[39]

The Palace of Industry sat along the North Walk next to exhibits of textiles, jewellery, and gas, with a large chemical section neighbouring the displays. The South Walk had exhibits of pottery and glass, sports and games, rubber, domestic utilities, leather, and food. Northern Ireland was therefore foregrounded within the bustling heart of imperial commerce depicted in the fairground. Ulster's Pavilion covered 6,187 square feet and revealed 'the unique status of the Government of Northern Ireland ... by the fact that instead of exhibiting in a separate pavilion the government preferred to come under the wing of the Mother Country and show Ulster's resources beside those of the United Kingdom', according to the *Official Guide*.[40]

A vast bureaucratic enterprise founded the display, which reveals a continuation in organising practices from the early-twentieth-century exhibitions. In November 1922 a Central Committee formed to decide the nature of Northern Ireland's participation in the Wembley Exhibition, consisting of nominees from various trade associations and the Chamber of Commerce in Northern Ireland. The Central Committee appointed an Executive Committee of traders and manufacturers, and it sent invitations to participate in the Exhibition to several associations, bodies, and individual firms representing the country's assorted industrial branches.[41] Advertisements to exhibit also appeared in multiple newspapers throughout the Six Counties. The *Mid-Ulster Mail*, the *Belfast News-Letter*, and others each ran several printed announcements calling on: 'All associations, firms and persons desiring to rent space in the Ulster Pavilion, [to] apply to the Ministry of Commerce, no later than 31 August 1923'.[42] The Parliament of Northern Ireland gave £5,000 for the rent of the Pavilion, and the exhibits were organised by individual companies.

The Pavilion was near the entrance of the Palace of Industry, and *Ballymena Observer* affectionately described it as the 'Donegal Place of the Exhibition'.[43] It contained a range of the arts and industries of Northern Ireland to educate visitors on the 'the idea of Ulster as an entity' and 'to acquaint them with Ulster people and their achievements'. The wording here is crucial: the presentation of Ulster as an 'entity' positioned it as separate from the rest of Ireland, namely the Free State. In the exhibit Northern Ireland's union with Britain emerged as an assurance of its loyalty following the divisive violence of the successive wars, the treaty, and partition. Various newspapers discussed the Pavilion's unionist stance: the *Ballymena Weekly Telegraph* explained that the site was 'chosen in order to preserve the idea that Ulster although enjoying political autonomy [wa]s still an integral part of the United Kingdom' in opposition to the Free State's new independence.[44]

Northern Ireland's valued relationship to Britain materialised symbolically and architecturally within both the exhibits and the design of the Pavilion itself. The Pavilion featured two grand entrance porticoes to its south and east. 'Above the colonnaded entrance of the south portico ... [wa]s emblazoned the Red Hand of Ulster between two symbolic devices of trireme form', and the words 'Ulster Pavilion' featured in gold above the entrance. The patriotism of Ireland was continually signalled visually and textually, but a distinctive Irishness was maintained. Outside the building, the Arms of Belfast and Londonderry stood proud, and the walls contained paintings of the heraldic arms of the chief cities of the Province.[45] Overall, the aesthetics of the Ulster Pavilion identified its close partnership with the United Kingdom, but within an Irish selfhood.[46]

The Pavilion depicted Northern Ireland as a 'commercial and industrial centre' through a display of its chief industries: linen and shipbuilding.[47] Contemporary literature positively received the linen exhibits: the *Official Guide* described Northern Ireland as the 'hub' of linen manufacture, evidenced by the fact that it owned over a million spindles. The Pavilion specifically contained dress linens of various colours, damask fabrics of 'surprising loveliness', table and bed linen of different varieties, handkerchiefs, embroideries, 'all the textile marvels for which Ulster is famous'.[48] Not only were Irish products exhibited in 1924, they were also manufactured in the Exhibition by workers; an electrically driven power-loom wove damask napkins inside the Pavilion for immediate sale as Exhibition souvenirs in a dynamic circulation of Irishness. Moreover, the Pavilion's commissioners dressed entirely in linen to extend sales of the fabric. The personification of Irish industry extended to 'A pretty Irish colleen [who could be] seen working at embroidery' – making real the process of manufacture.[49] The Wembley Exhibition demonstrated a continuity in using the body as a source of replication that emerged in Ireland's display in the 1893 Chicago Fair. Irish men and women therefore profitably enacted an embodiment of Irishness over successive decades. The 'linen [exhibit stimulated] immediate attention' through an interaction of object and person, together producing an attractive and lucrative Ireland.[50]

The shipping exhibit contained a large-scale model of Belfast harbour that recreated cross-Channel steamers arriving and departing between English, Scottish, and Belfast ports.[51] The realistic model sought to encourage the use of its transport services (built on a scale of fifty feet to one inch). It also included famous shipbuilding yards and a miniature modern leviathan to solicit global trade. The *Belfast News-Letter* described it as 'a remarkable ocular demonstration' that successfully 'conjure[d] up the vision of a real launch'.[52] Education and play worked in partnership to solicit interest and investment with Northern Ireland. For instance, the exhibit of

the rope, cordage, and twine industries of the country saw 'two girl workers demonstrat[ing] the manufacture of nets for fishing and other purposes'. Again, while the popular practice of exhibiting female workers in earlier Irish villages had traction decades later, by the twentieth century, ideas that rural female labour would miraculously save Ireland had dissipated, and a mechanised economy was instead prioritised.

A global capitalism united the project to sell Ireland and its products whether through trade nationally or the purchase of souvenirs locally, and so larger ideologies of Irish unionism and its closeness to the British Empire permeated the display. Aside from the bodies of Irishwomen, Northern Ireland's trades such as tobacco, whisky, aerated waters, soaps, candles, woollen goods, jams, and biscuits, among others, were showcased. The transfer of goods in exhibitions, argues Julie F. Codell, was part of wider 'processes of communication, transportation and imperialism' represented using 'intense visualisation [in] commercial and museum display systems, photography, illustrated magazines [and] newspapers'.[53] Building on this argument, the representation of Northern Ireland's industries purposefully blended the material and textual. Irish men and women became part of the display by performing various industries and humanising mechanisation, thereby embodying a living form of promotion for their country and its allegiance to Britain.

A large diagrammatic map of Northern Ireland comprehensively visualised the Province's wares: 'upon which the distribution of industries, the locality of pleasure resorts, railway and steamer routes [we]re lit electrically in turn'.[54] Friezes of Northern Ireland's industries of shipbuilding, linen, flax, and tobacco decorated the interior of the Pavilion. The *Northern Whig* described it as a 'harmony of colour'; however, the author criticised the absence of authenticity in recreating the County Down atmosphere as there was a '[lack] in smell'.[55] Crucially, visitors to Ireland's Pavilion in the 1924 Exhibition expected to see familiar stereotypes and prejudices of the country, as indicated by these comments. An absorbing experience was on offer to visitors whether through the objects or Irish women, and some visitors objected to the lack of sensory stimulation which negatively tempered the realistic effect of the Ulster Pavilion. Smells may have circulated in the agricultural section of the exhibit, which contained eggs, potatoes, and grass seeds for those who wanted a more immersive visit. An art section also displayed pottery and paintings by Northern Irish artists to complete the composite vision of the country.

The Ulster Pavilion received prominent visitors such as the Queen, dukes, ministers of commerce and finance, the Lord Mayor of Belfast, various chairmen, managers, presidents of large corporations, and leaders of different associations.[56] The *Ballymena Observer* described the Ulster

Pavilion as 'a centre of attraction to visitors from every corner', which may have reflected the successful enterprise of the cheap fares advertised by rail, shipping, and tourist companies.[57] Lady Craig (wife of the Prime Minister of Northern Ireland) celebrated that the Pavilion revealed 'the high place Ulster occupie[d] in the industrial world' and also the 'prominent and worthy … position [it held] among the industries of the Empire' to innumerable visitors.[58]

Prime Minister James Craig's (1871–1940) attempts to establish a predominantly Protestant unionist administration and parliament, after northern nationalists refused to recognise the state, underscored Northern Ireland's presentation in 1924. A populist rhetoric that defined Northern Ireland in contrast to the Catholic nationalist South, argue Holmes and Biagini, emerged in response to widespread unemployment and social deprivation during the Great Depression.[59] The heightening polarisation of partition politics saw around one-third of Southern Protestants leave the Free State by 1926, and the increased hostility between the two countries bolstered the separate identification of Northern Ireland as part of the United Kingdom in the Wembley display.

In direct opposition to official Exhibition literature, some Northern Irish visitors levelled concerted criticism of the Ulster Pavilion. Robert McKeown (Parliamentary Secretary to the Ministry of Commerce and Production for Northern Ireland) noted that 'he had heard some people say [that the Northern Ireland Pavilion] was splendid and others say that it was not at all representative'.[60] Criticisms of Northern Ireland's display encompassed two related strands: one that the Pavilion suffered negatively by comparison to the other exhibits in design and product; two that the exhibits were unrepresentative of the Province's industries. For instance, a harsh review in the *Northern Whig* claimed that the 'exhibit put up by the whole linen trade of Northern Ireland [wa]s eclipsed by that of one single linen firm from Scotland'.[61] This 'discredit[ed] Ulster' and gave 'an entirely wrong impression to [visitors] of the status and importance of Ulster industry' because Ulster had 'small[er] floor space' than the other countries. Even Belfast's reputation as the 'world's greatest linen centre' remained unknown in its exhibit as it 'suffer[ed] [in] comparison with the high standards which other exhibitors … set up'. Similarly, a contemporary visitor to the Exhibition, Robert Angus, called the Pavilion 'a travesty of Ulster industry' as '[they we]re inadequately represented and g[a]ve no true picture of their size and importance'.[62]

Yet the *Belfast News-Letter* described Northern Ireland's Pavilion as an 'outstanding success' and positively commented on the 'endless stream of people – English, Scottish, Welsh, Dominion, and foreign [who] passed through … to inspect the fascinating exhibits within'.[63] The divergent

opinions may be explained by a number of reasons. Perhaps some felt that Northern Ireland had sacrificed its industrial capacities for identification with Britain and a separate pavilion (not one located in the Palace of Industry) might have been more appropriate. The Pavilion did not emphasise the diversity of Northern Ireland and prioritised a homogeneity with Britain in order to dichotomise the distance between a Gaelic Catholic South and a Protestant Northern Ireland, perhaps to the frustration of some contemporaries in 1924. A dual separation emerged in the country's exhibit to create a distinct Irish economy and culture, but also to maintain a separation from the Free State to secure a stronger relationship with England. Clearly, conditions of Irishness were readily contested, and a greater disapproval of Northern Ireland's allegiance to Britain or unsuccessful attempts to adequately display the country might have underscored these criticisms.

The British Empire Exhibition was reopened for a second season from 9 May to 31 October 1925 because the organisers made a loss of more than £600,000 and sought to recoup some of their investment.[64] The Exhibition was largely the same as the previous one, and over twenty-five million people visited the Wembley Exhibition over the two years of its display.[65] Northern Ireland's new exhibit addressed the criticisms of the preceding year; the British government doubled the floor space it occupied to 12,825 square feet in the Palace of Industry. Many of the Ulster Pavilion's features were similar to the 1924 display but on a larger scale, and it was often described as 'bigger and better'.[66] The *Northern Whig* reported that UK exports to the overseas parts of the British Empire had increased after the 1924 Exhibition, although I have not been able to verify this, and the claim was likely circulated as propaganda for the Exhibition.[67] Moreover, Archdale informed the *Ballymena Weekly Telegraph* that Ulster's export trade benefited through 'a sustained co-operative advertising effort' as 'it had been abundantly proved that good publicity could indeed create a demand'.[68] This may have been a rebuke against the Free State who again refused to exhibit despite the promise of trade and profit from advertisements.[69] Aesthetically, the Pavilion's decorations and colour scheme were similar to the 1924 Exhibition, but the increased size made it 'stand out like a detached building' as it had a 'much more imposing and extensive frontage on the main avenue'.[70] The larger size may have rectified earlier discontent as there was no sustained disapproval of Ulster's Pavilion in the 1925 British Empire Exhibition as occurred in the previous year.

Northern Ireland's pavilions in the two Empire Exhibitions of the 1920s reveal that popular symbols of Ireland easily recognised as 'Irish' readily circulated in the interwar period. World Fairs, argues Carol Breckenridge, created new forms of seeing and constructed objects for the exclusive purpose of commerce and the nation-state.[71] Extending this argument through Northern Ireland's display, Irish images, and economies such as linen,

shipping, or Irish women became synonymous with Northern Ireland in negation of the Free State. Whether or not this had any tangible effect on trade to and from the Province was unclear, but Ireland's exhibitions packaged the Irish brand in an accessible manner. The symbolism and motifs of the Union distinguished Northern Ireland from the Irish Free State to assure Britain of the country's loyalty and closeness. The display exhaustively expounded a Northern Irish identity allied with Britain and separate from the Free State.

Ireland in the 1930s

In the 1930s the Free State was formatively shaped through domestic and foreign policies, and historical discussion on interwar Irish–British relations is divided.[72] The Free State's exhibits in the 1930s proves that there was a continuation between William Cosgrave's (1880–1965) *Cumman na nGaedheal* party and Éamon de Valera's (1882–1975) *Fianna Fáil*. While Cosgrave laboured to reformulate the Commonwealth, de Valera's strategy heightened the separation between the Free State and the Commonwealth following his policy of external association.[73] External association referred to an ideology that 'Ireland would be associated with, but not be a member of, the British Empire'.[74] D. W. Harkness has argued that de Valera pursued a unilateral stance, whereas Cosgrave sought change through bilateral agreement.[75] There was a continuity in Irish policies relating to autonomy, economic development, and modernisation between the two governments. Specifically, de Valera's campaign of increased national independence did not immediately confer a republican status to the Free State; however, he did abolish the oath to the Crown and played a vital role in discussions over the characteristics of dominion status and its relationship to Britain.[76]

The small nation of independent Ireland became a notable figure on the world stage. For instance, in the realm of international diplomacy, by 1930 the Free State sat on the Council of the League – building on its previous membership of the League of Nations in 1923 under Cosgrave.[77] De Valera's campaign for increased social and economic independence from Britain saw the Irish Nationality and Citizenship Act of 1935 replace British citizenship with Irish, which reinforced a separate Irish identity in legal terms.[78] His government pursued socially conservative policies that focused on the Irish language in education and administration.[79]

The Anglo-Irish Economic War (1932–38) began when de Valera's government stopped the payment of land annuities to Britain (around five million per year), arguing that it was the money of the Irish Free State.[80] Consequently, the British government enforced exorbitant tariffs

on agricultural exports from the Free State, such as cattle. A retaliatory policy ensued with de Valera restricting various British imports, and both sides escalated the Economic War with different sanctions, embargoes, and restrictions. The strategy of intensifying reprisals ended with the 1938 Trade Agreements. Negotiators finally resolved that ports retained under the 1921 Treaty would be returned to the Irish, and the land annuity fees would be cancelled in return for a one-off payment of ten million.

In the realm of the social and political, de Valera announced a new constitution in 1937 that removed almost all references to the King and instituted a central place for the Catholic Church in the Free State.[81] In a bid to maintain unity, the British government insisted that the new constitution did not impact Irish membership of the Commonwealth. Crucially, de Valera politically claimed all of Ireland, regarded partition as temporary and illegitimate, and maintained that the island of Ireland was a thirty-two-county one rather than the twenty-six counties of the Free State.[82] Overall, in the 1920s and 1930s, Canada, South Africa, and the Irish Free State worked to equate dominionhood with complete independence in a period of 'constitutional argument, innovation, and advance'.[83] The Free State sought to revise and formulate its relationship with empire not only through policy but also via cultural means, and I now consider how Irish displays reflected and accommodated the Free State's negotiation of its dominion status in the British Commonwealth of the 1930s.

1938 British Empire Exhibition, Glasgow

The interwar period's second official British Empire Exhibition opened from 3 May to 29 October 1938 in Glasgow's Bellahouston Park. The two territories of the island of Ireland unusually featured in the 'complete extent of the variety, colour and dimensions of the British Empire [in the Fair]'.[84] This was the first appearance of both countries of Ireland in a single international exhibition. The two nations imagined their relationship to the British Empire along distinct trajectories. The Free State emphasised a distance from the imperial project, whereas Northern Ireland demonstrated a closeness to the British Empire. Specifically, the Free State used its varied exhibits to showcase the benefits of independence in accordance with de Valera's policy of external association. While Northern Ireland highlighted the country's economic industries that relied on the Union in its exhibits.

The Glasgow Exhibition covered 175 acres (Figure 4.3) and attracted twelve million visitors. The pavilions were grouped around the left side of the grounds, and green space featured on the right. The buildings stood within a concert hall, cafés, and tea stands. The Scottish Development

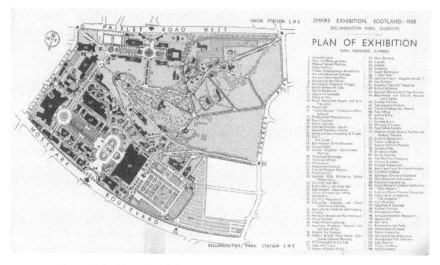

Figure 4.3 Plan of Exhibition (manuscript 'Official Catalogue of the Empire Exhibition, Scotland, 1938', 1938, p. 3)

Council centrally organised the Exhibition, which was a non-political organisation comprised of local authorities, commercial bodies, representatives of trade union organisations, industrialists, and private individuals. Glasgow, Aberdeen, Dundee, Perth, and a host of other municipalities, as well as individual firms, contributed to the Guarantee Fund of £750,000.[85] Like previous empire exhibitions, Glasgow displayed a '[characteristic] selection of the foodstuffs and raw materials of the Empire overseas and its potentialities, social, industrial, and economic' as well as the 'latest developments in the industrial equipment of the Home Country'.[86]

The 1938 Exhibition operated on a dual national and international front; to 'See the Empire at your door in its exhortation to the Scots who still live[d] at home' – reminiscent of the 1850s fairs that sought to inspire Irish citizens to compete with the empire's industries. In official Exhibition literature Glasgow was often described as 'One of the greatest industrial centres and ports in the British Empire' – heralded as the 'Empire's Second City'.[87] The types of buildings that the two countries occupied reveal their connection to empire. Northern Ireland's unionist position saw it exhibit in the Industries, Shipping, and Travel Pavilion and the Agriculture, Fisheries, and Forestry Pavilion. It was next to general exhibits of the 'raw materials, finished products, fauna and flora, scenic beauties and cultural achievements of the countries of the British Empire'. Whereas the Free State's independence was embodied in a separate Irish Pavilion in the 'fairyland of beauty' of the 1938 British Empire Exhibition.[88]

Similar to the 1924 display, there was significant debate over the Free State's participation in the Glasgow Fair.[89] Deliberations centred on the themes discussed previously such as the value of display to the Free State economy, the costs of a pavilion in the context of poverty, unemployment, and mass immigration, and more implicitly the problems of exhibiting alongside the British Empire.[90] At early meetings in 1937, the Minister for Industry and Commerce and the Minister for Agriculture argued in favour of participation on the grounds of international diplomacy. They insisted that Commonwealth competitors in the British market such as Canada, Australia, and New Zealand had pavilions, and the absence of an Irish display 'would be marked [negatively] by the general British public particularly in Glasgow and surrounding districts where a large proportion of Irish eggs, butter and bacon [was] sold'.[91] These arguments of trade and prestige echoed the discussions that took place in the 1920s.

Initial estimates suggested the cost of a separate Irish Pavilion (of at least 5,000 square feet) was £5,000, to be paid for by the Irish government, not private firms. Canada spent at least £20,000 on its Pavilion and South Africa about £10,000.[92] The Irish Exhibition Committee argued that a maximum cost of £15,000 'would be small relative to [Ireland's] total export to the British market' (about twenty million pounds worth), and so participation made sense from a trade perspective.[93] A secondary aim of the Exhibition was 'to demonstrate the national progress of the participating countries', and this finally secured the Free State's display in Scotland.[94] The 1938 event moved beyond an Exhibition of Empire and encouraged the individual agency of the participating countries. The Irish Executive Council solicited exhibits that served the 'dual purpose of trade and national publicity and prestige'.[95] Ireland's display did not focus on investment and development like previous exhibitions of the country, and instead highlighted the country's dominant position in global trade. Britain already bought Irish cattle, horses, eggs, butter, and bacon in vast quantities, and the country's display aimed to expand the market for its products as part of de Valera's policy of external association.

The Free State Pavilion demonstrated the country's economic and national independence through exhibits related to its agricultural and industrial products, an Irish history, tourist attractions, displays of industrial production, aviation, electricity, and the mining of turf. The Free State's national status was conferred by its closeness with other Commonwealth countries in Glasgow, and developments in Ireland contributed to greater sovereignty for emerging dominions, notably in India.[96] Different to earlier displays, the country's exhibits presented an assertive, prosperous Ireland with valuable economic and religious capacities as an independent nation. Ireland had 'arrived' and its presence in the Exhibition was to celebrate not to improve, to display Irish strength and prowess.

Three and a half million people visited the Free State's Pavilion in the 1938 Exhibition, including repeat visits by season ticket holders (about 125,000).[97] The Exhibition coincided with the signing of the Anglo-Irish Trade Treaty (April 1938) and boosted Irish–British diplomatic relations. J. D. Brennan, Staff Officer in the High Commissioner's Office, London, and Sean Keavy, Trade Inspector for Great Britain, organised the Irish Pavilion in Glasgow.[98] A competition to find the 'very best architectural brains of the country' secured an architect of Free State citizenship to design the Irish Pavilion.[99] The front of the rectangular building (Figure 4.4) was all white and bordered by a series of bays. Two prominently placed Irish flags dominated the façade, and balconies contained potted plants and small manicured trees. The signage read 'Ireland' in bold capital letters and evoked national confidence by visually claiming the whole island rather than just the twenty-six-county Free State. Smartly dressed men and women strolled in front of the Pavilion, signifying interest and approval. Ireland's display was architecturally simple and large in size and ambition.

The Irish Exhibition Committee considered exhibiting an Irish Village complete with an old thatched roof inn, a dairy farm, shops, weavers cottages, working exhibits of lacemaking and linen manufacture, a village road titled O'Connell Street, and a Blarney Castle. However, this was decided against; I read this as a rejection of the stereotypical representations of Ireland common to its displays in past international exhibitions. Irish independence signalled a new era in the country distanced from earlier negative

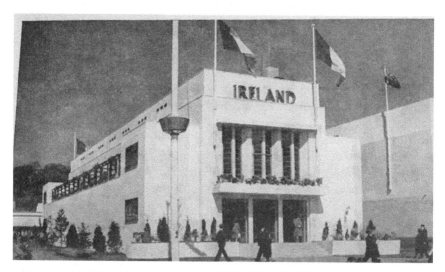

Figure 4.4 Irish Pavilion (manuscript 'Official Guide of the Empire Exhibition, Scotland, 1938', 1938, p. 142 – courtesy of the Glasgow Library)

discourse largely circulated by the British press.[100] The 1938 Exhibition was therefore an opportunity for the Free State to showcase its national modernity without the baggage of reductive discourses associated with the Irish landscape and the Irish people.

The Free State exhibit asserted its difference to both the Scottish exhibit as well as previous Irish exhibits by choosing not to construct an Irish Village in 1938, in a decisive statement of an Ireland opposed to its past identifications with the British Empire. Interestingly, Scotland's Highland Village, An Clachan, '[offered an] impression of the real old Scotland, the Land of the Gael, the Scotland that [wa]s fast passing before the relentless onrush of modernity'.[101] Similar to previous Irish villages, authenticity was key, and the Scottish organiser Colin Sinclair, imported 'plaster casts … from actual walls to reproduce cottages typical to those of Argyll, Skye and the Outer Isles'. Comparable to Ballymaclinton, a rural idyll emerged with white-walled structures, some 'grey with age, moss and linen'; there was also a post office, a shop, a smithy, and an inn. An ancient church and a stone cross signified a Scottish Gaelic heritage. A Gaelic-speaking population inhabited the Highland Village, and visitors could observe 'men mending the nets, making creels and the women tending their homes and spinning the yarn of the wheel'.[102] The similarities between Scotland's display and Ireland's extended to souvenirs; a collection of Highland tweeds and native crafts were on sale. The overlap in motifs of rurality in both the Scottish and Irish villages proves that certain logics of display persisted throughout the period. Similar to the early-twentieth-century Irish exhibitions, an immersiveness of country and person circulated and 'Plaintive songs of the Islanders' resounded, offering a 'mystic quality of the Isles of the West'. A continuation in profiting from cultural heritage evidently persisted.

The image of the Highland Village in the *Official Guide* (Figure 4.5) offers parallels to Ballymaclinton. Cottages set amid trees were surrounded by signs of activity around the post office, such as boats and paddles, as if in use. Curiously, in the background of the scene was a tall telecom building of concrete. Here, the dual project of tradition and modernity materialised for visitors. The placing of a modern structure directly behind the Village may have been an attempt to subvert criticism after viewing the exhibit that Scotland was a country stuck in the past. The juxtaposition of old and new illustrated Scotland's history as well as its position in the modern world alongside the technology and industry of the other participating countries. The possible negative connotations after viewing village life also concerned the Brown brothers at the start of the century. By the interwar period, the Free State's refusal to capitalise on an ancient, quaint, and traditional model of Irishness underscored its commitment to a modernist, independent project.

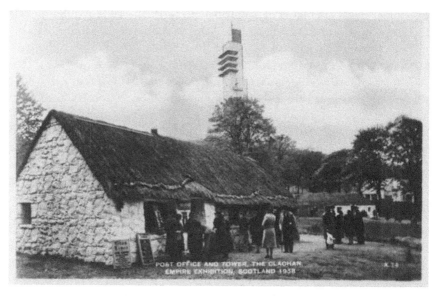

Figure 4.5 'Post Office and Tower, The Clachan. Empire Exhibition, Scotland 1938' postcard (courtesy of the Glasgow Library)

The Free State's rejection of an Irish Village in 1938 was financially risky as the Clachan was one of the few exhibits that made an overall profit in the entire Exhibition.[103] Nineteenth- and twentieth-century Irish villages created income by encouraging trade and investment in their Irish products as well as securing longer-term profit for Ireland by facilitating tourism. In 1938, however, organisers stimulated tourism by focusing on the beauty of the rural landscape, rather than the decaying Irish land and culture that typified earlier Irish villages and earlier iterations of tourism to Ireland. The Irish Tourist Association occupied a prominent position within the Pavilion, and a cinema in the Exhibition grounds showed several Irish films related to holidaying in the country.

Inevitably, the construction of an authentic Ireland remained a central concern of exhibition organisers in the interwar period. Efforts to offer an 'accurate picture of Ireland' meant that only Irish materials were used to furnish the Pavilion with Irish-made furniture, 'floor coverings … of marble, matting or carpets, … of Irish manufacture' and only Irish staff in attendance.[104] Bodily performance interacted with objects to extend the fiction of Ireland. An immersive atmosphere was cultivated, with sights intermingling with scents and sound.[105] A radiogram played Irish vocal and instrumental songs on loop, and 'subdued, hidden lights' and '[a] comfortable carpet underfoot' greeted visitors.[106] The Pavilion's organisers therefore made great efforts to envelop fair-goers in Irishness.

Once visitors were inside the Pavilion, they were exposed to a diversity of an Irish past, present, and future. Working models and relief maps illustrated the Free State's current industrial, agricultural, technological, and engineering products and developments. The contemporary world interacted with an Irish past – evoked with decorative church articles of stained-glass windows, marble floor pieces, vestments, metalwork, and a display of early ornaments such as replicas of the Lismore Crozier, the Shrine of Miosach, the Cross of Cong, and the Ardagh Brooch.[107] In a dizzying whirlwind of Irishness, visitors were again reminded of present Irish industry with displays of linens, lace, poplins, knitwear, embroidery, and tweeds. The effective representation of different temporal spheres, complemented by the material and the visual in the Pavilion, showcased Ireland to its fullest diversity.

Ireland's technological achievements featured in a wall map that illustrated the Northern Transatlantic air route, and the *Official Catalogue* declared that the 'Governments of the UK, Ireland, Newfoundland and Canada … and the US, [agreed that] all traffic in either direction over the Northern air route would pass through the Shannon Airport' – establishing the Free State as a notable partner in global affairs.[108] Should visitors be unconcerned with Irish technology, their interest was again piqued by art in the Pavilion. Lady Glenavy and Mainie Jellett painted colourful and innovative frescoes of Irish life that reimagined traditional scenes of farming, fishing, and spinning in abstract and modern designs. Dublin-born Protestant Jellett, notes Caroline Malloy, offered creative interpretations of an Irish culture adapted to a modern outlook.[109]

An Irish present was again aroused in the sale of butter, eggs, bacon, cheese, cream, and biscuit samples. The exhibit of Irish foodstuffs proved popular, and a total of 257,060 food items sold for four and a half million in total.[110] Visitors were therefore able to experience an Irish history, absorb an Irish culture, and consume an authentic Irishness – in this instance, food. As a 'practical advertisement' for Irish produce, 'several repeat orders were received' from those who had sampled the Irish goods at the Pavilion.[111] Therefore, practical profit became tied to Ireland's blend of natural beauty and industrial achievement in Glasgow. Malloy's contention that Ireland 'looked to the past, embraced the present, and projected Ireland into an international, multinational future through Jellett's artwork' is convincing for the Free State's politics more broadly.[112] Both in the 1938 Exhibition and in interwar domestic and foreign policy, de Valera's government laboured to frame Ireland as modern, progressive, and historically rich.

The alluring image of Ireland in the Pavilion with a precious Irish culture consolidated Irish products in the international market. The all-encompassing Free State section saw many high-profile visitors such as

Queen Mary (1867–1953), members of the royal family, and ministers of state, who added notoriety to the country's exhibits. Moreover, the *Official Catalogue* boasted that Glasgow had the 'largest external markets for Irish goods' and was 'home [to] many thousands of Irish exiles', and so 'a quarter of a million people in the West of Scotland [had] racial and religious connections with *Éire*'.[113] The positive response to the exhibit was in part created because of an affinity between the exhibits and visitors, whether Scottish locals or international guests.

Overall, a grand portrait of the Free State visually testified to the success of Irish independence and de Valera's policy of external association in 1938. A large number of the industrial classes visited the Exhibition from England and Wales through organised tours and excursions. The Irish Pavilion Report noted that '[In] June there was a large influx of school children from all over Great Britain', and around 20 per cent of the visitors to the Pavilion were 'money people' (read middle class).[114] Visitors did not fill in surveys of their economic background, so these statistics cannot be verified. However, the framing of the Pavilion as popular with the working class (roughly the remaining 80 per cent) suggests labourers were among the target audience, like Ireland's exhibitions in the 1850s.

It does not seem, however, that these visitors were encouraged to emulate the technology on display; they were not required to observe the lessons of the Fair in the same way that visitors to London, Cork, and Dublin were in the mid-nineteenth century. They were simply there to enjoy Irish achievement and join Ireland in their celebration. They did not have to act as saviours of the country, demonstrating that ideas of Irish development had largely dissipated by the 1930s since the country had already achieved a degree of industrial success, and it was only concerned with showcasing its triumphs. Further, whereas in the 1853 Dublin Exhibition the country's products were perceived by some as being insufficient and underdeveloped in comparison to the 1851 London Exhibition, the Glasgow Exhibition forcefully rejected these arguments. Visitors of varied social backgrounds witnessed a 'vivid … idea of the progress made [by the Free State] in industry, culture and social development'.[115] Ireland had developed, and a new Irish nation was celebrated by 1938.

Irish men and women disagreed over the style and cost of Northern Ireland's participation in the Glasgow event. John M. Davidson of Belfast petitioned for a separate pavilion to highlight Northern Ireland's economic and national utility in the United Kingdom. However, 'neither the government nor representatives of local industrial and trade interests [offered] the necessary financial backing'.[116] Belfast only gave £1,000 to the Exhibition, and so the *Northern Whig* complained that the country's display was not 'commensurate with its importance as a unit of Empire'.[117] Instead of a

separate pavilion, the Northern Irish Exhibition Committee 'organise[d] two separate exhibits' – one in the Agriculture, Fisheries, and Forestry Pavilion, where Ireland exhibited her farm and dairy produce combined with England, Wales, and Scotland.[118] The other was in the Industries, Shipping, and Travel Pavilion, where Northern Ireland exhibited 'her scenic beauties and industrial potentialities' (Figure 4.6) related to tourist interests.[119] The lack of financial and public support meant that Northern Ireland was obscured next to a cinema and a restaurant.

Northern Irish businesses may have prioritised their investment elsewhere as the country underwent economic stagnation in the interwar period.[120] While some may have considered exhibitions to be a frivolous endeavour, the absence of enthusiasm did not deter the few patriotic organisers. Northern Ireland's exhibits sought to 'bring home to the visitor with unmistakable effect ... the industrial quality of the Province, its wide-range of existing industries and suitability for new ones; [and] the superb attractions of [the country] as an arcadia for the tourist, the golfer and the fisherman'.[121] Unlike the Free State Pavilion, Northern Ireland wanted to 'make known both the present productive resources and the untapped potentialities of the Province' and not simply celebrate its current state. The priorities of the two parts of Ireland were notably demarcated: the Free State championed its independent wares, and Northern Ireland continued to solicit trade and investment allied to Britain.

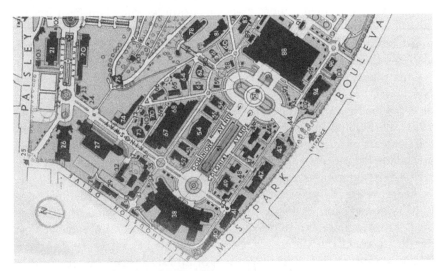

Figure 4.6 41: Industries, Shipping, and Travel; 42: Agriculture, Fisheries, and Forestry ('Official Guide of the Empire Exhibition, Scotland, 1938' – courtesy of the Glasgow Library)

The reception of Northern Ireland's Pavilion in 1938 resembled the divisive responses to the country's exhibits in the 1924 British Empire Exhibition. The *Official Catalogue* declared that 'Ulster is strongly represented ... emphasising her identity as part of the United Kingdom', and while the King, Lord Craigavon, and 'several distinguished visitors' received 'great satisfaction' by the exhibits, Alderman Henderson (of a unionist background) described the display as a 'disgraceful inefficiency'.[122] He complained that financial contributions had been 'squandered and destroyed' and denounced the exhibit as occupying 'merely a corner'.[123] Henderson claimed that there were only 'a few dummy bottles of whisky and "not enough rope to put up a line for a dozen people in a side street"'.[124] He emphasised that it was the country's exhibits that bore fault, not the country's industry, as 'the greatest linen place in Northern Ireland [had less space than] a Belfast shop window'.

Contrastingly, Henderson described the Free State exhibit as 'equal to any of the Dominions of the British Commonwealth of Nations'. He ended by stating that 'At the Free State Pavilion the visitors were given bundles of pamphlets but at the Ulster stand they got nothing, "not even a glass of water".'[125] There is no evidence that 'tens of thousands of Ulster-men bowed their heads in shame when they saw the display', but the response highlights the polarised opinions of Northern Irish citizens.[126] Some who perceived the country's union with Britain as a productive relationship perhaps saw the benefits of an integrated display within the Empire's exhibits. While others who may have wanted a more independent outlook for Northern Ireland possibly desired an autonomous set of exhibits.[127] Northern Ireland's disputed reception broadly reveals the contested politics of visitors to the Glasgow Exhibition.

Importantly, comparing the two Irish displays immediately places the Northern Ireland exhibits at a disadvantage as the Free State Pavilion was on a dominion scale, in the same way that comparing London's display in 1851 and Dublin's in 1853 offered unfair comparisons due to the financial contexts of the respective countries. Therefore, visitor responses reflect immediate judgements more useful for appraising their politics and the concerns of the exhibitions' organisers over the quality of the display itself.

There were early plans for Northern Ireland to join with the Free State in 1938 and expand its display by demanding 'the rights and privileges of the British Commonwealth of Nations'; however, this was decided against due to irreconcilable differences between the two countries.[128] Northern Ireland's prioritisation of its union with Britain set against the Free State in the Glasgow Exhibition was a determined and costly effort. Unionist propaganda during the Home Rule period, notes Henry Patterson, emphasised the distinctive traits of the Protestant population as creating economic

development since they were the 'embodiment of honesty, hard work, resolution, and resourcefulness' compared to the 'lazy' Irish Catholics.[129] Such historical prejudices partially continued in the post-1920 era following partition.

Efforts to emulate this narrative in Glasgow may explain the presentation of Irish exhibits in Britain's pavilions to illustrate the closeness between Protestant England and Northern Ireland. Moreover, some unionists explained Irish economic and social underdevelopment as the result of Catholic violence and perceived criminality. This may have underscored desires to present the country as separate and distant from the Free State in interwar exhibitions. Northern Ireland's display within Britain's exhibits points to the hold of historical discourses related to the 'regional and psychological distinctiveness' of Northern Ireland as well as broader political and religious tensions with the Free State. Northern Irish organisers refused concession to Free State identification in a heightening of nationalist tension between the two countries.

Irish citizens from industrialists to councillors disagreed over Northern Ireland's display in the clearest example of the continuing tensions surrounding the new nation. Some celebrated that there was 'no dull corner' in Northern Ireland's display.[130] Over 35,000 visitors signed the visitors' book, and many commented on the whisky-distilling exhibit as a highlight. The butteries exhibit uniquely featured an Irish homestead modelled in butter by a local trader named Bickerdike, and the *Northern Whig* reported that it was 'a definite hit with visitors'.[131] Yet Councillor F. Lavery, among others, argued that the display did not 'show that Ulster was the centre of five of the largest industries … in the world', and Councillor J. Kilpatrick described the exhibits as in 'no man's land'.[132] Finally, Guy Locock, Director of the Federation of British Industries, exclaimed that the linen display was a 'revelation … for beauty both of colour and texture', and the General Manager of the Export Credit Guarantee Department 'congratulated Northern Ireland on the excellence of the display'.[133] Overall, issues of the Union and the broader question of partition plagued the country's exhibit in 1938 and created passionate disavowals as well as laudatory appraisals representing larger trends of a contested Northern Irishness.

It is interesting to consider whether the lack of support from Irish industrialists, businesspersons, and municipalities could be explained by the *Belfast News-Letter*'s speculation that there was undue reliance on government, with a 'spirit of helplessness possess[ing] the community' in the interwar years.[134] However, this broadly reveals the continued influence of free trade discourses that were popular in the nineteenth century and held the individual to be responsible for industry and progress rather than the state. Northern Ireland's economy suffered significantly in the 1920s and 30s: the

staple industries of the country were left to expire, there were problems of rebuilding after violent conflict, and the country's natural resources were not being mined.[135] Within this context, the country's less extensive and disseminated set of exhibits in 1938 and the conflicting opinions on Northern Ireland's display reflect larger discontent with the Northern Irish government by its citizens and hostility to the Free State in a unionist nationalism.

1939 New York World's Fair

In the New York World's Fair of 1939 (30 April 1939 to 27 October 1940), the Irish Free State and Northern Ireland featured in the display, albeit separately.[136] Continuing the trend of previous exhibitions, Northern Ireland presented its Union with Britain as central to its political and cultural identity, while the Free State used experimental architecture to illustrate the success of independence. The Fair presented a 'clear, unified and comprehensive picture of the epochal achievements of … civilization in the fields of art and literature, of science and industry, of government and the social services' – this time over a mammoth 1,000 acres to over forty-four million visitors.[137] The event was described as 'Futuropolis' with its focus on technical progress, and the two countries depicted their national histories and present industries within a vast technological modernity.[138] This was the final amalgamation of a displayed Irishness in the interwar period.

Questions of Free State participation created heated discussion between the Exhibition's organisers and the Free State government. In 1935 the Irish Consul in New York, Leo T. McCauley, invited Ireland to participate in the 1939 Fair; however, both this and the official invitation sent to the Irish Department of External Affairs a year later were ignored.[139] In 1937 the Consul again beseeched the Secretary of the Department, arguing that 'the question of prestige is involved and the absence of an official Irish government would be noted and resented especially by the Irish-American population of New York.'[140] After intense deliberation, in August 1937 Ireland agreed to take part in the 1939 Fair. Historian Sean Rothery explains that there was 'energetic lobbying and manoeuvring to make absolutely sure that Ireland's Pavilion would be as far away as possible from anything to do with "Empire"'.[141] The display thus became an essential part of de Valera's broader policies to establish an Irish nationhood in the 1930s removed from the British Empire.

However, there were a few complications to de Valera's independent politics in New York. The British Foreign Office suggested that Ireland be included in a section 'showing as much as we can of the British Isles and Empire, our way of life; its foundations, development, enduring qualities,

dignity and harmony'.[142] However, Ireland vehemently rejected this proposal, and in the end Ireland's Pavilion sat on a site shared with Denmark, close to the United States Federal Building and removed from Britain's Pavilion. Michael Scott was appointed architect of the Free State Pavilion in June 1938 under the instruction to present something 'Irish'; he later became an honorary citizen of New York.[143] Unlike the displays of Ireland in nineteenth-century Chicago, the country's exhibit did not focus on Irish Americans and was aimed at a global audience to unveil a modern independent nation. Issues of national dislocation were not as pressing a concern to interwar (and later) Irish migrants since they were not escaping from tragedy or famine, and successive waves of relocation had formed large communities of Irish Americans.[144]

Scott worked with American architect L. H. Bucknell (designer of the Irish Pavilion at Glasgow) to plan the country's display.[145] Paul Larmour has described Scott as 'a committed modernist and [an] active advocate of the "new architecture" in Ireland'.[146] The Irish Pavilion was notable for its arresting architecture (Figure 4.7), with the front of the building made largely from glass and Irish flags decorating the lawn. Nature was absent in this image, with only a single tree present, which reflected the organisers'

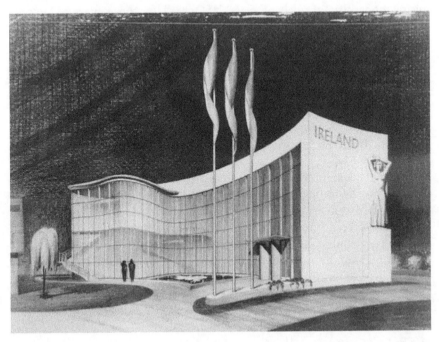

Figure 4.7 Michael Scott's drawings (1937–39) ((79/10.1/–97) – courtesy of the Irish Architectural Archive)

desire to convey an urban Irish modernity. A solitary couple drawn in front of the Pavilion epitomised a minimalist aesthetic, with the open space and sparse objects illustrating an expansive Irishness. Many visual tricks operated in the building. For instance, the all-white building was shamrock-shaped but only from the air. Moreover, the entrance was painted green and had an orange hood over it – which transformed itself into an Irish flag depending on the viewer's perspective. Therefore, emblems of Ireland emerged throughout, and if visitors stood in the right place or looked in a particular direction, they were able to see these illusions of Irishness. The structure was deceptive in its creative simplicity. The experimental modernist design sought to symbolically position the Free State alongside the world's powers in 1939.

Ireland's modernist project decisively offered a separate identity from Britain in a continuation of priorities from earlier interwar exhibitions. For instance, Irish motifs circulated throughout the Pavilion with an outside pool that resembled the entire map of Ireland and a statue of *Éire* on the lawn by sculptor Frederick Herkner.[147] The recognisable Irishness portrayed in the New York Fair traded in popular touristic images of the country that may have furthered national stereotypes. Yet Fintan Cullen has argued that the 'traditionalism of the clichéd shamrock was balanced by the uncompromising modernism of steel and glass'.[148] Overall, for those interested in self-fashioning Irishness, it seemed that exploiting nationwide prejudices was a worthwhile cost in the quest for an affable and convincing Irish identity.

As was the case in 1938, Ireland's modernity was complemented with its art and culture. The 8,000-square-feet Pavilion contained a gigantic mural by Sean Keating titled *The Shannon Basin*. The Ardnacrusha power plant harnessed the energy of the River Shannon and bought electricity to some of the remotest districts in the South of Ireland in what became a symbolic scheme of Ireland's innovation and strength.[149] Keating's mural has been described by Malloy as an 'explicit combination of patriotism, realist style, and technological innovation', acting as a 'tribute to Irish modernisation'.[150] Building on the technological and artistic showcase, bays with exhibits of both an 'industrial and cultural' nature featured in the stylish Irish Pavilion to extend the Free State's prowess.[151]

As in past exhibits, an authentic Irishness was sought. There was extended correspondence about setting up a handloom to demonstrate the weaving of Irish homespuns in the Irish Pavilion, as in 1890s Chicago.[152] However, the weavers Richard and Thomas Senior of Boston, Massachusetts, practised hand weaving in the United States, and McCauley decided that this compromised claims of an authentic Ireland, and, even though they trained at Clifden, Connemara, the American residents did not feature in the display.[153] The seriousness with which claims to a past Irishness were taken is

highlighted in this exchange. Both financially profitable motifs of Irishness (related to rural industries) persisted throughout the nineteenth and twentieth centuries, and questions of authenticity also remained a central concern for exhibition organisers.

As the country's final display, Ireland's ambition to develop 'a more modern type of ... agricultural economy, reducing its abject dependence [o]n the potato' after the tragedy of the Famine was authoritatively imagined in the well-crafted image of an Irish past, present, and future in the 1939 display.[154] The 'World of Tomorrow' showcased history, and the Ardagh Chalice and the Tara Brooch loaned from the Victoria and Albert Museum featured in an exhibit of early Celtic craftsmanship, as in the nineteenth-century exhibitions.[155] Overall, 1939 exemplified the Free State's assertive representation as an independent Irish nation in the exhibitions of the interwar period.

Interwar Irish exhibitions notably coincided with the formation of a thriving Irish tourist industry, and the two projects reinforced each other. Tourism was increasingly democratised in the interwar years for the middle and working classes, who generally had more time and disposable income for leisure.[156] The Free State government founded the Irish Tourism Association (ITA) in 1925, as Eric Zuelow has shown, to centralise the infrastructure of travel and accommodation in Ireland. A complex bureaucratic structure advertised affordable rail and air connections, liaised with hotels, and established tourist information centres.[157] Demonstrating the desire to make Ireland accessible for travel, a guidebook on tourism titled *Commemorating Ireland's Participation* was available to buy at the Irish Pavilion in New York. The book revealed 'life of a country ... which only those who visit it can ever really know and understand', according to Éamon de Valera.[158] Everything in Ireland, from its landscape to its history, its lifestyle, and its culture, became available for international tourism, as in the Irish Exhibition project.

There was significant debate on the type of Ireland to advertise in the interwar period. An Irish 'foreignness' was partly constructed based on an Irish history. In a similar style, organisers of Irish exhibitions were concerned with cultivating a specific Irish language, history, and landscape. For instance, tourism literature highlighted innumerable examples of 'Hiberno-Romanesque style' churches and doorways. The 1939 Fair also featured objects of an ancient Irish Christianity. Together, both the Exhibition and the tourist business invited visitors to see an Irish Christian history – 'relics of the past to quicken the imagination' – such as Celtic crosses, chapels, and round towers, whether in a pavilion or the country itself.[159]

In the Fair and in tourism literature, Irish bodies were used to sell an attractive Ireland. An 'Irish friendliness', notes Zuelow, became a 'positive "other"

to the harried people of industrial Europe and America' in popular tourist discourse.[160] Moreover, *Commemorating Ireland's Participation* noted that 'girls … trained in dairying and poultry keeping' were common to Ireland.[161] In both instances the attractiveness of Irish women in particular famed for their beauty and hospitality functioned to authenticate Irishness. The allure of Irish bodies reveals that the Brown brothers' earlier efforts to encourage tourism to Ireland by conflating an Irish land and its people were consolidated by the 1930s. Discourse on an authentic Irishness underwrote efforts to exclusively employ Irish men and women as trade ambassadors in interwar Irish exhibitions.[162] Tropes of Ireland used by contemporaries decades earlier (for example, in the exhibitions of the 1890s) thereby created exports of Irishness for entertainment purposes within capitalist structures of display or travel. Simultaneous initiatives to heighten the commodification of the country's people and its attractions therefore emerged for international consumption.

Irish tourism relied primarily on Gaelic lettering, language, and costume to signify an Irish 'foreignness'.[163] Irish difference was evoked in the shamrock building at New York and the distinct symbols of *Éire* constructed in 1939. Zuelow takes 'nations a[s] always in process, always changing'. This changing process ensured that adaptability became central to Irish identity which transformed itself 'from a revolutionary identi[fication] to a state building one' during the interwar years.[164] An Irish mutability can be mapped on to its exhibitions throughout the period; for instance, the Free State used its exhibits in the 1930s to heighten the country's distance from the British Empire to emphasise its independence in both economic and social spheres. This was part of de Valera's larger negotiation of dominion status within the Commonwealth. In contrast, during the 1920s and 30s Northern Ireland's state-building efforts constructed a closeness with the British Empire, and the country's exhibits highlighted the mutual benefits of trade with the United Kingdom.

The labour to construct Ireland in tourism and exhibitions had many similarities, and both solicited visits to the country. For instance, common motifs of Irishness related to an Irish self, and Irish objects circulated in the two forums. Further, the nation-building project of the island emerged through exhibits and the founding of commercial tourism. Yet the tensions of partition were ignored in both tourism and exhibition literature. As in the 1939 New York Fair and the international exhibitions that preceded it, tourism to Ireland promised visitors experiences of a wholesome, authentic Ireland. Irish self-fashioning within its exhibitions and popular tourism concurrently created an attractive Ireland for consumption related to the land and its people. Importantly, the tourist business grew steadily through the 1930s, and the Irish Tourist Board established in 1939 had a half a million-pound budget.[165]

Northern Ireland continued its unionist project in the New York World's Fair in the Pavilion of the United Kingdom, Australia, New Zealand, and the British Colonial Empire (Figure 4.8). Northern Ireland's exhibits were next to the Maritime Hall and a bandstand further into the Pavilion. Visitors walked through the royal room, silver room, and Westminster Bridge to observe Ireland's goods. The first floor contained the exhibits of Australia, New Zealand, and the British Colonial Empire. The second floor held Britain's exhibits (which included Ireland in the Gallery Hall). Britain used the Pavilion to narrate a history of its exceptionalism that began in the early Christian epoch and up to the contemporary period. A royal room held historic books such as the New Testament in Greek, and a popular replica exhibit of the crown jewels of Britain featured a sceptre, staff, crowns, diamonds, and rubies.

The careful construction of Britain's history featured the Union with Ireland in its story. For instance, in the Maritime Hall recesses contained models of Lincoln Cathedral in England, Stirling Castle in Scotland, Caernarvon Castle in Wales, and Carrickfergus Castle in Northern Ireland. Carrickfergus was an Irish seaport town situated on the north shore of Belfast Lough and on the south-eastern border of County Antrim. The castle stood on a rock and was 'reputed to have been founded by John de Courcy in the twelfth century [during] the partial conquest and settlement of Ireland under Henry II', according to the *Guide to the Pavilion*.[166] Evidently, within

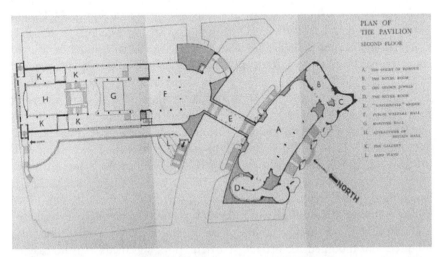

Figure 4.8 Plan of the Pavilion (manuscript 'Guide to United Kingdom, Australia, New Zealand and the British Colonial Empire Pavilion', 1939, p. 8 – Ireland's displays were in the Gallery (K))

the 1939 display Northern Ireland was entirely (and willingly) subsumed into the project of Britishness.

The Northern Irish section in New York replicated the conventions of past exhibits by featuring woollen goods, Irish linen, fine china, and leather. By 1939 Northern Ireland had a monopoly in the international market for textiles, and the *Guide to the Pavilion* celebrated that the 'wool of the small hardy Irish sheep ... favour[ed] the production of rough, sturdy fabrics'. For example, members of the Irish Linen Guild, Belfast, organised an exhibit which claimed that linen had its 'first beginnings in ancient Egypt' and had been a staple in 'Ireland since at least the thirteenth century'. This archaic history conjured images of 'crofters' wives' who '[sat] before their cottages using spinning wheels which b[ore] the indelible mark of time', and the trade's survival through 'skilled craftsmanship [with] modern methods' emerged as a triumph of the interwar period. Such stories heightened the attractiveness of the material; an emphasis on the singular Irish origin and character of the fabric boosted sales of Irish linen in New York. The author relayed the contemporary practice of linen making which involved 'girls drawing threads by hand' who then passed the fabric 'to the country districts where the embroidering [wa]s carried out carefully'. The display revealed the success of the project to sustain rural industries that spread with Lady Aberdeen and Alice Hart in the 1890s. Overall, a valuable network of Irish homespuns distinctive to Northern Ireland thrived.

Northern Ireland's display in New York was similar to its previous representations in international exhibitions; however, there was no sustained criticism or praise. This may have been because an exhibition in the United States received less traction in the British and Irish press, and so the Fair received less attention in Britain and Ireland. Northern Ireland continued its portrayal as allied to Britain for trade, commerce, and national prestige in the 1939 Fair, with a focus on its specialist industry, linen. Over fourteen million visitors attended the British Pavilion, and of these it is unclear how many visited the Irish section.[167] Northern Ireland's membership of the Union saw it celebrate the British monarchy; during the royal visit on 10 June 1939, *Land of Hope and Glory* and *Rule Britannia* were sung with gusto, and 'Union Jacks flew everywhere'.[168] The country's last interwar show in international exhibitions vociferously showcased its nationalist home in the Union to a global audience.

Even though exhibitions were imperial in nature, having originated in 1851 to celebrate Britain's Empire, in the interwar period, exhibitions were adapted and modified for broader participation, specifically in the case of Ireland where they became a notable way for the two nations to evoke their distinct relationships to Britain. In the exhibitions of the 1920s, the image of Ireland was dominated by Northern Ireland and its Union with Britain

as the Free State refused to participate. Symbols of Ireland related to Irish industries (such as linen and shipping) became important for profit and capitalism. Northern Ireland expressly used exhibitions to demonstrate its allegiance to the United Kingdom to further its trade and national standing. However, some Irish citizens critiqued this imperial identification as sacrificing and obfuscating the power and autonomy of Northern Ireland, which revealed the ongoing nationalist tensions of the unionist project. Broader discontent with the Northern Irish government by its citizens and antagonism to the Free State underscored the country's disputed display and reception in a revealing post-partition endeavour of state building.

Exhibitions of the 1930s saw a narrative shift as the Free State embraced exhibitions in their nation-building project. Irish cultural and political nationalism materialised in the exhibits. Organisers constructed displays of traditional arts and crafts alongside technological advancement and history to bolster their new country. They rejected past depictions of Irishness and espoused a confident portrayal of Ireland. The country's dominion status in the Commonwealth was negotiated and set apart from the British Empire. An Irish nation was formed cumulatively through its exhibits as thriving under its new-claimed sovereignty in a moment of 'arrival' and celebration.

For both the Free State and Northern Ireland, exhibitions were a platform to create new forms of Ireland and Irishness in the interwar period. The two countries presented discrete images of themselves to global audiences, and while Northern Ireland maintained its geographical separation, the Free State visualised the unification of the island of Ireland (along the lines of external association). Traditional motifs of Ireland were coupled alongside modern achievements to stimulate consumption of product and person. Distinct visions of industry, modernity, urbanity, authenticity, and rusticity were deployed according to specific needs. The common visual geographies in the Irish exhibition project and the Irish tourist industry revealed similar concerns in creating and profiting from Irishness in a mutually reinforced enterprise.

By analysing how Irish men and women crafted Irishness in exhibitions, the importance of cultural history in understanding interwar Ireland is revealed. The project of Irishness remained divided along Catholic and Protestant, Free State and Northern Irish, nationalist and unionist lines. International exhibitions were important in the formation of Irishness after formal empire, and they became a crucial forum through which an Irishness was debated and imagined. Different political and ideological positions on empire worked themselves out in the display whether through the exhibits or the subsequent reception of the country's display. The politics of Irish exhibitions sought a collective experience for Irish men and women and international visitors. As the final display of Ireland before the outbreak

of the Second World War, interwar Irish exhibitions notably revealed how Irishness was being conceived, contested, and performed. And the next chapter considers how the project of post-colonialism manifested through display.

Notes

1 See, for instance, M. Farrell, *Party Politics in a New Democracy: The Irish Free State, 1922–37* (Dublin, 2017); G. Keown, *First of the Small Nations: The Beginnings of Irish Foreign Policy in the Interwar Years, 1919–1932* (Oxford, 2016).
2 M. Moulton, *Ireland and the Irish in Interwar England* (Cambridge, 2014), p. 174.
3 G. K. Peatling, *British Opinion and Irish Self-Government, 1865–1925: From Unionism to Liberal Commonwealth* (Dublin, 2001).
4 Deirdre McMahon, 'Ireland, the Empire, and the Commonwealth', in Kevin Kenny (ed.), *Ireland and the British Empire: Oxford History of the British Empire Companion Series* (Oxford, 2004), pp. 182–219, pp. 208–9.
5 Fearghal McGarry, 'Southern Ireland, 1922–32: A Free State?', in Alvin Jackson (ed.), *The Oxford Handbook of Modern Irish History* (Oxford, 2014), pp. 647–69, p. 648.
6 Ibid., p. 649. See also P. Bew, *Ideology and the Irish Question: Ulster Unionism and Irish Nationalism 1912–1916* (Oxford, 1994), pp. 153–60.
7 Ibid., pp. 656–7. See I. Gibbons, *The British Labour Party and the Establishment of the Irish Free State, 1918–1924* (London, 2015).
8 See J. Anderson and L. O'Dowd, 'Contested Borders: Globalization and Ethno-National Conflict in Ireland', *Regional Studies*, 33:7 (1999), 681–97.
9 Moulton, *Irish in Interwar England*, pp. 160–2.
10 Andrew R. Holmes and Eugenio F. Biagini, 'Protestants', in Eugenio F. Biagini and Mary E. Daly (eds), *Cambridge Social History of Modern Ireland* (Cambridge, 2017), pp. 88–112, p. 101.
11 C. Townshend, *Political Violence in Ireland: Government and Resistance since 1848* (Oxford, 1983).
12 British Library, London, W27/8577, manuscript 'A Pictorial and Descriptive Guide to London and the British Empire Exhibition 1924'. See K. Walthew, 'The British Empire Exhibition of 1924', *History Today*, 31:8 (1981), 34–9.
13 'A Pictorial and Descriptive Guide to London', p. D, E [sic].
14 See S. Akhtar, 'British Empire Exhibition, 1924', in Mark Doyle (ed.), *The British Empire: A Historical Encyclopaedia, Vol. 2* (Santa Barbara, CA, 2018), pp. 13–15. Also, British Library London, YD.2017.a.1616, manuscript 'Daily News Souvenir Guide to the British Empire Exhibition: Concise 'Where Is It' Index and Complete Train, Tram and Bus Guide', 1924, p. 7.
15 'British Empire Exhibition', *Nature* (3 May 1924), p. 648.
16 British Library, London, W66/0147, manuscript 'Official Guide to the British Empire Exhibition', 1924, p. 9. See A. C. T. Geppert, *Fleeting Cities: Imperial Expositions in Fin-De-Siècle Europe* (New York, 2010), p. 177.

17 The 'Daily News Souvenir Guide' notes that estimated visitor numbers were twenty-five to thirty million – p. 7. See also British Library, London, YD.2007.a.9700, manuscript 'British Empire Exhibition, 1924: Wembley, London, April–October: Handbook of General Information', 1924.
18 'British Empire Exhibition', p. 12. See D. Hughes, 'Kenya, India and the British Empire Exhibition of 1924', *Race and Class*, 47:4 (2006), 66–85; D. R. Knight and A. D. Sabey, *The Lion Roars at Wembley: British Empire Exhibition 60th Anniversary, 1924–1925* (London, 1984).
19 Much of this is documented in letters, minutes of meetings, and memorandums in several files with a single shelf mark in the National Archives of Ireland. National Archives of Ireland, Dublin, BT 61/31/2, manuscript collection, British Empire Exhibition, 1924–1925, Articles of Association, Minutes of Executive Committee Meetings, Balance Sheets, etc. I will only give the title of the sources from now on as the archival information is the same. The addresses and titles of the sources will be reproduced exactly (note the inconsistencies in the names applied to individuals).
20 Letter to Mr Healy from the Duke of Devonshire, 30 December 1922.
21 Hughes, 'British Empire Exhibition', 69.
22 Letter to Mr Healy from the Duke of Devonshire.
23 Meeting of the Executive Council, 2 February 1923; Letter to Duke of Devonshire from T. M. Healy, 14 February 1923.
24 Letter to Duke of Devonshire – Secretary of State for the Colonies, 31 March 1923.
25 Letter to the Secretary, Ministry of External Affairs, Dublin, 7 December 1923.
26 Letter from Travers Clarke to Mr McNeill, 18 January 1924.
27 Letter to the Secretary, Ministry of External Affairs, Dublin from the Office of the High Commissioner (London), 19 January 1924.
28 Letter to Secretary, Executive Council, 12 December 1923.
29 Numerous letters were sent from the Exhibition Commissioners and the Ministry of External Affairs (UK) to the Secretary of the Executive Council of the Irish Free State and the President of the Ministry of Industry and Commerce and the Ministry of Agriculture (Free State). Some were responded to and many were ignored.
30 See E. Delaney, *Demography, State and Society: Irish Migration to Britain, 1921–1971* (Liverpool, 2000).
31 Memorandum by J. Hatchell on the British Empire Exhibition, April–October 1924.
32 Letter to Secretary, Executive Council, 12 December 1923.
33 Ibid.
34 Memorandum by Hatchell.
35 Deirdre McMahon, 'Ireland and the Empire–Commonwealth, 1900–1948', in William R. Louis and Judith M. Brown (eds), *The Oxford History of the British Empire. Vol IV. The Twentieth Century* (Oxford, 1999), pp. 138–62, p. 156.
36 David W. Harkness, 'Ireland', in Robin W. Winks (ed.), *The Oxford History of the British Empire. Vol V. Historiography* (Oxford, 1999), pp. 114–33, pp. 125–6. See also D. W. Harkness, *The Restless Dominion: The Irish Free State and the British Commonwealth of Nations, 1921–31* (London, 1970);

D. W. Harkness, 'Mr de Valera's Dominion: Irish Relations with Britain and the Commonwealth, 1932–1938', *Journal of Commonwealth Political Studies*, 8:3 (1970), 206–28.
37 L. J. McCaffrey, *The Irish Question: Two Centuries of Conflict* (Lexington, KY, 1995), pp. 145–8.
38 'Official Guide 1924', p. 1.
39 'A Pictorial and Descriptive Guide to London', p. L [sic].
40 'Official Guide 1924', p. 25.
41 'The Ulster Pavilion', *Belfast News-Letter* (30 May 1924).
42 'British Empire Exhibition: Ulster Pavilion', *Mid-Ulster Mail* (11 August 1923); 'British Empire Exhibition: Ulster Pavilion', *Belfast News-Letter* (13 August 1923).
43 'The Empire Exhibition. An Ulster Pavilion', *Ballymena Observer* (20 July 1923).
44 'The Ulster Pavilion. Great centre of interest. Lady Craig and the display', *Ballymena Weekly Telegraph* (3 May 1924).
45 'Ulster Pavilion. Thronged Yesterday', *Belfast News-Letter* (24 April 1924).
46 Philip Ollerenshaw, 'Businessmen in Northern Ireland and the Imperial Connection, 1886–1939', in Keith Jeffrey (ed.), *An Irish Empire: Aspects of Ireland and the British Empire* (Manchester, 1996), pp. 169–90, p. 174.
47 'Official Guide 1924', p. 25.
48 'Ulster Pavilion', *Belfast News-Letter*.
49 Ibid.
50 'Daily News Souvenir Guide', p. 67.
51 'Official Guide 1924', p. 26; 'Progress at the Ulster Pavilion', *Northern Whig* (23 January 1924).
52 'The Ulster Pavilion', *Belfast News-Letter* (12 December 1923).
53 Julie F. Codell, 'International Exhibitions: Linking Culture, Commerce, and Nation', in Dana Arnold and David P. Corbett (eds), *A Companion to British Art: 1600 to the Present* (London, 2013), pp. 220–40, p. 224.
54 'Official Guide 1924', p. 25.
55 'The Ulster Pavilion. Mr. Gordon's Paintings', *Northern Whig* (29 March 1924).
56 'The Queen at Ulster Pavilion', *Northern Whig* (1 July 1924); 'The Queen at Wembley. Visit to Ulster Pavilion', *Londonderry Sentinel* (1 July 1924); 'Distinguished Visitor at Ulster Pavilion', *Northern Whig* (14 July 1924); 'The Ulster Pavilion', *Northern Whig* (12 August 1924). The final article reported that MPs, senators, and representatives from Ulster Farmer's Union also visited the Pavilion.
57 'The Empire Exhibition. An Ulster Pavilion', *Ballymena Observer* (20 July 1923); 'The Ulster Pavilion', *Belfast News-Letter* (10 January 1924).
58 'The Ulster Pavilion', *Ballymena Weekly Telegraph*.
59 Holmes and Biagini, 'Protestants', p. 101. See A. Bielenberg, 'Exodus: The Emigration of Southern Irish Protestants during the Irish War of Independence and the Civil War', *Past and Present*, 218 (2013), 199–232, 221.
60 'The Ulster Pavilion', *Belfast News-Letter*.

61 'Ulster Pavilion', *Northern Whig* (21 May 1924).
62 'Complaint', *Northern Whig* (31 May 1924).
63 'Ulster Pavilion', *Belfast News-Letter*.
64 Geppert, *Fleeting Cities*, p. 146.
65 'The British Empire Exhibition, 1925. Opened by the King', *Coventry Herald* (15 May 1925).
66 'An Exhibition Worthy of the Six Counties', *Northern Whig* (9 May 1925).
67 'Space in Ulster Pavilion', *Northern Whig* (24 February 1925).
68 'Lessons of Wembley. Features of Ulster Pavilion. Publicity Value of Scheme', *Ballymena Weekly Telegraph* (28 February 1925).
69 See Meeting of the Exhibition Council (Free State), 1 December 1924; Meeting of the Exhibition Council (Free State), 5 March 1925.
70 'An Exhibition Worthy of the Six Counties'; 'Wembley in 1925. Ulster Pavilion to be enlarged', *Ballymena Observer* (30 January 1925).
71 C. A. Breckenridge, 'The Aesthetics and Politics of Colonial Collecting: India at World Fairs', *Comparative Studies in Society and History*, 31:2 (1989), 195–216, 195–6.
72 See Stephen Howe, 'Historiography', in Kenny (ed.), *Ireland and the British Empire*, pp. 220–50, p. 235.
73 Moulton, *Irish in Interwar England*, pp. 168–9; Harkness, *Restless Dominion*, pp. 249–53.
74 McMahon, 'Ireland, the Empire, and the Commonwealth', p. 208.
75 Harkness, 'Ireland', p. 128. See L. Kohn, *The Constitution of the Irish Free State* (London, 1932).
76 N. Mansergh, *The Unresolved Question: The Anglo-Irish Settlement and Its Undoing, 1912–72* (New Haven, CT, 1991), pp. 283–9; Deirdre McMahon, *Republicans and Imperialists: Anglo-Irish Relations in the 1930s* (London, 1984), pp. 287–9.
77 McGarry, 'Southern Ireland', p. 657.
78 Mansergh, *The Unresolved Question*, p. 290. See also N. Mansergh, *The Commonwealth and the Nations: Studies in British Commonwealth Relations* (London, 1948).
79 Moulton, *Irish in Interwar England*, p. 172; Diarmaid Ferriter, 'De Valera's Ireland, 1932–58', in Alvin Jackson (ed.), *The Oxford Handbook of Modern Irish History* (Oxford, 2014), pp. 670–91, pp. 677–8.
80 Land annuities were British government loans offered to Irish tenant farmers enabling them to purchase lands from their former landlords under the Irish Land Acts of the 1880s. In the 1920s the Irish government acknowledged its debts to Britain regarding the land annuities and other expenses. However, the 1925 London Agreement exempted the Free State from its treaty obligation to contribute towards the United Kingdom's public debt. De Valera held the annuities to be part of this public debt and passed the Land Act of 1933 which assigned the money to local government projects.
81 Mansergh, *The Unresolved Question*, pp. 299–301.

82 See D. K. Coffey, *Drafting the Irish Constitution, 1935–1937: Transnational Influences in Interwar Europe* (Dublin, 2018); R. Fanning, *Éamon de Valera* (Cambridge, MA, 2015).
83 Harkness, 'Ireland', p. 127.
84 '1938 Empire Exhibition', *Aberdeen Press and Journal* (10 April 1937).
85 British Library, London, W15/4654, manuscript 'Official Guide of the British Empire Exhibition, Scotland, 1938', p. 74. Guarantors ranged from banks to corporations, oil companies, car companies, food manufacturers, newspapers, insurance companies, shipping and industry, steamships, brewers, and insurance groups. See 'Exhibition for Glasgow. Empire display to be staged in 1938', *Linlithgowshire Gazette* (9 October 1936).
86 British Library, London, W15/4654, manuscript 'Come to Scotland in 1938', 1938. This was a folio inside the Official Guide and does not have page numbers. See also British Library, London, D–7959.ff.19, manuscript 'Official Catalogue of the British Empire Exhibition, Scotland, 1938', 1938.
87 'Official Guide 1938', p. 72.
88 See S. Britton, '"Come and See the Empire by the All Red Route!": Anti-Imperialism and Exhibitions in Interwar Britain', *History Workshop Journal*, 69 (2010), 68–89. The Glasgow Independent Labour Party (ILP) staged a 'counter-exhibition' (run over two months) to coincide with the 1938 Empire Exhibition, and historian Sarah Britton argues that the anti-imperial counter-exhibition was a working-class movement opposed to the main display and its jingoism. It was extensively reported on in Scotland's left-wing press. Also known as the 'Workers Exhibition', it detailed the abusive practices in the colonies and offered the 'real facts' about the British Empire's impact on people of colour.
89 Discussions related to Ireland's participation in the 1938 Exhibition were filed under one shelf mark in the National Archives of Ireland. National Archives of Ireland, Dublin, T 161/843/4, manuscript collection EXHIBITIONS. General: British Empire Exhibition (Scotland) 1938; participation by Service departments. I will only give the title of the sources from now on. The names of the texts will be reproduced exactly (note inconsistencies and incomplete information in the addresses).
90 Meeting of Inter-Departmental Committee appointed to examine the question of Saorstát participation in the Empire Exhibition, Scotland, to be held in Glasgow from May to October 1938.
91 Ibid.
92 Empire Exhibition, Scotland, 1938, May to October 1938 (under the auspices of the Scottish Development Council), 8 July 1937.
93 Meeting of Inter-Departmental Committee.
94 National Library of Ireland, Dublin, 334 i 4, manuscript 'Report of Proceedings held at the Empire Exhibition, Glasgow, Scotland, on July 18, 19, and 20, 1938. Imperial Conference on Agricultural Co-operation', 1938.
95 Memorandum for the Executive Council, 21 August 1937; Meeting of Executive Council, 24 August 1937 on extent of Saorstát Participation.

96 Deirdre McMahon, 'A Larger and Noisier Southern Ireland: Ireland and the Evolution of Dominion Status in India, Burma and the Commonwealth, 1942–9', in Michael Kennedy and Joseph M. Skelly (eds), *Irish Foreign Policy, 1919–66* (Dublin, 2000), pp. 155–91.
97 D. Keary, 'Irish Pavilion – Report', 28 November 1938, p. 1.
98 'Extra remuneration for Mr. Keavy trade inspector Glasgow and Mr. Brennan High Commissioners Office in connection with work on Glasgow Exhibition 1938', Letter to Secretary, Department of External Affairs, Dublin, 5 April 1939.
99 Letter from the Architectural Graduates' Association, N.U.I. regarding the design of the Saorstát Pavilion for the forthcoming exhibition at Glasgow to President De Valera, 20 September 1937.
100 See M. Nie, *The Eternal Paddy: Irish Identity and the British Press, 1798–1882* (Madison, WI, 2004), pp. 4–35; M. Nie, 'A Medley Mob of Irish-American Plotters and Irish Dupes': The British Press and Transatlantic Fenianism', *Journal of British Studies*, 40:2 (2001), 213–40, 215–20.
101 'Official Guide 1938', p. 121.
102 Ibid., p. 122.
103 S. Britton, 'Urban Futures/Rural Pasts: Representing Scotland in the 1938 Glasgow Empire Exhibition', *Cultural and Social History*, 8:2 (2011), 213–32, 217.
104 'Official Guide 1938', p. 144.
105 See M. M. Smith, *Sensory History* (Berkeley, CA, 2007), p. 119.
106 Keary, 'Irish Pavilion', p. 4.
107 'Official Catalogue of the British Empire Exhibition', p. 191. The Irish Pavilion was numbered 55 on the map of the 1938 British Empire Exhibition.
108 'Official Guide 1938', p. 141, p. 143.
109 C. R. Malloy, 'Exhibiting Ireland: Irish Villages, Pavilions, Cottages, and Castles at International Exhibitions, 1853–1939' (PhD dissertation, University of Wisconsin-Madison, 2013), p. 239, and discussion on Jellett, pp. 242–52.
110 Letter to Secretary, Department of External Affairs, Dublin, 5 April 1939.
111 Keary, 'Irish Pavilion', p. 9.
112 Malloy, 'Exhibiting Ireland', p. 252.
113 'Official Guide 1938', p. 141. See Kerby A. Miller, ' "Scotch-Irish" Myths and "Irish" Identities in Eighteenth and Nineteenth Century America', in Charles Fanning (ed.), *New Perspectives on the Irish Diaspora* (Carbondale, IL, 2000), pp. 81–98.
114 Keary, 'Irish Pavilion', p. 2.
115 'Official Guide 1938', p. 143.
116 'Ulster at the Empire Exhibition', *Northern Whig* (11 January 1938).
117 'Disgraceful', *Belfast News-Letter* (3 August 1938).
118 'Ulster at the Empire Exhibition'.
119 'Official Catalogue of the British Empire Exhibition', p. 79.
120 J. Ruane and J. Todd, *The Dynamics of Conflict in Northern Ireland: Power, Conflict and Emancipation* (Cambridge, 1996).

121 'Ulster at the Empire Exhibition'.
122 'Official Catalogue 1938', p. 79; 'Visit to Ulster Pavilion. Chorus of Praise for a Striking Exhibit', *Belfast News-Letter* (4 May 1938); 'Disgraceful', *Belfast News-Letter*.
123 'Criticism at Belfast City Council. Corner in Pavilion', *Belfast News-Letter* (3 August 1938).
124 'Ulster Exhibit Criticised', *Northern Whig* (3 August 1938).
125 'Ulster Pavilion at Glasgow. Portadown Disappointed', *Northern Whig* (18 January 1938).
126 'Ulster and Publicity', *Belfast News-Letter* (3 August 1938).
127 See Sydney Elliott, 'The Northern Ireland Electoral System: A Vehicle for Disputation', in Patrick Roche and Brian Barton (eds), *The Northern Ireland Question: Nationalism, Unionism and Partition* (Kent, OH, 1999), pp. 122–38.
128 'Disgraceful', *Belfast News-Letter*.
129 Henry Patterson, 'Unionism, 1921–72', in Alvin Jackson (ed.), *The Oxford Handbook of Modern Irish History* (Oxford, 2014), pp. 692–710, p. 692.
130 'Ulster Pavilion', *Northern Whig* (27 April 1938).
131 'A Definite "Hit" with Visitors', *Northern Whig* (5 May 1938).
132 'The Ulster Exhibit at Glasgow. Strong criticism. Disgrace to the Province', *Northern Whig* (3 August 1938).
133 'A Definite "Hit" '.
134 'Ulster and Publicity', *Belfast News-Letter*.
135 Patterson, 'Unionism', p. 692.
136 British Library, London, X 1187, manuscript 'Prospectus of the New York World's Fair, 1939. Created and supervised by Lord and Thomas, and the Administrative Staff of the New York World's Fair 1939 Incorporated', 1939. There are no page numbers. See N. J. Cull, 'Overture to an Alliance: British Propaganda at the New York World's Fair, 1939–1940', *Journal of British Studies*, 36:3 (1997), 325–54. Cull argues that Britain tried to use the fair to ask for American support against Nazi Germany in the lead up to the Second World War.
137 'Prospectus of the New York World's Fair'. See also M. Duranti, 'Utopia, Nostalgia and World War at the 1939–40 New York World's Fair', *Journal of Contemporary History*, 4:4 (2006), 663–83; R. Wurts, *The New York World's Fair, 1939–1940: In 155 Photographs* (New York, 1978).
138 P. Greenhalgh, *Ephemeral Vistas: The Expositions Universelles. Great Exhibitions and World's Fairs, 1851–1939* (Manchester, 1988), p. 24.
139 National Library of Ireland, Dublin, MS 17,457/241, Letter from Patrick McCartan to Joseph McGarrity regarding the setting up of an Executive Committee to organise Ireland's participation in the World Fair to be held in New York in 1939, 15 June 1936.
140 Cited in S. Rothery, *Ireland and the New Architecture 1900–1940* (Dublin, 1991), pp. 222–4.
141 Ibid.
142 Cited in Cull, 'British Propaganda at the New York World's Fair', 332.

143 P. Larmour, *Free State Architecture: Modern Movement Architecture in Ireland, 1922–1949* (Cork, 2009), p. 66.
144 See Linda D. Almeida, 'Irish America, 1940–2000', in J. J. Lee and Marion R. Casey (eds), *Making the Irish American: History and Heritage of the Irish in the United States* (New York, 2007), pp. 548–73.
145 See J. O'Regan and N. Dearey (eds), *Michael Scott, Architect, in (Casual) Conversation with Dorothy Walker* (Kinsale, 1995), pp. 96–102.
146 Larmour, *Free State Architecture*, p. 62.
147 Cited in Rothery, *Ireland and the New Architecture*, p. 226. See Irish Architectural Archive, Dublin, 0079/010.001/001–104, Michael John Scott Drawings, 1937–39; P. Larmour, '"The Drunken Man of Genius": William A. Scott (1871–1921)', *Irish Architectural Review*, 3 (2001), 28–41.
148 F. Cullen, *Ireland on Show: Art, Union, Nationhood* (London, 2012), p. 174.
149 For a discussion on the Shannon Scheme, see Larmour, *Free State Architecture*, pp. 13–17.
150 Malloy, 'Exhibiting Ireland', pp. 263–4.
151 'The Book of Kells. Suggestion that it should be shown in New York', *Belfast News-Letter* (15 April 1938). Documents related to Ireland's participation in New York ranged from petitions for exhibits to costs and the discussion of shipping. These were all filed under one shelf mark at the National Archives of Ireland, and I will only use the title from now on. Many of these texts had multiple folios. National Archives of Ireland, Dublin, CO 852/243/12, manuscript collection, New York World's Fair, 1939.
152 R. Senior, Boston, Demonstration of Irish Hand Weaving in the Irish Pavilion at the New York World Fair.
153 Letter by L. T. McCauley to Consulate General of Ireland, Chrysler Building, New York, 28 November 1938.
154 P. Bew, *Ireland: The Politics of Enmity, 1789–2006* (Oxford, 2007), p. 211.
155 Letters to Secretary, Department of External Affairs, Dublin, 21 March 1938, 19 December 1938, 23 February 1939, 15 March 1939, and 9 October 1940 all discussed the immediate return of the replicas to the Victoria and Albert Museum and the insurance taken out.
156 I. Furlong, *Irish Tourism 1880–1980* (Dublin, 2009).
157 E. Zuelow, *Making Ireland Irish: Tourism and National Identity since the Irish Civil War* (Syracuse, NY, 2009), p. 4.
158 National Library of Ireland, Dublin, LO 5172, manuscript 'Commemorating Ireland's Participation at the World's Fair, New York, 1939', 1938. There are no page numbers.
159 Cited in 'Commemorating Ireland's Participation'.
160 Zuelow, *Making Ireland Irish*, p. xxxii. See M. Clancy, *Brand New Ireland?: Tourism, Development and National Identity in the Irish Republic* (London, 2009).
161 'Commemorating Ireland's Participation'.
162 See 'Ulster at the Empire Exhibition'.
163 Moulton, *Irish in Interwar England*, pp. 196–205.

164 Ibid. Zuelow, *Making Ireland Irish*, p. xxx. See B. Anderson, *Imagined Communities: Reflections on the Origin and Spread of Nationalism* (London, 1983), p. 49.
165 See Spurgeon W. Thompson, '"Not Only Beef, But Beauty ...": Tourism, Dependency, and the Post-colonial Irish State, 1925–30', in Michael Cronin and Barbara O'Connor (eds), *Irish Tourism: Image, Culture, and Identity* (Toronto, 2003), pp. 263–81, p. 281.
166 British Library, London, 7960.df.20, manuscript 'Guide to the Pavilion of the United Kingdom, Australia, New Zealand and the British Colonial Empire: New York World's Fair', 1939, p. 51.
167 Cited in Cull, 'British Propaganda at the New York World's Fair', 346.
168 Ibid., 347.

5

Debt and disagreement: Post-colonial Ireland

Ireland in the 1960s debated, considered, decided, and undecided whether or not to exhibit its country, wares, and peoples in the exhibitions of neighbouring countries. Seattle in 1962 was the first to extend an invitation, which after due consideration and several months of deliberation was rejected. The next was New York in 1964, which clinched Ireland's presence. However, financial difficulties, recession, and political instability saw Ireland pull out of the long-awaited 1967 Exhibition in Montreal. What led to these decisions of to display or not to display is the subject of this chapter. It traces the extensive discussions involved from the initial invitations to the years'-long consideration of these international exhibitions. Weaved within this story of display is Ireland's post-colonial nation-building project that underscored many of its financial and economic choices. Ireland was suffering from new political upheaval and significant financial instability in the 1960s, yet expended labour in the visual project of post-colonial identity making – a project that was undermined at times by the international visitor who was used to the century-long tropes of Ireland as quaint, rustic, and expiring, not modern, innovative, and advanced. Whether or not to exhibit was tied up with debate on the country's present and future stability and standing on the global stage. Often, issues of diplomacy outweighed sensible financial planning, but as exhibitions became centrally funded by taxpayers and not private donors, the government faced public criticism about these huge displays of wealth and prosperity. By following Ireland's exhibitions in this period, the chapter brings together ideas of Irish nationalism in the post-colonial world through the socio-cultural lens of display.

Ireland in the 1960s witnessed a gradual series of changes over a range of issues, such as poverty and welfare, access to education, healthcare, women's rights, and equal pay. Importantly, the Ireland Act of 1949 stated that any change in the status of Northern Ireland was a matter for the Northern Ireland Parliament, which all but ended Anglo-Irish negotiations on the region. This constitutionally strengthened Northern Ireland's place in the United Kingdom, and the Belfast Parliament embarked on an ambitious

regional economic policy after the Second World War in order to encourage new industries to make up for the decline of the old staples. Overall, the new National Health Service of 1948, coupled with the Republic's struggling economy, 'strengthened the material argument for partition'.[1]

The Republic of Ireland experienced economic growth and social change between 1957 to 1973 as it embarked on a programme of economic development and a campaign to join the European Economic Community (EEC), which was secured in 1973 after a landslide referendum victory.[2] Notably, Ireland was admitted to the United Nations in 1955, and it became a member of the United Nations Security Council in 1961. In the late 1950s, Ireland's neutrality in the Second World War and its refusal to join the North Atlantic Treaty Organisation (NATO) affected its international standing. But overall, the country enjoyed rising living standards, a marriage boom, and a weakening of the Catholic Church's authority. The end of protectionism under President Éamon de Valera brought in free trade and the partial abandonment of the Irish Free State's founding values from 1922 (of preserving and creating a rural, Gaelic society in line with Catholic beliefs and against a more modern, industrialised, and Anglicised world).[3] Seán Lemass's (1899–1971) term as *Taoiseach* from 1959 to 1966 is credited with much of the country's growth. Ireland became increasingly industrialised, secularised, urbanised, and bureaucratised in the 1960s.[4] Mary E. Daly has explained that Ireland's participation in the 'global market of big trade' should not be read as a simple path towards modernisation where economic development brought with it a more liberal and secular society, as some have argued; instead, there was much conflict and fracture in this post-colonial nation-building project.

Yet in the aftermath of the Second World War, over 500,000 Irish men and women migrated to Britain. Net emigration was particularly high in the 1950s, reaching levels only seen in the post-Famine period in the 1880s. This remained the pattern until the 1960s, with emigration rates generally outweighing the natural rate of population growth, resulting in a continuous population decline that was unique in Europe. Specifically, the young and single made up a large number of the emigrant outflow. For example, between 1921 and 2001 one and a half million people left Ireland; an additional 500,000 left Northern Ireland.[5] But the 1971 Census recorded a population of 2,978,248 and saw a reversal of more than a century of population decline.

Whether Ireland experienced a more partial or limited transformation economically, socially, and culturally has been the subject of much research on post-colonial Ireland thus far.[6] Lemass's commitment to economic growth, his friendliness to Northern Ireland's business sector and government, prioritised an economic-centred approach to North–South relations.

Further, it is important to consider the scale of change in the 1960s, despite some calling it 'the best of decades'.[7] For instance, Daly reminds us that the key policy changes of the 1960s as Ireland moved from an agricultural economy were the 1965 Anglo-Irish Free Trade Area Agreement (AIFTAA) and EEC membership. And both sought to maintain the rural, farming community, while receiving funding from industrial firms established under the protectionist regime of the 1930s.[8] Notably in the 1960s, Ireland modernised its economy, dismantled economic protection while applying for EEC membership, and recruited foreign-owned firms. The peak year for new industries was 1969, with fifty-nine new firms established and over 7,000 jobs created.[9] Furthermore, economic development brought along with it an expansion of educational opportunities in the mid-twentieth century.[10] Ireland's entry to the EEC in 1973 became the end date for the post-war economic 'Golden Age' following the country's vast economic, social, and cultural development. It was in this context that Ireland's decisions on exhibitions took place in the 1960s.

Seattle World Fair, 1962

Despite Ireland's membership of the Council of Europe, the country did not have a pavilion at the Brussels World Exhibition in 1958 but was represented through the Council of Europe Pavilion. Fifty-one countries took part in the Exhibition over 494 acres, and around thirty million visited. A reporter at the *Catholic Standard* lamented Ireland's non-participation as a 'pity', reflecting that the country was losing a chance to 'make a lasting impression on world public opinion'.[11] However, Northern Ireland had a dedicated section in the British Pavilion, and so Ireland was 'the only country in Europe [without] a pavilion at the exhibition'. Further, Ireland decided not to exhibit at the Seattle Expo of 1962 dedicated to science and industry, which opened on 21 April with a 550-foot-high 'space needle' observation tower in the seventy-four-acre site and received almost ten million visitors.[12] The Fair saw one Irish author comment: where are 'our Donegal carpets and tweeds, our Waterford glass, Beleek pottery, linen, stout, cheeses, cakes, chocolates and the rest? Where, in fact, were *Gaeltarra 'Éireann, Córas Tráchtala*, and *Bord Fáilte?*'[13] He explained that the 'absence of Irish representation was the one sour note' during his trip to Seattle.

In an odd gesture to Irish migrants living in the United States, there were plans for Irish sod to be planted at the Seattle World Fair during St Patrick's Day. The Public Relations department engaged in bizarre celebrations to 'plant a bit of sod from the Emerald Isle' and encourage 'People with Italian, Czechoslovakian, French, German, and Outer Mongolian names [to] show

up wearing green neckties'.[14] The fun did not end there, as 'One malcontent [wore] an orange necktie and disappear[ed] mysteriously, never to be seen again.'[15] Unusually, the spot picked for the sod was right behind the British Pavilion, in a suspicious reimagination and gesture towards former British–Irish colonial relations.

New York Fair, 1964

By the mid-twentieth century, the Paris-based Bureau of International Expositions (BIE) emerged as the international body that officially sanctioned world's fairs and endorsed the participation of foreign nations. The BIE did not sanction the New York Fair of 1964 as it was planned for two years, and its organiser Robert Moses (1888–1981) wanted to charge foreign exhibitors rent at two dollars a square foot for two seasons.[16] Consequently, international participation was limited in the New York Fair, and despite overall attendance of fifty-one million people, it suffered a twenty-one million dollar loss in total.[17] The Fair's theme was 'Peace through Understanding', and President John F. Kennedy (1917–63) described it as an 'Olympics of Progress', offering an opportunity to learn about the world.[18] It marked two historical events: the tercentenary of the English acquisition of the area from the Dutch in 1664 and the twenty-fifth anniversary of the 1939 New York World's Fair. When compared to its predecessor from 1939–40, the event was widely regarded as 'a colossal failure'.[19]

Discussion within the Irish government on whether to exhibit in the New York Fair began in early 1961. At this point, archival records reveal a deep scepticism about the value of display for trade and global standing. For example, a memo from Ireland's Department of External Affairs held that after consultation with the Foreign Trade Committee, it could not support Ireland's involvement in 1964 as these events despite their long history had proved to be ineffective and were ultimately 'not remunerative from the trade point of view'.[20] However, the author went on to consider broader reasons to argue for participation, demonstrating the often very conflicting approach to world's fairs in the 1960s. The reasons for participation included the significance of trade with New York given its international financial standing, the always elusive potential to engender tourists and businesses to consume in Ireland, and a broader concern about Irish migrants in the United States as well as Irish–American relations and reasons of global prestige. Despite the fact that fairs rarely turned a financial profit, organisers still boasted about their value for material reasons even when there was no actual proof for these arguments. Evidently, rhetoric and grandstanding around fairs proved devoid from reality and were

almost entirely ineffectual. The arguments against Ireland's involvement in the 1964 Fair regarding its 'substantial cost' were eventually overruled as the Irish government voted in favour of participation.

Yet it took a while to firmly reach this decision as the Secretary of the Department of Finance claimed that the New York Fair should be avoided due to high costs and explained that the organisers 'are still in the 1939 world when enormous expenditures of this kind for prestige reasons was still acceptable to public opinion'. He argued: 'It is out of accord with present-day concepts of social obligations in the international sphere' for nations to devote large sums for 'prestige and self-glorification', and that using funds 'to the relief of want' and 'raising [the] standards in the undeveloped regions of the world' would further Irish interests instead.[21] On the other hand, the Minister of External Affairs stated that 'it would be very difficult for Ireland to justify a refusal to participate in an international manifestation of the magnitude and location of the proposed Fair' and that it would 'be a setback to our national prestige and would almost certainly be resented by many people of Irish descent, especially in New York itself, and by other Americans'.[22] While these arguments were common by the 1960s, they reveal the significant uncertainty around the value of display and the impact it might have on international relations. It seems for many that actual financial profit came second to vague notions of maintaining global allegiances and strengthening ties overseas. By late 1961 there was general support within the Irish government for Ireland to take part in the New York Fair. Some even reasoned that if the costs of the display proved too high, then Irish businesses and corporate interests could represent Ireland in the form of a smaller but not national display.[23] In the end the Republic of Ireland paid for a pavilion at the New York Fair designed by Irish architect Andrew Devane (Figure 5.1), and the watercolour reveals its sleek, minimalist, and modern design.[24]

The de Valera government was committed to avoiding any and all traditional, stereotypical representations of Irish land and people from previous displays, as they considered it damaging to global conceptions of the Irish national character and Irish standing overseas. The government explained that representations of 'thatched cottages, round towers, and peat bogs' should be resisted as these 'could indeed create a wrong image if presented on their own'.[25] For example, in *Dáil Éireann* a Mr Sweetman posited that 'when the exhibit is being planned, an attempt will be made to portray our country in a more dignified way than sometimes has been the case [which is] regarded as normal in the United States of America'. He concluded: 'Too often in the past it has been represented that the Irish were a wild and uncouth race of people, going [to America] to fill jobs and to carry out tasks and to occupy places not of the highest order'.[26] This shift in

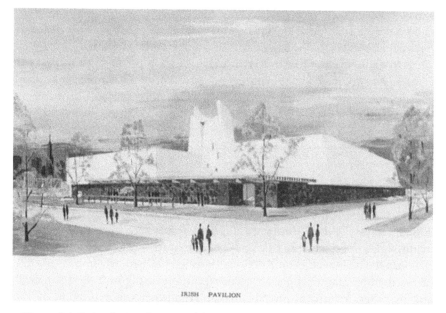

Figure 5.1 Ireland's Pavilion, World's Fair, 1964–65 (courtesy of the New York Public Library)

priorities reveals a continuation of de Valera's policy in the 1930s discussed in Chapter 4 and the Irish Republic's concern to distance themselves from clichéd tropes of Ireland. The gaudy facsimile displays of round towers and whitewashed cottages had served its function when Ireland was soliciting trade in the nineteenth century, but by the 1960s Ireland rejected global narratives of it as a rural haven with an underdeveloped economy. Within the Irish government there was no desire for Ireland to be featured in any colonial or Midway section, anything but the actual main space of the fairground. They decisively sought to move away from reductive and simplistic perspectives of Irishness in the post-colonial world (despite its profitability).

Daly argues that the 1960s saw rhetoric and action by the Irish government which signalled its disavowal of the past in favour of the present and a commitment to economic and social development in place of a previous concern over unification.[27] The mid-twentieth century saw an expansion in relations to the wider world, through the United Nations, international economic networks, a boom in television licences, student activism, and tourism. While the Irish government sought to finesse Ireland's international image to attract investment and strengthen the case for full membership of the EEC, Irish contemporaries did not entirely abandon profitable, marketable stereotypes of Irishness under capitalism. Roy Foster observes

that advertising agencies 'sold' Ireland as 'energetically and unrealistically as any seventeenth century plantation promoter'.[28] For example, 'Ireland was glossily advertised as a land of Edwardian comforts, limitless Guinness and tangible history' to encourage American tourism via Shannon Airport. Svetlana Boym's conceptualisation of 'restorative nostalgia' to 'characterise national and nationalist revivals all over the world, which engage in the antimodern myth-making of history by means of [a] return to national symbols and myths' explains these contradictory impulses.[29] Boym points to a more productive and complex kind of nostalgia which 'does not pretend to rebuild the mythical palace called home', and so is unlikely to be yoked to political goals.[30] Instead, through this 'reflective nostalgia … the past opens up a multitude of potentialities' and 'awakens multiple levels of consciousness'. We can see this happening in the presentations of Ireland as a rural haven untouched by modernity and resplendent in nature as manufactured by Ireland's Tourist Board. For instance, by 1967 receipts from tourism had passed eighty million, and continental and American visitors increased fourfold to 1.2 million in 1964, yet the exhibition enterprise tried to resist these financially lucrative tropes. Specifically, markers of Irishness rooted in the country's land and people thrived overseas irrespective of the government's agenda for modernisation and came to a head in the New York World's Fair of 1964.

The Republic of Ireland's Pavilion was next to India, the Republic of Korea, Argentina, and Thailand in the International Area along the Avenue of the United Nations (Figure 5.2) in a glass and metal building.[31] In the Irish Pavilion 'enclosed by a wall of native stone', the structure featured the 'historical, cultural, and economic heritage of Ireland' as a 'tribute to Irish-Americans'.[32] Look's *Guide to the New York World's Fair* explained that Ireland's exhibit contained a 'bit of the Auld Sod'. The Minister for Industry and Commerce, Jack Lynch, described Ireland's Pavilion as presenting 'a dignified image of a people with ancient traditions who are facing the challenge of modern times with industry' over 12,000 square feet. The Pavilion included a large map of Ireland with the names of prominent Irish families; a four-minute film depicting a flight in a balloon (occasional local noises, such as the sound of birds, a bell in a distant church steeple, the barking of dogs); 'listening posts' containing readings from famous Irish authors; a photographic display of Ireland's economic development; a Donegal weaver operating a loom; and an art exhibition featuring works by Jack B. Yeats. Among exhibits in the Irish Pavilion were samples of Johnson's wax products made in Ireland, which had a large export trade.[33]

Lynch boasted that a considerable volume of material had been compressed into the limited space, and verbal descriptions came second to display by sight and sound. This experimentation with form continued from

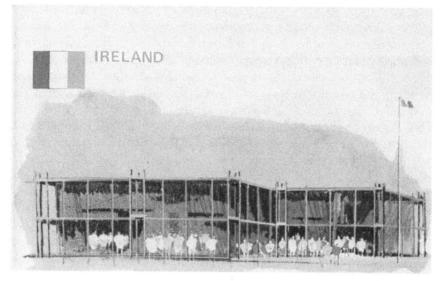

Figure 5.2 Watercolour sketch of draft drawings of Ireland Pavilion ('Official Guide New York World's Fair' – courtesy of the New York Public Library)

the fairs of the 1930s. Again, organisers prioritised authenticity, and where possible exhibits were made out of Irish materials constructed in Ireland. For example, designers built the conical tower and the seven-foot exterior wall of the Pavilion out of precast panels in Ireland. The panels contained a concrete core inset in large slabs of the Liscannon flag with a Howth stone and Connemara marble set in a bold and random pattern, which 'was transported in assembled sections to New York' to show off 'ingenious utilisation of Irish building materials'. Lynch stressed that the display presented a 'correct image of [Ireland]' as a 'haven of reality and tranquillity' as an invitation to tourists to come and see the country for themselves. Overall, the Exhibition catered to Irish American individuals, Irish airlines, and to entrepreneurs keen to invest in Ireland.

Notably, a world map (fifteen-feet long and seven-feet high) visualised 'the relationship of Ireland to the rest of the world in terms of cultural influence, missionary activity [and] emigration'. Other exhibits included excerpts from the Constitution and from speeches and writings of Wolfe Tone, Patrick Pearse, and Terence MacSwiney; an excerpt from President Kennedy's address to the Houses of the Oireachtas; about 300 slides depicting Irish domestic life; an eighteen-foot-high reproduction of the Celtic Cross at Moone, Co. Kildare, and stained-glass windows. The latter harkened back to Ireland's Christian antiquity.[34] Further, the floor of one part of

the Pavilion was a hand-knotted Donegal carpet, 625 square feet in size – loaned from a loom at Killybegs. A twenty-four-page brochure was available at the information desk which told the 'story of Ireland from the earliest times'. A tranquil atmosphere emerged in a garden where visitors could 'sit and drink Irish coffee or a soft drink' and listen to some Irish music. At the end of the garden area, there was a small stage from which contemporary artists gave lectures or readings from prose or poetry.

Jeffrey O'Leary has explained that

> in late May 1964, de Valera journeyed to the United States to meet with President Lyndon Johnson and to visit the New York fairgrounds. After his meeting with Johnson, Robert Moses, welcomed de Valera to Flushing Meadows where he inspected the Irish and US pavilions [and he] met with various officials at the fair's private Terrace Club.[35]

Journalists reported: 'table decorations were in green and Irish music was played by a trio wearing flowery green bow ties'.[36] The use of stereotypical decorations might have rankled de Valera's sensibilities, but he was committed to supporting Ireland's presence at the Fair and sustaining the transatlantic relationship between Ireland and the United States, and no criticism was reported. Later in 1965 the *Coventry Evening Telegraph* reported that 'Seán Lemass, drank Irish coffee at the Irish pavilion during a three-and-a-half-hour visit to the New York World's Fair'.[37] Irish government officials were intimately involved in curating Ireland's image overseas in the 1960s as key architects of the country's post-colonial future.

International visitors undermined the Irish government's post-colonial project in 1964. For example, Richard J. H. Johnson wrote in the *New York Times* that Irish Pavilion workers are 'being constantly diverted by visitors who want to know where the "little people" are kept, where the shillelaghs are to be found and where the shamrocks are sold' – all of which were not on display.[38] Moreover, according to Ted O'Reilly, spokesman for the Irish Pavilion, 'more than one non-Irish visitor had asked in all seriousness if there were any leprechauns to be seen at the pavilion, and others wanted to know why no one connected with the exhibit [smoked] a clay pipe'. These remarkable encounters between visitors and Irish officials reveal the hold that Irish stereotypes had in the global imagination. While Johnson argued that Ireland 'is an agricultural-industrial nation', visitors challenged the absence of kitsch-like representations of the country. Clearly, many were unconvinced by the modern portrayal of Ireland in the fairground and were keen to encounter the traditional images they had become used to. The Irish advertising machine of the late nineteenth and early twentieth centuries was perhaps too effective in equating Irishness to its women, hills, and peasants.

Even in the age of air travel, the images of rural Ireland that circulated within the fairs of the past two centuries and became central to tourist propaganda in the post-war period in Ireland were too powerful to refuse. Overall, Ireland's distance from its historic formula of rolling green fields, bogs, and 'colleens' caused some tension, partly because the hyper-commercialisation of traditional motifs was what visitors came to expect in these fairs.

Exhibition organisers did not act upon the visitors' criticisms of the Irish Pavilion. Yet these critiques demonstrate the transatlantic power structure between Ireland and the United States. Since one of the main reasons that Ireland participated at the New York Fair was to sustain its relationship with its American counterparts, this negative reception threatened the enterprise. Efforts to maintain Irishness without reducing its representation to mere caricatures were not straightforward. The commodification of Irishness had been profitable for over a century, and visitors had preconceived ideas as to what they expected in Ireland's fairs. The excerpts reveal tensions in who owned or curated Irishness despite the Republic of Ireland controlling how Ireland's history, culture, products, and people were represented in international displays. They signal the porous nature of what and who was Irish and how contested claims of ownership over the country were, even in public spaces. As part of post-colonial nation making, Irish leaders may have been keen to signal a break from past presentations, yet they held a currency abroad in the 1960s that was too difficult to shake. The post-colonial project was inevitably hampered by Ireland's past colonial representations.

The famed London-Irish Girl Pipers became one of the 'principal attractions' of the Fair. Over thirty women performed marching displays and also Irish dancing and songs. They had previously played in Holland, France, Germany, Belgium, Italy, and Denmark. They wore Kerry Tartan kilts and scarlet tunics to denote their Irish heritage. Further, three men and three women from the civil service stood behind the information desk, and three women from *Aer Lingus* offered information about tourism and air transport at the Pavilion.[39] The overall image of the London-Irish Girl Pipers and the Irish workers in the Pavilion demonstrates how women became symbols of modernity in the Fair. Women were a highlight; unlike in the twentieth century when they embodied rurality and tradition, they now exemplified Irish progress. As seen in photographs, promotional material, and widespread media coverage, women were important mediums of the Fair's message – chosen for their beauty, constantly on display, and ostensibly objects of attraction. These women represented new social roles for Irish women in the 1960s – participating in the workforce, existing in public spaces, and wearing modern clothing.

In a distinctive break from previous fairs, while the story of Irish economic development was still visualised, there was an avowed desire to distance the exhibit from the 'usual type of trade fair' and instead to stress the national element of the display. Thereby, only industry of 'major national importance or of special significance' was displayed instead of the products of individual firms as in previous fairs. Exhibition planners exempted some established industries such as brewing and distilling, which were among the few significant industries that existed before national independence. Organisers gave priority to newer electricity generation and peat development, the development of Irish airlines and shipping services, the manufacture of sugar, various foodstuffs, steel and cement manufacture, and the textiles industry. The industries established under the government's programme for the encouragement of foreign investment were showcased, such as diamonds, cranes, PVC pipes, and electrical components. Further, industries 'established with the aid of United States investment' were advertised. Again, organisers featured tweeds, poplin, and knitwear, as well as linen, and highlighted craft industries such as glassware and silverware. Instead of observing Irish women demonstrating these crafts, in the 1960s one could 'watch one of the [mechanised] handlooms used by the Donegal weavers in operation and [see] the fabric actually being woven by a master craftsman'.

Overall, the 1964 Fair sought to offer a new post-colonial vision of Ireland. For example, the Consul General from Ireland to New York, John O'Brien, described the Pavilion as offering a 'balanced picture of the cultural, historical and economic features of the country, and of progress and achievements in the agricultural and industrial spheres in modern Ireland'. This was seen as a counter to the 'false picture of our country' which O'Brien considered to be typical abroad, and he 'hoped that the Irish display will help in presenting a true image of a people whose traditions extend deep into the past, but who are at the same time facing with confidence and self-assurance the challenge of the modern world'.[40] While Ireland's display did indeed emphasise 'the connection between Ireland and the United States' and the 'outstanding contributions which our Irish emigrants and their descendants have made to the development' of the United States, American visitors critiqued the absence of traditional tropes of Irishness.[41] The Pavilion aimed to narrate 'the glories of the Irish people in the past ... [and] describe today and tomorrow – what Ireland is doing and what is aiming for' (Figure 5.3), as can be seen in Ireland's placement on the 'Avenue of the United Nations'. However, the post-colonial nation-building project did not convince most visitors and may explain why Ireland did not participate in any other exhibition in the 1960s.

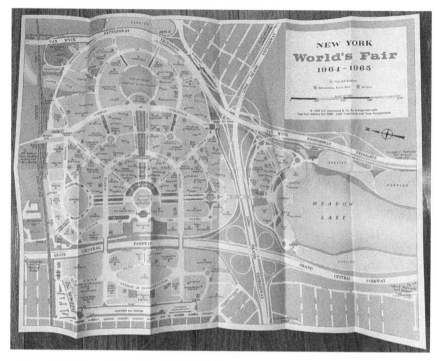

Figure 5.3 Map of the New York World's Fair, 1964 ('Official Guide New York World's Fair' – courtesy of the New York Public Library)

Montreal Expo, 1967

In the Montreal World Expo, years of negotiation and discussion, of ironing out the finer details, were set aside at the last moment when Ireland pulled out of its display, citing financial difficulties. However, the country's recession was long predicted, and the Irish government decided to exhibit a mere three years prior in 1964. The National Archives in Ottawa contain innumerable communications between the Expo body in Canada and the Irish counterpart in Dublin. The Irish Department of Foreign Affairs and Trade laboured over a decision that would have cost them hundreds of thousands, yet while they initially backed the enterprise, they eventually revoked their offer. This protracted process raises questions on the value placed on exhibitions, perceived worth in terms of financial and material return, and the complexities of the post-colonial identity-making project. Uncovering how a negative decision was reached in the very final moments of the Expo's planning sets us on a course to understand the many conflicting interests of exhibition in the 1960s. While organisers were aware of the immense

financial burden of such displays, they perceived the cultural, economic, social, and political benefits as outweighing the material costs. Indeed, Ireland was of this opinion in the two years of exhibition planning they engaged in, securing themselves a spot in the fairground, hiring architects to design their Pavilion, and inviting businesses and entrepreneurs to display their goods. However, in the end Ireland did not exhibit in Montreal, much to the disappointment of some of its inhabitants. Ireland felt the limits of the post-colonial nation-building project in New York only a few years prior and may not have wanted to encounter the same critiques again, revealing the disconnect between ideas of a modern Irish nation 'at home' in Ireland and perceptions of Ireland as an agrarian state 'abroad' in the 1960s.

In tracing the communications that began in 1964 and ended in 1966 to solicit Ireland's display in the 1967 Fair, the sheer complexity of debate on the country's participation is revealed. Speculation about Ireland's involvement at the Montreal Expo began even before the New York World's Fair. Newspapers from the *Irish Independent* to the *Evening Herald* and the *Evening Press* ran editorials promoting participation in the Exhibition. For instance, the *Irish Times* published 'Ireland may enter world exhibition' with an estimated forty million visitors, most of them from Canada and the United States, as early as April 1964.[42] Canada received fair status by the BIE in 1962, and the Expo's theme was 'Man and his World' to 'portray the story of man's hopes, fears, aspirations, and endeavours' on the St Lawrence River in Montreal.[43]

Despite the fact that the Irish government publicly foreswore participation in international exhibitions, Alfred Rive, Ambassador of Canada, and K. L. Marshall, Liaison Officer for Ireland's Participation in the 1967 Exhibition, delivered an invitation in person. Pierre de Bellefeauille, Director of the Exhibitors Department in Montreal, received and responded to many of the communications. Ireland's reasons for non-participation were the 'doubtful value to Irish exports of the traditional type of "trade fair"', as well as the budgetary limitations of a small country.[44] Further, there was a 'fair amount of press criticism of the Irish Pavilion at the New York World's Fair which has not had high attendance, [high] cost of that pavilion, and adverse publicity associated with it'.[45] Reports that the Irish Pavilion in the New York Fair had been a miserable failure was raised by J. J. Walsh at a meeting of the Committee of the Federation of Irish Manufacturers. Walsh argued that not only were there no souvenirs for sale, but further it was not possible to purchase the articles of Irish manufacturers, 'or to seek information of a practical kind on potential Irish exports'.[46] He regretted the £60,000 of the taxpayers' money spent on the Fair. Consequently, Frank Aiken said 'he would convey [the invitation] to [the] Prime Minister but that [Marshall] should not count on a favourable reply'. The explanation for

this refusal was Ireland's participation in any exhibition 'would strain Irish resources of men and money', and the decision against display remained 'unaltered', with Irish involvement at New York being 'the only exception'. Marshall persuaded on the reasons that Expo 67 'would be no ordinary trade fair', and there 'would be ample scope for an Irish exhibition within Irish resources and worthy of Ireland, as one of [the] mother countries Ireland owed it to herself to be represented' at the Expo.[47]

The plan of the Montreal Expo board was to get the public onside since the government proved reluctant. Ambassador Alfred suggested circulating publicity material on the Expo to the public through photographs, press releases, and adverts. Further he planned to lobby *Córas Tráchtala* (the Irish Exports Promotion Board) and the *Bord Fáilte* (the Irish Tourist Promotion Agency), which both had offices in Montreal.[48] Paul Bienvenu, Commissioner General, was responsible for petitioning the two boards and maintaining interest in official Irish circles.[49] Emphasis was placed on the small cost of participation, the fact that a unique site was offered, and the value of promoting Irish trade and tourism. Organisers expected the governments of all foreign airlines operating into Montreal International Airport to take part, including *Aer Lingus*.[50]

The problem quickly became the 'scale of participation', which depended on the treasury budget. W. H. Walsh, General Manager of the Irish Export Board, strongly supported participation.[51] A site in Lot 37 (75 feet by 120 feet) was marked for Ireland.[52] Ireland would become part of a grouping of six European countries, including the Netherlands, bordering the lake.[53] This was not a space for former colonies, and Ireland's demand to avoid subordination to Britain (visual or otherwise) was heeded in planning meetings. There were also plans for a common international garden beside the lake and for a series of connected floating national restaurants on the lake itself. A vast network of organisations and people in Dublin and Montreal remained in continuous contact during these discussions, namely between the Department of Industry and Commerce, the Department of External Affairs, the Department of the *Taoiseach*, the Irish Tourist Board, various editors of newspapers, and the Federation of Irish Industries. Overall, a large bureaucratic structure was involved in soliciting Ireland's participation in the Exhibition, an offer which was later revoked.

Pierre Dupuy, Commissioner General of the Canadian Universal and International Exhibition, visited Dublin from 8 to 10 April 1964 to encourage Irish participation in the event (Figure 5.4), as can be seen in the photograph.[54] He met with ministers and government officials to discuss the Fair. The *Irish Independent* affectionately reported that Dupuy's 'mother ... was an O'Brien who came from Ireland'.[55] Dupuy did interviews with *Raidió Éireann*, recorded a television interview at *Teilifís Éireann* studios, and met

Present at the reception at the Canadian Embassy, Killiney, last night, were (from left): Mr. P. V. McLane, charge d'affaires, Canadian Embassy; M. Pierre Dupuy, commissioner general of Canadian Universal and International Exhibition, which is being held in Montreal, 1967, who is on a short visit to Dublin; and Mr. E. T. Calpin, first secretary and consul, Canadian Embassy.

Figure 5.4 Extract from the *Irish Press* (10 April 1964) (courtesy of the Library and Archives Canada)

with Lemass, at Leinster House. He also met with Lynch, Walsh, and Dr T O'Driscoll, Director-General of the Irish Tourist Board. Dupuy noted that at the start of his conversation with the *Taoiseach*, he 'was rather guarded about Irish interest in the 1967 World Exhibition but that by the end of the interview Lemass was making enthusiastic enquiries about its possibilities'. Publicly, Lemass was reported to have been responsive to Dupuy's invitation, and they all attended a reception given in his honour at the Canadian Embassy by Edward Galpin (First Secretary and Consul).[56] At the Residence reception, Dupuy met many 'interested in Irish prestige abroad' and encouraged participation, revealing how elite and monied interests were central to influencing the government's decision.

Also, Tony Chipman, a liaison officer of the Canadian Corporation for the 1967 Expo, visited Dublin from 1 to 2 December 1964 to further discuss Irish participation and provide 'the latest technical information' for Irish

officials, at which point twenty-five countries had announced their intention of participating, with fifty spots available.[57] Chipman, like Dupuy before him, discussed the Expo in numerous meetings as well as in TV and radio interviews.[58] Mather Public Relations Ltd London were appointed to handle press and public relations for the 1967 Exhibition, in Britain and the Irish Republic. Mathers were instructed to stimulate the interest of the general public as well as relevant agents and officials in Ireland. In one of many meetings, S. Ronan, Assistant Secretary, Political and UN Affairs of the Irish Department of External Affairs, admitted 'that there would be a good deal of opposition to Irish participation within the government [as] the decision to participate in the New York World's Fair had been reached only after a great deal of discussion and over a great deal of opposition'.[59] Chipman felt 'that the Irish experience at New York ha[d] not made them any more likely to look favourably upon participation at Montreal particularly because of the short interval between the closing of the former and the opening of the latter'.[60]

In a telegram from the Canadian Embassy for Dupuy on 10 April 1964, the Department of External Affairs wrote that 'Although [the] Irish government ha[s] not yet recovered from [the] New York World Fair', participation in the 1967 Expo was favoured.[61] For instance, the former Irish Ambassador in Ottawa hoped 'that Irish emblems [would] be seen at the Exhibition in an Irish Pavilion'.[62] Ireland was even involved in conversations to feature in the entertainments programme of the Montreal Expo, specifically in a 'Horse Spectacular' show, and began soliciting Irish equestrian groups to take part.[63] Further, there were talks of a visit by the Lady's Choral Society (Dublin) to Montreal in 1967 – who specialised in Irish folk songs.[64] Their first record was titled *Ireland, Mother Ireland*, and they planned to take part in radio and television engagements during the Fair.

Canadian officials made emotional arguments to convince Ireland to participate; an undated letter by a government official wrote that 'hundreds of thousands [of] Canadians look to Ireland as their ancestral home'[65] and stressed the 'close associations and ties [between Canada and] the Irish government and people'. The author went on to say that the 'absence of Ireland, a country which has contributed so much to the development of Canada and indeed to North America, would be a most regrettable omission'.[66] Expo 67 authorities discussed multiple suggestions to reduce expense, one involving the Canadian government matching Irish participation costs at 50 per cent. Organisers made arguments about the benefit for tourism; for instance, one commentator reasoned that:

> At the New York Fair approximately four million people passed through the Irish Pavilion. If a similar number visited the Irish Pavilion in Montreal and less than one-tenth of one percent of them (3–4,000 people) visited Ireland as a result, the cost of the Pavilion will have been returned in tourist spending.

This is based on the average expenditure of American tourists of between fifty and seventy pounds per head. Conversely, if only one per cent of the people who pass through the Pavilion come to Ireland, the estimated revenue to this country would be between two and three million pounds minimum.[67]

In this respect, the Irish Pavilion's main selling point for the government was on stimulating tourism for the country – an argument that had convinced Irish officials in the past.

Pleas that the cost of participation was increasing 'each day due to delays in designing, planning and constructing [an Irish] pavilion' were ignored by the sceptics in the Irish government.[68] A telegram from January 1965 revealed that the 'Irish commerce and industry department ha[d] concluded it cannot justify recommending participation on [the] basis of trade prospects and [the] decision therefore will turn solely on questions of prestige and politics'. This observation gets to the heart of the debate on exhibitions in the 1960s; much of the rhetoric on the fiscal benefits of display were disproved, and instead arguments clung to abstract notions of future diplomatic benefits. There was speculation that while other departments and agencies might have interest in Irish participation, they were unable to exert persuasive influence against treasury reservations based on the serious budgetary situation in Ireland and the heavy expenditure of Irish participation in the New York World's Fair.

There was a degree of awkward diplomacy and negotiation between Dublin and Montreal. For instance, faced with 'some opposition to Irish participation', there was reluctance from the Canadian side to 'recommend to the Prime Minister that he write to Lemass to encourage Irish participation in the exhibition' for fear that it might 'appear as the exertion of rather too much pressure', as J. A. McCordick, Under-Secretary of State for External Affairs, put it, or it 'would be distinctly awkward if, after the Prime Minister had written to Lemass, the Irish Government decided nonetheless against participation'.[69] The delicacy involved in these discussions required subtle negotiations, hints, and petitions through countless letters, memos, and telegrams, each quietly persuading without being too forceful – encouraging but not heavy-handed.

Finally, a telegram on 26 January 1965 announced that 'Irish participation approved today. Issue press release early next week.'[70] The decision was made public via an announcement on 16 February 1965 at 11 p.m. A press release and background paper which contained information about the countries participating in the Fair and the Irish decision to exhibit was also published the following day. Newly appointed Ambassador of Canada, E. W. T. Gill, visited the Expo site on 10 March.[71] Immediately after, details regarding building and construction regulations, a building code, a building permits guide, guides for estimating participation cost and revenue, and

basic layout plans were communicated to the Irish Department of External Affairs in Dublin for final approval.[72]

Thus, by early 1965 Ireland's agreement to exhibit at Montreal had begun materialising on the fairground. Many newspapers ran editorials on the specifics of the exhibits to be displayed, commenting on everything from representativeness to the quality of goods and the overall aesthetic of Ireland that would be created.[73] Serious thought and consideration was given by the Irish public and its businesses and companies on what type of Ireland to curate on the global stage in Canada, given that its expected audience would largely be North American. There was of course a large number of Irish migrants in these countries, as Eugenio Biagini has shown.[74] And it was decided that 'Ireland's contribution to the civilisation of man down the ages, through its saints, scientists, writers, artists, scholars and craftsmen' will be featured.[75]

Of the ten million visitors that were expected, more than half were anticipated to come from the United States. By March 1965 the thirty-three countries that had agreed to participate included Britain, France, the United States, Belgium, Czechoslovakia, Denmark, West Germany, and Japan, and '300,000 visitors a day' could be accommodated in the 950-acre extravaganza.[76] The Exhibition came at a time when Lemmas was 'negotiating free trade with Britain', and so the Irish government was keen to exploit any further opportunities of free trade.[77] Lemass exclaimed that 'he welcomes Canadian industrial capital' and envisages 'closer relations with Canada and is ready to experiment with trade arrangements'.[78] A correspondent for the *Irish Times* romanticised that 'as early as 1595 ships were plying between Ireland and Newfoundland' and that by the mid-nineteenth century 'the Irish in Canada were more numerous than either the English or Scots'. They explained that 'from the beginning Irish people have made great contributions in forming this great country and will continue to do so in the years ahead'.[79] At this point the Canadian government was offering interest-free travel loans in Ireland to cover the cost of travel for those who 'because of their education, training skills and personal qualities [will] contribute and share in the growth and prosperity of a young and vigorous land'. Repayment was only required after employment in Canada, and 'travel loans [we]re honoured by the travel agent or transporting company for travel by air or sea'. As a result, in 1966 almost 300,000 people from Ulster 'made a new home in the land of the maple leaf'. This transatlantic migration was seen as a mutually profitable relationship in both movements of goods and people. Further, the Canadian government offered flights to Montreal at no extra cost to visit Expo 67, with up to eight flights a week from Shannon Airport.[80]

There was a pervasive desire to distance Expo 67 from previous trade fairs, with repeated proclamations that the Expo's purpose '[wa]s not to facilitate buying and selling but to demonstrate value and usefulness through originality of presentation'.[81] With this in mind, Irish architects Stephenson Gibney & Associates were appointed to design the Irish Pavilion in 1967; they made visits to the site (in September 1965) and went through several stages of draft drawings to cover 12,000 square feet at an estimated cost of £213,000.[82] There were worries that Canada's Telephone Association Pavilion would 'completely overpower the Irish Pavilion' due to its size and height.[83] A compromise was worked out whereby Ireland's Pavilion was moved further back from the roadway. In April 1965 John A. Belton, Ambassador of Ireland to Canada, was appointed as Commissioner General of Ireland at Expo 67 and Kester Heaslip as his Deputy Commissioner.[84] To rectify the mistakes of the New York Fair, the Irish contingent asked to have one boutique (non-food) in Expo 67 for Mullins Ltd, a Dublin-based company.[85] Mullins were suppliers of family coats of arms, Irish tweed, Irish linen, Belleek China, Waterford glass, Celtic jewellery, and boasted that their 'goods ... are of high standard and quality and are all handmade items'.[86]

However, the years of political manoeuvring abruptly ended after Ireland pulled out of the Montreal Expo in December 1965. An entire year after participation was announced, the Irish government decided on financial grounds to withdraw from Expo 67.[87] Frank Aiken explained that 'this decision was taken regretfully [and] was part of an extensive programme of retrenchment involving cutbacks in all government departments both in capital and current spending because of serious economic and balance of payment difficulties exemplified by recent import levy and other measures'. He continued that the 'Irish government were especially disappointed that this decision affected the Canadian Expo. He added that it was their 'wish to mark Canada's centenary by having suitable celebrations in Dublin'.[88]

Pierre de Belletoulle responded that Ireland's withdrawal was a 'serious blow which can have unfortunate repercussions among other countries'.[89] It is interesting to consider how much the contested reception of Ireland's display in 1964 impacted this decision. For instance, despite the Irish government's best efforts to move away from colonial and imperial depictions of the country, visitors noted and critiqued the absence of kitsch in the New York Fair. It may be that government officials in Ireland were aware of this difficulty and were unwilling to again squander huge sums of money to suffer criticism for not presenting a traditional view of the country. If this reading is indeed true, the limits of the post-colonial project in the 1960s become clear. As much as the Irish government tried to stress modern

advancement and technological prowess, they were hampered by almost a century's worth of stereotypical depictions of Ireland.

An author in the *Irish Times* described the withdrawal as a 'foolish form of economising having regard to our trade position with North America'. The author's regret rested in the fact that Canada had welcomed Irish men and women during the Famine years and worried this would be seen as 'an unfriendly gesture between two countries which have had so many close ties over the period of Canadian history' with an unfortunate loss in exploiting this 'largely untapped market for Irish goods'.[90] As a result Belletoulle strategised to get the highest Canadian authority, Prime Minister Lester B. Pearson (1897–1972), to make clear that 'Canada views the Irish decision with considerable alarm, to re-emphasise the links between the two countries and to hand [Belton] a letter for the Irish Prime Minister'.[91] However, by the end of 1964 Ireland had a budget deficit of ten million, which increased to sixteen million by the end of 1965. As a result the government had to reduce expenditures, of which 'Irish participation in [the] Expo was on a list of priority items for elimination and [the] Cabinet approved dropping it from next year's estimates'.[92]

The first letter inviting Ireland to participate was in January 1964, and it took almost two years for a firm negative decision to be made – demonstrating the enormous pressures placed on exhibitions in the realm of global diplomacy. Lemass explained in January 1966, after being urged to have participation reviewed, that 'their decision to participate had been deliberate; their decision to withdraw had been taken very reluctantly' and further that 'while the latter decision had drawn some criticism it was less in his opinion than that which would have been directed at the government if they had authorised continued participation when drastic cuts were being made in undertakings and services of domestic importance'. While he 'appreciated that Ireland was abandoning a project of long-term value for short-term considerations', he felt there was no alternative.[93] Again, if Ireland's successful participation relied on conveying stereotypical motifs of the country, the nation's withdrawal so late in the process can be understood as a project that was better abandoned. In January 1966 there was an ongoing press campaign conducted through Mathers for a reversal of the governmental decision, as well as a visit by the Montreal Mayor Jean Drapeau to Dublin.

Attempts to get private companies to cover the cost of an Irish Pavilion also failed, and fundraising in Canada among the Irish community had generated little interest. For example, the United Irish Society of Canada did not wish to donate to the Expo. Tellingly, contemporaries felt that 'although of Irish decent, many generations separate[d] them from Ireland and their interest [wa]s of a sentimental rather than tangible nature'.[94] Unlike previous decades (notably in the 1890s), nostalgia related to Irish migration had

dwindled by the 1960s. For instance, migrant communities were no longer a reliable source to extract money from for the 'Irish homeland'. Earlier capitalist exploitation of overseas Irish communities by way of nostalgic appeals to a 'lost Ireland' had lost currency by the late twentieth century. Further, 'some prominent citizens of Irish origin stated frankly that they are Canadians and it is up to the Irish Government to finance its own pavilion'.[95] Even in April 1966, efforts to solicit Irish engagement continued, at which point Ambassador Gill intervened to firmly state that 'No useful purpose could be served by seeking any further consideration of this question by Irish authorities and that any further attempt to do so could adversely affect our relations with the Irish.'[96] Subsequently, 'Belton confirmed that, in spite of tremendous agitation by members of Parliament, industrialists, bankers, civic officials, the Press, etc., the Irish Cabinet was firm in its intention not to participate in Expo 67'.[97]

Irish men and women further debated whether Northern Ireland would have an exhibit at Expo 67. Northern Ireland agreed to the option of being included in the British Pavilion as the region had 'not been invited to participate as a separate country'.[98] At a Belfast Press Conference on 19 July 1965, Yves Jasmin, Director of Public Relations for the Exhibition, announced that '*Éire* will have a "medium-sized" pavilion at the exhibition'. In the British Pavilion, the tourism potential for Northern Ireland held priority. For example, H. W. L. Stephens, chairman of the Tourist Board, claimed that 'Our country is full of beautiful scenery, excellent fishing and golf and other recreations, and interesting historic associations' and the country's display in 1967 would be of inestimable value in giving a complete picture of Northern Ireland'.[99] The final Exhibition saw sixty-two countries take part, of which the Republic of Ireland was not one.

Ireland in the 1960s

Ireland's debates on exhibitions stood in the backdrop of turbulent relations between the Republic of Ireland and Northern Ireland. Tom Garvin, among others, has noted the significance of the historic meeting between Lemass and Northern Ireland Prime Minister Terence O'Neill (1914–90) in January 1965. As the first such meeting of the two heads of government since 1922, it marked the end of divisive views on partition, and O'Neill made the return visit to Dublin in February 1965.[100] Lemass's successor, Jack Lynch (1917–99), met O'Neill for talks in December 1967; however, by January 1968 the situation in Northern Ireland had deteriorated, and consequently in April 1969 O'Neill resigned.[101] Daly argues that until the late 1960s, Northern Ireland was more productive than the Republic in

attracting overseas investment; it had an efficient marketing campaign and offered attractive capital concessions and modern factories for rent. Irish people could freely live and work in Britain without restriction, despite leaving the Commonwealth in 1949, and the number of Irish people in Britain increased significantly in the 1950s. But the outbreak of violence halted Northern Ireland's investment programme.[102]

There was growing unionist opposition against increased North–South co-operation. Notably, Ian Paisley had organised effective retaliation.[103] Discrimination against Catholics in Northern Ireland was a constant and politically volatile issue. Paul Bew has calculated that 'The Troubles' cost almost 3,500 lives, and 60 per cent of deaths were committed by the IRA or its allies, 30 per cent by loyalist paramilitaries, and 10 per cent by state-sanctioned forces.[104] Consequently, efforts to attract domestic investment were greatly hampered by political violence, resulting in the depletion of industrial employment.[105] Marches and counter-marches were organised, and most ended with bloodshed. There were mass meetings outside the General Post Office; on one occasion 4,000 people marched to the British Embassy, and some demonstrators were involved in disputes with the *Gardaí*. Armed robberies regularly occurred, and there was a sustained period of bombings, abductions, assassinations, shootings, population displacement, torture, hunger strikes, internment without trial, intimidation, and arson.[106] Ireland's displays in the 1960s were overshadowed by the decade's worth of violence that came after, which eventually led to the suspension of Stormont.

To draw some threads together, the fairs in the 1960s contended with many obstacles, mainly financial but also due to loss of public support, low return on investment, and contrary reception by visitors. Despite the many arguments against display, the fact that there was little material return, negligible monetary benefit, and dubious global standing benefits, there were still those within the Republic of Ireland and Northern Ireland that considered the hundreds of thousands invested as desirable, necessary, and worthwhile. This chapter has traced how such arguments were made in the 1960s from Seattle to New York, and Montreal. Again and again, the same arguments were deployed, dismissed, or else reasoned with. Crucially, Ireland's post-colonial project was prioritised. The country rejected visions of itself as a rural backwater with only rolling green hills and peasant industries, as in previous displays. It wanted to be avowedly modern and industrial; however, visitors were not always convinced by these narratives and questioned the omission of traditional culture as an inaccurate representation of Irishness. Fair-goers had become used to a particular image of Ireland over successive decades. The boom in the tourist industry which continued to present the country as a 'cultural oasis' reinforced international perceptions

of Ireland as resplendent, with beautiful women, peat, and bogs. Overall, the country's tourism, advertisement strategies, and former exhibitions partly undermined the effectiveness of Irish post-colonial nation building through display.

Economically, politically, and constitutionally, the Republic of Ireland witnessed a recession, border disputes, and internal violence at a time when it sought to display itself as a peaceful and productive country overseas. Again, we can see how fairs stood apart from the realities of everyday politics and engaged in ambitious plans for the future. Within the post-colonial project, the Constitution of Northern Ireland Act 1973 declared that Northern Ireland could not cease to be part of the United Kingdom without the consent of the majority of people in a referendum, and so firmed up Northern Ireland's place within the United Kingdom.[107] Further, the Belfast Agreement of 1998 left the constitutional position of Northern Ireland under London authority fundamentally fixed. These changes brought in the structures of power sharing, joint citizenship, and cross-border institutions.[108] After the Good Friday Agreement of 1998, Foster claims that 'the Republic could retire from its role as sundered mother to the orphaned north, just as the British adjured the role of adoptive father'.[109] In the 1960s Ireland's post-colonial project was complex and contested in the platform of display. The displays of this period provide a fitting end to the story of Irish exhibitions as they were no longer the sole means of curating ideas of the nation. The fact that Ireland's post-colonial project of modernity was consistently undermined reveals the secondary role exhibitions played next to tourism, capitalism, and global commerce in the 1960s. In the post-colonial world, the Republic of Ireland, Northern Ireland, and the United Kingdom had a degree of constitutional separateness. Despite Irish government officials' sustained efforts in the 1960s to challenge the commercial power of Irish stereotypes, its place in the global marketplace was too strong. Notwithstanding economic and cultural modernisation, the opening of Ireland to the wider world relied on reductive stereotypes of the country and people in the 1960s.[110] And I now go on to consider what the impact of a century of such Irish display had on visions of Irishness.

Notes

1 Gearóid Ó Tuathaigh, 'Introduction: Ireland 1880–2016: Negotiating Sovereignty and Freedom', in Thomas Bartlett (ed.), *The Cambridge History of Ireland: Volume 4: 1880 to the Present* (Cambridge, 2018), pp. 1–30, p. 1.

2 M. E. Daly, *Sixties Ireland: Reshaping the Economy, State and Society, 1957–1973* (Cambridge, 2016), p. 1. See M. O'Driscoll, D. Keogh, and J. Wiel (eds), *Ireland through European Eyes: Western Europe: The EEC and Ireland,*

1945–1973 (Cork, 2013); D. Ferriter, *Ambiguous Republic: Ireland in the 1970s* (London, 2012).
3 Enda Delaney, 'Modernity, the Past and Politics in Post-War Ireland', in Thomas E. Hachey (ed.), *Turning-Points in Twentieth-Century Irish History* (Dublin, 2012), pp. 103–18, p. 111; B. Girvin, *Between Two Worlds: Politics and Economy in Independent Ireland* (Dublin, 1989), p. 196 .
4 See B. Girvin and G. Murphy, *The Lemass Era: Politics and Society in the Ireland of Seán Lemass* (Dublin, 2005); J. Horgan, *Seán Lemass, The Enigmatic Patriot* (Dublin, 1997); D. J. Maher, *The Tortuous Path: The Course of Ireland's Entry into the EEC 1948–73* (Dublin, 1986).
5 E. Delaney, *Irish Emigration since 1921* (Dublin, 2002), p. 26.
6 K. Bloomfield, *A Tragedy of Errors: The Government and Misgovernment of Northern Ireland* (Liverpool, 2007); M. Kennedy, *Division and Consensus: The Politics of Cross-Border Relations in Ireland, 1925–1969* (Dublin, 2000); T. Brown, *Ireland: A Social and Cultural History 1922–1979* (London, 1981).
7 F. Toibín, *The Best of Decades: Ireland in the 1960s* (Dublin, 1996).
8 Daly, *Sixties Ireland*, p. 6.
9 Ibid., p. 256.
10 D. Ferriter, *The Transformation of Ireland 1900–2000* (Dublin, 2005), p. 537.
11 'No Irish Pavilion at Brussels', *Catholic Standard* (26 July 1957).
12 'Only on Pan Am – Jets Direct to the Seattle World's Fair – The Greatest Adventure of the Year!', *Birmingham Daily Post* (6 March 1962).
13 M. Kiely, 'Russia and Ireland Were Missing', *Irish Independent* (12 July 1962).
14 J. Jarvis, 'The Spalpeens! Planting Irish Sod near the Fair's British Pavilion', *Seattle Post-Intelligencer* (13 March 1962).
15 Ibid.
16 R. Moses, 'New York World's Fair 1964–65 Progress Report', 16 January 1961.
17 J. E. Findling and K. D. Pelle (eds), *Encyclopaedia of World's Fairs and Expositions* (Jefferson, NC, 2008), p. 330.
18 J. Tirella, *Tomorrow-Land: The 1964–65 World's Fair and the Transformation of America* (New York, 2014), p. 320.
19 Andrew V. Uroskie, 'New York 1964–1965', in Findling and Pelle (eds), *Encyclopaedia of World's Fairs and Expositions*, pp. 330–4, p. 330. See R. A. Caro, *The Power Broker: Robert Moses and the Fall of New York* (New York, 1975).
20 Much of the negotiations took place in letters, minutes of meetings, and memorandums. These files are under a single shelf mark in the National Archives of Ireland. National Archives of Ireland, Dublin, DFA/96/8/37, manuscript collection, New York World Fair, 1964/65. I will only give the title of the sources from now on as the archival information is the same. The addresses and titles of the sources will be reproduced exactly (note the inconsistencies in document presentation). Memo dated 4 February 1961, 'New York World Fair, 1964/65'.
21 Letter dated 1 March 1961, 'New York World Fair 1964/65'.
22 Ibid.
23 Memo dated December 1961, 'New York World Fair 1964/65'.

24 J. M. O'Leary, 'Manufacturing Reality: The Display of the Irish at World's Fairs and Exhibitions 1893 to 1965' (PhD dissertation, Kent State University, 2015), p. 293.
25 Note by Inter-Departmental Committee, 22 March 1962, 'New York's World Fair'.
26 'Extract from Official Report of Debates: New York's World Fair', 6 December 1962.
27 Daly, *Sixties Ireland*, p. 362.
28 R. F. Foster, *Luck and the Irish: A Brief History of Change from 1970* (New York, 2008), pp. 113–14.
29 S. Boym, *The Future of Nostalgia* (London, 2001), p. 41.
30 Ibid., p. 50.
31 New York Public Library, New York, MssCol 2234, manuscript 'Official Guide New York World's Fair 1964/65', 1964, pp. 6–7.
32 New York Public Library, New York, MssCol 2234, manuscript 'The New York World's Fair from A to Z, 1964–1965 and How to See the New York World's Fair', 1964.
33 *Irish Press* (28 February 1963).
34 'Report. Irish Pavilion at New York World's Fair, 1964–65', 6 April 1964. See E. Macaulay-Lewis and J. Simard, 'From Jerash to New York: Columns, Archaeology, and Politics at the 1964–65 World's Fair', *Journal of the Society of Architectural Historians*, 74:3 (2015), 343–64.
35 O'Leary, 'Manufacturing Reality', pp. 294–5.
36 B. Malin, 'De Valera Visits U.S. This Week, Will Get Full Honors From LBJ', *Boston Globe* (24 May 1964); 'Moses Welcomes De Valera on Visit', *New York Times* (31 May 1964).
37 'Irish PM at World's Fair', *Coventry Evening Telegraph* (6 October 1965).
38 Richard J. H. Johnson, 'Myths from Past Beset Ireland's Future at Fair', *New York Times*, 22 September 1964.
39 'Minister Reveals Plans for World's Fair Pavilion: Haven of Reality and Tranquillity', *Irish Times* (6 March 1964).
40 New York Public Library, New York, MssCol 2234, manuscript 'Ireland Commemoration Stone Ceremony at the New York World's Fair 1964–1965', 1963, p. 1.
41 Ibid.
42 'Ireland may enter World Exhibition', *The Irish Times* (10 April 1964).
43 'Extravaganza for Canada', *Irish Independent* (11 April 1964); 'Canada's Exhibition', *Irish Independent* (23 January 1965).
44 Expositions records are held at the Public Archives Record Centre in Montreal, and I consulted several files with a single shelf mark in the Library and Archives Canada in Ottawa. Library and Archives Canada, Ottawa, 23286003012717, manuscript collection Canadian Corporation for the 1967 World Exhange contains financial reports, attendance tables, departmental reports, primary research source for expo, and annual reports for 1963 through to 1968. I will only give the title of the sources from now as the archival information is the

same. The addresses and titles of the sources will be reproduced exactly (note the inconsistencies in the names applied to individuals). Letter on 14 April 1964 to the under-secretary of state for external affairs, Ottawa, Canada from the Canadian embassy, Dublin. Subject: Visit to Dublin of Expo Commissioner General.

45 Telegram on 28 September 1964.
46 'New York World Fair. Irish Pavilion Criticised', *New Ross Standard* (3 November 1939).
47 Telegram, 'Invitation to World Fair' (18 January 1963).
48 Letter on 4 February 1963 to the Undersecretary of State for External Affairs, Ottawa, Canada. From the Canadian embassy, Dublin, Ireland. Subject: Invitation to Ireland to Participate in Montreal World Fair, 1967.
49 Letter on 14th June 1963 to Alfred Rive, Ambassador of Canada from Paul Bienvenu Commissioner General.
50 Letter to Paul Bienvenu from K. L. Marshall Copy to Gerard Bertrand on 1 August 1963 re Irish Participation.
51 Telegram on April 1964. From Dublin to Expo Montreal for Shaw de Dupuy.
52 Letter to John Sharpe (First Secretary of Canadian Embassy) from Chipman on 29 October 1964.
53 Letter on 16 November 1964 to Belton.
54 He visited 120 countries over two years to promote the exhibition. 'Will Promote Canadian Fair', *Irish Independent* (8 April 1964); 'Canadian Exhibition Head for Dublin', *Evening Herald* (8 April 1964); 'Seeks Support for Trade Fair', *Evening Press* (8 April 1964).
55 'Canada Exhibition Chief in Dublin', *Irish Independent* (10 April 1964).
56 See 'Tom Hennigan and Eamonn Gilligan Meet a Man Who Strayed from Journalism into Diplomacy. Distinguished Canadian's story', *Evening Herald* (10 April 1964); I. French, 'Social Events. Diplomats, Daisies, Dining and Dresses', *Irish Times* (13 April 1964).
57 'Official of World Exhibition Here', *Irish Times* (4 December 1964); 'Canadian Exhibition', *Irish Times* (1 January 1965); 'Ireland at Exhibition', *Dublin Evening Press* (15 February 1965).
58 Report of Chipman to Ireland, 1–2 December 1964.
59 Letter on 3 December 1964 to the Under–Secretary of State for External Affairs, Ottawa, Canada from the Canadian Embassy, Dublin.
60 Ibid.
61 Telegram from Canadian Embassy, Dublin to Dominion London for External Ottawa for Dupuy on 10 April 1964.
62 Letter on 14 April 1964 to the Under–Secretary of State for External Affairs, Ottawa, Canada from the Canadian Embassy, Dublin. Subject: Visit to Dublin of Expo Commissioner General.
63 Letter on 28 October 1964 to McLane from W. N. A. Chipman.
64 Memo on March 1965.
65 Undated.
66 Ibid.

67 Memo re Irish Pavilion, Montreal, Expo on 23 December 1964.
68 Note (suggested signal to be sent by Mr Shaw) on 28 December 1964.
69 Letter on 17 December 1964.
70 Telegram on 26 January 1965. Newspapers regularly ran articles on this issue; for instance: M. Foy, 'Ireland May Have Stand at World Fair', *Irish Times* (1 March 1966).
71 Letter to Gill from Olga Maxwell on 12 March 1965.
72 Letter to D. O'Sullivan, Department of External Affairs, Dublin on 30 March 1965.
73 'Ireland for Canadian Exhibition', *Irish Independent* (18 February 1965).
74 Eugenio F. Biagini, 'Minorities', in Eugenio F. Biagini and Mary E. Daly (eds), *The Cambridge Social History of Modern Ireland* (Cambridge, 2017), pp. 439–1459, p. 440.
75 'Irish Place in Canadian Exhibition', *Irish Times* (18 February 1965).
76 'Ireland to Take Part in 1967 World Exhibition. Montreal Venue Fixed', *Irish Times* (5 March 1965).
77 'Ireland Looks to...', *Irish Times* (18 September 1965).
78 Ibid.
79 'Canada – The Place to Build a New Life', *Belfast Telegraph* (21 February 1967).
80 'It Cost £229 Million to Give You Expo 67', *Belfast Telegraph* (13 June 1967); 'Expo 67 Is On. The Greatest World Exhibition Ever Known to Man', *Belfast Telegraph* (7 December 1966).
81 'Pleasure–Dome Trends: Pavilions for Expo 67', *Illustrated London News* (12 February 1966).
82 Letter on 23 September 1965 to Marshall. Principal architects: Stephenson Gibney & Associates, Architects, 3, Winton Road, Appian Way, Dublin 6, Ireland. Canadian Associate – Murray & Murray, Architects, 1061, Merivale Road, Ottawa, Ontario.
83 Letter/Contact Report to Messieurs P. de Bellefeuille, R. Letendre, A. Kniewasser, and Colonel E. Churchill from: K. L. Marshall on 29 September 1965 and minutes of meeting held on 28 September 1965 on Ireland Pavilion.
84 Letter on 16 April 1965.
85 Letter to Marshall on 7 December 1965.
86 Letter from Thomas Mullins to Secretary of 1967 Expo on 25 March 1966.
87 Many newspapers ran articles: 'Withdrawal from Exhibition. Montreal Costs Rise Stopped Ireland's Entry', *Irish Independent* (9 March 1966); 'Still Trying to Have Pavilion in Montreal', *Irish Times* (14 March 1966); Maud Lennon, 'Ireland May Yet Have Pavilion at Montreal Fair', *Dublin Sunday Press* (20 March 1966). One author lamented that the decision to withdraw may seem 'sensible ... at home, tend to look ridiculously penny-pinching in the eyes of the world'.
88 Telegram on 23 December 1965.
89 See 'Irish Withdrawal from Exhibition', *Irish Times* (5 January 1966).
90 'Irish Pavilion', *Irish Times* (11 January 1966).
91 Letter to Gualtiri, External, Ottawa from Pierre de Belletoulle on 31 December 1965.

92 Letter on 24 January 1966.
93 Telegram on 13 January 1966.
94 Letter to Mayor Jean Drapeau on 6 April 1966.
95 Letter signed by Paul Martin on 12 April 1966.
96 Telegram on 25 April 1966.
97 Letter on Irish Participation on 25 April 1966. A letter by Katharine V. Fleming of 'Irish extraction' on 13 June 1967 to Pierre Dupuy found it 'very disturbing' that there was 'nothing in the booklet about Ireland' and that 'the Irish people have no representation there'.
98 'Ulster Firms May Exhibit at £230 Million Fair', *Belfast Telegraph* (19 July 1965).
99 '11th Hour Rush to Get Expo 67 Ready', *Belfast Telegraph* (27 April 1967).
100 T. Garvin, *Preventing the Future: Why Was Ireland so Poor for so Long* (Dublin, 2004), p. 144, p. 127.
101 Ó Tuathaigh, 'Introduction: Ireland 1880–2016', p. 634.
102 Daly, *Sixties Ireland*, p. 136, p. 318.
103 N. Mansergh, *The Unresolved Question: The Anglo-Irish Settlement and Its Undoing, 1912–72* (New Haven, CT, 1991), p. 344.
104 P. Bew and J. Bew, 'War and Peace in Northern Ireland: 1965–2016', in Thomas Bartlett (ed.), *The Cambridge History of Ireland. Vol IV. 1880 to the Present* (Cambridge, 2018), pp. 441–500, p. 474. See H. Patterson, *Ireland's Violent Frontier: The Border and Anglo–Irish Relations* (Houndsmills, 2013).
105 P. Canning, *British Policy Towards Ireland, 1921–1941* (Oxford, 1985), p. 822.
106 Ó Tuathaigh, 'Introduction: Ireland 1880–2016', p. 23.
107 Mansergh, *Unresolved Question*, p. 346.
108 P. Bew, *Ireland: The Politics of Enmity 1789–2006* (Oxford, 2007), p. 486.
109 Foster, *Luck and the Irish*, pp. 142–3.
110 K. O'Sullivan, *Ireland, Africa and the End of Empire* (Manchester, 2012).

Conclusion: Ireland on display

The impulse to display Ireland continued into the twenty-first century. The Irish displays of the 2000s, 2010s, and one in 2022 offer instances of continuity and divergence in the images of Irishness at exhibitions. Ireland's tour of exhibitions in the millennium went from Germany for the Hanover Exposition in 2000 to Aichi for the Japan Expo in 2005, and then China for the Shanghai Expo in 2010, and finally Italy for Expo Milan in 2015. So far in the 2020s Ireland has featured in the Dubai Expo in 2022. In the twenty-first century Ireland's displays presented the country as historical, technologically advanced, resplendent with culture and heritage, and as competitors in the global market. Established exhibitionary models emerged in the consolidation of Irish history, culture, and tradition, evoking an attractive past, present, and future distinct from the needs of the British Empire and active state building. In addition to this recent history, Ireland's past exhibitions embed Ireland's social and cultural history within its political history.

National and international spectacles were central to Irish identity from the first Great Exhibition of the Works of Industry of All Nations in 1851 and throughout the nineteenth and twentieth centuries. Exhibitions had a multitude of functions, from accelerating industrialisation to reviving extant rural industries, from nation making and state building to vehicles of trade and profit through commerce and tourism. This book has traced the display of Ireland and Irish identity at international expositions over two centuries, ending in the post-colonial period. Taken as a whole, the ways in which the visual metamorphosed into a vital arena of knowledge creation and the production of selfhood is evident. The visual and the cultural are essential to understand Irish identity alongside discussions of state formation and national politics. Interrogating diverse and dynamic displays of Ireland offers a unique vantage point as it demonstrates how fluidity became central to self-fashioning through display. This adaptability enabled an independent image of Ireland to emerge within the confines of an imperial platform.

By taking case studies from different decades and various junctures in Ireland's history, we can see that display functioned idiosyncratically for

Irish men and women to further their individual and national causes. The visual was a rich site for Irish individuals and groups to work out their politicised existences in a transatlantic forum. Each iteration of Ireland's display crafted a powerful vision of Ireland as a country and a people. Ideas of Irish development and recovery dominated its exhibits in the nineteenth century, while issues of nation building and commerce became the central concern in twentieth-century Irish displays. Non-Irish groups and individuals such as English industrialists and philanthropists largely created earlier ideas of Irish progress in exhibits, whereas Irish state actors directed the largely commercial exhibitions of the latter period. The changing images of Irishness highlighted in this study are therefore also broadly revealing of the transforming agency of Irish contemporaries. Overall, I have interrogated the myriad transformations of Irish identity through nineteenth- and twentieth-century exhibitions of the Irish in Britain, Ireland, and the United States.

Recent historiography disputes the idea of Irish whiteness. Display highlights that the Irish laboured for the political privileges associated with whiteness that English contemporaries had denied them based on discourses of civilisation and class. Representations of Irish identity at expositions revealed that a political whiteness emerged through commerce and Home Rule propaganda in the early twentieth century. This advances discussion on Irish whiteness by considering its formation through capitalist structures and Irish women, which challenges reductive scholarship on race and Irishness. It further proves that whiteness historically operated along a spectrum in terms of access to privilege that was itself gendered, sexualised, and dependent on ethnicity. Another contested phenomenon among historians is the issue of the Irish diaspora; some scholarship takes Irish migration to be a form of exile. Considering an Irish agency during the process of migration and settlement as an exchange between home and abroad is evident when analysing the work of female philanthropy and female labour in transatlantic Irish communities. Irish visitors to fairs actively participated in the rural revival project, bought souvenirs, and celebrated symbols of an Irish home in the United States via an organic process of transaction and consumption. *Exhibiting Irishness* underscores the geographic specificities of Irishness through its diachronic constructions over the nineteenth and twentieth centuries.

Exhibitions were not only a forum to create popular visions of Irishness but, further, the platform for voicing divergent political expressions to mass audiences. This was not a straightforward process and was often subject to revision and compromise, as this study has shown. Irishness was debated and imagined with different political and ideological positions manifesting through display. For example, each case study shows something unique to

Irishness and exhibitions and relates to different moments in Irish social, cultural, and political history. By demonstrating that Ireland's exhibits were organised by industrialists in the 1850s, by non-Irish women in the 1890s, Irish entrepreneurs in the twentieth century, Irish citizens in the interwar decades, and Irish government officials in the post-colonial period, broader state politics are mapped to the level of Irish organisers, industrialists, philanthropists, and visitors. In this sense, Irishness relied on mutability to appeal to different audiences across various historical moments.

Exhibiting Irishness uncovers connections in the importance of women to the project of Ireland; female labour became connected to ideas of an Irish recovery in the nineteenth century within post-Famine discourse and the rural revival project. Moreover, women later became important for creating an Irish nation allied with Britain and one that stimulated tourism in the twentieth century. Class also featured in the transatlantic sphere of display; philanthropy and activism combined to save Ireland from poverty in efforts directed by the wealthy during the 1890s. Meanwhile, later Irish organisers combated deaths from tuberculosis through the commercial enterprise of Irish villages tying trade and charity with elite concerns for the poor. The project of Irish tourism had its roots in the early twentieth century, which was formalised in the interwar period and boomed in the post-colonial era. In sum, this book reveals the importance of exhibitions in innovating the commodification of Irishness via networks of capitalism during the 1850s to the 1960s.

Competing notions of development influenced Irish display and its broader history. Differing state and non-state, Irish and non-Irish, actors envisaged industrialisation or rural commodification and tourism – all within a reflexive nationalist or unionist framework – as key for Ireland's potential progress. Visitors were cognisant to claims of authenticity that concerned exhibition organisers. The similarities of the exhibition project and the Irish tourist industry reveal how an authentic history and culture made Irishness accessible and profitable through the internationalism of a saleable Irish land and Irish character. Evidently, exhibitions were important spaces through which an Irishness was constructed while addressing issues related to Ireland and Britain at key historical moments.

By comparing Irish exhibits across a century of display, a change in Irish political thinking is illustrated. Throughout the nineteenth and early twentieth centuries, Ireland's display was relegated to the colonial, Midway sections of fairs. However, in the mid- to late twentieth century, Ireland's exhibits were no longer in village form but in more modern exhibits within pavilions and larger displays. The country's later exhibits rejected the traditional tropes utilised by Scotland, for example, in celebrating an agricultural or colonial past and focused its efforts on technology and modernity, in part

solidifying the perception of Ireland as a white and developed nation free from the shackles of colonialism. No longer was a peasant way of life seen as authentic and attractive for the Irish but as a harmful stereotype better avoided. However, visitors persistently undermined this project as they bristled against the absence of a rural and primitive Ireland in the fairground.

Exhibitions broadly operated under a triptych of motivations and outcomes: to stimulate trade for the tourist industry, to encourage sales for exhibitors, and to provide the employment of local labourers – all within a capitalist sale of goods. This synthesis of diverse practices demonstrates that using exhibitions as a lens for reading Irish history shows us concepts and themes that solely political histories undervalue. Irish women advertised Irishness, embodied modernity and rurality, and had their femininity used to push the sale of Ireland and its products. The Irish exhibition story mirrors the development of museums in nineteenth-century Ireland – concerned as both projects were with representing the Irish nation. Both state-sanctioned projects evoked a distinct political relationship with the past. The growth and development of Irish nationalism became intimately tied to ideas of the nation as represented through culture, history, and the visual.

This book has traced the fluid nature of Irish identity through its national and international displays in the nineteenth and twentieth centuries as it moved from a colonial to an independent state. The politics of display influenced the production of Irish identity according to a host of contexts which in turn reinforced Irish understandings of themselves politically, economically, socially, and culturally. I have demonstrated that the visual became a formative platform to both evoke organisers' and visitors' concerns and the forum through which to mediate and transform those ideals. Organisers of Irish exhibits reacted fluidly to the contexts of famine and poverty, migration and diasporic settlement, independence movements and partition, as well as post-colonial nation building, and this work highlights the agency of Irish men and women in presenting their own version of themselves.

Overall, distinctive visions of Ireland became important at different historical moments. In the nineteenth century, Ireland was concerned with development and industry and made efforts to recover from a depressed economy by highlighting the capacities of labour, mainly through women. In the twentieth century, Irish men and women became preoccupied with state building and sought to consolidate an Irish image for financial and political gain (whether unionism or republicanism) through tourism and a distinct Irish brand. Narratives of Ireland shifted from concerns of development and migration to commerce and trade and finally state building, and imagined a host of Irish pasts, presents, and futures. Irish identity on display is a key conduit in assessing the changing landscape of Irishness

over its formative centuries. Display emerged in tandem with the unfolding of Ireland's political transformation from a colony of the British Empire to a migrant community in the United States to a divided Ireland in the form of the Republic and Northern Ireland – a separation that continues today.

The *Irish Times* acknowledged the importance of expositions in the twenty-first century, stating that it was the 'world's biggest non-sporting recurring event'.[1] The presentation and meaning of Irish identity changed throughout the nineteenth, twentieth, and twenty-first centuries along discrete axes related to style and purpose. However, throughout the 2000s similarities persisted in efforts to create an authentic Ireland, to showcase a historic yet modern country. Distinct to the twenty-first century, organisers agreed that success was no longer defined by immediate financial profit but within the diplomatic sphere. Yet presentations of an immaculate Irish landscape and people continued while the funding of the events moved from private industrialists to public taxes. Tracing Irishness into the modern period enables us to see how an Irish selfhood adapted to diverse contexts, whether national, international, or global.

Nonetheless, exhibits have largely become redundant in the development of modern nations, and so the contemporary public has generally stopped paying attention to such displays. Instead, mass media and its innumerable visual and textual forms accommodate the needs of identity formation. Exhibitions are no longer needed for large-scale advertising, and the advent of social media has seen the diversification of political movements and collective activism, which has made the ideological motives of exhibits obsolete. Moreover, international Olympics, local and national elections, and the global market have absorbed the space that international exhibitions of the past typically occupied. However, there are still plans for expos in the future.

The commodification of Irishness now articulates itself in a multi-billion-pound industry, with Irish pubs in almost every country of Europe. Stereotypical images of Irishness rooted in the land and its people have a currency and traction that transcends borders, and we can see their origins in international exhibitions. The exhibitions created marketable symbols of Irishness that now have a life of their own. In the same way that exhibitions of the nineteenth and twentieth centuries accommodated for different politics and biases, the mass market of Irishness is deluged with predictable motifs of Irishness, typically divorced from its political sphere. A saleable Irishness emerged in exhibits of the past and are now the product of a lucrative global phenomena of Irish culture, whether related to the Irish landscape, the Irish people, or Irish products. *Exhibiting Irishness* tells the story of how an international Irish identity has always been about selling Irishness – an Irish identity always on sale.

Note

1 P. Agnew, 'Higgins to Open Irish Exhibition in Expo 2015 in Milan: Timed to Coincide with Bloomsday, Irish Participation is called "Origin Green"', *Irish Times* (16 June 2015).

Bibliography

Archives

British Library, London
Irish Architectural Archive, Dublin
Library and Archives Canada, Ottawa
Library of Congress, Washington, DC
National Archives of Ireland, Dublin
National Library of Ireland, Dublin
New York Public Library, New York

Primary sources

Periodicals

Aberdeen Press and Journal (Scotland)
The Advocate: or, Irish Industrial Journal (Ireland)
Ballymena Observer (Ireland)
Ballymena Weekly Telegraph (Ireland)
Belfast News-Letter (Ireland)
Belfast Telegraph (Ireland)
Belfast Weekly News (Ireland)
Bell's Weekly Messenger (England)
Birmingham Daily Post (England)
Boston Globe (United States)
Bradford Daily Telegraph (England)
Carlisle Journal (Scotland)
Catholic Standard (Ireland)
Chicago Tribune (United States)
Cork Constitution (Ireland)
Cork Examiner (Ireland)
Coventry Evening Telegraph (England)
Coventry Herald (England)
Coventry Standard (England)
Daily Chronicle (England)
Derry Journal (Ireland)
Donegal Independent (Ireland)
Dover Express (England)

Dublin Daily Express (Ireland)
Dublin Evening Mail (Ireland)
Dublin Evening Press (Ireland)
Dublin Evening Telegraph (Ireland)
Dublin Sunday Press (Ireland)
Dublin Weekly Nation (Ireland)
Dundee Evening Telegraph (Scotland)
Dundee, Perth, and Cupar Advertiser (Scotland)
The Evening Freeman (Ireland)
Evening Herald (England)
Evening Press (England)
Flag of Ireland (Ireland)
Freeman's Journal and Daily Commercial Advertiser (Ireland)
The Globe (England)
Greenock Advertiser (Scotland)
Hall and Theatre Review (England)
Illustrated London News (England)
The Illustrated Magazine of Art (England)
Irish Independent (Ireland)
Irish News and Belfast Morning News (Ireland)
Irish Times (Ireland)
Journal of the Royal Society of Arts (England)
Kerry Evening Post (Ireland)
Kings County Chronicle (Ireland)
The Lancet (England)
Leeds Mercury (England)
Linlithgowshire Gazette (Scotland)
Liverpool Mail (England)
London Daily News (England)
London Evening News (England)
Londonderry Sentinel (Ireland)
Mid-Ulster Mail (Ireland)
Nature (England)
New Ross Standard (Ireland)
Northern Whig (Ireland)
The Queen (England)
Reynold's Newspaper (England)
Roscommon & Leitrim Gazette (Ireland)
Seattle Post-Intelligencer (United States)
Southern Reporter and Cork Commercial Courier (Ireland)
St James's Gazette (England)
Tyrone Constitution (Ireland)
Tyrone Courier (Ireland)
Ulster Gazette (Ireland)
Waterford Standard (Ireland)
Weekly Irish Times (Ireland)
Wexford Independent (Ireland)
Wharfedale & Airedale Observer (England)

Published sources

British Library, London, 4406.b.60, manuscript 'Good News! Or, Free Admission to the Great Exhibition', 1853.
British Library, London, 4477.a.75, manuscript by Milligan, James, 'The Great Exhibition of 1853. Its Utility Defended; And Its Glory Eclipsed! A Sermon Preached on the Lord's Day Succeeding the Opening of the Exhibition', 1853.
British Library, London, 606 *48* DSC, manuscript by Cassell, John, 'The Illustrated Exhibitor, A Tribute to the World's Industrial Jubilee: Comprising Sketches, by Pen and Pencil, of the Principal Objects in the Great Exhibition of the Industry of All Nations, 1851', 1851.
British Library, London, 7956.f.33, manuscript by Maguire, John F., 'The Industrial Movement in Ireland, as Illustrated by the National Exhibition of 1852', 1853.
British Library, London, 7957.c.17, manuscript by Sproule, John (ed.), 'The Irish Industrial Exhibition of 1853: A Detailed Catalogue of Its Contents: With Critical Dissertations, Statistical Information, and Accounts of Manufacturing Processes in the Different Departments', 1854.
British Library, London, 7957.de.32, manuscript 'Official Guide for the Franco-British Exhibition, 1908', 1908.
British Library, London, 7958.aa.2, manuscript by Jones, T. D., 'Record of the Great Industrial Exhibition, 1853: Being a Brief Description of Objects of Interest, etc', 1853.
British Library, London, 8275.cc.24.(9.), manuscript 'Cottage Industries, and What They Can Do for Ireland', 1885.
British Library, London, 8277.d.15.(5.), manuscript by Hart, Alice, 'The Cottage Industries of Ireland, With an Account of the Work of the Donegal Industrial Fund', 1887.
British Library, London, 83/30328, manuscript by Drummond, James, 'Onward and Upward: Extracts (1891–96) from the Magazine of the Onward and Upward Association founded by Lady Aberdeen for the Material, Mental and Moral Elevation of Women', 1983.
British Library, London, D-7956.b.59.(2.), manuscript by Adley, Charles, 'Synopsis of the Contents of the Great Industrial Exhibition 1853 in Connection with the Royal Dublin Society', 1853.
British Library, London, D-7956.bb.25, manuscript 'Official Catalogue of the Great Industrial Exhibition (in Connection with the Royal Dublin Society), 3rd edition', 1853.
British Library, London, D-7956.f.18, manuscript 'Exhibition Inaugural Address Delivered by His Grace, The Archbishop of Dublin, in the Exhibition Pavilion, Cork, on the Evening of the Tuesday, 19th June, 1852, on the Opening of a Course of Lectures, Illustrative of Irish Art, Industry, and Science', 1852.
British Library, London, D-7959.ff.19, manuscript 'Official Catalogue of the British Empire Exhibition, Scotland, 1938', 1938.
British Library, London, H.3986.hh.(21.), manuscript 'Guide and Souvenir of Ballymaclinton', 1908.
British Library, London, J/7957.h.15, manuscript by Dumas, François G., 'The Franco-British Exhibition: Illustrated Review', 1908.
British Library, London, J/7960.dd.29, manuscript 'Illustrated Dublin Exhibition Catalogue, Published in Connection with the Art Journal', 1853.

British Library, London, LOU.EW S159, manuscript 'Herald of the Golden Age and British Health Review', 15:4, 1912.

British Library, London, LOU.IRL S12, manuscript 'Exhibition Expositor and Advertiser', 1853.

British Library, London, Mic.F.232 [no. 13920], manuscript by Stead, William T., 'Lord and Lady Aberdeen: A Character Sketch', 1893.

British Library, London, P.P.2505.r, manuscript 'Irish Exhibition Almanack', 1853.

British Library, London, P.P.2706.aka, manuscript 'Ballymaclinton and the Crusade against Tuberculosis in Ireland: Some Particulars Concerning One of the Most Remarkable and Successful of Modern Health Movements', *Good Health: An Illustrated Monthly Magazine devoted to Hygiene and the Principles of Healthful Living*, 6:8, 1908.

British Library, London, RB.23.a.15618, manuscript by Scribbler, Esq., 'A Versified Description of the Great Industrial Exhibition, in Dublin, 1853, in a letter from I. Donoghoe to his Brother Dan', 1853.

British Library, London, W15/4654, manuscript 'Official Guide of the British Empire Exhibition, Scotland, 1938', 1938.

British Library, London, W27/8577, manuscript 'A Pictorial and Descriptive Guide to London and the British Empire Exhibition 1924', 1924.

British Library, London, W30/2382, manuscript 'Tallis's History and Description of the Crystal Palace, and the Exhibition of the World's Industry in 1851, Vol. 2', 1852.

British Library, London, W47/3147, manuscript by Aberdeen, John C. G., and Temair (1st Marquis Of), Ishbel G. Aberdeen and Temair (Marchioness Of), ' "We Twa": Reminiscences of Lord and Lady Aberdeen, Volume 1 & 2', 1925.

British Library, London, W66/0147, manuscript 'Official Guide to the British Empire Exhibition', 1924.

British Library, London, X 1187, manuscript 'Prospectus of the New York World's Fair, 1939. Created and supervised by Lord and Thomas, and the Administrative Staff of the New York World's Fair 1939 Incorporated', 1939.

British Library, London, YD.2007.a.9700, manuscript 'British Empire Exhibition, 1924: Wembley, London, April–October: Handbook of General Information', 1924.

British Library, London, YD.2017.a.1616, manuscript 'Daily News Souvenir Guide to the British Empire Exhibition: Concise "Where Is It" Index and Complete Train, Tram and Bus Guide', 1924.

Irish Architectural Archive, Dublin, 0079/010.001/001–104, Michael John Scott Drawings, 1937–39.

Library of Congress, Washington, DC, T500.A1 F69, manuscript by Flinn, John J., 'Official Guide to the Midway Plaisance. Otherwise known as "The Highway through the Nations" ', 1893.

Library of Congress, Washington, DC, T500.C1 O8, manuscript 'Oriental and Occidental Northern and Southern Portraits of the Midway: A Collection of Photographs of Individual Types of Various Nations from All Parts of the World Who Represented, in the Department of Ethnology, the Manners, Customs, Dress, Religions, Music and other Distinctive Traits and Peculiarities of their Race', 1894.

Library of Congress, Washington, DC, T500.K1, manuscript 'Guide to the Irish Industrial Village and Blarney Castle. The Exhibit of the Irish Industries Association', 1893.

National Library of Ireland, Dublin, LO 5172, manuscript 'Commemorating Ireland's Participation at the World's Fair, New York, 1939', 1938.
National Library of Ireland, Dublin, P 432(1), manuscript 'Report of the Cork Cuvierian Society for the Cultivation of Sciences', 1855.
Petrie, George, 'The Ecclesiastical Architecture of Ireland, Anterior to the Anglo-Norman Invasion; Comprising an Essay on the Origin and Uses of the Round Towers of Ireland' (Dublin, 1845).
University of Illinois Urbana-Champaign, Chicago, 821 B32G, manuscript by Battersby, William J., 'The Glories of the Great Irish Exhibition of All Nations, in 1853', 1853.

Secondary sources

Akenson, Donald H., *Being Had: Historians, Evidence and the Irish in North America* (Charlottesville, VA, 1985).
Akhtar, Shahmima, Erika Hanna, Peter Hession, Mobeen Hussain, Krishan Kumar, Naomi Lloyd-Jones, Jane Ohlmeyer and Ian Stewart, 'Roundtable: Four Nations', *Modern British History*, 35, 1 (2024), 30–48.
Akhtar, Shahmima, 'Learning "The Customs of their Fathers": Irish Villages in Chicago's Columbian Exposition, 1893', *Journal of Victorian Culture*, 20:20 (2023), 1–25.
Akhtar, Shahmima, '"Have I Done Enough for Japan Today?": Japan's Colonial Villages in the Japan-British Exhibition of 1910', *Journal of National Taiwan Normal University*, 67:1 (2022), 41–69.
Akhtar, Shahmima, Dónal Hassett, Kevin Kenny, Laura McAtackney, Ian McBride, Timothy McMahon, Caoimhe Nic Dháibhéid, and Jane Ohlmeyer, 'Decolonising Irish History? Possibilities, Challenges, Practices', *Irish Historical Studies*, 45:168 (2022), 303–32.
Akhtar, Shahmima, 'British Empire Exhibition, 1924', in Mark Doyle (ed.), *The British Empire: A Historical Encyclopaedia, Vol. 2* (Santa Barbara, CA, 2018), pp. 13–15.
Allwood, John, *The Great Exhibitions* (London, 1977).
Almeida, Linda D., 'Irish America, 1940–2000', in J. J. Lee and Marion R. Casey (eds), *Making the Irish American: History and Heritage of the Irish in the United States* (New York, 2007), pp. 548–73.
Altick, Richard D., *The Shows of London* (London, 1978).
Anderson, Benedict, *Imagined Communities: Reflections on the Origin and Spread of Nationalism* (London, 1983).
Anderson, J. and L. O'Dowd, 'Contested Borders: Globalization and Ethno-National Conflict in Ireland', *Regional Studies*, 33:7 (1999), 681–97.
Armstrong, Meg, 'A Jumble of Foreignness: The Sublime Musayums of Nineteenth-Century Fairs and Expositions', *Cultural Critique*, 23 (1992–93), 199–250.
Arnesen, Eric, 'Whiteness and the Historians' Imagination', *International Labour and Working-Class History*, 60 (2001), 3–32.
Auerbach, Jeffrey A., 'Empire under Glass: The British Empire and the Crystal Palace', in John McAleer and John M. MacKenzie (eds), *Exhibiting the Empire: Cultures of Display and the British Empire* (Manchester, 2015), pp. 111–41.

Auerbach, Jeffrey A., *The Great Exhibition of 1851: A Nation on Display* (London, 1999).
Bailkin, Jordanna, *The Culture of Property: The Crisis of Liberalism in Modern Britain* (Chicago, IL, 2004).
Bain, Robert, 'Going to the Exhibition', in Richard Staley (ed.), *The Physics of Empire: Public Lectures* (Cambridge, 1994), pp. 113–42.
Balibar, Etienne, *Race, Nation, Class: Ambiguous Identities* (London, 1991).
Ballantyne, Tony, *Orientalism and Race: Aryanism in the British Empire* (New York, 2002).
Barringer, Tim, 'The South Kensington Museum and the Colonial Project', in Tim Barringer and Tom Flynn (eds), *Colonialism and the Object: Empire, Material Culture and the Museum* (London, 1998), pp. 11–27.
Bartlett, Thomas (ed.), *The Cambridge History of Ireland. Vol IV. 1880 to the Present* (Cambridge, 2018).
Bartlett, Thomas, '"This Famous Island Set in a Virginian Sea": Ireland in the Eighteenth-Century British Empire', in P. J. Marshall (ed.), *The Oxford History of the British Empire. Vol II. The Eighteenth Century* (Oxford, 1998), pp. 254–76.
Barton, Brian, 'Northern Ireland, 1920-25', in J. R. Hill (ed.), *A New History of Ireland. Vol VII. Under the Auspices of the Royal Irish Academy Planned and Established by the Late T. W. Moody 1921–84* (Oxford, 2010), pp. 161-98.
Beckett, J. C., *The Making of Modern Ireland* (London, 1966).
Benedict, Burton, *The Anthropology of World's Fairs: San Francisco's Panama Pacific International Exposition of 1915* (New York, 1983).
Bennett, Tony, 'Speaking to the Eyes: Museums, Legibility, and the Social Order', in Sharon Macdonald (ed.), *The Politics of Display: Museums, Science, Culture* (London, 1998), pp. 25–35.
Bew, Paul and John Bew, 'War and Peace in Northern Ireland: 1965-2016', in Thomas Bartlett (ed.), *The Cambridge History of Ireland. Vol IV. 1880 to the Present* (Cambridge, 2018), pp. 441–500.
Bew, Paul, *Ireland: The Politics of Enmity, 1789–2006* (Oxford, 2007).
Bew, Paul, *Ideology and the Irish Question: Ulster Unionism and Irish Nationalism 1912–1916* (Oxford, 1994).
Bhabha, Homi K., 'Life at the Border: Hybrid Identities of the Present', *New Perspectives Quarterly*, 14:1 (1997), 30–2.
Bhabha, Homi K., *The Location of Culture* (London, 1994).
Bhabha, Homi K., 'Of Mimicry and Man: The Ambivalence of Colonial Discourse', *Discipleship: A Special Issue on Psychoanalysis*, 28 (1984), 125–33.
Biagini, Eugenio F and Mary E. Daly (eds), *The Cambridge Social History of Modern Ireland* (Cambridge, 2017).
Biagini, Eugenio F., 'Minorities', in Eugenio F. Biagini and Mary E. Daly (eds), *The Cambridge Social History of Modern Ireland* (Cambridge, 2017), pp. 439–1459.
Bielenberg, Andy, 'Exodus: The Emigration of Southern Irish Protestants during the Irish War of Independence and the Civil War', *Past and Present*, 218 (2013), 199–232.
Bixby, Patrick and Gregory Castle (eds), *Irish Modernism: From Emergence to Emergency: A History of Irish Modernism* (Cambridge, 2019), pp. 1–24.
Bloomfield, Kenneth, *A Tragedy of Errors: The Government and Misgovernment of Northern Ireland* (Liverpool, 2007).

Bodnar, John, *Transplanted: A History of Immigrants in Urban America* (Bloomington, IN, 1985).
Bonnett, Alistair, 'How the British Working Class Became White: The Symbolic (Re)formulation of Racialized Capitalism', *Journal of Historical Sociology*, 11 (1998), 316–40.
Bowe, Nicola Gordon and Elizabeth Cumming, *The Arts and Crafts Movements in Dublin and Edinburgh, 1885–1925* (Dublin, 1998).
Boyce, David George and Alan O'Day (eds), *The Making of Modern Irish History: Revisionism and the Revisionist Controversy* (London, 1996).
Boym, Svetlana, *The Future of Nostalgia* (London, 2001).
Brady, Ciaran, *Interpreting Irish History: The Debate on Historical Revisionism, 1938–1994* (Dublin, 1994).
Brah, Avtar, *Cartographies of Diaspora: Contesting Identities* (London, 1996).
Breathnach, Ciara, 'Handywomen and Birthing in Rural Ireland, 1851–1955', *Gender and History*, 28:1 (2016), 34–56.
Breathnach, Ciara, 'Lady Dudley's District Nursing Scheme and the Congested Districts Board, 1903–1923', in Margaret Preston and Margaret Ó hÓgartaigh (eds), *Gender and Medicine in Ireland, 1700–1950* (Syracuse, NY, 2012), pp. 138–53.
Breathnach, Ciara, *Congested Districts Board, 1891–1923* (Cork, 2005).
Breckenridge, Carol, 'The Aesthetics and Politics of Colonial Collecting: India at World Fairs', *Comparative Studies in Society and History*, 31:2 (1989), 195–216.
Britton, Sarah, 'Urban Futures/Rural Pasts: Representing Scotland in the 1938 Glasgow Empire Exhibition', *Cultural and Social History*, 8:2 (2011), 213–32.
Britton, Sarah, '"Come and See the Empire by the All Red Route!": Anti-Imperialism and Exhibitions in Interwar Britain', *History Workshop Journal*, 69 (2010), 68–89.
Brown, Terence, *Ireland: A Social and Cultural History 1922–1979* (London, 1981).
Brundage, David, *'Green over Black' Revisited: Ireland and Irish-Americans in the New Histories of American Working-Class 'Whiteness'* (Oxford, 1997).
Brundage, W. F., 'Meta Warrick's 1907 "Negro Tableaux" and (Re)Presenting African American Historical Memory', *The Journal of American History*, 89:4 (2003), 1368–400.
Burn, W. L., *The Age of Equipoise: A Study of the Mid-Victorian Generation* (New York, 1964).
Cairns, David and Shaun Richards, *Writing Ireland: Colonialism, Nationalism and Culture* (Manchester, 1988).
Canning, Paul, *British Policy towards Ireland, 1921–1941* (Oxford, 1985).
Cantor, Geoffrey, 'Anglo-Jewry in 1851: The Great Exhibition and Political Emancipation', *Jewish Historical Studies*, 44 (2012), 103–26.
Cardon, Nathan, *A Dream of the Future: Race, Empire, and Modernity at the Atlanta and Nashville World's Fairs, 1895–1897* (Oxford, 2018).
Cardon, Nathan, 'The South's New Negroes and African American Visions of Progress at the Atlanta and Nashville International Expositions, 1895–1897', *Journal of Southern History*, 80:2 (2014), 287–326.
Caro, Robert A., *The Power Broker: Robert Moses and the Fall of New York* (New York, 1975).
Caslin, Samantha, *Save the Womanhood! Vice, Urban Immorality and Social Control in Liverpool, c. 1900–1976* (Liverpool, 2018).

Clancy, Michael, *Brand New Ireland? Tourism, Development and National Identity in the Irish Republic* (London, 2009).
Clear, Caitríona, *Social Change and Everyday Life in Ireland, 1850–1922* (Manchester, 2007).
Cleary, Joe, 'Amongst Empires: A Short History of Ireland and Empire Studies in International Context', *Éire-Ireland*, 42:1–2 (2007), 11–57.
Cleary, Joe, 'Postcolonial Ireland', in Kevin Kenny (ed.), *Ireland and the British Empire: Oxford History of the British Empire Companion Series* (Oxford, 2004), pp. 251–88.
Codell, Julie F., 'International Exhibitions: Linking Culture, Commerce, and Nation', in Dana Arnold and David P. Corbett (eds), *A Companion to British Art: 1600 to the Present* (London, 2013), pp. 220–40.
Coffey, Donal K., *Drafting the Irish Constitution, 1935–1937: Transnational Influences in Interwar Europe* (Dublin, 2018).
Cohen, Peter, 'The Perversions of Inheritance: Studies in the Making of Multi-Racist Britain', in Peter Cohen and H. S. Bains (eds), *Multi-Racist Britain* (Basingstoke, 1988), pp. 9–118.
Conn, Stephen, *Museums and American Intellectual Life, 1876–1926* (Chicago, IL, 1998).
Conzen, K. N., D. A. Gerber, E. Morawska, G. E. Pozzetta, and R. J. Vecoli, 'The Invention of Ethnicity: A Perspective from the U.S.A', *Journal of American Ethnic History*, 12 (1992), 3–41.
Coombes, Annie E. and Avtar Brah, 'Introduction: The Conundrum of "Mixing"', in Annie E. Coombes and Avtar Brah (eds), *Hybridity and Its Discontents: Politics, Science, Culture* (New York, 2000), pp. 1–17.
Coombes, Annie E., *Reinventing Africa: Museums, Material Culture and Popular Imagination in Late Victorian and Edwardian England* (New Haven, CT, 1994).
Cooper, Sophie, *Forging Identities in the Irish World: Melbourne and Chicago, c.1830–1922* (Edinburgh, 2022).
Cooper, Sophie, 'Irish Migrant Identities and Community Life in Melbourne and Chicago, 1840–1890' (PhD dissertation, University of Edinburgh, 2017).
Corbey, Raymond, 'Ethnographic Showcases, 1870–1930', *Cultural Anthropology*, 8:3 (1993), 338–69.
Cronon, William, *Nature's Metropolis: Chicago and the Great West* (London, 1991).
Crooke, Elizabeth, *Politics, Archaeology and the Creation of a National Museum of Ireland* (Dublin, 2001).
Crosbie, Barry, *Irish Imperial Networks: Migration, Social Communication and Exchange in Nineteenth-Century India* (Cambridge, 2011).
Cuív, Brian Ó., 'Irish Language and Literature, 1845–1921', in William E. Vaughan (ed.), *A New History of Ireland. Vol. VI. Ireland under the Union, II, 1870–1921* (Oxford, 1996), pp. 385–435.
Cull, Nicholas J., 'Overture to an Alliance: British Propaganda at the New York World's Fair, 1939–1940', *Journal of British Studies*, 36:3 (1997), 325–54.
Cullen, Fintan, *Ireland on Show: Art, Union, and Nationhood* (London, 2012).
Curtis, L. P., *Images of Erin in the Age of Parnell* (Dublin, 2000).
Curtis, L. P., *Apes and Angels: The Irishman in Victorian Caricature* (Washington, DC, 1971).
Curtis, L. P., *Anglo-Saxons and Celts: A Study of Anti-Irish Prejudice in Victorian England* (Bridgeport, CT, 1968).

Curtis, L. P., *Coercion and Conciliation in Ireland: A Study in Conservative Unionism* (Princeton, NJ, 1963).
Daly, Mary E., *Sixties Ireland: Reshaping the Economy, State and Society, 1957–1973* (Cambridge, 2016).
Daly, Mary E., *Dublin: The Deposed Capital: A Social and Economic History 1860–1914* (Cork, 1985).
Daly, Mary E., *Social and Economic History of Ireland since 1800* (Dublin, 1981).
Davies, Alun C., 'Ireland's Crystal Palace, 1853', in J. M. Goldstrom and L. A. Clarkson (eds), *Irish Population, Economy, and Society* (Oxford, 1981), pp. 249–70.
Davies, Alun C., 'The First Irish Industrial Exhibition: Cork, 1852', *Irish Economic and Social History*, 2 (1975), 46–59.
Davis, Graham, 'The Irish in Britain, 1815–1939', in Andy Bielenberg (ed.), *The Irish Diaspora* (Harlow, 2000), pp. 19–36.
Davison, Graeme, 'Festivals of Nationhood: The International Exhibitions', in S. L. Goldberg and F. B. Smith (eds), *Australian Cultural History* (New York, 1988), pp. 158–77.
De Barra, C., 'A Allant Little 'Tírín': The Welsh Influence on Irish Cultural Nationalism', *Irish Historical Studies*, 39:153 (2014), 58–75.
Delaney, Enda, 'Diaspora', in Richard Bourke and Ian McBride (eds), *The Princeton History of Modern Ireland* (Princeton, NJ, 2016), pp. 490–508.
Delaney, Enda, *The Curse of Reason: The Great Irish Famine* (Dublin, 2012).
Delaney, Enda, 'Modernity, the Past and Politics in Post-War Ireland', in Thomas E. Hachey (ed.), *Turning-Points in Twentieth-Century Irish History* (Dublin, 2012), pp. 103–18.
Delaney, Enda, 'Our Island Story? Towards a Transnational History of Late Modern Ireland', *Irish Historical Studies*, 37:148 (2011), 599–621.
Delaney, Enda, *The Irish in Post-War Britain* (Oxford, 2007).
Delaney, Enda, 'The Irish Diaspora', *Irish Economic and Social History*, 33 (2006), 35–45.
Delaney, Enda, *Irish Emigration since 1921* (Dublin, 2002).
Delaney, Enda, *Demography, State and Society: Irish Migration to Britain, 1921–1971* (Liverpool, 2000).
De Nie, Michael and Joe Cleary, 'Editors Introduction', *Éire-Ireland*, 42 (2007), 5–10.
De Nie, Michael, *The Eternal Paddy: Irish Identity and the British Press, 1798–1882* (Madison, WI, 2004).
De Nie, Michael, 'A Medley Mob of Irish-American Plotters and Irish Dupes': The British Press and Transatlantic Fenianism', *Journal of British Studies*, 40 (2001), 213–40.
De Nie, Michael, 'The Famine, Irish Identity and the British Press', *Irish Studies Review*, 6:1 (1998), 27–35.
Diner, Hasia R., '"The Most Irish City in the Union": The Era of the Great Migration, 1844–1877', in R. H. Bayor and T. J. Meagher (eds), *The New York Irish* (London, 1996), pp. 87–107.
Dolan, Anne, *Commemorating the Irish Civil War: History and Memory, 1923–2000* (Cambridge, 2003).
Dooley, Brian, *Black and Green: The Fight for Civil Rights in Northern Ireland and Black America* (London, 1998).

Douglas, R. M., 'Anglo-Saxons and Attacotti: The Racialization of Irishness in Britain between the World Wars', *Ethnic and Racial Studies*, 25:1 (2002), 40–63.

Doyle, David N., 'The Remaking of Irish-America, 1845–1880', in J. J. Lee and Marion R. Casey (eds), *Making the Irish American: History and Heritage of the Irish in the United States* (New York, 2007), pp. 213–52.

Doyle, David N., 'The Remaking of Irish-America, 1845–1880', in William E. Vaughan (ed.), *A New History of Ireland. Vol VI. Ireland under the Union, II, 1870–1921* (Oxford, 1996), pp. 725–63.

Duranti, Marco, 'Utopia, Nostalgia and World War at the 1939–40 New York World's Fair', *Journal of Contemporary History*, 4:4 (2006), 663–83.

Dyer, Richard, *White: Essays on Race and Culture* (New York, 1997).

Eagleton, Terry, 'The Ideology of Irish Studies', *Bullan*, 3 (1997), 5–14.

Earner-Byrne, Lindsey, 'Gender Roles in Ireland since 1740', in Eugenio F. Biagini and Mary E. Daly (eds), *The Cambridge Social History of Modern Ireland* (Cambridge, 2017), pp. 312–26.

Edwards, Steve, 'The Accumulation of Knowledge, or William Whewell's Eye', in Louise Purbrick (ed.), *The Great Exhibition of 1851: New Interdisciplinary Essays* (Manchester, 2001), pp. 26–52.

Elliott, Sydney, 'The Northern Ireland Electoral System: A Vehicle for Disputation', in Patrick Roche and Brian Barton (eds), *The Northern Ireland Question: Nationalism, Unionism and Partition* (Kent, OH, 1999), pp. 122–38.

Errington, Shelly, *The Death of Authentic Primitive Art and Other Tales of Progress* (Berkeley, CA, 1998).

Fanning, Ronan, *Éamon de Valera* (Cambridge, MA, 2015).

Farrell, Mel, *Party Politics in a New Democracy: The Irish Free State, 1922–37* (Dublin, 2017).

Ferriter, Diarmaid, 'De Valera's Ireland, 1932–58', in Alvin Jackson (ed.), *The Oxford Handbook of Modern Irish History* (Oxford, 2014), pp. 670–91.

Ferriter, Diarmaid, *Ambiguous Republic: Ireland in the 1970s* (London, 2012).

Ferriter, Diarmaid, *The Transformation of Ireland 1900–2000* (Dublin, 2005).

Fields, Barbara J., 'Whiteness, Racism, and Identity', *International Labour and Working-Class History*, 60 (2001), 48–56.

Filipová, Marta (ed.), *Cultures of International Exhibitions: 1800–1940: Great Exhibitions in the Margins* (London, 2015).

Findling, John E. and Kimberly D. Pelle (eds), *Encyclopaedia of World's Fairs and Expositions* (Jefferson, NC, 2008).

Findling, John E. and Kimberly D. Pelle (eds), *Historical Dictionary of World's Fairs and Expositions, 1851–1988* (New York, 1990).

Fitzpatrick, David, 'Ireland and Empire', in Andrew Porter (ed.), *The Oxford History of the British Empire. Vol III. The Nineteenth Century* (Oxford, 1999), pp. 494–521.

Fitzpatrick, David, *Oceans of Consolation: Personal Accounts of Irish Migration to Australia* (Ithaca, NY, 1994).

Fitzpatrick, David, 'A Curious Middle Place: The Irish in Britain, 1871–1921', in Roger Swift and Sheridan Gilley (eds), *The Irish in Britain 1815–1939* (London, 1989), pp. 10–59.

Fitzpatrick, David, '"A Peculiar Tramping People": The Irish in Britain, 1801–70', in William E. Vaughan (ed.), *A New History of Ireland. Vol V. Ireland under the Union, I, 1801–1870* (Oxford, 1989), pp. 623–60.

Flannery, Eóin, 'The Art of Resistance: Visual Iconography and the Northern "Troubles"', in Eóin Flannery and Michael Griffin (eds), *Ireland in Focus: Film, Photography and Popular Culture* (Syracuse, NY, 2009), pp. 125–43.

Flannery, Eóin, *Ireland and Postcolonial Studies: Theory, Discourse, Utopia* (London, 2009).

Foster, Roy F., *Vivid Faces: The Revolutionary Generation in Ireland 1890–1923* (Dublin, 2015).

Foster, Roy F., *Luck and the Irish: A Brief History of Change from 1970* (New York, 2008).

Foster, Roy F., *Modern Ireland* (Dublin, 1988).

Foster, Roy F., 'We Are All Revisionists Now', *Irish Review*, 1 (1986), 1–5.

Frankenberg, Ruth, *White Women, Race Matters: The Social Construction of Whiteness* (London, 1993).

Fried, Rebecca A., 'No Irish Need Deny: Evidence for the Historicity of NINA Restrictions in Advertisements and Signs', *Journal of Social History*, 49:4 (2016), 829–54.

Fritzsche, Peter, 'Spectres of History: On Nostalgia, Exile, and Modernity', *The American Historical Review*, 106:5 (2001), 1587–618.

Funchion, Michael F., *Chicago's Irish Nationalists, 1881–1890* (Chicago, IL, 1976).

Furlong, Irene, *Irish Tourism 1880–1980* (Dublin, 2009).

Gailey, Andrew, *Ireland and the Death of Kindness: The Experience of Constructive Unionism, 1890–1905* (Cork, 1987).

Garner, Steve, 'Ireland: From Racism without "Race" to "Racism without Racists"', *Radical History Review*, 104 (2009), 41–56.

Garner, Steve, *Racism in the Irish Experience* (London, 2004).

Garvin, Tom, *Preventing the Future: Why Was Ireland so Poor for so Long?* (Dublin, 2004).

Garvin, Tom, *The Birth of Irish Democracy* (Dublin, 1996).

Garvin, Tom, *The Evolution of Irish Nationalist Politics* (Dublin, 1981).

Geppert, Alexander C. T., *Fleeting Cities: Imperial Expositions in Fin-De-Siècle Europe* (New York, 2010).

Ghaill, Mairtin Mac An, 'The Irish in Britain: The Invisibility of Ethnicity and Anti-Irish Racism', *Journal of Ethnic and Migration Studies*, 26:1 (2000), 137–47.

Gibbons, Ivan, *The British Labour Party and the Establishment of the Irish Free State, 1918–1924* (London, 2015).

Gibbons, Luke, 'The Global Cure? History, Therapy and the Celtic Tiger', in Peadar Kirby, Luke Gibbons, and Michael Cronin (eds), *Reinventing Ireland: Culture, Society and the Global Economy* (London, 2002), pp. 89–106.

Gibbons, Luke, 'Race against Time: Racial Discourse and Irish History', in Catherine Hall (ed.), *Cultures of Empire: Colonizers in Britain and the Empire in the Nineteenth and Twentieth Centuries: A Reader* (Manchester, 2000), pp. 207–23.

Gibbons, Luke, *Transformations in Irish Culture* (Dublin, 1996).

Gibbons, Luke, 'Race against Time: Racial Discourse and Irish History', *Oxford Literary Review*, 13:1 (1991), 95–117.

Gilbert, James, *Whose Fair? Experience, Memory, and the History of the Great St Louis Exposition* (Chicago, IL, 2009).

Gilley, Sheridan, 'English Attitudes to the Irish in England, 1780–1900', in Colin Holmes (ed.), *Immigrants and Minorities in British Society* (London, 1978), pp. 81–110.

Girvin, Brian and Gary Murphy, *The Lemass Era: Politics and Society in the Ireland of Seán Lemass* (Dublin, 2005).
Girvin, Brian, *Between Two Worlds: Politics and Economy in Independent Ireland* (Dublin, 1989).
Gráda, Cormac Ó., *Famine: A Short History* (Princeton, NJ, 2009).
Gráda, Cormac Ó., *Ireland's Great Famine: Interdisciplinary Perspectives* (Dublin, 2006).
Gráda, Cormac Ó., *Black '47 and beyond: The Great Irish Famine in History, Economy and* Memory (Princeton, NJ, 1999).
Gráda, Cormac Ó., 'A Note on Nineteenth Century Emigration Statistics', *A Journal of Demography*, 29 (1975), 143–9.
Gray, Peter, *Famine, Land and Politics: British Government and Irish Society 1843–1850* (Dublin, 1999).
Greenhalgh, Paul, *Ephemeral Vistas: The Expositions Universelles, Great Exhibitions and World's Fairs, 1851–1939* (Manchester, 1988).
Greenhalgh, Paul, 'Art, Politics and Society at the Franco-British Exhibition of 1908', *Art History*, 8:4 (1985), 434–52.
Griffin, Patrick, *The People with No Name: Ireland's Ulster Scots, American's Scots Irish, and the Creation of a British Atlantic World, 1689–1764* (Princeton, NJ, 2001).
Guss, David M., *The Festive State: Race, Ethnicity, and Nationalism as Cultural Performance* (Berkeley, CA, 2000).
Hall, Catherine and Sonya O. Rose (eds), *At Home with Empire: Metropolitan Culture and the Imperial World* (London, 2006).
Hall, Catherine (ed.), *Cultures of Empire: Colonizers in Britain and the Empire in the Nineteenth and Twentieth Centuries* (Manchester, 2000).
Hall, Stuart (ed.), *Representation: Cultural Representations and Signifying Practices* (Cambridge, 1997).
Hall, Stuart, 'Our Mongrel Selves', *New Statesmen and Society* (19 June 1992).
Handlin, Oscar, *Uprooted: The Epic Story of the Great Migrations That Made the American People* (Philadelphia, PA, 1952).
Hanna, Erika, *Snapshot Stories: Visuality, Photography, and the Social History of Ireland, 1922–2000* (Oxford, 2020).
Harkness, David W., 'Ireland', in Robin W. Winks (ed.), *The Oxford History of the British Empire. Vol V. Historiography* (Oxford, 1999), pp. 114–33.
Harkness, David W., 'Mr de Valera's Dominion: Irish Relations with Britain and the Commonwealth, 1932–1938', *Journal of Commonwealth Political Studies*, 8:3 (1970), 206–28.
Harkness, David W., *The Restless Dominion: The Irish Free State and the British Commonwealth of Nations, 1921–31* (London, 1970).
Harris, Neil, 'All the World a Melting Pot? Japan at American Fairs, 1876–1904', in Akira Iriye (ed.), *Mutual Images: Essays in American–Japanese Relations* (Cambridge, MA, 1975), pp. 47–54.
Harvey, Penelope, *Hybrids of Modernity: Anthropology, the Nation State and the Universal Exhibition* (London, 1996).
Hassam, Andrew, 'Portable Iron Structures and Uncertain Colonial Spaces at the Sydenham Crystal Palace', in Felix Driver and David Gilbert (eds), *Imperial Cities, Landscape, Display and Identity* (Manchester, 1999), pp. 174–93.
Hechter, Michael, *Internal Colonialism: The Celtic Fringe in British National Development, 1536–1966* (Berkeley, CA, 1975).

Helland, Janice, *British and Irish Home Arts and Industries, 1880–1914: Marketing Craft, Making Fashion* (Dublin, 2007).
Helland, Janice, 'Authenticity and Identity as Visual Display: Scottish and Irish Home Arts and Industries', in Fintan Cullen and John Morrison (eds), *A Shared Legacy: Essays on Irish and Scottish Art and Visual Culture* (London, 2005), pp. 157–72.
Hickman, Mary J. and Bronwen Walter, 'Racializing the Irish in England: Gender, Class and Ethnicity', in Marilyn Cohen and Nancy J. Curtin (eds), *Reclaiming Gender: Transgressive Identities in Modern Ireland* (New York, 1999), pp. 267–92.
Hickman, Mary J. and Bronwen Walter, *Discrimination and the Irish Community in Britain: A Report of Research Undertaken for the Commission for Racial Equality* (London, 1997).
Hickman, Mary J. and Bronwen Walter, 'Deconstructing Whiteness: Irish Women in Britain', *Feminist Review*, 50:1 (1995), 5–19.
Hickman, Mary J., 'Alternative Historiographies of the Irish in Britain: A Critique of the Segregation/Assimilation Model', in Roger Swift and Sheridan Gilley (eds), *The Irish in Victorian Britain: The Local Dimension* (Dublin, 1999), pp. 236–53.
Hickman, Mary J., *Religion, Class and Identity: The State, the Catholic Church and the Education of the Irish in Britain* (Avebury, 1995).
Hill, John R. (ed.), *A New History of Ireland. Vol. VII. Under the Auspices of the Royal Irish Academy Planned and Established by the Late T. W. Moody 1921–84* (Oxford, 2010).
Hobsbawm, Eric and Terence Ranger (eds), *The Invention of Tradition* (Cambridge, 2012).
Hoffenberg, Peter H., *An Empire on Display: English, Indian and Australian Exhibitions from the Crystal Palace to the Great War* (Berkeley, CA, 2001).
Hoffenberg, Peter H., 'Equipoise and Its Discontents: Voices of Dissent during the International Exhibitions', in Martin Hewett (ed.), *An Age of Equipoise? Reassessing Mid-Victorian Britain* (Aldershot, 2000), pp. 39–67.
Holmes, Andrew R. and Eugenio F. Biagini, 'Protestants', in Eugenio F. Biagini and Mary E. Daly (eds), *Cambridge Social History of Modern Ireland* (Cambridge, 2017), pp. 88–112.
hooks, bell, *Black Looks: Race and Representation* (Boston, MA, 1992).
Hoppen, K. T., 'Gladstone, Salisbury and the End of Irish Assimilation', in Mary E. Daly and K. T. Hoppen (eds), *Gladstone: Ireland and Beyond* (Dublin, 2011), pp. 45–63.
Hoppen, K. T., *Ireland since 1800: Conflict and Conformity (Studies in Modern History)* (London, 1989).
Horgan, John, *Seán Lemass: The Enigmatic Patriot* (Dublin, 1997).
Howe, Stephen, 'Questioning the (Bad) Question: 'Was Ireland a Colony?', *Irish Historical Studies*, 36 (2008), 138–52.
Howe, Stephen, 'Historiography', in K. Kenny (ed.), *Ireland and the British Empire: Oxford History of the British Empire Companion Series* (Oxford, 2004), pp. 220–50.
Howe, Stephen, 'The Politics of Historical "Revisionism": Comparing Ireland and Israel/Palestine', *Past and Present*, 168:1 (2000), pp. 227–53.
Howe, Stephen, *Ireland and Empire: Colonial Legacies in Irish History and Culture* (Oxford, 2000).
Howe, Stephen, *Anticolonialism in British Politics: The Left and the End of Empire 1918–1964* (Oxford, 1993).

Hughes, Deborah, 'Kenya, India and the British Empire Exhibition of 1924', *Race and Class*, 47:4 (2006), 66–85.
Ignatiev, Noel, *How the Irish Became White* (New York, 1995).
Jackson, Alvin, 'Ireland, the Union, and the Empire, 1800–1960', in Kevin Kenny (ed.), *Ireland and the British Empire: Oxford History of the British Empire Companion Series* (Oxford, 2004), pp. 123–53.
Jackson, Alvin, *Home Rule: An Irish History, 1800–2000* (Oxford, 2003).
Jackson, Peter, 'Constructions of 'Whiteness' in the Geographical Imagination', *Area*, 30:2 (1998), 99–106.
Jackson, Thomas A., *Ireland Her Own* (Dublin, 1970).
Jacobson, Matthew F., *Whiteness of a Different Color: European Immigrants and the Alchemy of Race* (Cambridge, 1998).
Jacobson, Matthew F., *Special Sorrows: The Diasporic Imagination of Irish, Polish and Jewish Immigrants in the United States* (Cambridge, 1995).
Jenkins, Brian, *The Fenian Problem: Insurgency and Terrorism in a Liberal State, 1858–1874* (Liverpool, 2008).
Jones, G., *'Captain of All These Men of Death': The History of Tuberculosis in Ireland in Nineteenth and Twentieth Century Ireland* (New York, 2001).
Kaplan, Flora S., *Museums and the Making of 'Ourselves': The Role of Objects in National Identity* (Leicester, 1996).
Kee, Robert, *The Green Flag: A History of Irish Nationalism* (London, 1972).
Kelly, Matthew, 'Home Rule and Its Enemies', in Alvin Jackson (ed.), *The Oxford Handbook of Modern Irish History* (Oxford, 2014), pp. 582–602.
Kennedy, Michael, *Division and Consensus: The Politics of Cross-Border Relations in Ireland, 1925–1969* (Dublin, 2000).
Kenny, Kevin, 'Irish Emigrants in a Comparative Perspective', in Eugenio F. Biagini and Mary E. Daly (eds), *The Cambridge Social History of Modern Ireland* (Cambridge, 2017), pp. 405–22.
Kenny, Kevin, 'Twenty Years of Irish American Historiography', *Journal of American Ethnic History*, 28:4 (2009), 67–75.
Kenny, Kevin, 'American-Irish Nationalism', in J. J. Lee and Marion R. Casey (eds), *Making the Irish American: History and Heritage of the Irish in the United States* (New York, 2007), pp. 289–301.
Kenny, Kevin, 'Diaspora and Irish Migration History', *Irish Economic and Social History*, 33 (2006), 46–51.
Kenny, Kevin (ed.), *New Directions in Irish-American Historiography* (Madison, WI, 2003).
Kenny, Kevin, 'Diaspora and Comparison: The Global Irish as a Case Study', *Journal of American History*, 90:1 (2003), 134–62.
Kenny, Kevin, *The American Irish: A History* (London, 2000).
Keown, Gerard, *First of the Small Nations: The Beginnings of Irish Foreign Policy in the Interwar Years, 1919–1932* (Oxford, 2016).
Kiberd, Declan, *Inventing Ireland: The Literature of the Modern Nation* (Cambridge, 1996).
Kilfeather, Siobhan M., *Dublin: A Cultural History* (Dublin, 2005).
Kinealy, Christine, 'Was Ireland a Colony? The Evidence of the Great Famine', in Terence McDonough (ed.), *Was Ireland a Colony? Economics, Politics and Culture in Nineteenth-Century Ireland* (Dublin, 2005), pp. 48–65.
Kinealy, Christine, *A Death-Dealing Famine: The Great Hunger in Ireland* (Dublin, 1997).

King, Carla, *Michael Davitt: After the Land League, 1882–1906* (Dublin, 2016).
Kirkaldy, John, 'English Newspaper Images of Northern Ireland 1968–1973: An Historical Study in Stereotypes and Prejudices' (PhD, University of New South Wales, 1979).
Kirshenblatt-Gimblett, Barbara, *Destination Culture: Tourism, Museums and Heritage* (London, 1998).
Kirwan, Padraig, James P. Byrne, and Michael O'Sullivan, 'Introduction', in Padraig Kirwan, James P. Byrne, and Michael O'Sullivan (eds), *Affecting Irishness: Negotiating Cultural Identity within and beyond the Nation* (New York, 2009), pp. 1–17.
Knight, Donald R. and Alan D. Sabey, *The Lion Roars at Wembley: British Empire Exhibition 60th Anniversary, 1924–1925* (London, 1984).
Knight, Donald R., *The Exhibitions: Great White City, Shepherds Bush, London: 70th Anniversary, 1908–1978* (London, 1978).
Kolchin, Peter, 'Whiteness Studies: The New History of Race in America', *Journal of American History*, 89 (2002), 154–73.
Kramer, Paul, 'Power and Connection: Imperial Histories of the United States in the World', *Radical History Review*, 116:5 (2011), 1348–91.
Kramer, Paul, 'Making Concessions: Race and Empire Revisited at the Philippine Exposition, St. Louis, 1901–1905', *Radical History Review*, 73 (1999), 75–107.
Kriegel, Lara, *Grand Designs: Labour, Empire and the Museum in Victorian Culture* (London, 2007).
Kriegel, Lara, 'After the Exhibitionary Complex: Museum Histories and the Future of the Victorian Past', *Victorian Studies*, 48 (2006), 681–704.
Kriegel, Lara, 'The Pudding and the Palace: Labour, Print Culture, and Imperial Britain in 1851', in Antoinette Burton (ed.), *After the Imperial Turn: Thinking through and with the Nation* (Durham, NC, 2003), pp. 230–45.
Kriegel, Lara, 'Narrating the Subcontinent in 1851: India at the Crystal Palace', in Louise Purbrick (ed.), *The Great Exhibition of 1851: New Interdisciplinary Essays* (Manchester, 2001), pp. 146–78.
Kruger, Loren, '"White Cites", "Diamond Zulus", and the "African Contribution to Human Advancement": African Modernities and the World's Fairs', *TDR: The Drama Review*, 51:3 (2007), 19–45.
Kumar, Kanta, 'Nation and Empire: English and British National Identity in Comparative Perspective', *Theory and Society*, 29:5 (2000), 575–608.
Langlois, Lisa K., 'Japan – Modern, Ancient, and Gendered at the 1893 Chicago World's Fair', in T. J. Boisseau and Abigail M. Markwyn (eds), *Gendering the Fair: Histories of Women and Gender at World's Fairs* (Chicago, 2010), pp. 56–74.
Larmour, Paul, *Free State Architecture: Modern Movement Architecture in Ireland, 1922–1949* (Cork, 2009).
Larmour, Paul, '"The Drunken Man of Genius": William A. Scott (1871–1921)', *Irish Architectural Review*, 3 (2001), 28–41.
Larmour, Paul, *The Arts and Crafts Movement in Ireland* (Dublin, 1992).
Larson, Erik, *The Devil in the White City: Murder, Magic and Madness at the Fair That Changed America* (New York, 2003).
Lebow, Ned, *White Britain and Black Ireland: The Influence of Stereotypes on Colonial Policy* (Philadelphia, PA, 1976).
Lebow, Ned, 'British Historians and Irish History', *Éire-Ireland*, 8:4 (1973), 3–38.

Leerssen, Joep T., 'The Western Mirage: On the Celtic Chronotope in the European Imagination', in Timothy Collins (ed.), *Decoding the Landscape: Contributions towards a Synthesis of Thought in Irish Studies on the Landscape* (Galway, 2003), pp. 1–11.
Leerssen, Joep T., *Remembrance and Imagination* (Cork, 1996).
Lennon, Joseph, *Irish Orientalism* (Syracuse, NY, 2004).
Lewis, Arnold, *An Early Encounter with Tomorrow: European's, Chicago's Loop, and the World's Columbian Exposition* (Champaign, IL, 2001).
Litvack, Leon, 'Exhibiting Ireland, 1851–1853: Colonial Mimicry in London, Cork and Dublin', in Leon Litvack and Glen Hooper (eds), *Ireland in the Nineteenth Century: Regional Identity* (Dublin, 2000), pp. 15–57.
Lloyd, David, *Irish Times: Temporalities of Modernity* (Dublin, 2008).
Lloyd, David, 'Race and Representation', *Oxford Literary Review*, 13:1 (1991), 62–94.
Longair, Sarah and John McAleer (eds), *Curating Empire: Museums and the British Imperial Experience* (Manchester, 2016).
Lowry, Donal, 'Ulster Resistance and Loyalist Rebellion in the Empire', in Keith Jeffrey (ed.), *An Irish Empire? Aspects of Ireland and the British Empire* (Manchester, 1996), pp. 191–215.
Luckhurst, Kenneth W., *The Story of Exhibitions* (London, 1951).
Lyons, F. S., 'The Developing Crisis, 1907–14', in William E. Vaughan (ed.), *A New History of Ireland. Vol VI. Ireland under the Union, II, 1870–1921* (Oxford, 1996), pp. 123–44.
Lyons, F. S., *Culture and Anarchy in Ireland 1890–1939* (Oxford, 1979).
Lyons, F. S., *Ireland since the Famine* (London, 1971).
Macaulay-Lewis, Elizabeth and Jared Simard, 'From Jerash to New York: Columns, Archaeology, and Politics at the 1964–65 World's Fair', *Journal of the Society of Architectural Historians*, 74:3 (2015), 343–4.
MacDonagh, Oliver, *States of Mind: A Study of Anglo-Irish Conflict 1780–1980* (London, 1983).
MacDonagh, Oliver, 'The Irish Famine Emigration to the United States', *Perspectives in American History*, 10 (1976), 430–46.
Macinnes, Allan I., *Union and Empire: The Making of the United Kingdom in 1707* (Cambridge, 2007).
MacKenzie, John M., *Propaganda and Empire: The Manipulation of British Public Opinion, 1880–1960* (Manchester, 1984).
MacPherson, D., *Women and the Orange Order: Female Activism, Diaspora and Empire in the British World, 1850–1940* (Manchester, 2016).
MacRaild, Donald M., *Faith, Fraternity and Fighting: The Orange Order and Irish Migrants in Northern England, c. 1850–1920* (Liverpool, 2005).
Maher, Denis J., *The Tortuous Path: The Course of Ireland's Entry into the EEC 1948–73* (Dublin, 1986).
Maidment, Brian, 'Entrepreneurship and the Artisans: John Cassell, the Great Exhibition and the Periodical Idea', in Louise Purbrick (ed.), *The Great Exhibition of 1851: New Interdisciplinary Essays* (Manchester, 2001), pp. 79–113.
Malloy, Caroline R., 'Exhibiting Ireland: Irish Villages, Pavilions, Cottages, and Castles at International Exhibitions, 1853–1939' (PhD, University of Wisconsin-Madison, 2013).
Mansergh, Nicholas, *The Unresolved Question: The Anglo-Irish Settlement and Its Undoing, 1912–72* (New Haven, CT, 1991).

Mansergh, Nicholas, *The Commonwealth and the Nations: Studies in British Commonwealth Relations* (London, 1948).

Mark-FitzGerald, Emily, *Commemorating the Irish Famine: Memory and the Monument* (Liverpool, 2013).

Marshall, Peter J., 'The English in Asia to 1700', in Nicholas Canny and Wm Roger Louis (eds), *The Oxford History of the British Empire: Volume I: The Origins of Empire: British Overseas Enterprise to the Close of the Seventeenth Century* (Oxford, 1998), pp. 264–85.

McAleer, John and John M. MacKenzie (eds), *Exhibiting the Empire: Cultures of Display and the British Empire* (Manchester, 2015).

McAteer, Michael, 'Reactionary Conservatism or Radical Utopianism? AE and the Irish Cooperative Movement', *Éire-Ireland*, 35:3–4 (2000–01), 148–62.

McCaffrey, Lawrence J., *The Irish Question: Two Centuries of Conflict* (Lexington, KY, 1995).

McCaffrey, Lawrence J., Ellen Skerrett, Michael F. Funchion, and Charles Fanning, *The Irish in Chicago (Ethnic History of Chicago)* (Champaign, IL, 1987).

McClintock, Anne, 'Soft-Soaping Empire: Commodity Racism and Imperial Advertising', in Nicholas Mirzoeff (ed.), *The Visual Culture Reader* (London, 1998), pp. 304–16.

McClintock, Anne, *Imperial Leather: Race, Gender and Sexuality in the Colonial Contest* (New York, 1994).

McDonough, Terence (ed.), *Was Ireland a Colony? Economics, Politics and Culture in Nineteenth-Century Ireland* (Dublin, 2005).

McGarry, Fearghal, 'Southern Ireland, 1922–32: A Free State?', in Alvin Jackson (ed.), *The Oxford Handbook of Modern Irish History* (Oxford, 2014), pp. 647–69.

McGaughey, Jane G. V., *Ulster's Men: Protestant Unionist Masculinities and Militarization in the North of Ireland, 1912–1923* (Dublin, 2012).

McGimpsey, Christopher, 'Internal Ethnic Friction: Orange and Green in Nineteenth Century New York, 1868–1872', *Immigrants and Minorities: Historical Studies in Ethnicities, Migration and Diaspora*, 1 (1982), 39–59.

McMahon, Deirdre, 'Ireland, the Empire, and the Commonwealth', in Kevin Kenny (ed.), *Ireland and the British Empire: Oxford History of the British Empire Companion Series* (Oxford, 2004), pp. 182–219.

McMahon, Deirdre, 'A Larger and Noisier Southern Ireland: Ireland and the Evolution of Dominion Status in India, Burma and the Commonwealth, 1942-9', in Michael Kennedy and Joseph M. Skelly (eds), *Irish Foreign Policy, 1919–66* (Dublin, 2000), pp. 155–91.

McMahon, Deirdre, 'Ireland and the Empire-Commonwealth, 1900–1948', in Wm Roger Louis and Judith M. Brown (eds), *The Oxford History of the British Empire. Vol IV. The Twentieth Century* (Oxford, 1999), pp. 138–62.

McMahon, Deirdre, *Republicans and Imperialists: Anglo-Irish Relations in the 1930s* (London, 1984).

McVeigh, Robbie, 'Is Sectarianism Racism? Theorising the Racism/Sectarianism Interface', in David Miller (ed.), *Rethinking Northern Ireland: Culture, Ideology and Colonialism* (London, 1998), pp. 179–94.

McVeigh, Robbie, '"There's No Racism because There's No Black People Here": Racism and Antiracism in Northern Ireland', in Paul Hainsworth (ed.), *Divided Society: Ethnic Minorities and Racism in Northern Ireland* (London, 1998), pp. 11–32.

McVeigh, Robbie, *The Racialization of Irishness: Racism and Anti-Racism in Ireland* (Belfast, 1996).

McVeigh, Robbie, 'The Last Conquest of Ireland? British Academics in Irish Universities', *Race and Class*, 37 (1995), 109–22.

Meagher, Timothy, 'Irish America', in Eugenio F. Biagini and Mary E. Daly (eds), *The Cambridge Social History of Modern Ireland* (Cambridge, 2017), pp. 497–514.

Merrill, Lisa, 'Exhibiting Race "under the World's Huge Glass Case": William and Ellen Craft and William Wells Brown at the Great Exhibition in Crystal Palace, London, 1851', *Slavery and Abolition*, 33:2 (2012), 321–36.

Miller, Kerby A., 'Ulster Presbyterians and the "Two Traditions" in Ireland and America', in J. J. Lee and Marion R. Casey (eds), *Making the Irish American: History and Heritage of the Irish in the United States* (New York, 2007), pp. 255–70.

Miller, Kerby A., ' "Scotch-Irish" Myths and "Irish" Identities in Eighteenth and Nineteenth Century America', in Charles Fanning (ed.), *New Perspectives on the Irish Diaspora* (Carbondale, IL, 2000), pp. 81–98.

Miller, Kerby A., 'Class, Culture and Immigrant Group Identity in the United States: The Case of Irish-American Ethnicity', in Virginia Yans-McLaughlin (ed.), *Immigration Re-Considered* (Oxford, 1990), pp. 97–125.

Miller, Kerby A., *Emigrants and Exiles: Ireland and the Irish Exodus to North America* (Oxford, 1985).

Mitchell, Timothy, *Colonising Egypt* (Berkeley, CA, 1991).

Mitchell, Timothy, 'The World as Exhibition', *Comparative Studies in Society and History*, 31:2 (1989), 217–36.

Moody, T. W., F. X. Martin and F. J. Byrne (eds), *A New History of Ireland. Vol. IX. Maps, Genealogies, Lists* (Oxford, 1984).

Moody, T. W., F. X. Martin, and F. J. Byrne (eds), *A New History of Ireland. Vol. VIII. A Chronology of Irish History to 1976, I* (Oxford, 1982).

Moran, Gerard P., *Sending out Ireland's Poor: Assisted Emigration to North America in the Nineteenth Century* (Dublin, 2004).

Morgan, Hiram, 'An Unwelcome Heritage: Ireland's Role in British Empire-Building', *History of European Ideas*, 9 (1994), 619–25.

Moss, Kenneth, 'St Patrick's Day Celebrations and the Formation of Irish-American Identity, 1845–1875', *Journal of Social History*, 29:1 (1995), 125–48.

Moulton, Mo, *Ireland and the Irish in Interwar England* (Cambridge, 2014).

Mulligan, Fergus, *William Dargan: An Honourable Life, 1799–1867* (Dublin, 2013).

Murdoch, Alexander, *British History, 1660–1832: National Identity and Local Culture* (Basingstoke, 1998).

Nash, Catherine, 'Visionary Geographies: Designs for Developing Ireland', *History Workshop Journal*, 45:1 (1998), 49–78.

Nelson, Bruce, *Irish Nationalists and the Making of the Irish Race* (Oxford, 2012).

NicGhabhann, Niamh, *Medieval Ecclesiastical Buildings in Ireland, 1789–1915: Building on the Past* (Dublin, 2015).

Niquette, M. and W. J. Buxton, 'Meet Me at the Fair: Sociability and Reflexivity in Nineteenth-Century World Expositions', *Canadian Journal of Communication*, 22 (1997), 81–133.

O'Brien, Joseph V., *'Dear, Dirty Dublin': A City in Distress 1899–1916* (London, 1985).

O'Connor, Barbara, ' "Colleens and Comely Maidens": Representing and Performing Irish Femininity in the Nineteenth and Twentieth Centuries', in Eóin Flannery and

Michael Griffin (eds), *Ireland in Focus: Film, Photography, and Popular Culture* (Syracuse, NY, 2009), pp. 144–65.

O'Connor, Éimear, *Art, Ireland, and the Irish Diaspora: Chicago, Dublin, New York 1893–1939: Culture, Connections, and Controversies* (Dublin, 2020).

O'Connor, John P., ' "For a Colleen's Complexion": Soap and the Politicization of a Brand Personality, 1888–1916', *Journal of Historical Research in Marketing*, 6:1 (2014), 29–55.

O'Connor, John P., ' "Déanta i nÉirinn": The Reconstruction of Irish Stereotypes, 1888–1914' (PhD, University of Limerick, 2012).

O'Day, Alan, 'A Conundrum of Irish Diasporic Identity: Mutative Ethnicity', *Immigrants and Minorities: Historical Studies in Ethnicities, Migration and Diaspora*, 27:2 (2009), 317–39.

O'Day, Alan, 'Varieties of Anti-Irish Behaviour in Britain, 1846–1922', in Panikos Panayi (ed.), *Racial Violence in Britain in the Nineteenth and Twentieth Centuries* (Leicester, 1996), pp. 26–43.

O'Day, Alan, 'The Political Organization of the Irish in Britain, 1867–90', in Roger Swift and Sheridan Gilley (eds), *The Irish in Britain 1815–1939* (London, 1989), pp. 183–211.

O'Donnell, Sean, 'The Works of William Dargan', *Éire-Ireland*, 22:1 (1987), 151–4.

O'Driscoll, Mervyn, Dermot Keogh, and Jérôme aan de Wiel (eds), *Ireland through European Eyes: Western Europe: The EEC and Ireland, 1945–1973* (Cork, 2013).

O'Farrell, Patrick, *Ireland and England since 1800* (Oxford, 1970).

O'Leary, Jeffrey M., 'Manufacturing Reality: The Display of the Irish at World's Fairs and Exhibitions 1893 to 1965' (PhD dissertation, Kent State University, 2015).

O'Malley, Kate, *Ireland, India and Empire. Indo-Irish Radical Connections, 1919–64* (Manchester, 2009).

O'Regan, John and Nicola Dearey (eds), *Michael Scott, Architect, in (Casual) Conversation with Dorothy Walker* (Kinsale, 1995), pp. 96–102.

O'Sullivan, Kevin, *Ireland, Africa and the End of Empire* (Manchester, 2012).

Ohlmeyer, Jane, 'Ireland, India and the British Empire', *Studies in People's History*, 2:2 (2015), 169–88.

Ohlmeyer, Jane, 'Conquest, Civilization, Colonization: Ireland, 1540–1660', in Richard Bourke and Ian MacBride (eds), *The Princeton Guide to Modern Irish History* (Princeton, NJ, 2015), pp. 220–47.

Ohlmeyer, Jane, 'A Laboratory for Empire? Early Modern Ireland and English Imperialism', in Kevin Kenny (ed.), *Ireland and the British Empire: Oxford History of the British Empire Companion Series* (Oxford, 2004), pp. 26–60.

Olick, Jeffrey K. and Joyce Robbins, 'Social Memory Studies: From "Collective Memory" to the Historical Sociology of Mnemonic Practices', *Annual Review of Sociology*, 24 (1998), 105–40.

Ollerenshaw, Philip, 'Businessmen in Northern Ireland and the Imperial Connection, 1886–1939', in Keith Jeffery (ed.), *An Irish Empire: Aspects of Ireland and the British Empire* (Manchester, 1996), pp. 169–90.

Ollerenshaw, Philip, 'Industry 1820–1914', in Liam Kennedy and Philip Ollerenshaw (eds), *An Economic History of Ulster* (Manchester, 1985), pp. 62–108.

Patterson, Henry, 'Unionism, 1921–72', in Alvin Jackson (ed.), *The Oxford Handbook of Modern Irish History* (Oxford, 2014), pp. 692–710.

Patterson, Henry, *Ireland's Violent Frontier: The Border and Anglo-Irish Relations* (Houndsmills, 2013).

Peatling, Gary K., 'The Whiteness of Ireland under and after the Union', *Journal of British Studies*, 44:1 (2005), 115–33.
Peatling, Gary K., 'The Whiteness of Ireland under and after the Union: A Response to the Commentators', *Journal of British Studies*, 44:1 (2005), 134–45.
Peatling, Gary K., *British Opinion and Irish Self-Government, 1865–1925: From Unionism to Liberal Commonwealth* (Dublin, 2001).
Philip, Kavita, 'Race, Class and the Imperial Politics of Ethnography in India, Ireland and London, 1850–1910', *Irish Studies Review*, 10:3 (2002), 289–302.
Poole, Deborah, *Vision, Race, and Modernity: A Visual Economy of the Andean Image World* (Princeton, NJ, 1997).
Potter, David M., *People of Plenty* (Chicago, IL, 1955).
Pratt, Mary L., *Imperial Eyes: Travel Writing and Transculturation* (London, 2008).
Purbrick, Louise, 'Defining Nation: Ireland at the Great Exhibition of 1851', in Jeffrey A. Auerbach and Peter H. Hoffenberg (eds), *Britain, the Empire, and the World at the Great Exhibition of 1851* (London, 2008), pp. 47–75.
Purbrick, Louise, 'Introduction', in Louise Purbrick (ed.), *The Great Exhibition of 1851: New Interdisciplinary Essays* (Manchester, 2001), pp. 1–25.
Qureshi, Sadiah, *Peoples on Parade: Exhibitions, Empire and Anthropology in Nineteenth Century Britain* (Chicago, IL, 2011).
Rains, Stephanie, 'Colleens, Cottages and Kraals: The Politics of "Native" Village Exhibitions', *History Ireland*, 19:2 (2011), 30–3.
Rains, Stephanie, 'The Ideal Home (Rule) Exhibition: Ballymaclinton and the 1908 Franco British Exhibition', *Field Day Review*, 7 (2011), 4–21.
Rains, Stephanie, *Commodity Culture and Social Class in Dublin, 1850–1916* (Dublin, 2010).
Rains, Stephanie, ' "Here Be Monsters": The Irish Industrial Exhibition of 1853 and the Growth of Dublin Department Stores', *Irish Studies Review*, 16:4 (2008), 487–506.
Reed, Christopher R., *All the World Is Here: The Black Presence at the White City* (Bloomington, IN, 2002).
Richards, Thomas, *The Commodity Culture of Victorian England: Advertising and Spectacle, 1851–1914* (Stanford, CA, 1990).
Roddy, Sarah, Julie-Marie Strange, and Bertrand Taithe, *The Charity Market and Humanitarianism in Britain, 1870–1912* (London, 2018).
Roediger, David R., *Towards the Abolition of Whiteness* (New York, 1994).
Roediger, David R., *The Wages of Whiteness: Race and the Making of the American Working Class* (New York, 1991).
Roemer, Kenneth M., *The Obsolete Necessity: America in Utopian Writings, 1888–1900* (Kent, OH, 1976).
Rohs, Stephen, *Eccentric Nation: Irish Performance in Nineteenth Century New York City* (Cranbury, NJ, 2009).
Rolston, Bill, 'Are the Irish Black?', *Race and Class*, 41:1 (1999), 95–102.
Rosenberg, Chaim M., *America at the Fair: Chicago's 1893 World's Columbian Exposition* (San Francisco, CA, 2008).
Rothery, Sean, *Ireland and the New Architecture 1900–1940* (Dublin, 1991).
Ruane, Joseph and Jennifer Todd, *The Dynamics of Conflict in Northern Ireland: Power, Conflict and Emancipation* (Cambridge, 1996).
Rydell, Robert W., John E. Findling, and Kimberly E. Pelle, *America: World's Fairs in the United States* (Washington, DC, 2013).

Rydell, Robert W. and Rob Kroes, *Buffalo Bill in Bologna: The Americanization of the World, 1869–1922* (Chicago, IL, 2013).

Rydell, Robert W., 'New Directions for Scholarship about World Expos', in Kate Darian-Smith, Richard Gillespie, Caroline Jordan, and Elizabeth Willis (eds), *Seize the Day: Exhibitions, Australia and the World* (Melbourne, 2008), pp. 4–5.

Rydell, Robert W., 'Souvenirs of Imperialism: World's Fairs' Postcards', in Christraud M. Geary and Virginia-Lee Webb (eds), *Delivering Views: Distant Cultures in Early Postcards* (Washington, DC, 1998), pp. 147–77.

Rydell, Robert W. and Nancy Gwinn (eds), *Fair Representations: World's Fairs and the Modern World* (Amsterdam, 1994).

Rydell, Robert W., *World of Fairs: The Century-of-Progress Expositions* (Chicago, IL, 1993).

Rydell, Robert W., *The Books of the Fairs: Materials about World's Fairs, 1834–1916* (Chicago, IL, 1992).

Rydell, Robert W., *All the World's a Fair: Visions of Empire at American International Expositions, 1876–1916* (Chicago, IL, 1984).

Ryle, Martin, *Journeys in Ireland: Literary Travellers, Rural Landscapes, Cultural Relations* (London, 1999).

Said, Edward, 'Orientalism Reconsidered', *Race and Class*, 27 (1985), 1–15.

Said, Edward, *Orientalism; Culture and Imperialism* (London, 1978).

Samuel, Mark W. and Kate Hamlyn, *Blarney Castle: Its History, Development, and Purpose* (Cork, 2007).

Saris, Jamie, 'Imagining Ireland in the Great Exhibition of 1853', in Leon Litvack and Glen Hooper (eds), *Ireland in the Nineteenth Century: Regional Identity* (Dublin, 2000), pp. 66–86.

Scally, Robert, *The End of Hidden Ireland: Rebellion, Famine, and Emigration* (Oxford, 1995).

Schaffer, Gavin and Saima Nasar, 'The White Essential Subject: Race, Ethnicity, and the Irish in Post-War Britain', *Contemporary British History*, 32:2 (2018), 209–30.

Shackleton, Doris F., *Ishbel and the Empire: A Biography of Lady Aberdeen* (Toronto, 1996).

Shannon, Catherine B., *Arthur J. Balfour and Ireland, 1874–1922* (Washington, DC, 1988).

Sheehan, M. C., 'Issues of Cultural Representation and National Identity Explored in the Irish Village, Ballymaclinton at the Franco-British Exhibition, Shepherd's Bush, London, 1908' (MA dissertation, Royal College of Art, 2000).

Short, Audrey, 'Workers under Glass in 1851', *Victorian Studies*, 10:2 (1966), 193–202.

Silverman, Debora, 'The 1889 Exhibition: The Crisis of Bourgeois Individualism', *Oppositions: A Journal of Ideas and Criticism in Architecture*, 8 (1977), 71–91.

Silvestri, Michael, *Ireland and India: Nationalism, Empire and Memory* (London, 2009).

Sivulka, Juliann, *Stronger than Dirt: A Cultural History of Advertising Personal Hygiene in America, 1875–1940* (Amherst, NY, 2001).

Smith, Mark M., *Sensory History* (Berkeley, CA, 2007).

Smyth, Jim, *The Making of the United Kingdom, 1660–1800* (Harlow, 2001).

Stepan, Nancy, *The Idea of Race in Science: Great Britain, 1800–1960* (Hamden, CT, 1982).

Stephen, Daniel, *The Empire of Progress: West Africans, Indians, and Britons at the British Empire Exhibition 1924–25* (New York, 2013).
Stoler, Ann L., *Carnal Knowledge and Imperial Power: Race and the Intimate in Colonial Rule* (Berkeley, CA, 2009).
Stoler, Ann L., 'On Degrees of Imperial Sovereignty', *Public Culture*, 18:1 (2006), 125–46.
Stoler, Ann L. and Frederick Cooper, 'Between Metropole and Colony: Rethinking a Research Agenda', in Ann L. Stoler and Frederick Cooper (eds), *Tensions of Empire: Colonial Cultures in a Bourgeois World* (Berkeley, CA, 1997), pp. 1–58.
Strachan, John and Claire Nally, *Advertising, Literature and Print Culture in Ireland, 1891–1922* (London, 2012).
Swift, Roger and Sean Campbell, 'The Irish in Britain', in Eugenio F. Biagini and Mary E. Daly (eds), *Cambridge Social History of Modern Ireland* (Cambridge, 2017), pp. 515–33.
Swift, Roger, 'Identifying the Irish in Victorian Britain: Recent Trends in Historiography', *Immigrants and Minorities: Historical Studies in Ethnicities, Migration and Diaspora*, 27:2 (2009), 134–51.
Swift, Roger, 'Heroes or Villains?' The Irish, Crime and Disorder in Victorian England', *Albion*, 29:3 (1997), 399–421.
Swift, Roger, *The Irish in Britain: 1815–1914: A Documentary History* (Cork, 1990).
Thompson, Andrew S., *The Empire Strikes Back: The Impact of Imperialism on Britain* (London, 2005).
Thompson, Spurgeon W., ' "Not Only Beef, but Beauty …": Tourism, Dependency, and the Post-colonial Irish State, 1925–30', in Michael Cronin and Barbara O'Connor (eds), *Irish Tourism: Image, Culture, and Identity* (Toronto, 2003), pp. 263–81.
Thompson, Spurgeon W., *The Postcolonial Tourist: Irish Tourism and Decolonization since 1850* (Paris, 2000).
Thuente, M. H., 'The Folklore of Irish Nationalism', in Thomas Hachey and Lawrence McCaffrey (eds), *Perspectives on Irish Nationalism* (Lexington, KY, 2015).
Tirella, Joseph, *Tomorrow-Land: The 1964–65 World's Fair and the Transformation of America* (New York, 2014).
Toibín, Fergal, *The Best of Decades: Ireland in the 1960s* (Dublin, 1996).
Townshend, Charles, *Political Violence in Ireland: Government and Resistance since 1848* (Oxford, 1983).
Tuathaigh, Gearóid Ó., 'Introduction: Ireland 1880–2016: Negotiating Sovereignty and Freedom', in Thomas Bartlett (ed.), *The Cambridge History of Ireland: Volume 4: 1880 to the Present* (Cambridge, 2018), pp. 1–30.
Uroskie, Andrew V., 'New York 1964–1965', in John E. Findling and Kimberly D. Pelle, *Encyclopaedia of World's Fairs and Expositions* (Jefferson, NC, 2008), pp. 330–34.
Vaughan, William E. (ed.), *A New History of Ireland. Vol. VI. Ireland under the Union, II, 1870–1921* (Oxford, 1996).
Vaughan, William E. (ed.), *A New History of Ireland. Vol. V. Ireland under the Union, I, 1801–1870* (Oxford, 1989).
Wade, Louise C., *Chicago's Pride: The Stockyards, Packingtown, and Environs in the Nineteenth Century* (Urbana, IL, 1987).
Walter, Bronwen, *Outsiders Inside: Whiteness, Place and Irish Women* (London, 2001).

Walter, Bronwen, 'Challenging the Black/White Binary: The Need for an Irish Category in the 2001 Census', *Patterns of Prejudice*, 32 (1998), 73–86.

Walthew, Kenneth, 'The British Empire Exhibition of 1924', *History Today*, 31:8 (1981), 34–9.

Ware, Vron, 'Defining Forces: "Race", Gender and Memories of Empire', in Iain Chambers and Curti, Lidia (eds), *The Postcolonial Questions: Common Skies, Divided Horizons* (London, 1996), pp. 142–56.

Ware, Vron, *Beyond the Pale: White Women, Racism and History* (London, 1992).

Weimann, Jeanne M., *The Fair Women* (Chicago, IL, 1981).

Wells, Ronald A., 'Aspects of Northern Ireland Migration to America: Definitions and Directions', *Ethnic Forum*, 4 (1984), 49–63.

Whelehan, Niall (ed.), *Transnational Perspectives on Modern Irish History* (Abingdon, 2014).

Whelehan, Niall, *The Dynamiters: Irish Nationalism and Political Violence in the Wider World, 1867–1900* (Cambridge, 2012).

Wiebe, Robert H., *The Search for Order, 1877–1920* (New York, 1967).

Williams, Margaret M., 'The "Temple of Industry": Dublin's International Exhibition of 1853', in Colum Hourihane (ed.), *Irish Art Historical Studies in Honour of Peter Harbison* (Dublin, 2004), pp. 261–76.

Williams, Raymond, *Culture and Society 1780–1950* (New York, 1983).

Williams, William A., *Empire as a Way of Life* (New York, 1980).

Wills, Claire, 'Language, Politics, Narrative, Political Violence', *Oxford Literary Review*, 13:1 (1991), 21–60.

Winks, Roger W. (ed.), *The Oxford History of the British Empire. Vol V. Historiography* (Oxford, 1999).

Wittke, Carl, *The Irish in America* (Baton Rouge, LA, 1956).

Wright, Julia, *Ireland, India and Nationalism in Nineteenth-century Literature* (Cambridge, 2007).

Wurts, Richard, *The New York World's Fair, 1939–1940: In 155 Photographs* (New York, 1978).

Young, Paul, *Globalization and the Great Exhibition: The Victorian New World Order* (Basingstoke, 2009).

Zuck, Rochelle R., *Divided Sovereignties: Race, Nationhood, and Citizenship in Nineteenth-Century America* (Athens, GA, 2016).

Zuelow, Eric, *Making Ireland Irish: Tourism and National Identity since the Irish Civil War* (Dublin, 2009).

Index

Aberdeen, Lady (Ishbel Hamilton-
 Gordon, Marchioness of Aberdeen
 and Temair)
 activism and political views
 of 56–8, 60–2, 68, 82, 84
 Irish dress code advocated
 by 63–5
 Irish Village of 55, 60, 62–6, 68–9,
 71–4, 77–81, 84–7, 97, 158
Aberdeen, Lord (John Hamilton-Gordon,
 1st Marquess of Aberdeen and
 Temair) 58, 63, 66
Act of Union (1800) 8, 84
agency
 of 'colleens' 110–11
 of exhibition visitors 16
 imperial and state constraints
 on 10, 14
 of Irish individuals 2, 7, 17, 74,
 198, 200
Aiken, Frank 187
Amos, A. B. 112
Ancient Order of Hibernians 83
Anglo-Irish Economic War
 140–1
Anglo-Irish Free Trade Area Agreement
 (AIFTAA, 1965) 171
Anglo-Irish Treaty 99, 128
Angus, Robert 138
anti-consumption campaign 97, 106–7,
 112–13, 120, 199
Ardagh Brooch 147
Ardagh Chalice 70, 155
Armstrong, Meg 68
assimilation 9, 81, 100, 117
autoethnography 69

Balbriggan stockings 64, 114
Balfour, Arthur 59
Balfour Report 133
Ballymaclinton Village 96, 101–21
 'colleens' in 97, 101–5, 107–15,
 118–20
 criticisms of 113–15
 Home Rule and 99, 101
 role of inhabitants 98–9
 whiteness and 100, 102, 105, 110–13,
 115–18, 121
beauty 11, 74, 77–8, 110, 142, 156
Belfast Agreement (1998) 191
Bellefeauille, Pierre de 181, 187–8
Belton, John A. 187–9
Benson, John 36
Bew, Paul 37, 190
'bhoys' 97, 107, 109
Biagini, Eugenio 129, 138, 186
Bienvenu, Paul 182
Blarney Castle 55–6, 72, 78–9
Blarney Stone 72, 102, 105
bodies
 commodified Irish 155–6
 conflation of land and Irish 74, 155–6
 as embodiment of Irishness 63, 85,
 103, 114, 136
 female 78, 103, 114, 137
 Irish working 97
Book of Kells 66, 70
 see also Kells embroidery and motifs
Boundary Commission 129
Boym, Svetlana 81, 175
Breathnach, Ciara 60, 63
Breckenridge, Carol 139
Brennan, J. D. 144

British Empire Exhibition (Glasgow, 1938) 127, 141–52
 Free State Pavilion 143–8, 150–2
 Highland Village 145
 Northern Ireland exhibits 148–52
British Empire Exhibition (London, 1924) 129–40
 Irish Free State's absence from 131–4
 shipping exhibit 136–7
 Ulster Pavilion 127, 134–9
British Empire Exhibition (London, 1925 reopening) 139–40
Brown, David and Robert 96–101, 103, 107
 capitalisation of Irish images 105, 108
 conflation of business and philanthropy 120–1
 Irish utopian vision of 118
 soap marketing 96, 104–5, 111–13
 use of 'colleens' 109–10, 113–14, 119
 see also Ballymaclinton Village
Brussels World Exhibition (1958) 171
Bucknell, L. H. 153
Bureau of International Expositions (BIE) 172
Butt, Isaac 58

capitalism 10, 12, 16, 27, 29, 31, 33, 40, 42, 85, 88, 113, 118, 137, 159, 174, 189, 198–200
 see also commodification and commercialisation
Carrickfergus Castle 157–8
Carson, Edward 99
Carson, Rhea I. 108–9
Catholic 37
Catholic Association 38
Catholicism and Catholics 5, 37–8, 59, 78, 99–100, 117–19, 129, 141, 151, 170, 190
Cavendish, William 131–2
Celtic Revival movement 61, 66, 85, 114
Chicago World's Fair
 see World's Columbian Exposition (Chicago, 1893)

Chipman, Tony 183–4
Clan na Gael 83
Clarke, Travis 132
Codell, Julie F. 137
'colleens' 76–7
 in Aberdeen's Irish Village 74, 77
 agency of 110–11
 in Ballymaclinton Village 97, 101–5, 107–15, 118–20
 in Hart's Irish Village 72
 letters written by 108–10
commodification and commercialisation
 Irish American participation in 16
 of Irish tradition and tropes 4, 10, 96–8, 107, 116, 155–6, 178, 201
 of whiteness 96–8, 100–1, 111–12
 see also capitalism
Congested Districts Board (CDB) 60–1, 65
Conn, Seven 84
Constitution of Northern Ireland Act 1973 191
Constructive Unionism 60
consumption
 see anti-consumption campaign
Cosgrave, William 140
cottage industries 61–2, 86–7
Council of Europe 171
Council of the League 140
Craig, James 138
Crooke, Elizabeth 8, 13, 70, 83, 104
Crossley, F. W. 112–13
Crystal Palace
 see Great Exhibition of the Works of Industry of All Nations (London, 1851)
Cuív, Brian Ó 83
Cullen, Fintan 154
Cumman na nGaedheal 140
Curtis, L. P. 120

dairy industry 77, 156
Daly, Mary E. 170–1, 174, 189
Dargan, William 37–8, 46–7, 57, 85
Davidson, John M. 148
Davies, Alun C. 35
Delaney, Enda 31, 46, 100

228 Index

de Valera, Éamon
 1937 constitution 141
 1964 New York Fair and visit 173, 177
 Anglo-Irish Economic War 140–1
 external association policy 127, 140–1, 143, 148, 159
 Fianna Fáil 140
 interwar exhibits and fairs 152, 155–6
 Land Wars 9
 trade policies 170
Devane, Andrew 173
diaspora, Irish 12–13
 scholarship 198
 statistics 58–9
diasporic imagination 59
display, use of the term 3
Donegal Industrial Fund (DIF) 56, 65–86
Doyle, David Noel 59, 81
Drapeau, Jean 188
Dubai Expo (2022) 197
Dumas, François G. 96, 114
Dun Emer 85
Dupuy, Pierre 182–4

entrepreneurs 4, 11, 15, 26, 29, 56, 63, 86, 176, 199
European Economic Community (EEC) 16, 170–1, 174
Expo Milan (2015) 197
Exposition Universelle (Paris, 1889) 61

Famine
 Dublin 1853 Exhibition and 36, 41–4, 46–8
 post-Famine reconstruction 5, 12, 14, 26–7, 29–31, 33–4
 potatoes and 32, 41, 46, 59–60, 155
femininity 77, 101, 200
Fenian Brotherhood 83
Findling, John E. 16
First World War 99, 130
Fitzpatrick, David 99–100
Flannery, Eóin 8
Foster, Roy 84, 174, 191
Franco-British Exhibition (London, 1908) 97, 101–4, 107, 119–20

free trade 12, 27, 30, 40, 85, 151, 170–1, 186
Fritzsche, Peter 80

Gaelic Athletics Association 61
Gaelic League 61, 83, 114
Gaelic Revival 57, 84–5, 87
Galpin, Edward 183
Garner, Steve 114
Garvin, Tom 189
George V, King 130
Gill, E. W. T. 185, 189
Gladstone, William Ewart 58, 99
Glasgow Exhibition
 see British Empire Exhibition (Glasgow, 1938)
globalisation 5, 16, 42, 136–7, 143, 191
Good Friday Agreement (1998) 191
Government of Ireland Act (1920) 99, 128
Great Depression 138
Great Exhibition of the Works of Industry of All Nations (London, 1851) 1, 28–31, 197
Great Industrial Exhibition of Art and Industry (Dublin, 1853) 26, 35–48
Greenhalgh, Paul 115

Hall, Catherine 13
Hall, Stuart 100
Hanover Exposition (2000) 197
Harkness, D. W. 140
Hart, Alice 68–71, 158
 activism and political views of 56–8, 60–3, 82, 84–5, 87
 Irish Village of 55, 60, 65–6, 69–72, 80, 83–7, 97, 104
Hatchell, James 132–3
Healy, Tim 131
Heaslip, Kester 187
Helland, Janice 61, 65, 70, 85–6
Henderson, Alderman 150
Herkner, Frederick 154
Hickman, Mary 100, 117
high crosses 105, 117
historiography 11, 100, 105, 198
Hoffenberg, Peter 30

Index

Holmes, Andrew 129, 138
Home Rule
 see Irish Home Rule
Home Rule League 58
Hughes, Deborah 131
hybridity 8, 10, 27
Hyde, Douglas 83

imperialism 8–12, 31
 anti-Irish discrimination and 5
 capitalism and 97
 contact zones 69
 patriarchal concerns of 110
 whiteness and 96–8, 116, 121
 see also British Empire Exhibition (London, 1924); British Empire Exhibition (Glasgow, 1938)
in between space 55
industrialists 4, 26–7, 29, 31, 35, 43, 131, 199
International Exhibition of Industry, Science and Art (Edinburgh, 1886) 61, 65
internationalism 134, 199
 see also globalisation
Irish Civil War 99, 127
Irish consciousness 11, 84, 107
Irish Export Board 182
Irish Home Rule 58, 66, 69, 79–80, 84–7, 99
 capitalism and 98, 101
 Catholicism and 78
 land question and 82
 nationalism and 85, 118
 propaganda and 150, 198
Irish Industrial Exhibition (Cork, 1852) 1
Irish Industrial Exhibition (Dublin, 1907) 97, 101
Irish Industries Association (IIA) 56, 60–1, 65–6, 74, 85
Irish Nationality and Citizenship Act (1935) 140
Irish National Land League
 see Land League
Irish Parliamentary Party 58
Irish Republican Army (IRA) 99, 128–9, 190
Irish Revival movement 61, 66, 85
Irish Tourist Association (ITA) 146, 155

Irish Tourist Board 156, 175, 182–3
Irish War of Independence 99, 127–8

Jackson, Alvin 9
Jacobson, Matthew Frye 81
Japan Expo (Aichi, 2005) 197
Jasmin, Yves 189
Jenkins, Brian 83
Johnson, Lyndon 177
Johnson, Richard J. H. 177

Kaplan, Flora 13
Keating, Sean 154
Keavy, Sean 144
Kells embroidery and motifs 61, 66, 70, 104
Kennedy, John F. 172, 176
Kenny, Kevin 8
Kiberd, Declan 84, 107
Kilkenny Woodworkers 106
Kinealy, Christine 47
King, Carla 60
Kriegel, Lara 30

Ladies Land League 83
laissez-faire economics and politics 27, 40
Land League 61
Land Wars 9
Larmour, Paul 61, 153
League of Nations 140
Leerssen, Joep 8
Lemass, Seán 170, 177, 183, 185–6, 188–9
Locock, Guy 151
London International Inventions Exhibition (1885) 61
London-Irish Girl Pipers 178
Lynch, Jack 175–6, 183

McCauley, Leo T. 152, 154
McClintock, Anne 112
McCordick, J. A. 185
McGarry, Fearghal 128
McGrath, Joseph 132
MacKenzie, John 13
McKeown, Robert 138
McMahon, Deirdre 133
McNeill, James 132
MacPherson, Donald 119

Maguire, John Francis 32–5
Malloy, Caroline 147, 154
Maquire, John Francis 43
Marshall, K. L. 181–2
Mary, Queen 148
mechanisation 28, 31, 34, 41,
 55–6, 118
 of economy 131, 137
 gendered 35
 humanising 137
 religious views of 46
 of rural industries 57, 68, 81,
 87, 179
Miller, Kerby 82
Milligan, James 46
Mitchell, Timothy 38
Montreal World Expo (1967) 180–9
 Irish agreement to participate
 in 185–7
 Irish negotiations and
 discussion 180–5
 Irish withdrawal from 187–9
Moses, Robert 172, 177
Moulton, Mo 100, 128
museums 13, 200

Nally, Claire 84–5
Nasar, Saima 117
Nation, The (Irish nationalist
 newspaper) 58
National Health Service 170
National Industrial Exhibition of
 Ireland (Cork, 1852) 32–5
nationalism 8, 200
 Catholic nationalism 37
 economic nationalism 85
 golden age of 70
 Irish American nationalism 48,
 56, 82–3
 Irish Home Rule and 82–5, 98,
 101, 118
 museums and 13
 nineteenth-century exhibitions and
 27, 32, 35
 unionist nationalism 152
National Literary Society 61, 83
Nelson, Bruce 59
New York World's Fair (1939) 15, 127,
 152–8, 172
 Irish Free State Pavilion 152–6

Northern Ireland exhibits and
 participation 152, 157–8
New York World's Fair (1964) 172–9
 Irish Pavilion 175–9, 184
North Atlantic Treaty Organisation
 (NATO) 170
nostalgia 8–9, 12–13
 in nineteenth century 40, 43, 56–9,
 80–2, 87, 97
 reflective 175
 restorative 175
 in twentieth century 101, 188–9
nostalgic remembering 77, 80

O'Brien, John 179
O'Connell, Daniel 37–8, 84
O'Connor, Barbara 97, 110, 115
O'Connor, Éimear 61
O'Connor, John Philip 101, 117
O'Day, Alan 100
Ohlmeyer, Jane 8–9, 117
Olick, Jeffery K. 80
O'Leary, Jeffrey 177
O'Neill, Terence 189
Orange Order 118
O'Reilly, Molly 108
O'Reilly, Ted 177
Others, racialised 5, 69

Paisley, Ian 190
Parnell, Charles Stewart 58, 61
Patterson, Henry 150
Paxton, Joseph 28
Pearson, Lester B. 188
Pelle, Kimberly D. 16
Petrie, George 104
Philip, Kavita 113, 117
Phoenix Park murders 61
photographs 71–2, 74, 101, 106–7, 182
Playfair, Lyon 29, 38
Plunkett, Horace 60, 86
postcards 72, 101, 103–4, 107–9, 113
Pratt, Mary Louise 69
Presbyterian Church 46, 98
protectionism 85, 170–1
Protestants 5, 37–8, 99–100, 117–19,
 129, 138–9, 150–1
 Ulster Protestants 59
 unionism 96–7, 99, 101, 138
 see also Presbyterian Church

racialisation 5, 9, 11–12, 67–8, 100, 105, 113–14
Rains, Stephanie 110, 113
Rive, Alfred 181–2
Robbins, Joyce 80
Rohs, Stephen 72
romanticism 40, 56, 62, 64, 77, 82, 85, 110, 120
 see also nostalgia
Rothery, Sean 152
round towers 69, 96, 102–5, 155, 173–4
Royal Dublin Society 37, 60
 see also Irish Industries Association (IIA)
Ryle, Martin 82

Saris, Jamie 37
satire 5, 45–6
Schaffer, Gavin 117
Scott, Michael 153
Seattle World Fair (1962) 169, 171–2
Second World War 15, 160, 170
seeing, use of the term 3
Senior, Richard and Thomas 154
sermons 46
Shackleton, Doris French 58
shamrocks 34, 64, 107
 as cliché 154, 177
 commodification of 4
 exhibition building shape 154, 156
 symbolism of 12
Shanghai Expo (2010) 197
Shannon Airport 4, 147, 175, 186
Shannon Basin, The (mural) 154
Shannon Development movement 4, 112, 154
Shaw, William 58
Sinclair, Colin 145
social capital 44
Solemn League and Covenant 99
souvenirs 10, 47, 57, 70, 72, 84, 87, 136–7, 145, 198
Stephens, H. W. L. 189
Strachan, John 84–5
Swift, Roger 99

tabula rasa, exhibitions as 9, 12, 43
Tallis, John 30
Tara Brooch 17, 70, 72, 155

textile industry 30–1, 63, 101, 136, 158, 179
textile looms 1, 40, 154, 179
Thompson, Spurgeon 105
Thompson, William 112
Trade Agreements of 1938 141, 144
Trevelyan, Charles E. 27, 43, 58
Troubles, The 190
tuberculosis
 see anti-consumption campaign

United Nations 170, 174
urbanisation 29, 110, 170
utopianism 3, 6, 40, 47, 57, 81, 96, 98, 110, 114, 118, 121

Van Buren, Martin 44
Victoria and Albert Museum 155
Victoria, Queen 47
visual, use of the term 3

Walsh, J. J. 181
Walsh, W. H. 182
Walter, Bronwen 113, 115
whiteness 14, 72, 74, 99
 Ballymaclinton Village and 102, 105, 110–18
 commodified 96–8, 100–1
 as global capitalist category 10–12
 performing 15
 scholarship on 10–12
 unionist propaganda based on 119
Williams, Margaret M. 40
World's Columbian Exposition (Chicago, 1893) 55–8
 Irish Village of Alice Hart 55, 60, 65–6, 69–72, 80, 83–7, 97, 104, 158
 Irish Village of Lady Aberdeen 55, 60, 62–6, 68–9, 71–4, 77–81, 84–7, 97, 158
 Midway Plaisance 55, 67–72
 racialised organisation of 67

Yeats, Jack B. 175

Zuck, Rochelle Raineri 59
Zuelow, Eric 155–6

EU authorised representative for GPSR:
Easy Access System Europe, Mustamäe tee 50,
10621 Tallinn, Estonia
gpsr.requests@easproject.com

www.ingramcontent.com/pod-product-compliance
Lightning Source LLC
LaVergne TN
LVHW050048200525
811683LV00004B/75